A

HATTIE

Black Ambition, White Hollywood

"Watts offers a thoughtful portrait of a talented and complex woman." *—Booklist*

"Watts's sympathetic biography . . . tracks the career of the actress who, in 1940, became the first African American ever to win an Oscar. Watts [has a] skill for concise, thematic storytelling." *—New York Times Book Review*

"McDaniel's fascinating story and struggle abound in irony." *—BookPage*

"This engaging tome gives depth to a woman who was plagued by offers of stereotypical roles and the anger she incurred from African Americans for her willingness to play them." *—Uptown Magazine*

"My deepest gratitude to Jill Watts for making us aware of the life of the extraordinary Hattie McDaniel—multi-talented actress and performer who, though outspoken, never lost her humility. African-American actresses today must acknowledge the dignity and capacity of this highly gifted actress." *—Diahann Carroll*

HATTIE McDANIEL

Jill Watts

• • •

Amistad

An Imprint of HarperCollins*Publishers*

HATTIE McDANIEL

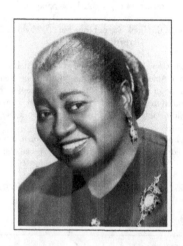

Black Ambition,
White Hollywood

Permission to cite and quote material from the following archival sources is acknowledged with thanks: David O. Selznick Collection, Daniel Mayer Selznick and the Harry Ransom Research Center, The University of Texas at Austin; Roscoe Conkling Simmons Papers, University Archives, Pusey Library, Harvard University; Warner Bros. Archives, School of Cinema and Television, University of Southern California and Warner Bros. Entertainment Inc. Additionally, permission to use photographs from the following sources is also acknowledged with gratitude: California Eagle Collection, Southern California Research Library for Social Studies and Research; Colorado State Archives; Margaret Herrick Library, Academy of Motion Picture Arts and Sciences; Western History Collection, Denver Public Library; Doris Watts; Donald Woo. The author has made every effort to locate and credit owners of copyrighted photographs.

A hardcover edition of this book was published in 2005 by Amistad, an imprint of HarperCollins Publishers.

HarperCollins books may be purchased for educational, business, or sales promotional use. For information, please e-mail the Special Markets Department at SPsales@harpercollins.com.

First Amistad paperback edition published 2007.

Designed by Kate Nichols

The Library of Congress has cataloged the hardcover edition as follows:

Watts, Jill
Hattie McDaniel : Black ambition, white Hollywood / Jill Watts.—1st ed.
p. cm.
Filmography:
Includes bibliographical references.
ISBN-10: 0-06-051490-6 (acid-free paper)
ISBN-13: 978-0-06-051490-7
1. McDaniel, Hattie, 1895–1952. 2. Motion picture actors and actresses—United States—Biography. I. Title.

PN2287.M165W38 2005
791.4302'8'092—dc22
2005042126

ISBN: 978-0-06-051491-4
ISBN-10: 0-06-051491-4

HB 05.17.2021

To Sarah and Abby Woo

and

To the Memory of Richard Newman

Acknowledgments

ALTHOUGH SOME SAY that writing a book is a solitary endeavor, for me that has not been completely true. This book came about because of the help and support of many people, and to all of them I am tremendously grateful.

Finding material on Hattie McDaniel was not easy, and this project benefited significantly from the assistance of archivists and librarians. I owe a great debt to Howard Prouty, Barbara Hall, Jenny Romero, and Fay Thompson of the Margaret Herrick Library of the Academy of Motion Picture Arts and Sciences; Ned Comstock of the Performing Arts Archives and Randi Hockett of the Warner Bros. Archives, both at the University of Southern California; Gwendolyn Crenshaw and Brent Wagner of the Denver Public Library; Terry Ketelsen and George Orlowski of the Colorado State Archives; Steve Wilson of the Harry Ransom Humanities Research Center of the University of Texas at Austin; Cheryl Collins and Linda Glasgow of the Riley County Historical Society and Museum in Manhattan, Kansas; Julie Graham and Lauren Buisson of the Arts Library Special Collections at the University of California, Los Angeles; Teri

Robertson of the Southern California Library for Social Studies and Research; and Frances West of the Lincoln County, Tennessee, Library. I am also grateful to Daniel Mayer Selznick for allowing me access to the David O. Selznick Collection, and to Bill Fagelson, who provided me with outstanding research assistance in that collection. Additionally, Petula Iu of the University of California, Los Angeles, helped me to complete some important parts of my research in the Special Collections division of the University Research Library. My thanks also goes to Lelond Holbert for sharing his research on his Holbert family line, Danny Goodwin for his guidance on the history of radio, and Sameerah W. S. Muhammad of Angelus-Rosedale, Inc. for providing me with key historical information on the Rosedale cemetery. I appreciate the support provided by the librarians at California State University, San Marcos, including Debbie Blair, Rosa Castro, Judith Downey, and Teri Roudenbush. I am grateful to California State University, San Marcos, for its encouragement during this project and the students in my classes who have been a constant source of inspiration.

This book was greatly enriched by the memories of Hattie McDaniel's good friend Wonderful Smith, who graciously invited me to his home for an interview. Additionally, I am grateful for the help and support of the family of Ruby Berkley Goodwin, the first African-American woman journalist to cover Hollywood, who later became Hattie McDaniel's close friend and personal secretary. Thanks go to Ethel Jordan, Ruby Berkley Goodwin's daughter, for spending time talking with me about her mother and Hattie McDaniel. I am also grateful to Paul Goodwin, Ruby Berkley Goodwin's son, who as a child lived with Hattie McDaniel and who so generously shared his memories. James Goodwin, Ruby Berkley Goodwin's oldest son, spent hours talking with me and reading materials I sent him. I thank him and his wife, Eva, for their insights and friendship.

I have also been fortunate to have the support of good friends and colleagues. My thanks go to Peter Arnade, Belynda Bady, Staci Beavers, Emily Bernard, Lois Brown, Randall Burkett, Jeff Charles, Cara Fraker, Michael Fitzgerald, Carol V. R. George, Ben Holman, Judy Kutulas, Sherry Little, Anne Lombard, Carmen Nava, Martha Nochimson, Barry Moreno, B. J. Piracci, Ellen Slatkin, Emory Tolbert, Margaret Washing-

ton, Richard Weiss, and Zhiwei Xiao. This project benefited significantly from the comments of Richard Newman, who was not only a committed scholar of African-American studies but possessed an encyclopedic memory of black history. He read early drafts of the chapters that follow and, even after felled by illness and unable to read, continued to advise, encourage, and cajole me along until his death. I mourn the loss not only of a true friend but a scholar and a mentor.

My gratitude also extends to my agent, Victoria Sanders, who helped me refocus a much larger project regarding African Americans in Hollywood, which had grown out of my book on Mae West, into a biography of Hattie McDaniel. I am grateful to her for her wholehearted belief in this book. I owe a debt of gratitude to Imani Wilson, who read and made helpful comments on the proposal for this project. I also thank my editor, Dawn Davis, for her commitment to the book and her insights, as well as her kind support. My thanks also go to her assistant, Stacey Barney, for her cheerful helpfulness.

My special thanks go to my family. My mother, Doris Watts, has read every word of this manuscript. Her knowledge, love, and understanding have sustained me. Wally, the dog, has been a patient friend. My aunt, Nancy Peck, and my uncle, Bill Watts, have offered solid encouragement along the way. I also thank my sister and brother-in-law, Rebecca and Donald Woo, for standing by me as I have worked on this project. My nieces, Sarah and Abby Woo, have remained constant sources of joy. I only hope that the work I do in some way helps to make the world they will inherit a better place.

Contents

Contents

Hattie McDaniel

HARPER PERENNIAL

1

. . .

Your Father Wore
the Blue . . .

. . .

*Your father wore the blue, greatest sign of free men history
speaks of; wore it like a man and a soldier.*

Roscoe Conkling Simmons to Hattie McDaniel,
January 5, 1945

I N EARLY SPRING 1915, the McDaniel family of Denver, Colorado,
received a questionnaire from the United States Department of Inte-
rior. A survey of veterans, it was addressed to Henry McDaniel, a for-
mer Civil War soldier who had served in Tennessee's Twelfth United States
Colored Infantry. In failing health and with a limited education, he called
upon his youngest daughter, Hattie, to help fill out the form. As her father
spoke, Hattie McDaniel carefully inscribed the story of her family, detail-
ing the events of her father's life before, during, and after the Civil War.
Indeed, that war had impacted both the nation and Henry McDaniel. He
had returned from battle so badly injured that it would shape the rest
of his life and, later, the lives of his wife and children. In many ways, al-
though she was born almost thirty years after the conflict was over, Hattie
McDaniel was a child of the Civil War. Her father's war wounds were a
daily reminder of his fight for his country and against slavery and racism.
On that spring day in 1915, many, many miles away from Hollywood, the
town that would make her famous, Hattie McDaniel sat with her father,
listening as he told her about his past and her history.[1]

Born into slavery in Spotsylvania County, Virginia, Henry McDaniel was never certain of his birth date. He thought it was in October, probably the fifteenth, and guessed that since he was able to work a plow alone by 1847, he must have been born about 1838. He seemed to have no memories of his mother or father. But he clearly recalled growing up with his older sister and younger brother on the plantation of Robert Duerson. Although Duerson was not among the largest slave-owners, he came from an old Virginia planter family that had held slaves for several generations. In 1840, when Henry McDaniel was still a toddler, Duerson had thirteen slaves, seven working his fields exclusively. As was Southern practice, only the very old and the youngest, in this case Henry and his newborn brother, were exempt from labor.[2]

By the time he was five, Henry McDaniel was put to work weeding fields and caring for Duerson's livestock. From the beginning, life was hard for Henry McDaniel. Slavery in the United States had first sprung on Virginia soil, and by the 1800s, the cruel institution was well entrenched. Slaves were defined as property and subject to the demands and whims of their masters. Denied all rights, including that to marry, to hold property, to possess firearms, to vote, and, in many places, to learn to read and write, those enslaved had no protection under the law. At some point, most families were broken up by sale. The labor demanded by masters was grinding; workdays lasted from dawn to dusk. Punishments for even the most minor infractions were often whippings, some so brutal that they resulted in death.[3]

Yet those in bondage resisted slavery in a variety of ways—including working slow, pretending to be ill, running away, and maintaining separate and often secret cultural and religious practices. In some cases, slaves resorted to violence in attempts to win their freedom. In 1831, only a few years before Henry McDaniel was born, enslaved preacher Nat Turner led a group of fellow bond servants from Virginia's Southampton County in one of the nation's bloodiest slave uprisings. Although Turner's revolt failed and he was executed, white Virginians became obsessively fearful of further slave rebellions. Subsequently, the state tightened its already oppressive slave codes, stepping up the policing of the black population and suppressing the religious practices of the enslaved. But the slave commu-

nity continued to worship despite these restrictive circumstances. Faith was a cornerstone of those in bondage, and their private religious lives stood as an activist rejection of white domination and the institution of slavery. By many accounts, as an adult, Henry McDaniel was a deeply religious man; his spirituality no doubt evolved during his formative years.[4]

Still, the daily existence of American slaves like Henry McDaniel was bleak. Planters maximized their profit by providing minimal food, clothes, and shelter. Most slaves lived cramped together in either cheaply constructed slave cabins or barns and outbuildings. Provisions were meager; the staples of the slave diet were corn meal and pork fat. Clothing was either hand-me-downs or made from a cheap burlap-like material called slave cloth. Although many masters provided shoes, they were poorly made and fit so badly that even in the winter, many slaves refused to wear them. Medical care was virtually nonexistent. Cut off from his parents, Henry McDaniel's early childhood was one of both hard work and hardship.[5]

About the age of nine, Henry McDaniel faced one of the worst of slavery's horrors. In 1847, Duerson sold him, with his eleven-year-old sister and six-year-old brother, to Sim Eddings, a slave trader from Lincoln County, Tennessee. Although the international slave trade had been outlawed, the domestic trafficking of bondspersons flourished. The cotton economy produced a ravenous demand for labor in the Deep South, and the price of slaves, especially young males, skyrocketed. Eddings was a well-known trader with a thriving business. He transported Henry McDaniel and his siblings to his marketplace in Fayetteville, Tennessee, where he put them up for sale. In autumn 1847, John McDaniel, a farmer who lived near the town of Boonshill in Lincoln County, Tennessee, bought all three. Henry McDaniel was certain it was the fall of 1847; he clearly recalled John McDaniel's flamboyant younger brother Coleman "C. A." McDaniel returning home from fighting in the War with Mexico. Although Henry McDaniel and his siblings escaped separation and being sold into the Deep South, their lives hardly improved. Henry McDaniel was immediately put to work husking corn. Throughout the winter, he chopped firewood and, the following spring, plowed John McDaniel's fields for planting.[6]

John McDaniel, like other farmers of his region, almost certainly made his living raising and selling grain and livestock. As a border state consisting primarily of small cereal farms, Tennessee was not as dependent on large, labor-intensive crops like cotton or tobacco as were other parts of the South. And when it came to slavery, it was a complicated case. In the eastern part of the state, the institution was not particularly common, but at the same time, in western and in middle Tennessee, where Lincoln County was located, slavery held strong. These regions became a thoroughfare for slave traders like Sim Eddings, transporting human "chattel" further south. In fact, Lincoln County was situated on the Tennessee-Alabama border, and slavery was firmly entrenched in the culture and economy of that community.[7]

In these parts of Tennessee, slavery was just as brutal as it was in Virginia and mirrored that state's slave codes. "No master was really good to his slaves," recalled Moses Slaughter, a former slave from Tennessee who also joined the Union Army. "The very fact that he could separate a mother from her babies made him a tyrant. Each master demanded exact obedience from his slaves." It is almost certain that life in Tennessee did not improve much for the young Henry McDaniel.[8]

Slave labor made the white McDaniels wealthy and successful, and like other white families in the region, they clung to the institution. C. A. McDaniel was the most notable member of the family, joining the California Gold Rush, then serving in the Tennessee State Legislature, and marrying into the well-placed Buchanan family. John McDaniel's farming earned him a comfortable income as well as a respected place in society. Records in 1860 show that John McDaniel had eleven slaves (well above the state's average of four) and that his combined worth was over $17,000, a figure that placed him in solid standing among slaveholders of the region.[9]

For over ten years, Henry McDaniel worked John McDaniel's land, plowing and planting his crops. But in 1858, he was probably lent out, most likely to John McDaniel's brother C. B., who owned a farm near the Elk River. Not long after he arrived, Henry McDaniel struck up a friendship with Aaron Holbert, a slave possibly owned by one of the wealthiest families in the region, headed by a planter named Pleasant Holbert. By 1860, Pleasant Holbert held over one hundred slaves who worked his

sizable holdings, but other members of this large family in the nearby areas also listed slaves in their inventories. The white Holberts and white McDaniels shared close ties; like C. A. McDaniel, Pleasant Holbert had also married a Buchanan. So it was not surprising that those they held in bondage, like Henry McDaniel and Aaron Holbert, also became acquainted.[10]

About the same time that Henry McDaniel began working closer to the Elk River, tension and turmoil escalated within the nation. The debate over slavery and its extension into the territories now burned openly, as more vocal sectors of the North called for its end. With the November 1860 election of Abraham Lincoln to the presidency, Southern states, fearing the end of states' rights and of slavery, began seceding from the Union and organizing the Confederacy. Several months later, the first shots of the Civil War were fired at Fort Sumter, South Carolina. A long and deadly conflict ensued, waged by the North to preserve the union and by the South to preserve a way of life that centered on slavery.

With the outbreak of hostilities, Tennessee faced a dilemma. The state's deep divisions made its position within the union initially uncertain. Ultimately, Tennessee's secessionists delivered the state into the hands of the Confederacy. The white residents of Lincoln County played a critical role in this alignment; they voted unanimously to secede and eagerly volunteered to defend the Confederacy. In support of the Southern cause, C. A. McDaniel helped raise Tennessee's Forty-Fourth Confederate Infantry Regiment. He rode off to war ranked as a colonel and led his men in some of the war's fiercest engagements, including the grisly battle at Shiloh. John McDaniel did not join his energetic younger brother. At the age of fifty-three, he was probably too old and too infirm. In October 1861 he made out his will and, only a few weeks later, died. He left all of his slaves, with the exception of one named Adam, to his wife, Mary. Adam, very possibly Henry McDaniel's younger brother, was sold to the son of his deceased master.[11]

Despite the continuance of such complicated transactions, slavery in Lincoln County, as in other parts of the South, was beginning to unravel. Tennessee's centrality and its loyal Unionist strongholds made it a focal point for early federal campaigns. While the state's secessionists vigorously

resisted, by 1863 the Union Army had successfully secured control of much of Tennessee, including the region around the Elk River in Lincoln County. It was a key area both in terms of geography and railway access. In summer 1863, the military began construction on the Nashville and Northwestern Railroad, designed to carry federal troops and supplies through Tennessee to southern battlefields. As the Union Army arrived near the Elk River, former slaves flocked to its lines, claiming freedom under the Emancipation Proclamation of January 1863. Henry and Adam McDaniel, along with several members of the black Holbert family, fled and joined others gathering on the banks of the Elk River in what the army had designated as a "contraband camp." Here, for the first time, Henry McDaniel met Susan Holbert, probably Aaron's sister. She had been born in Tennessee in May 1850 and, like other black Holberts, had spent her entire life in bondage, possibly in the neighboring Giles County. This "contraband camp" would be her first taste of freedom.[12]

In addition to freeing the slaves in the "states in rebellion," the Emancipation Proclamation had authorized the enrollment of African-American soldiers. Urgently needing manpower to build and defend the Nashville and Northwestern Railroad, in July 1863, the military organized the Twelfth United States Colored Infantry Regiment at the Elk River. Within the first week of recruitment, Henry McDaniel signed up, the military scribe recording his name as McDaniels, a misspelling that many would make in the future. Illiterate, Henry McDaniel marked his name on the enlistment application with a steady "X."[13]

While C. A. McDaniel, his former master's brother, led Confederate forces against federal troops, Henry McDaniel commenced the life of a Union soldier of Company C, preparing to fight those same secessionists who had enslaved him. Adam McDaniel also joined, and for almost four months, the two drilled with their regiment in the area around the Elk River. The exercises, as one of the regiment's white officers, Henry V. Freeman, recalled, were absolutely "incessant." White commanders rigorously instructed the new black recruits on military tactics and discipline, quickly dismissing any who failed to live up to the highest standards. The regiments' immediate commanding officers, all white, insisted that these new recruits master not only military protocol but also rudimentary reading

and writing skills. They issued the ill-clad former slaves, many of whom had enrolled with only the clothes on their backs, uniforms and arms. The African-American soldiers embraced their tasks, working hard by day to become the best soldiers the Union Army could field, soaking up as much education as possible, and engaging in prayer services each night. On many different levels, enlisting was liberating for men like Henry and Adam McDaniel. Reverend O. Summers, the African-American chaplain who ministered to the black regiments in Tennessee, recalled that "they were proud of their uniform and desired, above all things, to be led against their ancient and inveterate foes." Finally, in November, Henry McDaniel's regiment was deployed to Nashville to begin construction on the Nashville and Northwestern Railroad. It was not only hard but also dangerous work. Each soldier had the dual duties of both laying and guarding the new lines.[14]

Still, Henry McDaniel's initiation into the military, like that of other African-American soldiers, was difficult. Black troops faced discrimination from white officers and were generally accorded unequal treatment from the United States government. The Twelfth Regiment's senior commander, General George H. Thomas, was a Southerner with tremendous prejudices. He resisted using African-American soldiers in battle, insisting that they would be too fearful to fight their former masters. Additionally, black soldiers' paychecks, when they received them, were significantly smaller than those of their white counterparts. The black troops' equipment and clothing were substandard. That winter, Henry McDaniel was outfitted with a bayonet and rammer, cap, and pouch, all charged against his pay. But soon he would have to turn these in; on January 14, 1864, both Henry and Adam McDaniel were imprisoned in Nashville. The military made no record of the charges against them or of a trial. After almost eight weeks, Adam McDaniel was released and later promoted to corporal. But Henry McDaniel spent the next six months in prison, the length of the sentence at the height of the war indicating that whatever he did, his superior officers considered it a serious infraction.[15]

Once released, Henry McDaniel returned to active duty on the Nashville and Northwestern Railroad. In September 1864, his superiors assigned him to a detachment constructing ammunition-storage facilities

spread out along the tracks. But at the beginning of November, Henry McDaniel rejoined the rest of his regiment, which had begun moving toward Nashville in anticipation of an attack by Confederate Army troops commanded by General John B. Hood. Determined to drive Union forces out of Nashville and seize control of rail lines, the rebels were preparing for a massive push through the region. As the Union troops amassed near the city, no doubt, tensions ran high through the black ranks. The Confederate Army had threatened African Americans with a "no-quarter policy," promising death to all captured black Union soldiers. Only that previous spring, at Fort Pillow near Memphis, the Confederate Army led by General Nathan B. Forrest had massacred many of the black soldiers they had taken prisoner. (Forrest had formerly been Tennessee's largest slave trader.) No doubt the Twelfth United States Colored Infantry could not forget what Forrest had done. In tribute to their fallen comrades, many black soldiers had adopted the cry "Remember Fort Pillow."[16]

Fort Pillow must have been on the minds of men like Henry McDaniel as they encamped outside of Nashville for several weeks in freezing rain and sleet. Finally, on the morning of December 15, they received their orders. With the weather slightly warming and a dense fog lifting, Henry and Adam McDaniel charged with their unit and several other black regiments over Brown's Creek toward the right flank of the Confederate forces. Despite his dismissive attitude toward blacks, Thomas's strategy was to use the black units as decoy to distract Hood's army and slide white troops in behind the rebels. The African-American soldiers fought hard and succeeded in luring the bulk of Hood's army into a bloody battle. That night, having driven the Confederates into the hills, the black regiments halted to rest. But at six o'clock the following morning, at Thomas's orders, they began to advance on the Confederates' position at Overton's Hill. Certainly, the black fighting men quickly realized it was a suicide mission. Between them and the Rebels perched on the ridge lay a freshly plowed field (soggy and muddy from the rain and melting ice), a wooden fence, and a steep rocky hillside thick with a web of low bushes and trees. As the black regiments began charging through the open field and climbing the fence, the clash turned grisly. From the hill, the Confederates fired on the men in

blue struggling below. The African-American soldiers began dropping, dead and wounded, to the ground. They were followed by successive waves of men scrambling bravely up the hill.[17]

Throughout the day, the black regiments fought hard, but the Confederates held their ground. Adam McDaniel eventually left the battlefield; he had taken ill and was sent to a hospital in Nashville. But Henry McDaniel, with a ready rifle, covered an artillery battalion, firing on the Confederate soldiers as he protected the men setting off the cannons. "De noise am awful," recalled John Finnely, another black soldier present at the battle, "jus' one steady roar of guns and cannons." During one exchange, the secessionists sent a volley of shells. One exploded near the right side of Henry McDaniel's head, throwing him to the ground. He roused himself and, although he could not hear, could barely see, and had intense pain in his jaw, he fought on. At the end of the day, the black regiments had lost 64 percent of their men and had failed to take the position. But as one white officer observed, the African-American "troops exhibited courage and steadiness that challenged the admiration of all who witnessed the charge."[18]

Although the African-American regiments did not take Overton's Hill, their deadly assignment did ensure a Union victory, and with Thomas advancing quickly, Hood's army abruptly retreated. The Battle of Nashville was a decisive blow in the Civil War, one of the most important triumphs of the Union forces. Although seriously injured, his jaw shattered by the shell's concussion, Henry McDaniel received no medical attention and, with his unit and several other regiments, was ordered to pursue Hood's army through Tennessee. They had proven themselves to the skeptical Thomas. Henry McDaniel must have been among those black soldiers who, as they marched out of Nashville, paraded past the general proudly singing the abolitionist standard, "John Brown's Body."[19]

Behind the fleeing Confederate troops, the Union Army came. Henry McDaniel, despite his wounds, marched on with his unit. The weather turned bad again, leaving the roads and byways deep with snow, ice, and slush. Even the animals pulling wagons and artillery stubbornly resisted negotiating the paths. Food and supplies ran low but the men pushed

ahead; this was the first time in the war that the Confederate Army had been so soundly defeated in battle. For black troops, it was especially significant. Among the fleeing forces were General Forrest and his men.[20]

On December 23, the Twelfth Regiment boarded a train that took them over the Cumberland Mountains as an advance unit to clear the way for the thundering Union Army behind them. Henry McDaniel and his comrades were ordered onto an open flat car. For over two days, in freezing rain, sleet, and ice, he rode, as one of his commanding officers later recalled, "facing outward, musket in hand, ready to repeal the enemy."[21]

The Union troops chased the Confederate Army into Alabama, where they clashed with the remnants of Hood's army. But Henry McDaniel was not there to enjoy the victory. Compounding the injuries he suffered at Nashville, the long icy ride on the flatcar had left both of his legs frostbitten from his knees to his ankles. On December 26, his commanders sent him to the hospital in Huntsville, Alabama. After only a few weeks of treatment, he was released and returned to active duty. In January 1865, the Twelfth Regiment was recalled to Nashville, and it was likely then that Henry McDaniel received the sad news—Adam had died there of "acute diarrhea" and had been immediately buried. All that was left of Adam McDaniel's personal effects were a pair of trousers and a watch. The government charged him posthumously for a haversack, canteen, and straps.[22]

For Henry McDaniel, the fight continued. And he was still serving when the Union forces triumphed and General Robert E. Lee, the head of the Confederate military, finally surrendered in April 1865. He finally mustered out only when his regiment was disbanded in Nashville on Tuesday, January 16, 1866. He left with a final paycheck from the government, which totaled $5.88. Before the week's end, he had made his way back to the Elk River, where one of the first things he did was attend services at the newly established African Methodist Episcopal (AME) church at the nearby Swan Creek. The AME church was an exclusively black denomination organized in 1816 after African-American leaders separated from Philadelphia's Methodist church protesting the discrimination they had faced in that congregation. Although the AME had been virtually banned in the slaveholding South, once the Civil War was over, it quickly gained converts throughout black communities below the Mason-Dixon Line.

Henry McDaniel's affiliation, like that of others who were uniting with this independent all-black denomination, was a statement of both his deep faith and his continued resolve to resist white domination.[23]

That Sunday, Henry McDaniel met up with Aaron and Susan Holbert. They had been joined by Nicholas Holbert, probably a brother who been held in slavery in Alabama. The Holberts instantly realized that the war had changed Henry McDaniel significantly. As Aaron Holbert recalled, Henry McDaniel had left for battle as a "sound, able-bodied man." But he had returned "with deafness of the right ear," and as Susan Holbert remembered, "He also walked lame and told me that his feet had been frozen." The explosion at the Battle of Nashville had left an open wound inside his mouth, and bone fragments and infection were now oozing from it. Henry McDaniel could do little about it. There was no medical care for veterans, and he could not afford to see a doctor.[24]

Regardless, Henry McDaniel was determined to build a new life in the area where he had once been a slave. He hired out as an agricultural laborer; farming was something that he knew well. On January 30, 1868, he married Louisa "Lou" Harris who worked as a servant in the home of a white family. By 1870, the McDaniels were living near Boonshill on the property of a wealthy white merchant named T. E. Dobbins. Residing with Henry and Lou McDaniel were Mary McDaniel and a teenager named Sally. Both were also working as domestics, and they may have possibly been Henry McDaniel's older sister and her daughter. His good friend Aaron Holbert lived nearby, as did Nicholas and Susan.[25]

Life had also changed for Susan Holbert. On Christmas Day 1867, about a month before Henry McDaniel and Lou Harris tied the knot, she married Charles "Charlie" Staton. Born in Alabama in 1835, Staton was a farm laborer of mixed race, identified as "mulatto" in the United States Census. Most likely, he had also been a slave. Charlie and Susan Staton began to build a family together. In 1868, Susan Staton gave birth to their first child, George. Addie and Orleana ("Lena") quickly followed, in 1870 and 1871. Henry McDaniel remained a special friend of the family, visiting their home at least once a week. Together the McDaniels, Holberts, and Statons attended the AME church on Sundays.[26]

African-American families found that post–Civil War Tennessee was

filled with rapid changes, vast uncertainties, and tremendous challenges. Between 1865 and 1876, Washington lawmakers embarked on reconstruction programs designed to bring the South back into the Union. But as many have pointed out, while the South may have lost the Civil War, it triumphed in the battle over Reconstruction. White Southerners bitterly resisted Republican-led congressional Reconstruction programs aimed at ensuring African Americans education, the vote, and equal rights. Washington lawmakers had established temporary military governments in parts of the former Confederacy, and, in response, white Southerners organized the underground terrorist network, the Ku Klux Klan. (One of the Klan's founders and most active leaders was former Confederate general Nathan B. Forrest.) Henry McDaniel may have directly experienced the horrors of the Klan, which persecuted the African Americans with violence and lynchings. In 1868, Tennessee's Freedman Bureau, assigned to oversee the welfare of the black population, received a complaint made by a Henry McDaniel, who along with two other men, Leander Wright and Nathan Harris, was working as a hired hand in an area recorded as Sinclair County. The three testified that they had been brutally attacked by the KKK, which had warned them against voting for the Union loyalist William G. Brownlow and forced them out of the area.

At every turn, white Southerners tried desperately to turn the clock back to the days of slavery. Probably their most potent weapon came in the form of economics. Ex-bondpersons started out with nothing—no homes, no property, and no jobs. Many had hoped that the United States federal government would compensate them for their years, and often generations, of servitude. Although the military had offered such reparations in some areas early in the war, Washington resolutely refused to redistribute the property of ex-Confederates. With few alternatives left to support their families, many African Americans found themselves locked into the perpetual indebtedness of sharecropping or working for meager wages as laborers for white families who had previously enslaved them.[27]

Still Tennessee's uniqueness made the postwar years slightly different. Reconstruction programs were barely applied in Tennessee, which had hosted a large population of loyal unionists, some of them formerly slaveholders. By 1866, the state was readmitted to the Union, and before long,

old Southern Democrats reestablished an extremely conservative govern-
ment determined to restrict the rights of freed persons. Furthermore, the
state's agricultural economy, based on small farms, made sharecropping
less prevalent than in other parts of the South. Land was expensive, and
the few African Americans who could buy property discovered that most
whites refused to sell it to them anyway. The situation for agricultural la-
borers like Henry McDaniel was precarious. While he now controlled his
own labor, he had to contract with white farmers for work. Employment
was seasonal and dependent on the success of each year's crops. In theory,
Henry McDaniel was free to pick where he wanted to live, to marry the
woman of his choice, and to make decisions about the direction of his life.
But his freedom was restricted by racism, segregation, and the economic
realities of postwar Tennessee. Finding work was critical to survival and al-
ways took precedence in Henry McDaniel's life.[28]

Henry McDaniel faced other adversities. In March 1875, Lou died.
Within the year, Henry McDaniel decided to leave Boonshill permanently.
With Aaron Holbert, he journeyed first to Rutherford County, where they
both found jobs. But shortly after, the two men made their way to
Nashville, most likely with the hope that there were more opportunities in
the city. By 1878, Susan Staton, now a widow with three children, had
joined them. That year, on February 9, in a ceremony conducted by an
AME preacher in a private home, she married Henry McDaniel. He em-
braced the Staton children and raised them as his own. Together the cou-
ple forged a close-knit, strongly devout family. They celebrated their first
son, born in Nashville in 1879, with a special name—Hosea, reflecting
their deep faith in God and Old Testament mercy.[29]

Shortly after Hosea's birth, Henry McDaniel was on the move again.
Like other African Americans in Tennessee, he had become frustrated with
persistent Southern white racism and repression. With the federal govern-
ment's complete abandonment of Reconstruction programs in the mid-
1870s, African Americans faced heightened segregation, discrimination,
and disenfranchisement throughout the South. Even in Tennessee, with its
mild Reconstruction, the backlash was apparent, and black political rights
swiftly eroded. By the late 1870s, there was much talk, especially around
Nashville, of the freedoms tendered by life in Kansas. Nashville's Benjamin

"Pap" Singleton, a former slave who had invested in land there, vigorously promoted migration to the place known as the "Garden Spot of the World." He believed it was a solution to both white oppression and black poverty. For the black population, Kansas held a symbolic place in history. In the 1850s, it had been home to the radical abolitionist John Brown who had led a fierce assault on a proslavery faction in Potawatomi, Kansas. Many African Americans viewed migration to Kansas in religious terms. One migrant explained to a white journalist, "We's like de chillum ob Israel when dey was led form out o' bondage by Moses . . . if we sticks togeder an' keeps up our faith we'll get to Kansas and be out of bondage for shuah." Those heading west became known as "exodusters."[30]

Sometime between 1879 and 1880, the McDaniels, along with Nicholas Holbert, packed as many of their belongings as they could carry and set out for Kansas. Like most exodusters from Tennessee, they must have made their way across their home state to the Mississippi River, where they would have paid a steep price to sleep on an open deck of a riverboat bound for Kansas City, Missouri, a border port where exodusters set out for the plains. The McDaniel-Holbert party must have been shocked when they arrived in Kansas City. Up and down the city's levee were hundreds of African-American families fleeing the South, living in tents and makeshift dwellings. Many nearby river towns were packed with exodusters, who discovered that land was beyond their economic reach and jobs were few. Additionally, Kansas City's white population had become increasingly hostile. In spring 1879, white residents took up a collection to relocate black migrants to the small town of Manhattan, Kansas.[31]

By spring 1880, the McDaniels and Nicholas Holbert had landed in Manhattan, Kansas. They quickly joined in establishing the black community in the area and became active in founding the town's first AME congregation, the Bethel African Methodist Episcopal Church. (Nicholas Holbert served as a church trustee.) Susan and Henry McDaniel sent their children to the local schools, which were integrated—Manhattan was too small to maintain a segregated educational system. The McDaniels family began to expand. In December 1880, Ernest was born and he was followed by Otis, born in November 1882.[32]

The McDaniels' experiences in Manhattan did prove heartbreaking. Henry McDaniel had a hard time securing steady employment; the competition for jobs was keen in this small town. And those jobs open to Henry McDaniel all demanded hard physical work. Autumn through spring, he toiled as a day laborer at anything he could find; the winters, when the local farms went dormant, were especially rough. Every summer he took a job in a local brick kiln, hot and draining work for anyone, especially for a badly injured Civil War vet. Beyond this, Manhattan quickly turned inhospitable: white residents became increasingly more resentful as the exoduster presence grew. In 1884, responding to protests from white parents, the city segregated its schools. Additionally, blacks were restricted to living in certain parts of town. Henry McDaniel and Nicholas Holbert, who was now himself married with children, found themselves confined, along with numerous other black families, to makeshift structures along a single block in Manhattan. Certainly, like other exodusters, Henry McDaniel must have been dismayed to discover that life in Kansas was not significantly better than the one he had known in Tennessee. To add to their suffering, the McDaniels lost Hosea only a few years after they arrived.[33]

Fighting off poverty and suffering from lingering war wounds, and with another child on the way, around 1885, Henry McDaniel took his family to live with Aaron Holbert, who was now farming in Baxter Springs, Kansas, an all-black colony founded by Benjamin Singleton. As they attempted to put down roots, they suffered only more heartbreak. Shortly after they settled there, Johnny was born but lived only four months. Having no money to invest in land, after their son Samuel was born in January 1886, the McDaniels set out to join Nicholas Holbert in Wichita. No doubt, Henry McDaniel again was wagering that there would be more opportunities in a larger city. As he later reflected, "[I] moved about frequently to wherever I could find work."[34]

The McDaniels arrived in Wichita in the midst of a boom. Fueled in part by a healthy cattle market, it was a major railroad stop and was bustling with new construction. The black community established a thriving business district on Main and North Water Streets, which also boasted several churches with large and active congregations. By 1887, Wichita

also had two African Americans serving on the police force, and a black city clerk. Yet Wichita had its drawbacks; early on, white citizens had turned away a group of exodusters. By the time the McDaniels settled in the city, the black population had grown but still only numbered just over five percent of Wichita's total residents. Furthermore, racism persisted. Although the city schools were integrated, African Americans lived in segregated neighborhoods. Most black men were relegated to hard, unskilled labor. Still, Wichita was expanding, and Henry McDaniel, who had gained considerable construction experience in the army, found a job quickly. By spring 1886, he was working for J. M. Campbell, a white building contractor. It was intense physical labor; as a hod carrier he spent long days climbing up and down scaffolding, balancing pallets of brick and mortar on his shoulders.[35]

Henry McDaniel was, as his coworkers remembered him, dedicated and hardworking. But he found that his ability to make a living was increasingly impeded by his persistent war injuries. He remained deaf on his right side and was plagued by constant headaches and ringing in his ears. His shattered jaw had never healed, pieces of bone continued to break off, and infection drained out of his right ear, and from his mouth into his throat. His feet and legs, scarred by frostbite, swelled, the pain making it difficult for him to walk. Before long, Henry McDaniel found he was only able to work part-time. Regardless, Campbell kept him on, allowing McDaniel to do what he could. The family needed the money. Two more daughters arrived—Aidia in 1886 and Mary in 1890. But grief soon followed. Aidia died at age three, and baby Mary only lived a week.[36]

In 1886, with his health deteriorating and his family in dire circumstances, Henry McDaniel secured the services of a white attorney, J. R. H. King, and applied to the United States government for a disability pension. For King, it probably seemed like easy money; Henry McDaniel was clearly a sick man who would certainly merit a pension. With only a few completed forms and a physical for the injured vet, King stood to make twenty-five dollars once the government okayed the request. King submitted the claim, and in April 1887, the War Department granted Henry McDaniel a medical examination. Physicians concluded that his wounds were definitely inhibiting his ability to earn a living. Nonetheless, pension bu-

reau officials pressed for more evidence, claiming that McDaniel's war records contained "no mention of disability of injury." King returned with affidavits from family, friends, and Campbell, all testifying to McDaniel's suffering and his inability to work full-time.[37]

The United States government continued to demand more, however, questioning the veracity of the testimony King submitted and requiring documentation that Henry McDaniel had been treated for his disabilities after the war. But Henry McDaniel had only been able to afford to see a doctor once, in Baxter Springs in the summer of 1885, and that physician was now dead. By 1891, King had submitted numerous affidavits, and Henry McDaniel had undergone two more medical examinations. The government finally rejected Henry McDaniel's pension claim, declaring his impaired hearing and frostbite were not "ratable."[38]

Henry McDaniel was not satisfied. He had sacrificed to preserve the Union and to end the institution of slavery. He had been a loyal soldier who fought on despite his wounds. And he was certain that he was due a pension from his government. Steadily and stubbornly, he continued to petition the pension bureau. As his coworker Henry Sherrill testified, "Henry McDaniel is a proud man and will work when he can and is anxious to do all that he can and does all he can for the support of his family." In June 1892, Henry McDaniel protested to the government, demanding that they reconsider their decision and give him a "fair and impartial" physical. "The rejection was a great injustice to me," he stated in an affidavit. "[The] disability exists now and has existed ever since the origin of my disability in the army."[39]

As time had passed, Henry McDaniel could work less and less. The only jobs available to him required hard labor, and his physical condition was deteriorating. While the older children may have been able to supplement the family's income, it was hardly enough to get by on. To add to the McDaniel's hardships, they lost Ernest at the age of thirteen, in 1893. And the family had two new mouths to feed: Etta, born December 1, 1891, and their last child, Hattie, born June 10, 1893. Susan McDaniel had borne thirteen children, only to see seven left alive.[40]

By the time Hattie McDaniel made her way into the world, her family was absolutely desperate. Later, when discussing her family's extreme

poverty and malnourishment, she claimed that she weighed only three-and-a-half pounds at birth. Her father worked sporadically; his pension applications remained entangled in bureaucratic red tape. Only a few months before her birth, a physician, Dr. S. Hupp, pleaded with the government to grant Henry McDaniel his pension. "He is a good, honest man and is willing to do what he can to get along honestly in this world," the doctor wrote, noting that the family was "destitute" and needed food and clothing. Nonetheless, after another medical examination and more affidavits, both in 1894 and again in 1895, the government rejected Henry McDaniel's claim. Despite testimony from the Twelfth United States Colored Infantry's surgeon and a superior officer, the pension bureau insisted that there was no evidence that his jaw had been broken in the line of duty and that since there was no record of the nature of his injuries when he was hospitalized at Huntsville, he could not make a claim for his wounded legs and feet.[41]

Henry McDaniel's experience with the pension bureau was not uncommon. While white veterans of the Civil War often easily won pensions, retired African-American soldiers found their claims repeatedly questioned and turned down. Proportionally, black veterans received far fewer pensions than their white counterparts. African-American writer Richard Wright vividly remembered his grandfather's attempts to secure a pension. His grandfather's requests were declined because his name was grossly misspelled on his enlistment form. According to Wright, every time his grandfather received a rejection, "he would put the letter away carefully and begin his brooding, trying to recall out of his past some telling fact that might help him in getting his pension." Wright wrote, "He tried desperately to persuade the authorities of his true identity right up to the day of his death and failed."[42]

Likewise, Henry McDaniel continued to pursue his claims and filed more rounds of pension applications. Attorney King was outraged with the government's callousness and earlier had fired off a letter exclaiming "a man with part of his jaw gone—pieces of bone sloughing off—is certainly entitled to a rating of $2.00 or $4.00 per month, if he had no other disability whatever." The pension bureau was deaf to his pleas and continued to delay or deny Henry McDaniel's pension claims.[43]

From the time she was born, Hattie, the youngest McDaniel, lived with this constant reminder of the Civil War and its impact on the life of her family. With each pension application came a recitation of her father's service to the country and the lifelong wounds he received in the Battle of Nashville. The inequitable treatment of black veterans by the United States government was only one indicator of the tremendous discrimination that African Americans continued to face. In 1896, when Hattie McDaniel was only three, the Supreme Court had signaled its endorsement of segregation in *Plessey* v. *Ferguson*, stating that separate-but-equal conditions were acceptable under federal law. Although equality was never a reality, separation of the races was the norm. Jim Crow laws formally segregated blacks and whites in the South, but such discrimination was a de facto way of life in the rest of the country. Interracial marriages were illegal not only in the South but in other states as well. African Americans were relegated to the worst jobs and the poorest housing. In many areas, even outside of the South, blacks were disenfranchised.

Confronting a society where racism and inequality persisted throughout the nation, one that offered few opportunities for African Americans, from the earliest years of childhood, Hattie McDaniel knew only want. As Dr. Hupp witnessed, the family lacked the "basic necessities of life." The McDaniel children often went hungry and did not have proper clothes. But their parents taught them pride and perseverance as well as the importance of hard work, family, and faith. For despite all their hardships, the McDaniel family faced them together. It was a lesson the young Hattie McDaniel learned well.[44]

When Hattie was five, Henry McDaniel, with his health worsening, took the family to Denver, Colorado. Family ties probably drew them there. Between 1890 and 1892, Lena and Addie, both married with children, had left for Colorado, a state that had a reputation for making people wealthy. (They were now Lena Taylor and Addie Lawrence.) Surely, the McDaniels, like others, had heard the stories of everyday Americans who had struck it rich in Colorado mining camps. This included black prospector Jeremiah Lee, a former slave of General Robert E. Lee, who enjoyed an extravagant life in Central City, Colorado, after hitting a mother lode.[45]

Not far from Central City, Denver was home to a small but lively black community, numbering about four thousand around the time the McDaniels arrived. As a booming frontier metropolis, it seemed to hold some promise for an African-American Civil War veteran and his family. Joseph Rivers, publisher of the *Colorado Statesman,* one of the West's leading black newspapers, heralded turn-of-the-twentieth-century Denver as a place of great potential for African Americans. "The rapid growth of the state," he wrote, "indicates that it will be a Mecca for home seekers and all classes of industrious people." When Hattie McDaniel was a child, white Denver businesses not only welcomed but also courted black patronage. The city had African Americans serving on the police force and in city government positions. Paul Laurence Dunbar, heralded by influential African-American educator Booker T. Washington as the "poet laureate of the Negro race," briefly resided in Denver while receiving treatments for consumption; he gave several well-remembered readings in the black community. A number of African-American families owned homes and property; black entrepreneurs enjoyed some success in the city. The town boasted several black undertakers, a number of social clubs for black porters and railroaders, several black doctors (one was a woman), black lawyers, as well as African-American-owned stores and restaurants. Madame C. J. Walker, who parlayed her hair-straightening business into a million-dollar empire, got her start in Denver in the early 1900s. Her husband made his livelihood buying and selling real estate.[46]

Denver's black community also hosted an activist population that openly challenged American racism and discrimination. African-American lodges, fraternal organizations, and women's clubs flourished, providing forums for discussion and debate on racial issues. Local leaders urged black residents to exercise their rights and register and vote. White candidates courted the black vote and ran extensive advertisements in the *Colorado Statesman.* Numerous black churches served as organizing bodies sponsoring political and protest rallies and discussions on black progress. Determined to claim autonomy, one group of black Denverites bought land outside of the city and organized the all-black settlement of Deerfield. Denver even had its own "Back to Africa" movement, one that predated

that of the famous Black Nationalist Marcus Garvey. Led by the outspoken J. Nash Walker, father of the popular entertainer George Walker, this group contended that real equality could only be achieved by complete separation and relocation to Liberia.[47]

Despite Denver's opportunities and channels for activism, a cloud of racism hung over the city. Increasingly, as the black population grew, African-American families were segregated and confined to the most impoverished neighborhoods. Blacks were only permitted to sit in the balcony of the city's most popular theater, the Tabor Grand Opera House. White Denverites were just as bigoted as their counterparts in other regions. "The future of America will be distinctively Aryan," proclaimed an editorial in the *Denver Republican*. "There will be no prevalent mixture of Asiatic or African blood." Furthermore, police brutality was commonplace, and racial violence broke out sporadically. No doubt Hattie McDaniel heard of the fate of Preston John Porter of nearby Limon, Colorado, a black teenager accused of killing a white girl in 1900. Before he could be put on trial, white farmers abducted him and set him ablaze, burning him to death.[48]

The McDaniels discovered that Denver's racist environment extended to the job market. Despite its reputation as a city of opportunity, most African Americans there were limited to employment in the service industry, in white households, or as menial laborers. The McDaniel family— poor and working-class—continued to struggle financially. Wife Susan McDaniel found work as a cook, nanny, and maid in white homes. Addie Lawrence and Lena Taylor, like their mother, worked as domestics. By 1900, the two older sisters were sharing a house with five of their six children, Lena's mother-in-law, and two cousins. (Addie's husband had died and Lena's was probably working out of town.) Otis McDaniel, now out on his own, found a position as a porter in a white barbershop. In addition to his war injuries, Henry McDaniel developed arthritis, suffered from kidney disease, and endured painful, bleeding hemorrhoids. He continued to work as much as possible, but the hard labor was taking its toll. Physical exertion now triggered painful episodes and, as Henry McDaniel described it, caused "rumblings in the ears, headache more or less all the

time, so that I cannot concentrate my thoughts and any excitement or anxiety brings on a muddled feeling of the brain." For much of the spring of 1902, he was bedridden.[49]

However, back in 1898, as soon as he settled in Denver, Henry McDaniel renewed his fight for his pension. It is possible that he anticipated that the city's medical board would be fairer than their counterparts in Kansas. This time, he filled out his first application himself, with the help of a notary. In summer 1899, when he did not hear from the government, he wrote the bureau on his own, attempting to spell and punctuate his letter as best he could. "Dar sar," his letter begin. "i. Have. A. clame. ther. And. Ef. you. plese. give. me. my. pensions. for. I. desere. it. for. I. am. gating. old . . . I. Cant. make. a. laving. for. my. self. and. famey . . . Henry. Mc.Daniel. Co. C. 12. Regt. . . . May. the. lord. Bles. you." In October 1899, the government ordered another medical examination, but Denver's board also rejected his claim. In 1900, he requested an appeal. The government misfiled it.[50]

Still determined, in 1901, Henry McDaniel relocated briefly to Fort Collins, where he joined the local Grand Army of the Republic (GAR) post, an association of Civil War veterans. There he filed a new pension application. Perhaps he was hoping that in Fort Collins he could get a more sympathetic assessment. Affiliation with a GAR post had proven helpful to some other black veterans seeking pensions—it was often seen as validation of their claims. In July, Henry McDaniel received a medical examination there and, unknown to him, the physician recommended that he receive a pension of $10 a month for severe arthritis. The government continued to view his claim with suspicion and demanded evidence of treatment from his current doctor. Returning to Denver within the year, Henry McDaniel, with the help of a new lawyer, Joseph H. Hunter, replied tersely, "[T]he reason why I could not furnish medical evidence as to treatment since Sept. 6th, 1900 was because of being unable to pay a physician for his services as I was out of money and unable to do any work to earn money."[51]

Finally, in 1902, after several more delays, the government awarded Henry McDaniel a monthly pension. The bureau never admitted that his injuries were war related, and had greatly reduced the amount recom-

mended by their own doctor to $6 a month. It took eighteen years, but Henry McDaniel's persistence had produced results. It was hardly the pension Henry McDaniel deserved, but it did help the family's meager income and allowed him to finally seek more consistent medical care. Furthermore, it validated Henry McDaniel and his contributions to the war effort. He remained intensely proud of his service to his country and his career as a soldier.[52]

In 1905, the National Branch of the Grand Army of the Republic commemorated the fortieth anniversary of the end of the Civil War with an encampment at Denver, Colorado. In general, these gatherings were large affairs, drawing vets and their families from across the nation. Old comrades reunited, reminisced about the war, and celebrated the Union's victory. Denver had prepared an elaborate welcome for former Civil War soldiers, many now in their seventies and eighties. The African-American community participated as well. Black churches organized special services, African-American social groups planned programs dedicated to the veterans, and black residents threw open the doors of their homes to African-American ex-soldiers and their families who headed to Denver for the celebration.[53]

On the opening day of the encampment, the *Colorado Statesman* set up an information and sign-in table for African-American attendees. The second name on the guest list was Henry McDaniel. It is likely that the entire McDaniel family, including thirteen-year-old Hattie, took part in the encampment. The activities were numerous, including late-night campfires, speeches, rallies, concerts, and special receptions. But the climax came with a massive parade through downtown Denver, with dignitaries, floats, and bands rolling past a crowd of 125,000 spectators. According to the *Colorado Statesman*, cheers went up as the veterans marched past, representing their states' regiments. Joseph Rivers applauded the former fighting men, reporting that many of the retired black and white soldiers marched side by side regardless of race. Certainly, despite his infirmities, Henry McDaniel must have fallen in line with his former comrades of Tennessee. A photograph of him taken sometime after the encampment showed him in front of an aging wooden house, with the outlines of children peering out of the front door. His face expressing fortitude and

strength, Henry McDaniel stood proud and erect, rifle in hand, and a GAR medal prominently displayed on his lapel.[34]

Henry McDaniel's life in slavery, his wartime experiences, and his fight for what he believed was due to him from his government were a constant echo in his household. His youngest daughter, Hattie McDaniel, carried these experiences with her; they were central to the formation of her values and sense of self. Her father made a profound impact on her and she shared his legacy with people that she encountered along the way. Later, her good friend Roscoe Conkling Simmons, orator and nephew of Booker T. Washington, paid a glowing tribute to Henry McDaniel and the daughter he had nurtured. "Your father wore the blue, greatest sign of free men history speaks of; wore it like a man and a soldier," he wrote to Hattie McDaniel. "His daughter, one of the great girls and women of her hour and day, honors it in her life and by display of character few can boast and ability none can match."[35]

2

· · ·

Comedienne

· · ·

The people of the Great $4,000 Electrical Ball last Wednesday night at East Turner Hall were greatly entertained by the special features. . . . First, Sam Edwards made a hit singing his late comedy songs; second George Elkins, the champion buck dancer of the state, did some very neat and clever work. Miss McDaniels is one of Denver's clever little singing comediennes and she brought the house down with applause.

Franklin's Statesman, October 8, 1910

I N A 1947 INTERVIEW with white gossip columnist Hedda Hopper, Hattie McDaniel reflected on the prominent role religion played in her life and in the African-American community. "My race has given me a deep sense of spiritual values, a pride in its achievements during the eighty-odd years since slavery," she commented. "Faith has been the black man's federal reserve bank, and it's paid off." It is likely that Hopper, deeply bigoted, missed the real substance of McDaniel's remarks and the actress's subtle link between faith and black resistance to racism. Instead, Hopper delighted in McDaniel's seemingly humorous, but also extremely revealing, confession of her priorities. "In my life, God comes first," the then-famous performer mused, "work second, and men third."[1]

Hattie McDaniel's outlook was dramatically shaped by her parents. As they combated poverty, Susan and Henry McDaniel attempted to instill deep spiritual devotion in their children. Shortly after they moved to Denver, the McDaniels joined Campbell Chapel AME. Primarily a working-class congregation, Campbell Chapel prided itself on its down-to-earth

and hospitable atmosphere. "This is the people's church," one of their announcements read, "and a hearty welcome awaits you here." It was a fully encompassing spiritual community—weeknight prayer meetings, choir practice, evangelical rallies, church school, and Sunday worship services. The dynamic—and a bit unconventional—Reverend James Washington pastored Campbell Chapel. Washington was an innovator and experimented with a variety of evangelistic techniques, including illustrated sermons and, on occasion, early motion pictures. He also encouraged parishioners to use the church's facilities for secular events. There congregants staged plays, concerts, tableaus, contests, and literary gatherings as well as political forums on race relations. Sam McDaniel acknowledged that his earliest musical exposure came from the church; later he claimed to be an expert on African-American spirituals. His little sister Hattie grew up singing in the choir during her most formative years.[2]

In addition to church, the McDaniel family also prized education. While Henry McDaniel possessed rudimentary reading and writing skills, his wife, Susan, who had spent her life raising children and working in white homes, remained illiterate. Denver's educational system was integrated, and when the McDaniels arrived there, they enrolled young Hattie in the Twenty-fourth Street Elementary School. A class photo shows her, in the front row, as one of only two African-American children in her class. She appeared to be a good student. Her sixth-grade spelling book contains meticulously inscribed words, almost all perfect, with hardly a lesson missed.[3]

But Hattie McDaniel's early life remained filled with adversities. The McDaniels could never quite beat poverty; they moved often and from one rental to another, mostly in and around Denver's segregated Five Points district. Henry McDaniel continued to deteriorate; he grew weaker and soon was almost completely blind. To add to their burdens, Susan McDaniel's health also declined until she was hardly able to work. Henry McDaniel's six-dollar monthly pension was barely enough to sustain both his family and his medical care. However, in 1908, realizing that since he was now over seventy he qualified for a significantly larger pension, Henry McDaniel petitioned the government for a raise. Pension officials, as they had before, repeatedly denied his request. "Your claim for increase of pen-

sion is rejected on the grounds of your inability to furnish evidence that you had reached the age of 70 years," wrote one commissioner curtly. "It is impossible for me to furnish a record of my birth," Henry McDaniel replied. "I was a slave." He continued to apply and reapply, receiving repeated rejections. Growing more frustrated, he sought help from his congressional representatives. Eventually, after six years of appeals, the pension bureau increased his stipend to $17 a month. But it was still not enough for a seventy-six-year-old sick veteran to take care of his wife, his family, and his dire medical needs.[4]

The McDaniel children did their best to pitch in. But they had their own struggles. Lena Taylor and Addie Lawrence were both soon widowed and had young children to worry about. Otis McDaniel was working for modest wages in the barbershop, waiting on white patrons and cleaning the floors and counters. Jobs for African Americans had always been restricted but were becoming even more scarce. In 1909, the *Colorado Statesman* cited with alarm the "gradually diminishing opportunities for labor along various lines for members of our race." Denver was no longer a Rocky Mountain boomtown but rather an established urban center with a powerful and oppressive white majority.[5]

Susan McDaniel made sure that her youngest daughter was prepared to survive in this world of limited opportunity. Beginning when Hattie McDaniel was just a toddler, her mother took her along to work in white homes. There she learned to cook, clean, tend children, do laundry, and serve meals properly. The experience left a deep impression on the young Hattie McDaniel. Later she vividly recalled a particular incident that occurred while she was helping her mother who, at the time, was a cook for a wealthy white family. They were preparing a meal and the family's matriarch brought her youngest daughter, named Alice, to the kitchen to observe. "I heard her say to Alice, 'It isn't that you'll ever have to cook,' " Hattie McDaniel later recalled, " 'but I want you to know how so you can better care for yourself. . . .' " The message was clear. These two little girls, one black and one white, were growing up in a rigid, racially hierarchical society, one that prescribed their future in a castelike manner. For the young white child, kitchen skills were an option. But for the young black child, they were a necessity—she would *have* to know how to cook. Susan

McDaniel had seen many things change and many things stay the same. She believed that her daughter's life would not be that much different from her own—that society would compel Hattie McDaniel to follow her into domestic service someday. It was imperative that little Hattie McDaniel have the proper skills.[6]

But there was another force operating in the young life of Hattie McDaniel—that of her brother Otis McDaniel. Impatient with American society's racial barriers, he became determined to reject the life of menial labor that had locked his parents into perpetual poverty. Dashing and debonair, he was a talented young man, regarded as "brilliant" by many in Denver's black community. Otis McDaniel was a bit of a free spirit; although he most certainly was marched to Sunday school every Sabbath, as an adult, he did not join the church. A hardworking young man, he was independent-minded and intensely creative. He drew cartoons; he could also sing and dance. Before long, the enterprising Otis McDaniel realized that certain talents could be parlayed into earnings. He set his sights on show business.[7]

He had strong role models to emulate. Otis McDaniel and his younger siblings came of age at a time when the entertainment profession seemed to open up, at least slightly, to African Americans. In the 1890s, George Walker, son of Denver's J. Nash Walker, and the beautiful Aida Overton (soon to become George's wife) joined up with the West Indian–born Bert Williams to form the comedy troupe of Williams and Walker. By the mid-decade, they were catapulted into the national limelight by their unique revival of the cakewalk, a dance which had originated in slavery and was used by those in bondage to slyly mock traditions of white slaveholders. Williams and Walker transformed the cakewalk into a national fad, popular not only among blacks but also with whites who remained ignorant of its deeper messages. (It was the ultimate in-group joke to see whites performing a parody of themselves.) Riding on the cakewalk's success, Williams and Walker became the first black team to break into white vaudeville. In 1898, they landed starring roles on Broadway in *Clorindy: Origins of the Cakewalk*. As their fame grew, they established their own musical road shows and toured the nation appearing in both black and

white theaters. They achieved not only national but eventually interna-
tional acclaim and made a very good living in show business.[8]

Although Bert Williams performed in blackface and much in their
shows drew from the white minstrel tradition, the team won respect and
admiration from the black community for their satirical comedy and for
breaking down barriers in the white entertainment world. The McDaniels
certainly were admirers. Sam McDaniel recalled attending a Williams and
Walker performance in 1897. No doubt, other family members, including
Otis McDaniel and possibly little Hattie, went along that night. For Sam
McDaniel it was a transforming experience; he credited it as inspiring his
interest in music and stage. Hattie McDaniel was equally influenced by
Williams and Walker. Later, she would borrow heavily from Bert Williams
as she forged her own performance style.[9]

Although Etta McDaniel later told a journalist that her parents
were both musically talented, it was the creative and enterprising Otis
McDaniel who encouraged his younger siblings to develop their perform-
ing skills. Some sources indicate that early on he stationed himself, along
with Sam and Etta, on Denver's busy street corners, singing and dancing
for passersby. Hattie McDaniel recalled later that it was as much poverty
as creative drive that motivated them; Otis McDaniel had realized that this
was a way to supplement the family's meager income. Among his early en-
deavors, Otis McDaniel attempted to cash in on the cakewalk's appeal.
Along with his brother Sam and four other friends, he organized the
"Cakewalk Kids" and hired out the group to perform at socials and com-
munity functions. A 1902 photo of the troupe, taken at a Walden, Col-
orado, engagement, shows a confident twenty-year-old Otis McDaniel
with a derby and a cane in hand, and a tentative teenage Sam McDaniel
with rumpled suit and well-worn shoes. A pleased white audience looks on
approvingly.[10]

It may have been with Otis McDaniel's support that his brother Sam
got some early and important breaks. Sam McDaniel claimed that when he
was very young he was selected to perform the ballad "Mother Are There
Any Angels Black Like Me?" in a traveling variety show called *The South
Before the Civil War*, which then starred black singer and songwriter

Ernest Hogan. Additionally, he appeared with the Black Patti's Trouba-dours, featuring Sissieretta Jones, renowned for her tremendous operatic voice but forced by racial discrimination into performing popular, minstrel-type music. Yet Sam McDaniel's most important early accom-plishment was when he secured a spot as a dancer in Williams and Walker's touring musical titled *In Dahomey*. Whether or not he traveled with these shows or was confined to a local appearance is unclear. Often, juvenile roles were filled by hometown talent to save the expense and trou-ble of taking care of children and teenagers on the road. In any event, it exposed Sam McDaniel and his siblings to the era's most celebrated and successful black entertainers. Otis McDaniel may very well have also ap-peared in these shows, but even if he did not, he no doubt made every ef-fort to make himself known to these black show-business giants.[11]

While Sam McDaniel may have been talented and mastered both the piano and (while playing with a circus band) the drums, it was Otis McDaniel that everyone considered exceptional. In the early 1900s, Otis McDaniel began focusing on establishing a place for himself within Den-ver's black entertainment circles. Inspired by Williams and Walker, Otis wanted to do more than perform—he wanted to produce. In early 1908, he made one of his first attempts at staging an original show, a musical comedy he called *The Isles of Pingapoo or the Alabama Missionary*. He wrote the script, constructed and painted the scenery, and recruited a cast of thirty from the local African-American community. On February 20, 1908, *The Isles of Pingapoo* played to an enthusiastic audience in a local auditorium. *Franklin's Statesman*, a rival black newspaper of the *Colorado Statesman*, raved, "The excellence of the production was evidenced by the fact that though it was nearly midnight when it concluded, there was not a dull moment and not a person left the hall." In their opinion, *The Isles of Pingapoo* was the "best farce comedy that ever has been shown to a Denver audience by local talent." Otis McDaniel had scored a triumph.[12]

Riding on his success, Otis McDaniel plunged vigorously into local show business. The next month, he appeared with the "All Star Min-strels," a local Denver troupe comprised of some of the city's best black song-and-dance men. At the end of the first act, Otis McDaniel, joined by close friend and associate James Brown, performed an innovative clog

dance in which they imitated colorful, flickering electric lights. In the second act, Otis appeared in drag as the "stagless" Aunt Miranda opposite his brother Sam, who played the country bumpkin "Pappy Rube, the Lazy Peanut." *Franklin's Statesman* rated the show a "big hit." Its reviewer singled out Otis McDaniel and James Brown as a team that "had few equals and no superiors."[13]

Soon, Otis McDaniel was in great demand, forging a reputation as a local "theatrical man." In October 1908, he staged a special program for the People's Alliance, a local activist group that met regularly to discuss race relations. In January 1909, with James Brown, he performed at a benefit for Denver's "Colored Brass Band." That April, he staged a skit at Campbell Chapel, starring as "Professor Make Over" for a "Spinsters' Convention." He joined James Brown and toured Rocky Mountain mining camps, where isolation made entertainers extremely valued and welcome visitors.[14]

For some time, Hattie McDaniel, the youngest, watched on the sidelines as her older siblings began their careers as entertainers. But she soon came to share their ambitions. Of all the McDaniel children, she was the most like Otis. "I knew that I could sing and dance," she recalled. "I was doing it so much that my mother would give me a nickel sometimes to stop." Susan McDaniel, Hattie recalled, was "old fashion religious" and "didn't believe in shows." But her youngest daughter was fiercely independent and later known to be "free-thinking" and even "free-speaking." Hattie McDaniel claimed that at age six, she decided to become an actress, that from then on she was driven by a desire to be on stage. "I always wanted to be before the public," she remembered and then tellingly confessed, "I'm always acting. I guess it's just the ham in me."[15]

It was not long before little Hattie McDaniel got her chance. Reportedly, when she was around eight, the family was in particularly desperate circumstances. One day after school Otis McDaniel, without their parents' knowledge, took her to a carnival, where they sang and danced for the crowd. "The man who ran the carnival, he needed some little colored children for one of the acts," she recalled. Appreciative spectators rewarded her with tossed coins and cash, and, by the end of the week, she had earned five dollars, which she took home to her parents. Whether or not

it won over her disapproving mother, the money came in just as the family needed it. While Hattie McDaniel had strong artistic impulses, it was lessons she learned in poverty and from her brother that really shaped her outlook on the popular arts. This was a way to lift the family out of poverty—this was a way to reject the racist restrictions placed on black women by white society.[16]

Hattie McDaniel continued to perform with her siblings after school and, when she got old enough, joined them for out-of-town engagements during her summer vacations. In the fall of 1908, she enrolled in East River High School where, she later insisted, she had a life-altering experience. During her freshman year, she entered a drama contest sponsored at her school by the Women's Christian Temperance Union. She wowed both the judges and the crowd with a touching rendition of "Convict Joe," a prohibitionist poem that told of a remorseful husband who, in an alcoholic rage, had brutally murdered his beloved wife. Hattie McDaniel always claimed that she won first place—a gold medal—for her reading. Whether or not her claims were true is hard to verify. But the WCTU did stage a massive conference in Denver in October of 1908—the year Hattie McDaniel was exactly fifteen.[17]

Although in later interviews with white journalists she often pointed to this as the event that propelled her onto the show-business path, by the time she reached high school she was already an experienced amateur who had cut her teeth not on prohibitionist tracts but on church music and the popular arts. Not too long after the WCTU conference, Otis McDaniel secured what became her first chance to earn real notice—something beyond the church choir, impromptu sidewalk performances, and their homegrown regional tours. In December 1908, Otis McDaniel, along with Sam, Etta, and Hattie, appeared with J. M. Johnson's Mighty Minstrels. A Denver group, the Mighty Minstrels was organized by J. M. "Poor Jack" Johnson, a successful African-American businessman who owned a cigar store and newsstand. In addition to the McDaniel siblings, the company included members of the Howard family, known as the "Merry Howards," comedian "Happy" Dick Thomas, and V. N. Wolfskill, who sometimes served as Campbell Chapel's Sunday School superintendent. The high point of the show came with a grand cakewalk in which members of the

audience competed with the performers. The *Colorado Statesman* declared the revue a hit. "Every character seemed to vie with each other in their superb talent and thus made everybody happy," the paper claimed. "The cake walk was extremely interesting and brought forth rounds of applause."[18] While *Franklin's Statesman* heralded Otis McDaniel as "our old favorite," in their view, it was his petite youngest sister who really stole the show. "Hattie McDaniels, our own Denver girl," they reported, "brought down the house in *Baby Doll.*" The Mighty Minstrels were so successful that Denver's white Democrats as well as another local organization, the Traffic Club, immediately hired them for special engagements.[19]

Hattie McDaniel's own career began to take off. In early March 1909, the high-school sophomore won a spot with Red Devils, a New York–based minstrel show that had booked into Denver for a few days. The Red Devils commonly supplemented their shows with local entertainers they recruited along the way. Billed as "Denver's Favorite Soubrette," Hattie McDaniel received accolades for her performance; *Franklin's Statesman* described her as "winning" and "clever."[20]

Shortly after her appearance with the Red Devils, Hattie McDaniel co-starred in one of Otis McDaniel's most ambitious productions, *J. William Johnson or Champion of the Freedman*, a three-act musical "comedy-drama." Her brother had conceived of *Champion of the Freedman* as a satirical critique of "Back to Africa" and other post–Civil War emigration plans (like Singleton's exoduster movement) that targeted and, in some cases, exploited newly freed slaves. The leader of an immigration organization, J. William Johnson (played by Otis McDaniel) was largely based on J. Nash Walker. Through a zany series of events, Johnson's emigration plans are exposed as a cover for a corrupt real estate scheme that bilks good, although foolish people, out of their savings. Otis McDaniel cast Hattie as "Miss Susanna Higgins," whose father, Cyrus, an investor in an African repatriation plan, has "more money than sense." On March 25, 1909, *Champion of the Freedman* played to a large crowd. "The McDaniels at Campbell Church Thursday night," reported *Franklin's Statesman*, "drew a good house and presented a playlet of their own writing and setting to the satisfaction of all present."[21]

That spring, not too long after she appeared in *Champion of the Freed-*

man, Hattie McDaniel quit high school.[22] Although Hollywood publicity later insisted that she left to join her mother as a domestic in white homes, this was hardly what Hattie McDaniel had in mind. She had watched as her sister Etta succumbed to that traditional life. By the summer of 1909, Etta McDaniel had married a Denver hotel porter named John Goff and given birth to a son, Edgar. The young couple moved in with Susan and Henry McDaniel. With an infant and a husband, Etta Goff now had little time for show business. She would have to take in laundry and work as a servant to help support her new family and her aging parents. But her sister Hattie McDaniel had other ambitions. She was determined to make a place for herself in show business. Her brother Otis McDaniel would help her.[23]

By 1910, following the example of Williams and Walker, Otis McDaniel had organized his own theatrical troupe—which he called a "carnival company"—and booked dates on the road. The company consisted of nine members, including Otis, his new wife, Sue, and seven other performers. He was determined to round out the number to ten and take his talented sixteen-year-old sister Hattie on tour with them. Some sources maintain that his mother opposed the idea, insisting that Hattie was too young. But Otis prevailed and Hattie later indicated that her father was supportive of her aspirations. "There is so much trouble in this world," she recollected her father telling her. "I hope you will pray that through you the Lord will make people happy." Even Susan McDaniel came around. Later, no doubt, Hattie McDaniel was thinking of her mother when she paid homage to those women "bending their backs over wash tubs . . . [who] smiled encouragement to daughters who wanted an artistic career." By April 1910, she was in the small town of Altus, Oklahoma, playing its local theater with Otis McDaniel's stock company.[24]

Back in Denver, Sam McDaniel attempted to follow in his older brother's footsteps. That following summer, he teamed up with James Brown, Otis McDaniel's former partner, and assembled his own touring company. They left Denver and played engagements in Colorado, Kansas, and Nebraska. When he returned to Denver in October, he received a special welcome in the pages of *Franklin's Statesman*, which boasted that his tour had been "very successful."[25]

Not too long afterward, Sam and Otis McDaniel disbanded their old troupes and struck out for Kansas City, Missouri, where they organized the McDaniel Brothers stock company. According to Sam McDaniel, they booked out of that location for four years. It is not surprising that the gifted and determined Otis McDaniel eventually left Denver. Colorado was far from the show-business hubs where the nation's black stars had claimed fame and modest fortunes. However, Kansas City was a pulsating metropolis with a thriving entertainment community. There Otis McDaniel promoted himself as a "theatrical producer" and continued to perform, remaining a deliberately unique artist. He even developed an act in white-face, a bold move for an African-American entertainer in an era when as-sertive black men who openly critiqued the racial norm were not only persecuted but sometimes lynched. Yet Otis McDaniel did well and earned the admiration of Clarence Muse, a former attorney who, finding the legal profession hostile to African Americans, had established himself as a respected actor, singer, and producer. No doubt, the word home was that Otis McDaniel was bound for success.[26]

Left behind in Denver, little sister Hattie McDaniel was winning acco-lades. At the "Great $4,000 Electrical Ball," in the fall of 1910, she was a smash. "Miss McDaniels is one of Denver's clever little singing comedi-ennes," *Franklin's Statesman* wrote, "and she brought down the house with applause." But chances like these for Hattie McDaniel were few and paid little if anything at all. As an African-American woman from a working-class background, Hattie McDaniel faced an uphill struggle in the arts. Show business in general remained both dominated by men and extremely segregated. Although African-American dance and music, par-ticularly ragtime, were popular nationwide, opportunities for African-American performers were limited. A few African-American entertainers had crossed over onto white stages but there was no organized network of black theaters to showcase black talent. And only one black woman, Aida Overton Walker, had achieved real national prominence. Most African-American women were held to rigid gender conventions, expected to settle down into a traditional marriage with children, and, confronting economic realities and racism, to accept jobs primarily working as servants for white families.[27]

At this point in her life, it seemed as if this would be Hattie McDaniel's future as well. By necessity, she would have to take jobs as a maid. It was difficult, low-paying work; wages, usually three to seven dollars a week, were hardly enough to support one person, not to mention a family. Often these jobs required domestics to "live in," placing them on call twenty-four hours a day with only Sundays off. In these arrangements, employees were on duty from the time the household awoke until everyone was in bed and the dinner dishes had been done. As historian Elizabeth Clark-Lewis argues, the work for black female domestics like Hattie McDaniel was not too far removed from slavery. White employers were exploitative and abusive, often demeaningly racist. Domestics had little freedom; poverty locked them into these positions and often away from their families. Before she was out of her teens, Hattie McDaniel experienced all of this in some fashion firsthand. It is not surprising that a career in entertainment looked so appealing. It was a way to break out of this modern-day bondage. But later in life, Hattie McDaniel emphasized that she had been proud to take on such hard work, that a servant's job was an honorable way to "make an honest dollar." She also insisted that she never supported herself for an entire year as a maid, that it was "a means to an end"—ultimately, a career on stage.[28]

While racism and economic realities impeded Hattie McDaniel's hopes of pursuing the stage, she was also sidetracked by another distraction. She had fallen in love with the tall, thin, and handsome Howard J. Hickman. Born in 1889, in Kansas, Howard Hickman had migrated with his family to Denver at the age of eight. Hickman came from a good family with solid standing in Denver's black community. His parents, Sarah and Isaac Hickman, had some of the best jobs available to African Americans; his father worked as a laborer on the Burlington Railroad and his mother was on the United States Post Office's cleaning crew, a federal service job. The Hickmans were members of Central Baptist Church, owned their home, and occasionally appeared in the *Colorado Statesman*'s society columns.[29]

Despite the family's sterling reputation, like other young black males, Howard Hickman confronted a society that offered him few opportunities. He left school after completing the ninth grade and secured a job as

a cook, probably on the railroad. But in early January 1909, he stood accused of stealing a watch and some cuff links from the Pullman porter office at Denver's Union depot. He did not contest the charges and pleaded guilty. Since he was only twenty and, under Colorado law, still considered a juvenile, he was sentenced to the state reformatory. Whether or not he committed the crime is unclear; young black males had difficulty getting fair hearings in Denver's courts. But his record hints that this incident was certainly an anomaly in his life. The reformatory clerks noted that while he chewed tobacco, he did not drink, smoke, or use drugs, and had never been in trouble before. Additionally, he was a model prisoner, receiving bonus points and an early parole in July of 1909 for good conduct. He returned home, quickly found a job as a laborer for a mining supply company, and resumed a respected position within the black community.[30]

How or when Hattie McDaniel first met Howard Hickman remains buried somewhere in the past. Their families may have shared Kansas ties; the Hickmans had family in Manhattan, where the McDaniels had resided many years before Hattie was born. Hattie McDaniel was certainly familiar with Central Baptist; she and her sister Etta Goff had sung for the congregation there. In spite of these possible connections, it is almost certain that show business in some way brought the couple together. Hickman was an extraordinarily talented pianist, a popular member of the black entertainment community. He had the distinction of becoming the first African-American pianist in Denver hired to accompany silent films. At some point, Howard Hickman began courting Hattie McDaniel, and before long they were serious. On January 19, 1911, the couple was married before a justice of the peace in Denver. Hattie McDaniel was still only seventeen and Howard Hickman was twenty-two.[31]

Hattie McDaniel-Hickman, as she now preferred to be known, embarked on what looked like a fairly conventional life. With her new husband, she moved into a home near his parents. The couple labored at their regular jobs during most of the week but continued to pursue their artistic ambitions during their days and nights off. The relationship seemed to be a happy one, filled with mutual interests, genuine respect, and love.[32]

This may have been the happiest period of Hattie McDaniel's personal life. It was certainly one of the most artistically original periods in her en-

tertainment career. She strove to follow her brother's example and mount her own productions. It took a while, but finally, in May 1914, with help from her sister Etta Goff, she organized her first large-scale endeavor—an all-female minstrel show. It was a benefit for a local women's organization, the Mizpah Art Club. Five hundred people turned out to see Hattie McDaniel-Hickman guide her female troupe, supported by a few token males, through the evening's performance. She wrote the script and composed two songs, "Don't You Know It?" and "San Francisco Bound," for the show. The *Denver Star* (formerly *Franklin's Statesman*) enthusiastically reported that the revue generated "a constant, uninterrupted series of hearty laughter, pleasant ebullitions of joy and pleasure." Hattie McDaniel-Hickman received a special commendation for sending "the audience into the deepest and heartiest of laughter" as well as for her astonishingly "graceful tango."[33]

Hattie McDaniel-Hickman's female minstrels, billed as the McDaniel Sisters Company, created such a sensation that Denver's African-American citizens demanded more. For almost a year, all or portions of the troupe played various dates throughout the community. In August, Hattie McDaniel-Hickman and Etta Goff staged *The Return of Letty*, which was described as a "screaming comedy." That fall, they became a weekly fixture at Eureka Hall's Saturday night vaudeville show. In February 1915, the full troupe performed at a fund-raiser for the Sojourner Truth Club, a black women's organization named in honor of the ex-slave and abolitionist who became an outspoken activist and pioneering feminist. Costumed in narrow black skirts, black jackets, white shirtwaists, white gaiters, and bright red ties, and made up with traditional burnt cork, McDaniel's company was applauded for bringing an innovative twist to traditional minstrelsy. The *Colorado Statesman* noted the "novel" quality of the exclusively female production and added that "the program was carried out very successfully with energy and taste." Its critic also insisted "special mention must be given of Mrs. Hattie McDaniel-Hickman who by her years of stage experience piloted the others to success."[34]

It is not surprising that Hattie McDaniel-Hickman chose to work within the blackface-minstrel genre. Dating back to the 1840s, minstrelsy was one of the oldest continuous entertainment traditions in the United

States. White Americans, who originated and dominated minstrelsy, based their performances on blackface imitations of song and dances appropriated from African Americans. The result was extremely derogatory, depicting blacks as happy, lazy, and dimwitted, or dangerous, violent, and sex-crazed. In the antebellum era, blackface minstrelsy, perpetuated by traveling companies of white male entertainers, effectively promoted racism through the powerful venue of the American stage.[35]

After the Civil War, troupes of African-American minstrels arose, some organized by white promoters and others led by black performers themselves. While they adopted many of the characters common in white minstrelsy, including the blundering country bumpkin Jim Crow, the fast-talking citified dandy Zip Coon, the coy, seductive Mullatta, and the silly, doting Mammy, the goal of reclaiming black culture drove many black performers into this field. In assessing white minstrelsy, George Walker observed that "nothing about these white men's actions was natural, and therefore nothing was as interesting as if black performers had been dancing and singing their own songs in their own way." Many African-American minstrels attracted a large number of fans in the black community. Blacks patronized these shows, in large part, to support African-American performers. But they also considered these minstrel routines to be hysterical spoofs on white minstrelsy and its outlandish racial stereotypes. Several black troupes, in turn, became popular among white audiences unaware of the criticism embedded within African-American performances. But those blacks who crossed over into the white entertainment world found themselves rigidly restricted by white show-business entrepreneurs who controlled the industry and mandated the perpetuation of degrading stereotypes.[36]

At this point, Hattie McDaniel-Hickman was free of white demands. She played to predominantly African-American audiences and was more concerned with appealing to their concerns and tastes. Through her troupe, McDaniel-Hickman dared to challenge assumptions about both race and gender. Even among African-American minstrels, women had been generally barred from the stage until the late nineteenth century. (Traditionally, in minstrelsy, men dressed as women to play the female parts.) By the 1880s, a few women starred in minstrel shows, but most

were confined to supporting roles as men continued to play the lead parts, dominate the chorus line, and determine the shows' content. McDaniel-Hickman's female minstrels centered entirely on women and wove the story lines and skits around their lives. The exclusively female chorus, seated in a traditional minstrel semicircle, stood as a constant reminder that women controlled this scene. Even the interlocutor, the genre's master of ceremony, was a woman. The key roles went to women, and men were virtually invisible for most of McDaniel-Hickman's productions, playing only minor parts.[37]

Hattie McDaniel-Hickman also bravely attacked the central female character of white racist fantasies, the plantation Mammy. At this stage in her development as a performer, McDaniel-Hickman took an image common not only in minstrelsy but also throughout white American culture and exposed it as utterly ridiculous by exaggerating it to grotesque extremes. When she first appeared with her female minstrels in May 1914, the *Denver Star* heaped praise on McDaniel-Hickman for her "ludicrous manner." Their correspondent recounted how the all-black audience roared as she made her first entrance:

Imagine a person with cactus hair, each hair sticking out independently to itself, fix in your mind a disfigured, clumsy, blackened, 200 pound woman whose color was a deeper black than ten midnights without a sun, then observe a misfit dress whose colors were those of the rainbow with the tango bloomers made of white sheetings which effect completely harmonized with her big, awkward feet filled with corns. When she batted her eyes it looked as if two white marbles were placed in a bucket of soot and when she opened her mouth, it looked like a bottomless pit.

Although on the surface McDaniel-Hickman's image reinforced the most horrific racist stereotypes of black women, her audience clearly understood her intentions. The popular entertainer was parodying the foolish, silly, and asexual caretaker Mammy. This stereotype, like other black images, was a by-product of white imaginations. This audaciously comedic, yet forcefully serious performance won her admiration within

Denver's black community. It was funny but it was also revolutionary, exposing white America's weaknesses and delusions. "Her very appearance," the *Denver Star* remarked of McDaniel-Hickman's character, "would cause you to crack your sides laughing."[38]

McDaniel-Hickman's zany minstrel Mammy defied white racism by magnifying its offensiveness. Her blackface makeup and wide minstrel mouth transformed the familiar tools of white minstrelsy into an unsettling nightmare. Now a well-proportioned young woman, she exaggerated her curves to create a character that was not passive and acquiescent but rather assertive and bold. She could not be ignored or invisible. Her Mammy would not dote on others and sacrifice herself. She was in the center of all action, wittily quipping and brazenly singing. An outrageous flirt, the character conveyed an undercurrent of sexuality as she eagerly pursued her desires. McDaniel's comedic style worked; on stage she was free, uncontrolled, and impudent. This was pure back talk. "In the world of the southern black community I grew up in," writes cultural theorist bell hooks, " 'back talk' or 'talking back' meant speaking as an equal to an authority figure. It meant daring to disagree and sometimes it meant having an opinion." McDaniel had hit upon a venue by which she, as a poor black woman, could have a voice in society. By revising, and thereby rejecting, the Mammy image, Hattie McDaniel stood bravely defiant and was praised for it within her community.[39]

In comedy, Hattie McDaniel-Hickman discovered a liberating weapon with which she fired off subtle yet incendiary critiques of white America. While funny on the surface, at a deeper level, her minstrel romps communicated serious messages. As *Franklin's Statesman* observed in a 1908 review of the All Star Minstrels, "A comedian can say in a joke, something he dare not breathe in seriousness. Yet the effect will be produced."[40]

Hattie McDaniel-Hickman learned quickly that comedy could be extremely subversive, and, like other African-American performers, she drew from the black tradition of signifying. Originating during slavery, signifying in the black community was the act of creating as well as expressing double and often contradictory messages. Held in subjugation and forced to suppress their opinions by a violent white power structure, those in slavery handed down the tradition to successive generations. By using

parody, satire, pastiche, and almost every other rhetorical or visual technique at hand, African Americans created two voices—one that placated white society and another that communicated a somber rejection of oppression.[41] Out of this creative, and rebellious, process came what African-American writer Paul Laurence Dunbar described as "the mask." "We wear the mask that grins and lies, it hides our checks and shades our eyes," his poem "We Wear The Mask" begins. In his verses, he captured the pain hidden beneath the laughter: "We smile, but, O great Christ, our cries— to thee from tortured souls arise." Hattie McDaniel came to embrace the mask and its powerful ability to signify both humor and tragedy.

For Hattie McDaniel-Hickman's generation, the master of signification was Bert Williams. At one level, Williams's blackface buffoon reified white racism. On stage, he was slow moving and projected a complete befuddlement. But his performances always contained something deeper. He was described as "mournful," conveying constant disappointment with the world around him. While, on the surface, his signature song, "Nobody," was a comedic hard-luck tale, it simultaneously offered an indictment of white society's exploitation of black Americans. "Until I get something from somebody sometime," Williams sang. "I'll never do nothing for nobody no time."[42]

Williams also had a specific outlook on white American society. Although he never openly advocated Black Nationalism or endorsed J. Nash Walker's African colonization plans, he remained pessimistic about the possibilities for full black integration into American life. From Williams's perspective, self-reliance and self-improvement were the keys to the African-American struggle. "Social distinctions are inevitable," he wrote in an article reprinted by the *Colorado Statesman* in 1916. "Develop yourself individually, and you will be more distinguished than if you were to merge into the mass of white men, most of whom live humble lives."[43] Indeed, Williams's success and hard work had brought him considerable respect and admiration. Booker T. Washington, who advocated accommodation and economic uplift over fighting segregation and racism, lauded Williams as "a tremendous asset of the Negro race."[44]

Although Williams avoided openly criticizing white society, he was

outspoken in his pride in the African-American people. "Our race has taken root upon this soil; after two hundred years of struggle upward, we may be apart here, but not alien," he wrote. He vigorously contended that American culture owed its existence to African Americans. "The only music that may be regarded as typically American is Negro music," he insisted in 1910. "Minstrelsy is now firmly imbedded in the American comic spirit; and syncopation, or 'rag-time,' an African contribution, has tinged all the popular balladry of this generation."[45]

Additionally, both Bert Williams and George Walker viewed their success as a symbol of progress for the race as a whole. "Over and behind all the money and prestige which move Williams and Walker is a love for the race," George Walker wrote in 1908. "We represent the race and every hair's breadth of achievement we make is to its credit. For first, last and all time, we are Negroes." For the most part, these older performers' contributions came as they broke down the doors of white show business—just having a presence was a major achievement in white vaudeville and on Broadway. It was not easy, and they faced persistent racism. In fact, when Williams was hired to headline with the Ziegfeld Follies of 1910, his white costars shunned him and the producers prohibited him from sharing the stage alone with a white woman. No matter how stereotyped Williams's act was—and it often was embarrassingly so—his existence within white show business alone stood as a rejection of white racism.[46]

These black performers, whose philosophy, performances, and achievements molded Hattie McDaniel-Hickman, viewed themselves engaged in critical battles—to end segregation in the thriving entertainment industry, to increase awareness of African-American contributions to American culture, and to secure basic human rights for African Americans. Black entertainers considered themselves "race men and women" intensely proud of their heritage. In turn, they embraced their responsibilities as leaders and celebrated their race consciousness. "In this age we are all fighting the one problem—that is the color problem," wrote Aida Overton Walker. "Our profession does more toward the alleviation of color prejudice than any other profession among colored people . . . we come into contact with more white people in a week than other professional colored people meet

in a year." In essence, this generation of performers—and Hattie McDaniel-Hickman would come to count herself as one of them—believed that the struggle could be carried out both through and on the stage.[47]

Although many black entertainers were admired, they often faced criticism within the African-American community. Some black leaders looked askance upon those who pursued show business, considering it vulgar and debased. When the Red Devils played Denver, a prominent black citizen, Mrs. Lillian Jones, ran an announcement in the *Colorado Statesman*, declaring the "use of her name on the program of the Red Devils is entirely unauthorized and without her knowledge or consent. She desires friends to understand she does not sing for minstrel shows."[48] Reverend A. M. Ward, pastor of the city's Shorter AME Church, blasted popular entertainment in the columns of *Franklin's Statesman*. "The dancing master is the Devil's drill instructor," he wrote, "just as the theater is the Devil's church."[49] Yet many in the black community still held African-American performers in high esteem, and the African-American press was filled with praise for black stars and the potential the field of entertainment had not only for young men but for women as well. "So to young ladies who wished my advice, I say come, work, and do," counseled Aida Overton Walker. "And when you have made a mark you will feel proud and your friends and race will feel proud of you."[50] Those could be inspiring words, especially for a young, creative, and race-conscious woman like Hattie McDaniel-Hickman.

By the winter of 1915, Hattie McDaniel-Hickman had reached a pinnacle in her early career. She was a popular local entertainer and highly regarded within Denver's black circles. "Mrs. Hattie McDaniel-Hickman," the *Denver Star* commented, "stands in the front rank of comediennes and character artists." To celebrate her success, she began planning an elaborate showcase for her talents—a "character recital"—in which she would perform "the latest song hits" and play a variety of "different nationalities in their native brogue and dress." She secured Fern Hall, a local auditorium, for the night of March 4 and assembled a group of performers to assist her in this starring effort.[51]

This ambitious project required hours of writing, planning, and rehearsing; it promised to be one of McDaniel-Hickman's most innovative

as well as most subversive performances. This recital performance would not only highlight her artistic flexibility but also permit her to parody whites by mimicking characters from around the world. It is even possible that she planned to use whiteface, just as Otis McDaniel had done in his act. But even if she did not, for an African-American female performer to appropriate whiteness and to lampoon members of the dominant culture (and their European roots) was brazen. McDaniel-Hickman was in the process of turning blackface minstrelsy on its head, creating a type of whiteface minstrelsy, either real or implied, that offered commentary on white society and its racism. This promised to be a turning point in Hattie McDaniel-Hickman's evolution as a performer. "Stay off this date; March 4," the *Denver Star* warned readers. "It belongs to Hattie McDaniels Hickman who will give something new."[52]

But on February 22, Howard Hickman fell ill. His condition rapidly worsened and he developed pneumonia. In the midst of her final preparations for her solo show, his wife tended him at home. But nothing seemed to help. Shortly after midnight March 3, just one day before the biggest night of Hattie McDaniel-Hickman's career, her husband died. "Character recital by Hattie McDaniel-Hickman at Fern Hall . . . has been indefinitely postponed due to the death of husband Howard Hickman," read a large notice in the *Denver Star*. "Kindly tell your friends."[53]

Howard Hickman's death at age twenty-six was a shock to the entire community. He was an active young man and a vital presence. On March 7, his wife, family, and friends gathered at Central Baptist Church for his funeral. The sanctuary was packed wall-to-wall with mourners. According to the *Denver Star*, the church's minister, Reverend Price, eulogized the young Hickman "with much power and very touching effect." The black community's popular "Colored Brass Band" turned out and played in his honor. Others paid tribute to Hickman for paving the way for black pianists and musicians in white movie houses. "It was," as the *Denver Star* reported, "a very solemn funeral."[54]

Hattie McDaniel-Hickman was devastated. She left the home she had made with her husband and moved back in with her parents. Permanently canceling her character recital, Hattie McDaniel-Hickman withdrew from the entertainment scene. She returned to domestic work and looked to her

faith for comfort. "Whereas it has pleased God to take from our midst my beloved husband, Howard John Hickman," her card of thanks in the *Denver Star* began and continued:

> But warm, sweet, tender even yet,
> A present life is he;
> And faith still has its Olivet.
> And hope its Galilee.

Hattie McDaniel-Hickman was only twenty-one years old and already a widow."

About the time Hattie McDaniel-Hickman retired from the stage, grieving the loss of her husband, American show business was undergoing some significant changes. Although it had never been particularly welcoming to African Americans, black performers found that the environment had grown even more frigid. The black Broadway shows, like those of Williams and Walker, closed down; ragtime and the cakewalk were fast becoming outdated. White performers had pilfered black song and dance, using it to build their careers. Those few African Americans who had made it into white vaudeville found themselves hindered by booking agents who refused to engage black solo artists and limited black acts to one per bill. The rare exceptions were male—Bert Williams who continued to be one of the nation's biggest stars, and the grand master of tap, Bill "Bojangles" Robinson.[56]

Out in California, the newly emerging film industry also did not offer much for black performers. Controlled by whites as well, major black roles were usually played by whites in blackface, with African Americans consigned to bit parts and working as extras. By 1915, the film industry seemed to have turned overtly hostile to the African-American population as a whole. That year, director D. W. Griffith released *The Birth of a Nation*. Based on Thomas Dixon's novel *The Klansman*, the film's account of the Civil War and Reconstruction glorified slavery and the Southern cause. Griffith's depiction of blacks ranged from silly and loyal servants who refused to leave their masters after emancipation to violent and lusty black Union soldiers and politicians who purportedly cruelly denied white

Southerners their civil rights and pursued white women for their pleasure. The film climaxed with the organization of the Ku Klux Klan, heralded by Griffith, a Southerner and son of an ex-Confederate officer, as the noble guardian of the white South and its white women.[57]

The Birth of a Nation was a tremendous box-office hit among whites. Even the president of the United States, Woodrow Wilson, endorsed it, declaring, "It is like writing history with lightning. And my regret is that it is all so terribly true." But the result of the film was deadly. Dormant since the federal government abandoned Reconstruction, the Ku Klux Klan reemerged. This time the organization spread nationwide and, in addition to African Americans, targeted immigrants, Catholics, Jews, Mexican Americans, and Asian Americans. While it would take a few more years for the Klan to gain a foothold in Colorado, that state was no exception, and by the early 1920s, the city of Denver would become a hotbed of Klan activity.[58]

With The Birth of a Nation's release, the black community of Denver organized protests against the film. In 1915, as the film hit the theaters, black Denverites established a branch of the National Association for the Advancement of Colored People (NAACP) and joined its campaign against The Birth of a Nation. In early December, the city's black leaders organized massive rallies and circulated petitions demanding that the city bar the film from its theaters. Campbell Chapel supported the outcry against Griffith's film, Reverend James Washington praising the community's "efforts to suppress The Birth of a Nation."[59]

Although the community fought hard, The Birth of a Nation showed in Denver anyway. While there is no evidence that the McDaniels participated in the city's demonstrations against the film, Denver's black community's response was so vocal and so massive that they must have been at least aware of the controversy. No doubt, the film industry must have seemed like a remote and unfriendly venue for any of the McDaniel siblings.

Still, Hattie McDaniel-Hickman had not given up entirely on show business. After the appropriate year of mourning, she began to reemerge. On March 11, 1916, she commemorated the first anniversary of her husband's death with a memorial to him in the Denver Star. "The chained

order broken; a clear face missed day by day from its accustomed place," it read. "But cleansed and perfected by grace." In the same issue of the *Denver Star*, Hattie McDaniel-Hickman announced that on April 24, at East Turner Hall, she would star in her own play *Spirella Johnson from Memphis, Tennessee*. Scheduled as a benefit performance for Denver's African-American Masonic lodge, *Spirella Johnson* was a two-act "farce comedy." (The lead character, Spirella, was probably named after a popular corset of the era.) McDaniel-Hickman assembled a cast that included Etta Goff, Addie's son Lorenzo Lawrence, and Lena's daughter Mabel Taylor. A full-page advertisement for the play promised "continuous side splitting laughs" and urged patrons to show up early, before tickets sold out.[60]

That was good advice. For on April 24, East Turner Hall was packed with an audience of two thousand that included the city's former mayor Robert A. Speer. When the curtain went up, the audience found itself in a contemporary Denver roadside inn run by Anita Johnson (Etta Goff). Her sister Spirella (Hattie McDaniel-Hickman), fresh from Memphis, Tennessee, arrives and for two acts drags the other characters, which included a British noble, a German immigrant, two unemployed drifters, and a tango dancer, through a series of madcap escapades. But most outrageous of all was Spirella's hysterically grand social debut at a local reception held at Anita's tavern. As Spirella, McDaniel-Hickman delivered two songs, "I'm Going Back, Back, Back to Memphis" and "Back Home in Tennessee," and led the entire company in "Take Me to That Midnight Cakewalk Ball."[61]

Spirella Johnson was a success. "The entertainment was the grandest, the largest, and best patronized event ever given by the Centennial Lodge [Masons]," the *Denver Star* observed. The *Colorado Statesman* reported, "Outbursts of laughter and numerous applauses greeted the performers." Praise went to Hattie McDaniel-Hickman and Etta Goff. "The McDaniel Sisters clearly showed themselves to be funmakers," the *Star* insisted "and deserved all the applause they received." Spirella was an extension of McDaniel-Hickman's back-talking, audacious earlier characters, playing stereotypes to expose their illogical extremes. Hattie McDaniel-Hickman was back.[62]

Ironically, the family that had gained a reputation for merrymaking on the stage continued to endure many burdens in real life. Sometime in late summer or early fall 1916, Otis McDaniel returned home to Denver. It must have been clear to those around him that his health was failing. On October 29, while worshiping at Campbell Chapel, Otis McDaniel officially joined the church. In less than two weeks, he was dead. On November 15, a grieving McDaniel family held his funeral at the church and, later that day, they buried him in Denver's Riverside Cemetery. The *Colorado Statesman* reported that "many beautiful tributes evidenced the esteem" that friends and family had for the young man whose end had come too soon and whose future had seemed so bright.[63]

Otis McDaniel's loss was tragic, but his siblings carried on in his memory. Hattie McDaniel, who had dropped Hickman from her professional name, had moved out on her own again. In the spring of 1917, Etta Goff, now divorced and continuing to support her son as a washerwoman and a cook, joined Hattie to revive their all-women's minstrel troupe. Billed as The McDaniel Sisters and Their Merry Minstrel Maids, in April and May, they appeared before capacity crowds, winning accolades in the African-American press. When Hattie McDaniel donned a grass skirt and danced a hula, the crowd roared with laughter. "Some are still laughing yet," the *Denver Star* claimed several days after her performance.[64]

Although McDaniel had made her mark as a sly comedienne, she also welcomed the opportunities to work with more serious material. On a number of occasions at local community functions, she recited Shakespeare as well as the poems of Paul Laurence Dunbar. She was particularly fond of Dunbar's work and sang at the inauguration of Campbell Chapel's Dunbar Literary Society. For a time, she even served as the church's choir director; her moving solos were reputed to have brought many a repentant sinner to "the mourner's bench." While she won praise and recognition within the black community for these performances, she remained stifled. There were virtually no outlets outside Denver's small black church and society circles for Hattie McDaniel to explore her more serious and dramatic side.[65]

Opportunities for African-American performers in Denver remained limited. The city's stages were generally segregated. Although Denver had

an active and talented population of black entertainers, it had no venue solely dedicated to black performers. Almost all performances were booked into churches or the community's local auditoriums. In 1910, Leon Pryor, who earlier had appeared with the McDaniel brothers, called for the community to open its own theater, which would allow black artists to explore the full range of their talents. But it was not until late 1917 that Sam McDaniel, now an accomplished musician and experienced show-man, took action. With two partners, J. C. Boone and H. P. Covington, he organized the Five Points Theater. Proudly, they announced their grand opening in the *Denver Star*. "Go to Our Own Theater," the advertisement read, "Run by Our People." Hattie McDaniel was on hand for the inaugu-ration of the theater; for her turn she sang the torchy "I'm a Real Kind of Momma Looking for a Lovin' Man." Hailing her the "sorrow wreaker of Five Points," the *Denver Star* rated her "the hit of the evening."[66]

The Five Points Theater screened films and offered variety shows featur-ing Denver's favorite African-American performers. And Sam McDaniel's vision received hearty endorsements. The *Denver Star* urged the city's black population to get behind the Five Points Theater, which promised to pro-vide African Americans with an independent entertainment outlet for their creative endeavors. "They deserve, solicit, and are entitled to your unlim-ited support," the *Star* insisted, calling on African-American businessmen to invest in Sam McDaniel's endeavor.[67]

Despite the excitement and pride produced by Sam McDaniel's ven-ture, his resources were limited, and Denver's financially depressed African-American community could not sustain the costly effort of run-ning a theater. By mid-February 1918, he was forced to close the Five Points Theater's doors. Sam McDaniel hit the road with a singing quartet, and they secured a long-term engagement in an upscale white Salt Lake City hotel. The act was classy: they performed in dinner jackets in the af-ternoon and tuxedos at night. The reviews were all raving.

And the *Denver Star*, always supportive of African-American perform-ers, optimistically boasted of Sam McDaniel's achievements, maintaining, "The Negro is cutting away prejudice through his music."[68]

3

. . .

Blues Singer

. . .

Richard M. Jones and his Knights of Syncopation have
returned to the city after a successful engagement at the
Broadway Theater, Gary, Ind. Through their engagement the
theater was filled to capacity. Hattie McDaniels, blues singer,
and Maxie of the team of Maxie and Sumter were
enthusiastically received.

Chicago Defender, April 23, 1927

JANUARY 1, 1920, was not only the beginning of a new decade but also a dawning of a new era. Federal Prohibition, which outlawed the production, sale, or distribution of alcohol, went into effect. Later in the year, American women (at least those who were not disenfranchised in the South) had the opportunity for the first time to vote in a presidential election. The Great War, the worst armed conflict that the world had witnessed to date, was over. Young fighting men came home; disaffected intellectuals went abroad. Americans were already being encouraged to buy, buy, and buy. And they did, snapping up tempting consumer items including automobiles, washing machines, and, a little later in the decade, radios. Stock-market investment, as one advertisement in the *New York Times* read, was no longer "a rich man's game." It became an American pastime as the Dow began to rise to unprecedented heights. This was the age of jazz and the Charleston, where black music and dance were embraced by rebellious white youth. This was a society of flappers and sheiks whose ideas about courtship and sex were significantly more open than those of their parents. Across the country, the elite—worldly, restless, and

adventurous—prowled speakeasies and night clubs looking for the latest in music, entertainment, and thrills. The Roaring Twenties seemed, at least to some, like one big, wild, endless party.[1]

That was for a select portion of America. For African Americans, the twenties marked another decade of struggle against poverty, inequality, and racism. The preceding summer, that of 1919, was dubbed the "Red Summer": in various parts of the nation, race riots broke out and led to death and destruction in black communities. A Tuskegee Institute study released in late 1919 concluded that the lynchings of African Americans had steadily increased during the previous year. After hiring an advertising team, the Ku Klux Klan was rapidly gaining momentum across the country. In the South, as well as in other parts of the country, segregation was the norm. Most African Americans remained trapped in poverty, forced into menial jobs as urban laborers, rural farmhands, or servants. There was little extra money to spend on the latest delights of consumer culture or to play the stock market. Generally, during the "Roaring Twenties," African Americans like Hattie McDaniel and her family fought just to make ends meet, constantly battling discrimination and a world that offered few opportunities to the black working class.[2]

Despite these obstacles, out of the 1920s did come a revived spirit of resistance and protest within the African-American community. In the prior years, between 1915 and 1920, the "Great Migration" had begun. In those five years, a million African Americans, weary of vicious Southern racism, left the South for the North and Midwest, drawn by new jobs in the war industry and the seemingly more progressive racial attitudes in these regions. Additionally, African Americans stepped up to support World War I—the "War to Save Democracy." Many young black men enlisted or were drafted and, as a result, fought in some of the war's key battles. They returned home heroes, celebrated by the black community for their bravery on the battlefield and contributions to winning the war. And their accomplishments reenergized the African-American commitment to securing the promises of democracy at home. This era of renewed enthusiasm and determination became known as the Harlem Renaissance, a broad movement that encompassed not only a heightened political activism but also a celebration of African-American culture and history. As

the largest African-American community in the nation, Harlem became the center of this rebirth, drawing activists and artists from across the country and around the world. There, literature and art flourished, and music, in particular jazz and blues, thrived. Harlem's spirit of self-assertion and creativity rapidly radiated outward to other African-American communities throughout the nation.[3]

But just as a new era began, another one was coming to a close. Many of the black community's elders, those who had been born in and struggled against slavery, were passing on. In 1920, at the age of seventy, Susan McDaniel passed away. The family called upon the Reverend H. Mansfield Collins, from Pueblo, Colorado's St. Paul's AME Chapel, to preach the funeral sermon, and on June 21, just over ten days after her twenty-seventh birthday, Hattie McDaniel along with the rest of her family followed the hearse out to Riverside Cemetery for her mother's burial.[4]

Although her own health had not been good, Susan McDaniel spent her final years caring for her grandson Edgar, while her daughter Etta Goff worked as a live-in cook for an elderly white farmer on Denver's outskirts. With her mother gone, Etta Goff had to move home to take care of her father. Henry McDaniel, now well over eighty, suffered from advanced kidney failure, untreated war wounds, persistent infections, and constant pain. For over two years after his wife's death, he fought on, sometimes seized by spells that required around-the-clock nursing. Then on November 20, 1922, he suffered a particularly serious episode and began to decline rapidly. Together, Hattie and Etta, who had also enlisted the help of a family friend named George Eli, spent ten days and nights caring for their father. Finally, on November 30, at one o'clock in the afternoon, Henry McDaniel died.[5]

Henry McDaniel's grieving children organized yet another AME service with Reverend Collins and returned, on December 5, 1922, to Riverside Cemetery. They arranged for their father to be interred there with military honors and laid to rest in the cemetery's Veteran's Circle with a simple headstone reading "Pvt. Henry McDaniel, Co. C, 12th USC INF." When Etta Goff filled out his death certificate, she gave only one occupation for Henry McDaniel—"retired soldier."[6]

Despite his service to his country and years of hard labor, Henry McDaniel died penniless.[7]

That was the reality of black life in the 1920s. Etta Goff, a single mother with limited resources, absorbed most of the cost for his care and funeral. She carefully returned her father's December pension check, informing the bureau of his death. With her sister Hattie's help, she began petitioning the government for a customary veteran's survivors' reimbursement. It took six months of correspondence and documentation before the United States government finally agreed to cover $45 of the more than $200 that Etta Goff owed a doctor and the undertaker.[8]

That summer after her father's death, Etta Goff gathered up her belongings and, with her young son, left Denver. Opportunities for black Denverites were becoming even more limited. By 1923, the Ku Klux Klan was firmly ensconced in the city's power structure, dominating the police department and mayor's office and terrorizing the African-American population with bombings, cross burnings, and death threats. For a woman like Etta Goff, who survived as a domestic, there was little incentive to stay in a town that was becoming increasingly hostile to African Americans. She was looking for something better.[9]

Etta Goff's first stop was San Diego, California, where she visited her brother Sam McDaniel and his wife, Lula, whom he had married in Casper, Wyoming, in 1918. After years on the road, Sam McDaniel had decided to make his home in Southern California. He organized a band, Sam McDaniel and His Kings of Syncopation, and played the nightclubs of Tijuana, Tecate, and Mexicali, Mexico. Unrestricted by Prohibition, alcohol flowed freely in Mexico, and liquor-parched Americans flooded in, demanding not only booze but also entertainment. South of the border, businessmen rushed to open up nightspots catering to Americans; some even attempted to recreate the distinctive atmosphere of popular places like the Cotton Club in Harlem, which catered to whites but offered all-black musical revues. As a result, the talented Sam McDaniel was doing pretty well, benefiting from both Prohibition and the popularity of jazz music.[10]

Before long, Etta Goff was off again; she had decided her prospects would be best in Los Angeles. By late 1923, she had settled there and quickly found work as a housekeeper for a family in the swanky, old-money neighborhood known as the West Adams District. Over the next several years, Etta Goff occasionally attempted to resurrect her stage ca-

reer, booking some vaudeville dates and touring briefly with a production called *California Poppies*. But family responsibilities and the need for a steady income always eventually compelled her to return to working as a maid for white West Adams families.[11]

Back home in Denver, her sister Hattie was experiencing similar frustrations. No doubt, Hattie McDaniel had endeavoured to keep her show-business aspirations alive, and she had possibly done a little touring herself during the very early 1920s. But, like Etta Goff, Hattie McDaniel found herself repeatedly forced back into domestic service, primarily as a cook. While leaving Denver may have looked attractive to the youngest McDaniel sibling, she also had personal reasons for staying behind. Sometime before 1922, she had remarried. Her second husband, Nym Lankfard (often also spelled Lankford or Langford), was a native of St. Joseph, Missouri, who had arrived in Denver in April 1918 to visit his parents and other relatives. Shortly afterward, he settled in the city and found work as a laborer and a porter. How or when he met the widowed Hattie McDaniel-Hickman is not certain. Perhaps it was through show-business circles. It is possible that Nym Lankfard was related to Fred Lankfard, who was also from St. Joseph and who had become popular in black Denver as a "tango banjoist." An absence of a marriage license in city records indicates that Hattie McDaniel and Nym Lankfard were married somewhere outside Denver; perhaps he, too, was an entertainer and they tied the knot on the road. At some point, they returned to the city and, by 1922, had set up housekeeping not too far from Henry McDaniel's home. But the relationship between Hattie and her second husband quickly went sour. By the time of her father's death, she had moved back into the family home and before long reverted to using her maiden name. She would share a seemingly stormy on-again, off-again relationship with her husband for the next several years.[12]

Perhaps more important than her marriage were the compelling professional reasons that kept Hattie McDaniel in Denver. She had established a reputation in the black community as a popular performer and was working closely with the celebrated local orchestra leader and violinist George Morrison. It was an electric combination. In January 1923, when she performed with Morrison at a benefit concert for Denver's Phillis

Wheatley YWCA, the *Colorado Statesman* reported, "Hattie McDaniels gave a reading that was accorded an unusually warm reception."[13]

George Morrison, regarded as a musical genius by many, was an old friend of Hattie McDaniel. His wife, Willa May, was related to Hattie McDaniel—possibly a cousin. The two women, born only months apart, had grown up together and shared a strong bond. Willa May was there the day Hattie McDaniel married Howard Hickman; she served as one of the couple's two witnesses. It is likely that Hattie McDaniel was a part of the wedding party when Willa May became the talented George Morrison's wife several months later.[14]

At that time, Morrison was a fairly recent arrival in Denver. Born in poverty in Missouri in 1891, he taught himself to play the violin as a child. At the age of ten, he was sent to live with an older sister in Boulder, Colorado, where he received classical training from the area's finest musicians. As a young man, he began touring the region and rapidly gained a following in Denver, which he made his permanent residence in 1911 just after his marriage to Willa May. Acclaimed by the celebrated violin virtuoso Fritz Kriesler as a "very, very talented musician," Morrison, nonetheless, found his career as a classical violinist impeded by racism. As he recalled, the conductor of the Denver Symphony praised his musicianship but drew the color line when it came to allowing him to play with the orchestra. "I'd have you as my concertmaster," the conductor stated, "if you were a white man."[15]

George Morrison made his living playing popular music. At first, he performed with a small band in Rocky Mountain bordellos and mining camps. Shortly afterward, he organized an orchestra that played classical, sacred, and modern tunes. But it was jazz, uniquely improvised on his violin, that both Denver's black and white communities demanded. Morrison rapidly emerged as one of Denver's most popular black entertainers. It is not surprising that Hattie McDaniel quickly linked up with Willa May's brilliant and creative husband. During the teens, Morrison and his orchestra had accompanied Hattie McDaniel for several of her local stage productions, including her all-female minstrel show for the Sojourner Truth Club.[16]

The collaboration between Morrison and McDaniel was interrupted

when, in 1920, he attracted the attention of New York talent scouts. That year, he signed a contract with Columbia Records and packed up the orchestra and moved to Manhattan. He recorded two numbers and quickly secured a long-term engagement at a local nightspot. Not surprisingly, Morrison was immediately drawn into the Harlem Renaissance's artistic whirlwind; he cultivated connections within New York's expanding community of black musicians, which included William C. Handy, widely acknowledged as the father of the blues. Additionally, Morrison became acquainted with successful black songwriter Perry Bradford, who convinced the orchestra leader to help out a struggling, unknown blues singer, Mamie Smith. Morrison not only advised Smith but also outfitted her with a new wardrobe. Prevented by his contract with Columbia from accompanying her, he nonetheless helped Smith record a number called *Crazy Blues*. It became the first blues recording ever made by a woman, immortalizing Mamie Smith in music history.[17]

It was not long before Morrison grew disillusioned with the stifling nature of the recording industry, which dictated his career and refused to allow him to record his own compositions. "We record[ed] what they say, what they wanted us to do," he later recalled. Fiercely independent and uncompromising, he left New York and returned to Denver, performing with his orchestra there and throughout the West, Midwest, and the Plains. He also found a partner and opened a nightclub, a place he called Rockrest. It became an immediate hit, offering music, dancing, and entertainment to a Denver crowd that arrived with their own liquor stashed away in their cars, back pockets, and purses. Rockrest was a booming establishment—that was until Denver's Klan shut it down.[18]

Still, the New York music scene and the Harlem Renaissance had left their mark on George Morrison. In particular, after his contact with Mamie Smith, who rapidly ascended to national fame with her solo debut, the orchestra leader gravitated more toward the blues. After returning home, he decided to add a female blues singer to his ensemble. He did not have to search far, for he already knew someone who had experimented a little with that form—Hattie "the Sorrow Wreaker of Five Points" McDaniel. Reportedly, McDaniel became a mainstay with Morrison's orchestra, performing in nightclubs and other venues around Denver. She

also joined him for several road dates, including engagements with the Shriners and Elks Indoor Circuit, which she later claimed toured the entire South, and at the Latino Americano nightclub in Juarez, Mexico.[19]

By summer 1924, Morrison and McDaniel had secured an audition with the white-owned Pantages vaudeville circuit. It was a tremendous opportunity, and they rehearsed diligently. "I got my band together and Hattie McDaniel and I got our act worked up," Morrison told an interviewer years later, "practicing about seven or eight hours a day, every day, and got it down pat." It paid off and Pantages granted them a contract for the 1924–25 season.[20]

While the Pantages was second-tier vaudeville, serving smaller cities in the United States and Canada, it was a major break for Hattie McDaniel. For most of her career, she had been primarily confined to local venues with an occasional out-of-town, small-time tour. But the Pantages was a step up in the show-business world, a nationally recognized vaudeville circuit that catered to audiences around the country. Crossing-over into the national white entertainment scene not only netted more money, it was a proud accomplishment for both Morrison and McDaniel. Each black act that broke through represented a challenge to racism and segregation.[21]

On November 17, 1924, George Morrison and Hattie McDaniel opened at the Pantages Theater in Minneapolis, Minnesota, and then for five months traveled thousands of miles that took them north, west, then to the middle part of the country, and finally south. They played Saskatoon, Calgary, Seattle, San Francisco, Los Angeles, San Diego, Denver, Omaha, and Memphis, among other cities. Although this was an exciting opportunity for Hattie McDaniel, touring on the Pantages circuit presented definite hardships. These engagements were draining. Performers had little spare time between the three shows they played each night six days straight. Sundays were traveling days, and every week brought a different town; the pace was unrelenting. To complicate matters, African-American artists had difficulty securing adequate accommodations and food. Very few of these cities had black hotels, and since white establishments usually refused to serve or lodge them, African-American vaudevillians had to arrange for room and board in private black homes. Transportation was also problematic. Most vaudevillians traveled by

train—it was the fastest way to get to the next date. But in some parts of the country, black performers were forced to endure long trips in segregated and dilapidated Jim Crow cars. In each town and at every theater, they encountered some form of racism and discrimination. Pay was low, the hours were long, and the tours were exhausting.[22]

Regardless, McDaniel and Morrison worked hard to please their audiences. While their act was a smash in most towns, the competition was not particularly stiff. They shared the program with Kara the Juggler, an Italian singing duo Moro and Yaco, a male crooner named Cliff Nazarro, the Renee Sisters (accompanied by their mother on the piano), and several terriers, a shaggy Airedale, two monkeys, and a pony that comprised an act known as Gus Thalero's circus. Morrison and McDaniel provided a sparkling highpoint in what several critics rated as a generally dull bill.[23]

The duo had pulled together an upscale, highly professional act. Morrison opened with a classical piece; as the curtains lifted, the orchestra played a selection from *Pagliacci*. He followed up with a lively version of *By the Waters of Minnetonka* and several jazzy numbers described by a critic in San Jose, California, as "the peppiest music ever heard in this man's town."[24] After the crowd was warmed up, he introduced "the female Bert Williams," and Hattie McDaniel made her entrance. Described by one reviewer as a "humorous surprise," she blended comedic banter with blues songs and dynamic dance numbers. With her energy and brazenness, it was hardly just an act that mimicked the lethargic, woeful Williams. The *Oregon Daily Journal* reported: "She does a hop, skip, and a jump act back and forth across the stage while keeping up her vocal stints."[25]

The Morrison Orchestra Featuring Hattie McDaniel received accolades. A *Variety* reviewer, who caught their act in Los Angeles in February 1925, observed that Morrison's ensemble could compete with "any of the big-time traveling orchestras." He also praised Hattie McDaniel as "buxom, noisy, and funny." She received equally encouraging reviews at other points along the road; these audiences, mostly white, liked her. "Hattie McDaniel was taken in riotous fashion," reported the *Portland Telegram*. The *Los Angeles Times* lauded McDaniel as "the old pep machine of the company with her hearty cheer." There, the local black news-

paper, the *California Eagle,* proclaimed Hattie McDaniel a "talented enter-tainer." The Los Angeles African-American community threw a reception for the Morrison troupe. Morrison and McDaniel reciprocated with a free performance at Central Avenue's Assembly Auditorium, located in the heart of the black community.[26]

By this point, Hattie McDaniel had fashioned an act that combined the subtle, signifying comedy of Bert Williams with blues music and jazz dance. Her brand of humor was, in part, based on her physical presence. Hattie McDaniel was an attractive woman with a generous figure who pos-sessed a remarkable agility that, in the rail-thin-flapper era, caught specta-tors off-guard. Her bold personality on stage and her sassy presence left a deep impression. Although she continued to draw from Williams, she also countered his deliberately slow, downtrodden pace with her energetic hoofing. During the tour, McDaniel was also billed as the "Sepia Sophie Tucker." A white woman renowned as "the last of the Red Hot Mamas," Sophie Tucker had built a career as a blackface performer singing saucy compositions, many written by African-American musicians. In a sense, McDaniel, like Williams and Walker and other African-American perform-ers, was attempting to reclaim the black culture that had been exploited and distorted by white performers seeking fame and fortune. Yet, unlike Williams, whose character always remained cautiously asexual, Hattie McDaniel infused a smoldering bluesy sensuality into her performances. Hattie McDaniel was in a continual process of reinventing a complex and nuanced stage persona, one that signified both humor and seriousness while simultaneously embracing and critiquing societal stereotypes.[27]

In early May 1925, Hattie McDaniel and George Morrison returned to Denver just in time to celebrate their triumphant tour with an appear-ance at Denver's annual Music Week festival. Although Morrison's well-received Pantages appearances were locally heralded as a remarkable achievement, little more came of the tour. He returned to the regional en-tertainment circuit, where his music remained in great demand. Just Mor-rison's name alone on a program drew large crowds, in both the black and white communities. In December 1925, his popularity also won him a date on Denver's KOA Monday *Radio Concerts.* Although she was not men-tioned in reviews, it is possible that Hattie McDaniel made her radio debut

that night. Later, she claimed that early in her career she sang on the air with Morrison and boasted that she was the first African-American woman to perform on the radio with an orchestra.[28]

Hattie McDaniel now had set her sights beyond Denver and aspired to carve out a permanent place for herself in the national entertainment scene. Out in California, Sam McDaniel was enjoying some success. By the mid-twenties, he and his wife had moved into a rented home in Los Angeles, just around the corner from his sister Etta. While he occasionally continued to play with his band in Mexico, he also secured vaudeville bookings with a female partner, Roberta Hyson, a former member of Harlem's prestigious theatrical company The Lafayette Players. By 1926, he had even scored a part as an extra in a film. But his real break had come in 1924, when, as the doleful "Deacon McDaniel," he joined KNX Los Angeles's *Optimistic Do-Nuts*, a weekly radio variety revue sponsored by the Perfection Bakery. Sam McDaniel patterned the character directly after Bert Williams; even a publicity photo he inscribed to "Sis Hattie McD." showed him in blackface and wearing a Williams-style costume. Sam McDaniel even altered the family history some, insisting that his father had been a Baptist preacher. Although Henry McDaniel was a lifelong member of the AME church and may have been a type of exhorter, he was never a minister. However, Sam McDaniel's fictionalization of his father's past served as a public relations stunt that authenticated his radio character and made him, as a supposed son of a preacher, safely nonthreatening to the white entertainment establishment. Before long, Sam McDaniel became a name widely recognized among Los Angeles's radio listeners. It was hardly the independent, creative outlet that he had earlier sought with endeavors like the Five Points Theater, but it certainly helped pay the bills.[29]

At home in Denver, Sam McDaniel's sisters were struggling. Lena had remarried—a man named Gary—and was widowed again. She supported herself as a washerwoman while two of her daughters worked as maids. Addie had also found a new husband, most likely a laborer, named John Haig, who had boarded in her home in 1910. But by the late 1920s, her husband had either died or left her. With few resources, Addie Haig went to live with her son Lorenzo Lawrence.[30]

Hattie McDaniel faced similarly bleak prospects. After she returned to

Denver in 1925, despite her success on the road, all that was available to her were positions as maids or cooks. As far as her marriage went, Hattie McDaniel and Nym Lankfard were drifting even further apart. He may not have even been in town by the time she arrived home; he appears to be absent from the city directory and McDaniel later told an interviewer Lankfard had left for New York. With her marriage in shambles, and refusing to accept a dead-end future working as a servant for white families, Hattie McDaniel again packed her bags and this time left Denver for good.[31]

Hattie McDaniel first headed northeast. Basing herself in Chicago, over the next several years she trouped the country, picking up engagements wherever she could find them. She developed a solo act out of songs and material she had written and billed herself as the "Female Bert Williams, The Lone Worker." While she claimed that she also appeared on the Orpheum route, another "medium-time" western vaudeville circuit, McDaniel spent most of this period playing dates on the TOBA, the Theater Owners Booking Association's black vaudeville circuit. Organized in the 1910s by African-American comedian Sherman Dudley, the TOBA had financial backing from both black and white investors and provided a black alternative to the almost exclusively white vaudeville circuits. By the 1920s, Dudley and his partners controlled a nationwide chain of African-American theaters that offered all-black vaudeville bills and musical shows for black audiences.[32]

While the TOBA was popular in the black community, it was grueling and unpredictable work for performers. Many African-American vaudevillians reviled TOBA as "Tough on Black Actors" or, even worse, as "Tough on Black Asses." TOBA engagements could run as long as an entire season or as short as one night. The circuit's bosses often abruptly changed bills, reassigning or even dropping acts on short notice. As in second-rate white vaudeville, performers played three back-to-back shows, six days a week. For all but the biggest stars, the pay was meager. Dishonest theater managers, both black and white, commonly cheated black vaudevillians out of their earnings. Clarence Muse, who had a long association with the TOBA, later insisted that "the actor who played this time usually ended up at the close of the season as broke as when he

started." To add to the hardships, securing food, lodging, and transportation, especially in the Jim Crow South, ran from difficult to dangerous. It was a lonely, difficult life.[33]

Still, a TOBA gig was considered a good break for lesser-known artists like Hattie McDaniel. It was a chance to gain some recognition within black entertainment circles and to play material to exclusively African-American audiences. By the early 1920s, the TOBA featured some of the era's biggest names, including Bill "Bojangles" Robinson, Bessie Smith, and Ethel Waters. For McDaniel, it offered a chance to network with some of the most accomplished black show-business professionals. But while those acts toured in style, up-and-coming hopefuls like Hattie McDaniel often found themselves suddenly struck from the bill and stranded in a town without pay. When those tough times came—and they did—Hattie McDaniel scrambled around for a position as a cook, maid, waitress, or dishwasher, and worked until she had enough money to hit the road again.[34] Both personally and professionally, those years were trying. They were filled with "ups and downs," as Hattie McDaniel later recalled, "and they seemed to be mostly downs."[35]

By early summer 1926, Hattie McDaniel, on tour with her solo act, had landed in Kansas City, Missouri. It was an important turning point for Hattie McDaniel. Sometime during her stay there she teamed up with another ambitious and talented African-American performer, Hartzell "Tiny" Parham. Born in Canada in 1900 and a brilliant pianist, Parham was raised in Kansas City's thriving jazz-and-blues community. The bespectacled Parham was an enormous man, professorial in appearance despite his youth. In the mid-twenties, Parham organized a band and moved to Chicago where he both performed and worked as an arranger. He advertised his services ("Let Tiny Do Your Arranging") for struggling black musicians in the pages of black periodicals. During recording sessions, he helped those who lacked formal musical training by transcribing their original compositions onto paper. It not only generated income, as sheet music companies were always looking for new songs to market, but also preserved those songs for posterity.[36]

While it is not clear how Hattie McDaniel met Tiny Parham, they developed a professional bond that lasted several years. It is possible she

came to know the talented Parham through their mutual friends, the black vaudeville team Butterbeans and Susie, a popular comedy duo whose act later inspired Burns and Allen. While on this stop in Kansas City in June 1926, McDaniel, joined by Parham, recorded two sides, "Quittin' My Man Today" and "Brown Skin Baby Doll," for the local Merrit label issued by the Winston Holmes Music Company. While her record only reached a limited audience, it did give McDaniel an entrée into the recording industry. With Parham's help, she began to establish herself in black entertainment circles not only as a blues singer and comedienne but also as a recording artist and songwriter.[37]

By late July, Hattie McDaniel had moved on to Cincinnati, Ohio, where she was knocking crowds dead at the TOBA's Roosevelt Theater. "An artist in the front line is this performer," the *Chicago Defender* proclaimed, "who gives it to her audience right from the shoulder." In August, she returned to the Windy City where she began rehearsing with a jazz band for her next season's road tour. By the year's end, she was back in the recording studio, this time working with Lovie Austin's Blues Serenaders. Austin was one of the few black women who had risen to a position of relative authority within Chicago's musical community. Born Cora Calhoun in Chattanooga, Tennessee, Austin was a college-educated pianist who, like other classically trained black artists, had resorted to popular music to make a living. After coming to Chicago, Austin organized her own band, which became the house orchestra for the popular Monogram Theater. During her career, Austin worked with some of the era's most famous blues singers, including Ida Cox, Ethel Waters, Alberta Hunter, and the pioneering Ma Rainey. This experienced musician was the perfect mentor for McDaniel. In November of 1926, together they recorded two more McDaniel originals, "I Wish I Had Somebody" and "Boo Hoo Blues."[38] Both were issued on OKeh's "Race Records" line, the pinnacle for black musicians and singers. The first major label to record African-American artists, OKeh's records were sold nationwide. For McDaniel, to cut two songs with the well-regarded Lovie Austin on such a prestigious label was a significant step up in the entertainment field. But it was also an important stage in McDaniel's transformation from a satirical comedienne into an empowered and bold blues queen.[39]

By this point, Hattie McDaniel had discovered that through the blues, she could articulate, or signify, opinions and ideas that she was normally prohibited from expressing publicly. On one level, she could air her private pain; many of her songs were deeply personal in nature and reflected the despair of a woman struggling through a bad relationship. Both "Boo Hoo Blues" and "I Wish I Had Somebody" were laments of a woman done wrong. In these songs, McDaniel rejected the isolation and loneliness of her heartbreak. "I'm coming from seclusion to tell you about my man," she sang in "Boo Hoo Blues," "Just a few things about how my troubles began."[40] It was a man, and an unfaithful one at that, who was the root of her turmoil. "I Wish I Had Somebody" set a similar tone:

> I wish I had somebody,
> Who didn't love nobody but me, just me.
> I'd like to know at nighttime,
> Someone's coming home to me.[41]

McDaniel's emotional despair ran so strong that in "Boo Hoo Blues" she mentions suicide, threatening to "drink poison to get out of my misery." That song's refrain literally was a mournful weep.[42]

Although these lyrics present telling evidence regarding McDaniel's devastated emotional state, they also hint that she still maintained an inner strength and resolve. Both songs functioned at another, deeper level as a general statement of dissent. They were forthright critiques of the male exploitation of women, containing an undercurrent of simmering anger. Using the blues, McDaniel could declare her grievances openly. "I Wish I Had Somebody" began brazenly:

> Every time I think I'm set,
> With someone I just met.
> I'm bound to discover another heavy lover,
> Getting what I ought to get.

"No wonder I complain," McDaniel states, eagerly airing her dissatisfaction with her lover's betrayal. And her lyrics made plain that she was not

going to accept the role of the silent, passive, asexual, and long-suffering partner. Not only did she enjoy her own series of lovers, she had just as many needs as any man. Her man needed to "be always at my heel" and "call me up a dozen times in the day just to find out how I feel." Obedience was not solely a woman's obligation, it was a man's as well.[43]

With her music, McDaniel contested critical assumptions about women—that they were all sentiment and no sex. In many respects, McDaniel attempted to turn gender assumptions upside down. Women had their desires and they deserved better treatment from their men. Even McDaniel's vocalizations—she delivered these songs in a husky, almost gravelly voice—countered notions of feminine weakness and submissiveness. She was not just pining away, she was angry. "I'm going to sing this verse and I ain't going to sing no more," McDaniel's "Boo Hoo Blues" ends, "because these dog-gone blues sure do make me sore."[44]

As Hattie McDaniel increasingly immersed herself in the blues, she began to harness what was a powerful force. For Hattie McDaniel, like for other female blues singers of her generation, this genre provided a potent weapon of protest. As scholar Angela Davis contends, the musical essence of the blues furnished African-American women with a forum through which they could criticize both sexism and racism by rejecting the traditional roles and assumptions thrust upon them. "The most frequent stance assumed by the women in these songs," Davis writes, "is independence and assertiveness." McDaniel's emboldening collaboration with Lovie Austin sent her on a journey to find even more ways to signify—to talk in two voices. It must have been liberating for a woman who, confined by racism and sexism, found she had little power or control over much of her life. Hattie McDaniel's was a constant struggle to claim control, to gain her independence. And with the blues, she was in the process of developing a persona that was brazen and insubordinate, a powerful, black, feminist stage presence.[45]

McDaniel's exposure to the blues was significantly enhanced by her decision to work out of Chicago. It was a logical and smart career move. The Windy City had been long regarded as one of America's major entertainment and music meccas. Beginning in the 1910s, Chicago had drawn some of the finest African-American musicians from across the country.

Many had joined the Great Migration north, earlier attracted to wartime industrial jobs and midwestern freedoms (however limited). Although at the end of WWI employment began to dry up, throughout the twenties, Chicago remained a destination point for those rejecting Southern poverty, discrimination, and disenfranchisement. This resettlement brought together African Americans from all parts of the country, and they began an exchange of musical traditions in the theaters and nightclubs of Chicago's South Side. It was an exciting and lively community, bursting with creative energy and inspiration for performers like Hattie McDaniel. She immersed herself in this Windy City renaissance as she continued her maturation as a performer.[46]

But Chicago was a long way from Hattie McDaniel's strict church upbringing in the comparatively slow-paced Rocky Mountain city of Denver. Although McDaniel had existed on the margins of show business for years, bouncing back and forth between performing and domestic work, she was no innocent to the ways of show people. While performers worked hard, many also lived fast. With its bustling nightlife, Chicago offered plenty of temptations to the entertainment community. Despite Prohibition, alcohol flowed freely in most entertainment spots. Drugs and casual sex were commonplace. In some black neighborhoods, black and white crime bosses purchased police protection, which allowed them to openly run narcotics, bootleg, numbers, and prostitution rings. The Chicago of the 1920s that Hattie McDaniel knew was dangerous, exciting, and worldly.[47]

How McDaniel reacted to these big-city thrills is not certain. If she had a reckless period, she later carefully covered it up. It is more likely that the hardworking and ambitious McDaniel had little time to devote to the wilder side of Chicago nightlife. Climbing performers such as Hattie McDaniel often found themselves stretched thin. They played engagements until the wee morning hours, then caught a little sleep only to be up early and back to their jobs as maids, cooks, laundresses, porters, or laborers the next day. For struggling but serious entertainers, there was probably little time left for either fun or church.

Hattie McDaniel had to face the reality that while in her hometown of Denver, she had been a celebrity in the local black community, in the big

city of Chicago, she was a nobody who had to start from scratch. Although she made some headway with her music career, it was still an uphill battle. In fact, not too long after she arrived, she found herself completely destitute and, with few show-business possibilities on the horizon, had to take a full-time position as a maid for a local white family. But she worked hard to keep her career alive and successfully continued to forge relationships with some of Chicago's most innovative and accomplished musicians.[48]

By the spring 1927, she was able to quit her domestic job and signed on as a singer with Richard M. Jones and his Knights of Syncopation. Jones was also an important figure in black Chicago's music world. Louisiana-born, he had started his career in New Orleans and was a close friend of jazz pioneers King Oliver and Louis Armstrong. In addition to performing and writing songs, Jones worked for OKeh records and, like Parham, used the *Chicago Defender* to solicit artists with new material. Perhaps McDaniel saw Jones's call that appeared in a November 1926 issue. "Mr. Jones will be glad to hear from all musicians," the *Defender* notice read, "especially artists who are ready to record." Hattie McDaniel was certainly ready. She had continued to pen her own tunes and Jones's style, rooted in jazz and the blues, suited her perfectly. By April, she was touring with his band, playing packed houses at the Broadway Theater in Gary, Indiana. After returning to Chicago in May, they recorded four of McDaniel's songs. But OKeh outright rejected one of the sides, "Sam Henry Blues," and never issued the other three, "Destroyin' Blues," "Lonely Heart," and "Poor Boy Blues." McDaniel cowrote several more songs with Jones, but they appeared to make it only as far as sheet music.[49]

McDaniel had better luck when she reunited with Tiny Parham in a Chicago recording studio in December of that year. While OKeh shelved her second attempts at "Sam Henry Blues" and "Destroyin' Blues," it did issue "Just One Sorrowing Heart" and "I Thought I'd Do It." Both of these songs indicated that McDaniel had progressed considerably as a blues singer and lyricist. Her vocal work had become much smoother, and her delivery on "Just One Sorrowing Heart," probably the most moving of all of her songs, was far more subtle than in her previous sessions with Austin. These recordings also indicated that McDaniel was evolving on a

personal level. "Just One Sorrowing Heart" picked up on the themes of her earlier work—despair, heartbreak, and unfaithfulness:

I've got just, just one sorrowing heart.
I've got just, just one sorrowing heart.
Seems like sorrow
Seems to be my part.

Despite this song's weariness, it focused on revenge. It told the story of a woman, "young and green" with "such careless ways," who falls for a man who turns her into "his slave." Overcome by rage against her mistreatment, she kills him: "I slew my Dan, and I loved him so." Although she grieves at the loss, there is a tone of resignation. He brings on his own demise; although it is regrettable, it is inevitable because of his abuse. And what makes McDaniel's song even more powerful is that it could also be more broadly interpreted as a message regarding the black experience in general. McDaniel's lyrics speak of a difficult life, one that has few choices and a dim future. "Rock and gravel is one hard, hard road," she sings. "Sorrowing Heart" was also an admonishment to the powerful. The ultimate price for enslaving someone, the song implies, is death. It was, on any level, a radical message from a woman, a sometime domestic, who herself had experienced a modern form of servitude—this entrapment by both men and white society.[30]

While "Just One Sorrowing Heart" maintained a serious tone, McDaniel countered it with the saucy, jaunty, B-side "I Thought I'd Do It." Here, a woman's sexual desires were more than just suggested, they were boldly proclaimed. "This frame was made for loving," she belted out, "so you won't do for me." Again, McDaniel sings of a two-timing male lover, but this time, she does more than complain—she tells him off. "Kick it, son, while I get him told," she commands as Parham pounds away at the piano. "Don't you come here lying about you working late," she warns, "cause your mama's going to give you the gate." In this number, McDaniel emerges as the strong one; his response is to "sniffle, whimper, and whine." There were no second chances for this wayward lover; she was not

going to take him back, affirming "Several times I thought I'd do it, but I knew I'd rue it, so I changed my mind."[51]

By this point in her career, Hattie McDaniel had successfully reconstructed herself as a blueswoman, embracing an image of power, strength, intelligence, and wit. This revised fictional presence was yet another attempt at challenging the simpleminded, happy-go-lucky, silly, and childlike black stereotypes used by white society to justify the oppression of African Americans. Although in some ways it only reinforced the degrading image of black hypersexuality, McDaniel also used it to undermine the stock character of the self-sacrificing Mammy. Furthermore, it provided distinct commentary on her real-life experiences as an employee of white people. When working as a domestic, McDaniel was expected to remain a nearly invisible, voiceless, and compliant caretaker. But as a blues singer, she could, unafraid, speak frankly and loudly and express her needs, desires, and complaints. Hattie McDaniel, the blues singer, refused to accept her "place" both as a woman and an African American.[52]

McDaniel was making considerable progress both artistically and professionally. OKeh had a wide distribution, and her music began to reach listeners around the country. Although she was hardly a celebrity, the *Colorado Statesman* proclaimed her as a "famed vocal star." By spring 1928, she was back on the road again; this time she scored a chance to play venues in the East.[53]

But Hattie McDaniel's personal life remained filled with disappointments. She marked 1928 as the year that her marriage to Nym Lankfard completely dissolved. It is possible that while on tour in New York, she looked up her husband and discovered he had been unfaithful in a deeply hurtful way. Records show a Nym Langford from Missouri living at a Harlem address with a brand-new wife and a baby. If this was McDaniel's husband, and it most likely was despite the variation in the last name, he was not yet divorced from her. But even if it was not Lankfard, something happened that year that convinced McDaniel that her marriage was finally over—although she made no attempts to formalize its end legally at the time. Then, making an already hard time in her life even more difficult, while she was on the road, she received word that her sister Addie Haig had died. Hattie McDaniel was left to grieve alone—the obligations of the

tour prevented her from joining the rest of the family for her sister's funeral at Campbell Chapel on April 15, 1928.[54]

By 1929, Hattie McDaniel was back in and around Chicago. While big-time success eluded her, she continued to pursue it. In March 1929, she teamed up with bandleader Vance Dixon, a Virginia native who had come to the Windy City after playing with jazz bands in New York. Although Dixon did not possess the stature of her other collaborators, he was a highly respected clarinetist who had once declined an invitation to join the acclaimed Fetcher Henderson Orchestra. This time, McDaniel tried her luck with Paramount Records, which had hired Tiny Parham as a talent scout. In March 1929, McDaniel and Dixon recorded two more of her songs: "Any Kind of Man Would Be Better Than You" and "That New Love Maker of Mine." Both indicated that she had emerged out of the despair brought on by her failed marriage to Nym Lankfard. They had a spirit of joyful resolve, a sense of emancipation not present in McDaniel's earlier recordings. And "Any Kind of Man" was certainly directly addressed to Lankfard. "You drag me around until I lost my pride, and when I lose you, I'll be so satisfied," McDaniel intoned. And with a little spicy aside, she continued:

> Any kind of man would be better than you.
> If he got one leg,
> That will be all right.
> Just so long that he brings that one leg home to Mama every night.

If there were any doubts that McDaniel was moving on, they were quelled in "That New Love Maker," which not only expressed revived sense of personal independence ("Why should I grieve about him, when I'm doing fine without him?") but also rejoiced in an unleashed and liberated female sexuality. McDaniel's lyrics extol the remarkable virtues of her "new love maker," an incredible "shimmy shaker" who is the "sweetest man that's known." This song conveyed a sexual boldness and frisky disobedience that now became the hallmark of her music. "I believe that if I was dead and in my grave," McDaniel sang, "that if he came near my coffin, I couldn't behave." This was the original, sassy, back-talking McDaniel. A

self-assured, impudent, and proud blueswoman, McDaniel had created an imagined persona who openly enjoyed sex, praising the men who pleased her and fearlessly rebuking those who crossed her.[55]

That March, shortly after her sessions with Vance Dixon, Hattie McDaniel was back in the studio recording two more songs for Paramount. This time she teamed up for a duet with the master of double entendre, Papa Charlie Jackson. Known for his stripped-down style and his humorously suggestive lyrics, Jackson produced some of the rawest recordings of the era—including "What's That Thing She's Shaking?" and "You Put It In, I'll Take It Out." The result of the McDaniel and Jackson collaboration was the raucous and raunchy "Dentist Chair Blues." The playfulness between the two and McDaniel's saucy delivery indicates that she indeed conquered most of her despair:

> *I'm having so much trouble with that toothache blues . . .*
> *It got me floor walking and wearing out my shoes, ohhhh Doctor . . .*
> *I need a quick filling dentist, I'm feeling mean and strong . . .*
> *At night I'm hot with fever and I just roll and toss.*

Jackson, playing the dentist, warns his gleefully shrieking patient, "I'm going to put my drill in your cavity." McDaniel half-complains, "You make me moan and groan." With some "cocaine and liquor" to ease his "probing," McDaniel leaves, a satisfied customer. "You're rough," she praises him. "But you're *so good.*" McDaniel's white employers would have probably been shocked to learn that their reliable and hardworking domestic moonlighted as a provocative and hardboiled blues siren.[56]

It is possible that McDaniel may have been almost as liberated in her personal life. Although she was a deeply religious person, she had an unconventional streak and was a beautiful, vivacious woman proud of her ample, strong figure. Later friends remarked that McDaniel could be extremely charming and possessed a magnetism that drew people to her. Definitely, she made a number of male friends along the way. And it is likely that during her Chicago years, she may have even had a fling with Booker T. Washington's nephew Roscoe Conkling Simmons. Later correspondence from Simmons, a Windy City resident, indicates that the two

shared some kind of romance during an early phase in her career. It would not be surprising that Hattie McDaniel accepted the attention of such a handsome, well-educated, and well-positioned man. Indeed, Simmons was a bit of a showman himself, a flamboyant figure regarded as one of the finest orators of his era. Through his illustrious pedigree, he enjoyed powerful connections both in the black and white communities and was an influential presence within the Republican Party. He even wrote a regular column for the *Chicago Defender*. But this relationship between the respected member of the black elite and the struggling, working-class blues singer did not last long. The missed opportunity was something that Simmons later seemed to deeply regret.[57]

In many ways, Simmons and McDaniel were worlds apart. She often was desperate for work; she even went hungry during these years. And she persistently hunted for any show-business opportunity that she could find. In the fall of 1929, one small opening appeared. Florence Ziegfeld, the famous Broadway producer, booked the smash musical hit *Show Boat* into Chicago's Illinois Theater. Although *Show Boat* focused on a white theatrical family who toured the Mississippi on a riverboat, its subplot centered on a tragic black character, Julie, whose light skin allowed her to pass for white but only brought her heartbreak. In addition to Julie, the production had several other black roles, including those of Joe, a riverboat hand, and Queenie, the family's cook.[58]

In years to come, many assumed that McDaniel played Queenie in this version of *Show Boat*. However, Ziegfeld gave the part to Tess Gardella, a white woman who had gained fame in vaudeville performing in blackface as "Aunt Jemima" and had already played Queenie on Broadway. Although it was widely acknowledged that McDaniel was a member of the cast, she must have won a place in the production's thirty-six-person Jubilee Chorus. While she was only a face in the crowd, just a small part in a Ziegfeld musical must have seemed like an incredible break, especially because the great showman traveled from New York to Chicago to personally supervise the opening.[59]

Ziegfeld's Windy City production of *Show Boat* debuted to receptive audiences and overwhelmingly positive reviews. The *Chicago Daily Tribune* raved that it was "far out of the common and commonplace" and, in

addition to praising the main cast members, cited the impressive perform-
ance of the Jubilee Chorus. The *Chicago Defender* reported that *Show
Boat*'s tickets immediately sold out, and proudly noted the extensive con-
tributions of black performers to the production, especially that of
African-American singer Jules Bledsoe as Joe. For most of its fifteen-week
run, *Show Boat* drew capacity audiences. In mid-January 1930, when
ticket sales finally dipped, *Show Boat* departed for a road tour. The first
stop was Milwaukee, where it played to standing-room-only crowds for a
week. Although this was yet another triumph, it was not enough to keep
Ziegfeld solvent. That previous October 1929, just after *Show Boat* opened
in Chicago, the stock market had crashed, plunging the entire nation into
a depression and leaving the producer nearly broke. With creditors haunt-
ing him, Ziegfeld eventually had to downsize the pricey and elaborate
Show Boat tour. Before it left for its next stop—Detroit—he laid off a large
portion of the cast, including Hattie McDaniel. She was left stranded in
the cold and unfamiliar Wisconsin town. "I landed there broke," she later
recalled. It was another low point in her life, and the situation looked
grim.[60]

But Hattie McDaniel remained resilient. She managed to rent an
apartment, taking in a boarder to help make ends met, and listed herself
in the city directory as "Mrs. Hattie McDaniel, entertainer." Acting on a
tip from a new boyfriend, who worked at a barber's shop, she found a job
as a restroom attendant at Sam Pick's Suburban Inn, a white nightspot on
the outskirts of town. Sam Pick offered dining ("Best Food Served at
All Times"), entertainment, dancing, and, most likely, bootleg alcohol.
McDaniel's job was not only dreary but also unpleasant as she waited on
white women using the toilet. While the wages were equivalent to domes-
tic work—seven dollars a week—what probably made her take this job
were both the tips and its proximity to a little show business. The Subur-
ban Inn featured a nightly floor show with a full orchestra.[61]

Although Sam Pick's may have initially seemed like just another dead
end, surprisingly it eventually paid off. As McDaniel later recalled, one
night, all the singers had left before midnight, and the house band was
floundering without a vocalist. When a desperate call went up from the

club's manager for help, Hattie McDaniel stepped forward and delivered a commanding rendition of W. C. Handy's "St. Louis Blues":

> *I hate to see the evening sun go down.*
> *I hate to see the evening sun go down.*
> *It makes me think that I'm on my last go round.*[62]

Her performance "stopped the show," and when she passed the hat, patrons showered her with ninety dollars in tips. Hattie McDaniel had surprised everyone, and on the spot, Pick hired her to sing. "I never had to go back to my maid's job," she remembered. Pick recruited several other black entertainers, and for most of the next two years, Hattie McDaniel headlined what he promoted as an "all-star show."[63]

Yet even the Suburban Inn began to feel the Depression's pinch. Unemployment and homelessness escalated, soon to heights that had never been imagined within the United States. "Every town had its breadline and its hobo jungle," McDaniel recollected. Throughout 1930, the economy grew worse and worse, and what Americans previously spent on entertainment now had to go to the basic necessities of life. The economic downturn finally forced Sam Pick to close his doors. By 1931, Hattie McDaniel was on the move again. "Feelin' tomorrow, like I feel today," she sang in "St. Louis Blues," "I'll pack my grip and make my get away." She had only twenty dollars in her purse and she was headed west in a car with some friends. Hattie McDaniel was bound for Hollywood.[64]

4
· · ·

The Dilemma

· · ·

The dilemma of the Negro actor still exists. He is perplexed—
two audiences, white and black. What shall he do if he wants
to move to higher things?

Clarence Muse, *The Dilemma of the Negro Actor*, 1934

ONE NIGHT in early May 1931, Sam McDaniel made his way
backstage at Los Angeles's Tivoli Theater looking for his old
friend from the TOBA circuit, Harry Levette. A seasoned per-
former and journalist who edited the *California Eagle*'s sports and enter-
tainment page, Levette managed nightly vaudeville shows for the Tivoli, a
white-owned theater that catered to the African-American community.
"My sister Hattie has just come in from Denver, Harry," Levette remem-
bered Sam telling him. "We will both appreciate it if you will introduce
her to the Tivoli audience." Always willing to give a newcomer a break,
Levette put Hattie McDaniel on to sing a solo with one of Los Angeles's
most popular choral groups, Sara Butler's Old Time Southern Singers. She
was an immediate sensation. He recalled, "Her sparkling smile and natu-
ralness at once won over the applauding audience."[1]

Hattie McDaniel landed in Los Angeles with the same vigor and deter-
mination that had propelled her around show-business circuits across the
United States. Just after she hit town, Harry Levette grandly announced
her arrival. (It was probably the result of some urging from her brother

Sam McDaniel.) Hailing her as "the famous stage and radio star," Levette claimed she had been recently "wined and dined" by the citizens of Denver (including the mayor) during a brief stopover there on her way west. This little piece of puffery, no doubt, was intended to give McDaniel a boost as she attempted to jump-start her career. Although opportunities in the entertainment industry certainly drew her to Los Angeles, the chance to be reunited with her family for the first time in many years also must have motivated McDaniel's decision to come to California. Since she was reportedly nearly broke when she first arrived, she probably settled for a time with Sam McDaniel or Etta, who still lived within a block of each other in South Central Los Angeles. It would be in this area, the heart of the black community, that Hattie McDaniel made her home during her earliest years in Los Angeles.[2]

By 1930, the majority of black Angelenos resided in South Central Los Angeles. Over the preceding years, the city's white population had forced most African Americans into segregation in this area, using restrictive covenants and "neighborhood agreements" to prevent them from buying property or living in other parts of Los Angeles. As a result, the black community spread south along Central Avenue, the main thoroughfare that ran into downtown Los Angeles. Numerous black businesses—including markets, restaurants, doctors' offices, beauty shops, hardware stores, and pharmacies—sprouted along the bustling street. In one of his columns, Harry Levette listed them off proudly: "second hand stores, gilded emporiums, colored banks—a wonderful colored life insurance building, colored gas stations. . . ." Towering at one end of the "Avenue" was the exquisite Dunbar Hotel, built by the African-American dentist Dr. J. A. Somerville and offering first-class accommodations to black visitors to the city. A number of African-American churches and headquarters for black political and social organizations lined the street. The *California Eagle* maintained its offices there; its plucky, activist female editor Charlotta Bass ran a column on Central Avenue happenings titled "On the Sidewalk." Theaters and nightspots thrived on and near the Avenue; it became the entertainment hotspot for the black West. Its clubs, many mixed-race, drew a clientele from around the region as well as across the nation. Among others, there was the Kentucky Club, with its race-track theme, the enor-

mous and swanky Club Alabam, employing a staff that numbered over one hundred, and Jack Johnson's Show Boat Café, run out of the Dunbar by the former heavyweight champion. At night, people filled the sidewalk and strolled past crowded movie houses showing Hollywood films, theaters hosting black vaudeville and musical comedy, and cabarets featuring the best in black entertainment, including Duke Ellington and Louis Armstrong. Central Avenue was popularly known as Los Angeles's "Brown Broadway."[3]

Central Avenue provided a climate of energy and inspiration for an ambitious artist like Hattie McDaniel. Soon she found an apartment, less than half a block from the thriving thoroughfare and only a short distance from her siblings. It was a quick walk to the Dunbar, Club Alabam, and most of the rest of the community's numerous nightspots. Only four blocks away was the Tivoli and just a little farther were the Lincoln, the Gayety, and the Rosebud theaters, which all played Hollywood's most popular studio releases. In fact, when Hattie McDaniel stepped out of her front door, she could see the large sign for the Florence Mills Theater, named in honor of one of the nation's most celebrated black female stage stars of the 1920s, who had died at a tragically young age. It was a constant reminder of a young woman who was revered for not only her beauty and talent but also her intense race consciousness. In 1923, Mills had done the unthinkable, turning down Ziegfeld to work with white producer Lew Leslie to create an all-black musical review. The Florence Mills Theater demonstrated black Angelenos' deep regard for the commitment and racial pride of black performers such as Mills.[4]

There, in the shadow of the Florence Mills Theater, Hattie McDaniel, in her modest flat, began one more time at age thirty-eight to restart her career in yet another new town. Her first priority was to find a job. And the outlook probably seemed pretty grim. She arrived just as the Great Depression worsened—even sunny southern California was reeling from the impact of the dire economic downturn. Unemployment in Los Angeles was reaching an all-time high of 20 percent. For the black community, the numbers were even worse—almost one-third of black Angelenos were out of work. Around the country, many jobs traditionally relegated to

African Americans, especially those in the service and domestic industry, either disappeared or went to whites. These were uncertain times as the economy continued to plummet.[5]

Although Etta Goff and Sam McDaniel had their struggles, both had succeeded in securing steady employment. Etta Goff shared a home with her now grown and married son, Edgar, who worked as an auto mechanic. Since 1926, she had been employed as a live-in housekeeper for the wealthy Kelsey family of the swanky, old-money West Adams district. The Kelseys were headed by a widowed matriarch, Ada, who regarded Etta Goff as a confidante. While this job must have been consuming, Etta Goff still dabbled in show business in her off hours. By 1927, Etta, using the last name of McDaniel, began occasionally working as a movie extra. She quickly became convinced that film held significant promise and had even written to Hattie in Milwaukee, urging her sister to come to Hollywood to give movies a try.[6]

Sam McDaniel, on the other hand, was the family's real success story. He was now enjoying acclaim as a local celebrity, playing Deacon McDaniel for almost seven years on the *Optimistic Do-Nuts*. By the early thirties, he was the show's headliner, broadcasting over L.A.'s KNX along with his orchestra and his partner Roberta Hyson. From eight to nine o'clock every Friday night, McDaniel's "Doleful Deacon" entertained radio listeners with music and laughs designed "to please young and old alike." KNX claimed that the *Optimistic Do-Nuts* was so popular that "hundreds of people storm the studio every Friday night."[7] The *Optimistic Do-Nuts* did so well that the station scheduled it opposite one of the nation's highest-rated radio shows, *Amos 'n' Andy*, which starred two white men using dialect to play black characters.

While Sam McDaniel was a big hit on KNX, it was the film industry that probably provided most of his income. Although he continued to play local nightspots with his band, by the early thirties his film career blossomed. He even scored several speaking parts. In 1931, the year Hattie McDaniel arrived in town, Sam was cast as a nightclub headwaiter in James Cagney's *Public Enemy*. While his appearance on screen was in a small, subservient role, it was significant nonetheless. Sam McDaniel's

character orders two white bouncers to toss out a couple of white men who have passed out. It was a brief and exceptionally rare cinematic display of black authority.[8]

Although Hattie McDaniel eagerly followed her siblings into film, in many ways, she was almost forced into a movie career. Opportunities for black entertainers were rapidly narrowing. The TOBA had gone bankrupt and folded. Wounded deeply by the economic downturn, theaters across the country were struggling or even closing. The recording industry was on the skids. Vaudeville was making a brave but pathetic last stand, unable to compete with films as America's top leisure-time activity. Blues singers, even the most famous, like Bessie Smith, had fallen out of vogue. Hattie McDaniel was among these women who discovered that Depression-weary audiences had little appetite for hardship songs. To make sure she could get by, just after arriving in Los Angeles she signed up with an employment agency to do washing and ironing for white families, work just flexible enough to allow her to continue to pursue her entertainment career.[9]

But Hattie McDaniel remained resilient. She was, as Harry Levette remembered, "happy" and "optimistic," as well as "studious." Hattie McDaniel was a pragmatist—a tough-minded career woman who had already adeptly survived lean times. It was clear from Sam McDaniel's experiences that the film industry offered a potential line of work that, while not lucrative for blacks, could provide a much-needed supplement to a Depression-era income. So, shortly after her arrival, Hattie McDaniel paid a visit to the Hollywood office of Charles Butler of Central Casting.[10]

Of all African Americans working in Hollywood, Charles Butler was, by far, the most powerful. As the studios began to increase their output during the 1920s, their need for African-American players grew so great that they would send trucks or buses to Central Avenue to recruit black extras. Tapping into this demand, Butler opened the Cinema Exchange, a talent agency that placed African-American performers in film parts, usually as extras. In 1926, the newly organized Central Casting Corporation, run by the Motion Picture Producers Association and devoted to assigning all extra and bit parts, hired Butler to head a division to recruit and cast all black performers. His responsibilities also included two daily runs to fourteen Hollywood studios to deliver casting calls, studio gate passes,

and paychecks for all photo players, black and white, handled by Central Casting. Butler was a workaholic, a highly efficient and loyal studio employee who labored long hours with few breaks. He had a keen memory and knew the name and telephone number of almost every one of the 1,500 African-American players registered with Central Casting during the early thirties.[11]

While Butler became a well-known figure in both Hollywood and black Los Angeles, he was often at the center of controversy. A number of African Americans praised his accomplishments in the film industry, hailing him for securing employment for black players as well as fending off the studios' plans to substitute whites in blackface in black roles. But others regarded Butler, so closely tied to the white Hollywood establishment, with suspicion. For some, he seemed uncomfortably faithful to white movie bosses. Others alleged that he played favorites, accepting money under the table from scurrilous and ambitious black players in exchange for choice roles. Butler and his supporters vehemently denied such charges. Harry Levette, himself reliant on Butler for film work, defended the casting agent as "one of the greatest aids to local Race economics in the West, jobs assigned daily by him are bringing thousands of dollars into Negro purses each year."[12]

Despite the rumors that surrounded Butler, he held the keys to Hollywood for struggling newcomers like Hattie McDaniel. In late spring 1931, when she presented herself to Butler, McDaniel had to provide a résumé of her past show-business experiences, an address and telephone number where she could be reached on a moment's notice if studio calls came, detailed measurements, and a photograph. When studios sent in requests for black performers, they came in the form of a call for "types," focusing almost solely on physical appearance over talent. Butler's task was to match up black actors with the idealized image demanded by white producers and directors. This could be on a grand scale—for crowd scenes, he delivered as many as five hundred "types"—or, in the case of individual roles, he sent several performers he deemed potentially appropriate to audition for a part. Butler did his work diligently and to the great satisfaction of his white employers. "Very seldom does any of the players called fail to fit the order," the *California Eagle* observed.[13]

While typecasting was not confined to black performers, black performers were confined to typecasting. White bit players could maintain at least a remote hope that they would eventually play a variety of roles. But African Americans were almost immediately typed and forever locked into restricted parts. Hattie McDaniel quickly discerned what Sam and Etta probably already knew—the roles available to African-American performers were rigidly limited to demeaning stereotypes. With the help of the Hays Office, the censorship agency organized by motion picture producers to ward off criticism and external interference, studios tenaciously held on to these images. The censors were headed up by former postmaster general and Republican Party notable Will Hays, whose responsibilities focused on protecting the industry from harmful controversies. Although after *The Birth of a Nation,* the film industry backed away from depictions of blacks as violent and hypersexual, they worked assiduously to protect other key elements of white supremacist ideology. The Hays Office was instrumental in forbidding even the hint of miscegenation and permitted only the mildest, most nonthreatening black images to reach the silver screen. Consequently, African-American performers were almost exclusively confined to roles as servants—mammies, maids, butlers, waiters, and porters—habitually denied any kind of authority or power. America's racist social codes and Jim Crow traditions were sustained as Hollywood's black characters entered through back doors, lived contentedly in segregated impoverishment, behaved obsequiously when interacting with whites, and joyfully served their white employers. Black characters became props, manipulated by white filmmakers to signal specific messages regarding white social position and racial ideology. Additionally, these images were often used as comic relief, expressed through distorted accents, large rolling eyes, wide minstrel-like grins, and dimwittedness. Indeed, these characterizations dated back to the days of blackface minstrelsy, the genre that Hattie McDaniel had so devastatingly satirized in her early career.[14]

Hollywood's system of typecasting only further ingrained these degrading racial images into American popular culture. And movie bosses consistently spurned opportunities to break down black stereotypes. Studios repeatedly rejected light-skinned African Americans for movie roles,

giving preference to those who had the darkest complexions. (Light-skinned African Americans were literally labeled "off-types" in the files of Central Casting.) Casting directors usually sought large women for maids and mammies and small or lean men to play servants and butlers. Studio makeup was exaggeratedly dark and glossy, and costuming consisted of servant uniforms, often worn and torn clothes, or garish dresses and suits—all designed to evoke memories of the old American minstrel stage. Speaking parts also only went to those who could successfully recite the contrived black dialect manufactured by white screenwriters. But despite the best efforts from black performers, capturing the white movie world's adulterated Black English was often impossible. Sam McDaniel's partner Roberta Hyson was shocked when she was turned down for one role because of her proper diction. Hollywood's stereotypical black speech was so foreign to such a large number of African-American players that, in some cases, studios hired white speech coaches to instruct them on their lines.[15]

Hattie McDaniel, whose generous figure and dark skin made her a suitable "type," did not wait long for her first studio call. In May 1931, she began working as a film extra at $7.50 a day. She was thrilled; Harry Levette recalled her ebullience just after she landed her first assignment in an African scene in a short starring white comedian Lloyd Hamilton. While the daily pay was much better than maid work, it still was unpredictable. "One month you are getting a lot of work and fat checks," testified Levette, "then . . . your bubble bursts and your ears ache from listening for that call as you gaze at the massive studio gates." But Hattie McDaniel stuck with it. Even if she only worked six days a month, she could actually make more than in four solid weeks of domestic work. Watching the economy reeling out of control and bearing clear memories of a childhood of poverty, Hattie McDaniel sought whatever cinematic employment the studios had to offer. She later insisted, "A call from Charles Butler at Central Casting was like a letter [from] home."[16]

Yet, at this point, McDaniel seemed to regard her film career as secondary, a way to make some money to get by as the Depression deepened. During her first three years in Tinseltown, she appeared as an extra in hundreds of films. With this newfound source of income came compromises—

McDaniel agreed to play those stereotypes she had earlier lampooned, and ultimately participated in reinforcing American racist ideology on the silver screen. In a way, she began to lead almost a double life. Although increasingly dependent on film for her livelihood, she remained devoted to her stage career. It was through these appearances, especially in front of black audiences, that she maintained the freedom to express herself and perform her own material, keeping alive her bold blueswoman persona. By summer 1931, she was pleasing audiences on Central Avenue. "The Tivoli Theater soared," Harry Levette reported, "with Hattie McDaniel on the bill." Later in the year, she headlined the "Powder Puff Frolic" at Los Angeles's Follies Burlesque Theater. Known for its more risqué performances, the Follies often presented all-black revues featuring comedians, singers, and a chorus line of "forty pretty girls who have the ability to hold step in some of the most difficult dancing ever seen on any stage." The management promised "side-splitting fun" and promoted McDaniel as the "famous blues singer and comedienne."[17]

Certainly, burlesque was hardly a top-notch entertainment venue, but Hattie McDaniel scrambled for whatever was available. Shortly after she arrived, in June 1931, she also joined the Old Time Southern Singers. The group was founded by an African-American woman, Indiana native Sara Butler, to preserve and perform African-American spirituals in as traditional a manner as possible. Butler, who was formally trained in music, was energetic and enterprising, securing engagements for the Old Time Southern Singers throughout the Southern California area. She marketed the choir to the white community by often costuming singers in "plantation"-style clothes, playing on the romanticized images of the Old South. While McDaniel was with the group, they entertained at a host of churches, schools, and auditoriums as well as for Warner Bros. studio Christmas parties, at American Legion functions, and at a tribute to the beloved Florence Mills.[18]

McDaniel's vast stage experience won her a position as a featured soloist with the nearly forty-voice chorus. No doubt, her early experiences singing and leading her hometown church choir also helped her secure a place with the Old Time Southern Singers. McDaniel was well known in the black film colony as a churchgoer, a deeply religious person who,

Levette claimed in his columns, led an exemplary personal life. In part, McDaniel's evolving spiritual interests may have drawn her to the Old Time Southern Singers; she had become a bit of a religious seeker. She would tell journalists that she usually worshipped in Baptist or Methodist churches but also embraced all Christian religions. McDaniel may have been drawn to Sara Butler's intense spiritual commitment. In 1935, Butler founded the Zion Temple Church, which served as a home base for her own ministry. But affiliation with the Old Time Southern Singers carried other, more secular, benefits. Butler's group frequently appeared in film sequences or provided choral accompaniment to sound tracks. Most important, the choir mistress was the much-revered wife of the powerful casting agent Charles Butler—a connection that brought Hattie McDaniel just a little closer to Hollywood.[19]

In August 1931, Hattie McDaniel was booked to appear with Butler's choir in *Echoes of a Plantation*, a fund-raiser for Los Angeles's African-American Boy Scouts. Planned as an extravagant musical review, *Echoes* was slated to include some of show business's most successful black performers. Scripted by former minstrel man Billy McClain, who had turned stage producer and movie actor, the benefit was the brainchild of Clarence Muse.[20] Muse had arrived in Tinseltown in 1929, recruited by Fox Studios for a lead role in their all-black musical *Hearts in Dixie*. Cast as the elderly Uncle Napus, Muse was an instant hit with white audiences and subsequently in frequent demand by white filmmakers for bit parts. In turn, he became thoroughly typecast and, for most of his film career, played small parts as a smiling, bowing, and devoted servant. Offscreen, Muse emerged as a forceful activist, one of the local black community's most tireless and politically dynamic figures. After settling in Los Angeles, he plunged into the social and political life of Central Avenue, became an active member of the National Association for the Advancement of Colored People (NAACP), later coordinating their membership drive, and emerged as a blunt critic of racism and segregation. In 1935, he began contributing a regular column, titled "A-Talking to You," to the *California Eagle*. He used it to push for a variety of causes, including anti-lynching legislation, African independence from colonial powers, and the desegregation of both the city and the nation. He was instrumental in raising money to help

defend the Scottsboro Nine, a group of African-American teenage boys falsely accused of rape by two young white girls. He often railed against the inequalities of the justice system. "Crime is not measured by the seriousness or damage to other people," he wrote in one column, "but by the color of your skin." If anything, Muse was outspoken on the issues of race in America.[21]

Muse also emerged, early on, as a cautious critic of the white entertainment industry. Not too long after his arrival in Hollywood, the California Art Club, a group of white artists and writers, invited him to speak on the issues facing African-American performers. He eventually printed his remarks in a self-published pamphlet titled *The Dilemma of the Negro Actor.* In it, Muse reprimanded the white entertainment world for failing to tap into the multifaceted talents of black performers. Although the bulk of Muse's discussion was devoted to stage, his remarks applied to film as well. From his perspective, black artists in show business were caught in a quagmire. "There are two audiences in America to confront," he wrote, "the white audience with a definite desire for buffoonery and song, and the Negro audience with a desire to see the real elements of Negro life portrayed." The responsibility for the perpetuation of black stereotypes, in Muse's opinion, rested with the whites who held the entertainment industry's purse strings and pandered to white racist tastes and demands. It was "the mighty dollar of the white race" that drove show business—and entertainment moguls, the only ones who could pay an artist a living wage, would only do so for performances that reentrenched black stereotypes. The "dilemma of the Negro actor," he argued, centered on two contradictory impulses: the need to earn a living wage and the desire to express oneself artistically. As long as the status quo persisted and whites refused to address the problem, this serious dilemma, he believed, would remain unresolved. Muse called on progressive whites to pressure those who controlled show business to improve roles for African Americans. In this short essay, Clarence Muse summarized the quandary that the black entertainer faced. "He is perplexed—two audiences, white and black," Muse wrote. "What shall he do if he wants to move to higher things?"[22]

It is not surprising that once in Los Angeles, Muse used his connections and his talents to stage numerous independent black productions,

many of these benefits for African-American causes. *Echoes of a Plantation* was designed to be one of his most elaborate local projects to date. Muse spent weeks recruiting and rehearsing a cast that numbered over one hundred performers. In addition to Butler's choir and Hattie McDaniel, these included the beautiful African-American songstress Albertine Pickens, the acclaimed dancing team The Four Covans, and comedian Eddie Anderson, who later gained fame as Jack Benny's sidekick, Rochester.[23]

Muse's biggest triumph came when he convinced Hollywood's first black film star, Stepin Fetchit, to appear. Born Lincoln Theodore Monroe Andrew Perry in 1902 in Key West, Florida, Stepin Fetchit had left black vaudeville for films during the 1920s. After several early roles, including one in MGM's *In Old Kentucky* and another in Fox's *Hearts in Dixie*, Stepin Fetchit rocketed to fame in white Hollywood and among white movie fans. Tall and lanky, Fetchit developed a distinctive characterization that magnified the worst elements of black stereotypes. He delivered his lines in a slurred, high-pitched, almost incomprehensible whine. His characterizations were marked by extreme laziness and total ignorance, underscored by sleepy-eyed mugging. Fetchit literally shuffled through his scenes with a rubbery, lethargic walk.[24]

Fetchit later argued that he had fashioned a style that he claimed was a caricature of black stereotypes (much like the young Hattie McDaniel had done in Denver). But his performances were so unsubtle that he only succeeded in perpetuating the most hurtful myths embedded in such black images. Studio publicity, which insisted that Stepin Fetchit was the same on and off screen—foolish and indolent—only served to reinforce white racist assumptions. The wild clowning of Stepin Fetchit alarmed many in the black community. After viewing *Hearts in Dixie*, which starred both Fetchit and Muse, Charlotta Bass insisted that there was a distinct difference between the two actors. Although both men played stereotypical roles, in her opinion, they tackled them in very different ways. "I recognized in Clarence Muse an artist," she wrote. "In Stepin Fetchit, I would say there isn't."[25]

Despite negative reaction from race leaders like Bass, Fetchit did have his admirers. He had climbed higher than any other African American in Hollywood. Eager to profit from him, Fox Studios had signed Fetchit to

an exclusive, long-term contract—the first ever offered to a black film player. With this came real money, which he spent on a lavish home with servants (all Asian) and an extravagant motorcar with his name embla-zoned in neon across its side. Additionally, as Fox's executives quickly learned, Fetchit was extremely temperamental and manipulative. Off-camera, he constantly challenged studio bosses, and news of this trickled back to the black public. After reaching stardom, he began ignoring report times and sometimes even refused to show up at all. He could be arrogant and had occasional run-ins with the law. Although able to read, he con-vinced some directors that he was illiterate, which allowed him to change his lines as the camera ran. Writer Mel Watkins contends that in many ways, Fetchit practiced deceitful tactics similar to those used in the days of slavery—feigning the acceptance of white authority while, at the same time, undermining it.[26]

With Fetchit's name featured prominently in advertisements for *Echoes of the Plantation*, on the evening of August 20, 1931, a sizable crowd gathered at Los Angeles's swanky Shrine Auditorium for what Muse promised to be "a glorious spectacle." While it did indeed turn out to be a spectacle, it was not the one that Muse had planned. He had talked most of the participants, including Hattie McDaniel, into working pro bono. But he had promised to pay the orchestra, The Four Covans, and Stepin Fetchit. Just before the curtain time, the orchestra leader de-manded Muse shell out the band's fee. Muse disappeared and then re-turned with some bad news; someone had absconded with the money, which totaled over $2,000. The orchestra packed its instruments and walked out. As the audience filled the seats, confusion broke out back-stage. Muse tried to rally the players with "the show must go on," but one of the female Covans slapped him in the face and the troupe angrily left. Stepin Fetchit was enraged. He threatened to throttle the besieged Muse. "No you don't, that's my boy," Billy McClain warned. "Who are you?" yelled Fetchit. "I'm Billy McClain," replied the veteran star of the black stage coolly. "Who are you?" With that, Fetchit, the star attraction, stormed out.[27]

After hours of tense wrangling, at ten p.m. the curtain finally lifted, with Muse, McClain, and the Sara Butler Singers left to carry on the show.

In place of the full orchestra, a single pianist provided musical accompaniment. Muse and McClain ran through what material they could. Wowing the crowd, Sara Butler's singers delivered old secular standards "Let's Go Down South" and "Come to the Cotton Fields," as well as several stirring gospel numbers, including "Wade in the Water," "Every Time I Feel the Spirit," and, with Hattie McDaniel as the soloist, "Revival Days." Although the *California Eagle* deemed the benefit "a colossal failure," it credited the Butler singers for rescuing the evening.[28]

McDaniel continued to subsist on what she earned with the Old Time Southern Singers, live performances, bit parts as a movie extra, and her wages as a laundress. But in fall 1931, she discovered another source of income. Always looking out for his little sister, Sam McDaniel talked KNX into signing her up for the *Optimistic Do-Nuts*. McDaniel's versatile talents allowed her to play three roles on the series. Although the rest of the cast appeared in workday attire, McDaniel showed up for her first broadcast, which was done before a live audience, in an elegant evening gown. The show's white announcer, Tom Brenneman, teased her for being overdressed, chiding her for going "high hat." Consequentially, McDaniel quickly gained local fame on the air as "Hi Hat Hattie." She liked the nickname; "Hi Hat" appealed to her rebellious side. For a black woman to go "high hat" implied wealth and haughtiness, a rejection of poverty and white expectations. McDaniel adopted it and used it in her live acts. It was a perfect complement to her stage presence, forged out of biting comedy and the brassiness of the blues.[29]

McDaniel's radio appearances were so successful that KNX eventually gave her a show of her own. In a spot known as *Hi Hat Hattie and Her Boys*, McDaniel teamed up with a male musical ensemble, the pioneering Los Angeles jazz group Sam McVea's Band. The show gave McDaniel the chance to mix music with her own brand of sassy comedy. While the show's sponsors must have made certain demands, the airwaves offered McDaniel a channel through which she could continue to perform her own material. Hattie McDaniel would be a saucy presence on Los Angeles radio off and on throughout most of her early years in the city.[30]

While radio proved appealing, film still offered the best wages. Although McDaniel had quickly established a career as an extra, she aspired

to move into the much higher–paying speaking roles, where black per-
formers made as much as fifty dollars a day and sometimes even more. In
the depths of the Depression, that was an almost-unheard-of wage. Many
of those in the black community, like the McDaniel siblings, pursued film
roles more out of the need to put food on their tables than to fulfill cre-
ative drives. They practiced their real art in other, unfettered but far less
lucrative venues.[31]

Hattie McDaniel's luck was running pretty low when, in late 1931, she
got a call from Butler to audition for her first speaking role. Later she
claimed that she had to borrow money just to catch the streetcar to the stu-
dio. "Don't let anybody know you're down and out, Hattie," a friend
counseled her. "Look breezy and people will think you are." The advice
must have worked. In January 1932, with the debut of *The Impatient
Maiden,* starring Lew Ayres and Mae Clarke, film audiences heard Hattie
McDaniel speak her first lines on film. It was an unusual role, not the typ-
ical maid or mammy part, but was still intended to play on white audi-
ences' racist assumptions. McDaniel played a woman hospitalized after a
hard-fought but victorious brawl with her husband.[32]

Throughout 1932, McDaniel was increasingly drawn into film, work-
ing mostly as an extra but scoring a few more parts with dialogue. In these
early films, she played a singer in *The Crooner,* a servant in *Washington
Masquerade,* starring Lionel Barrymore, and a frontier mammy in *The
Golden West,* whose cast also included Sam McDaniel. But her real break
came in midyear, when Paramount cast her as a maid in *Blonde Venus.* Di-
rected by cinematic genius Josef von Sternberg, *Blonde Venus* was planned
as a major vehicle for the woman he had made a star, Marlene Dietrich. In
this role, Dietrich played Helen Faraday, a devoted wife and mother
whose husband suffers from radiation poisoning. His treatments are ex-
pensive; to pay for them, Helen has to take to the stage and later sleeps
with a wealthy gambler for money. Learning of her infidelity, her husband
rejects her and tries to take their young son away. Helen flees with the
child, and her life commences a downward spiral.

Helen Faraday hits rock bottom in Texas, where she hides out in a run-
down shack in a small rural town. Despite her destitution, she somehow
can afford a maid, the devoted Cora, played by McDaniel. When Cora

spies a lurking detective, obviously working for Helen's husband, she confronts him boldly. "Hello Bull," she greets him, coyly demanding to know why he is there. When he insists he is "just browsing around," Cora flashes an expression of both suspicion and disdain. "That white man's up to something," she reports to Helen, remarking with disgust, "I know when a white man's browsing around and when he ain't."[33]

With *Blonde Venus*, McDaniel had accepted a part that was derogatory and servile. Her broken English, ragged dress, unkempt hair, and unconditional loyalty to a white woman were fashioned out of the common negative stereotypes of black women. Yet, Cora's frankness and inappropriately forward interactions with a white man offered a new spin. Hattie McDaniel infused a blunt assertiveness into this character, something that was a departure from traditional stereotypes. In part, she was able to do this because von Sternberg had created Cora to purposefully break the code of passive meekness demanded from on-screen black servants. Cora did not know nor accept her "place"; she had the audacity to not only distrustfully question a white man but to actually identify him, in a less than flattering manner, as a *"white"* man. Cora was created as a commentary on Helen Faraday's degraded status. Only the most desperate and marginalized white woman would employ a maid so unrestrained by customary racial boundaries.

McDaniel used Cora to slyly talk back on the screen. She secured this role because of her unconventionally sassy approach. After years of perfecting her blueswoman persona, when Hattie McDaniel arrived in Hollywood, she was no Mammy, real or imagined. She quickly began refashioning her fictive image by drawing from a mixture of her minstrel parodies and her blueswoman defiance. It allowed her to assert, however minimally, some control over her screen presence. With straightforward bossiness, a contemptuous (mostly behind the back) scowl, and an edgy, sometimes blatantly angry, outspokenness, McDaniel countered white fantasies of docile and contented black female servants. As she had in the past, McDaniel relied on signifying, using the tone of her voice, her facial expressions, and body language to challenge the stereotypes that formed the foundation for her characters. Such a screen presence was both overtly and covertly deceptive. White audiences found McDaniel's unexpected

portrayals entertainingly eccentric. Yet they were unaware of how much explosive disdain for white authority they conveyed. In front of the camera, McDaniel created a maid that she knew in real life would be fired in an instant. For McDaniel, it was an insider's joke. She was not playing but parodying a servant.

However, McDaniel had landed squarely in the middle of Clarence Muse's "dilemma of the Negro actor." Success for McDaniel became defined in contradictory ways. On the one hand, she needed to be true to her art and to maintain the respect of the African-American community. Over the years, McDaniel had carved out a niche in black arts, earning admiration as a satirist in her hometown of black Denver and later, in other regions, as a powerful blueswoman. On the other hand, breaking down the doors of white show business would also be regarded as an important achievement, and to do that she would have to compromise her art. The film industry had a poor track record in terms of employing black performers and creating black roles. Hollywood was a tough place for any African American, especially a woman, to get ahead. Challenging white filmdom's racial barriers and reaching stardom within it would be a triumph over racism. It had been a battle that black entertainers, such as pioneers Bert Williams, George Walker, and Aida Walker, had fought many years before in other white forums. In the past, these black artists, despite the concessions they made to the white public, had earned respect within the black community for their successful, albeit token, integration of the white world of show business.

To claim such a victory, Hattie McDaniel had to immerse herself in the white fantasy world of powerless and submissive black women whom the dominant culture considered suitable only for domestic work. In the effort to bridge the gap between her creative impulses and Tinseltown's expectations, Hattie McDaniel had to find ways to stretch beyond her earlier work. McDaniel began experimenting with a style that could satisfy white filmmakers and audiences while offering unexpected and, if possible, unsettling aftereffects. The challenge was for Hattie McDaniel to become ever more subtle yet more subversive to conquer the dilemma posed by Muse. With the enormous power and watchful racism of the white studios,

McDaniel's job would be a hard one. Could she continue to successfully signify her indignation and still make a living?

In these early and difficult years, Hattie McDaniel, like most black film players, received little acclaim outside the African-American community that watched intently for black artists to break through in Hollywood. Studios did not include her in the credits, which usually went only to the top five to ten white principals. White reviewers ignored her presence. Even when she did garner attention in print, she remained nameless. White cultural critic Gilbert Seldes acknowledged McDaniel in a 1934 *Esquire* magazine article, ranking her with the controversial screen siren (and blues singer) Mae West and the respected veteran comedic actress Marie Dressler. He effusively praised McDaniel as "that superb, almost anonymous negress whose great mahogany shining face and divine smile are among the major pleasures of dozens of films through which she passes." But Seldes's tribute revealed the racism that McDaniel constantly encountered and the inability of whites to see beyond the cinematic image. Rather than focus on her skills as a performer, Seldes hailed her "shiny face and divine smile"—Hollywood's visual attributes that resonated with racist fantasies. Still, for a well-regarded, even highbrow, critic like Gilbert Seldes, something about McDaniel separated her from other photo players. In later years, Clarence Muse identified McDaniel's uniqueness as her special ability to play characters born of white imaginations with a particular originality.[34]

McDaniel's unconventional style gave her an edge in some auditions but set her back in many more. And the competition for parts was stiff. Butler's registry contained profiles of hundreds of women listed as suitable for maid or mammy roles. Only a few of these aspirants had risen to the top. One was Gertrude Howard who, before her untimely death in 1934, had become one of the most sought-after black actresses in Hollywood. Born and raised in Hot Springs, Arkansas, Howard in 1919 moved to Los Angeles, where she began playing small roles in silent films. By the late 1920s, she had become a familiar face to filmgoers, with featured roles in *Uncle Tom's Cabin*, *Hearts in Dixie*, and *Show Boat*. During the early thirties, her career thrived, and in 1933, she secured a sizable part as Mae

West's maid Beulah in *I'm No Angel*. Howard's characterizations were viewed as homey and humorous. On screen, she had a hearty laugh and a folksy delivery. Off camera, she was sincere and religiously devout, a well-respected figure in L.A.'s African-American community. Everyone liked Gertrude Howard.[35]

Although Howard was a pioneer among black women in film, during the early thirties, the biggest name among African-American film actresses was Louise Beavers. Born in Cincinnati, Ohio, in 1902, at the age of eleven she moved with her parents to California where she attended public schools, graduating from Pasadena High School. An extremely bright student, Beavers aspired to become a doctor. However, confronting a world that discouraged the pursuit of such dreams by young black women, Beavers, like many other young women of her generation, was eventually forced to accept work as a domestic.[36]

In the 1920s, Beavers secured a position as a maid to film actress Leatrice Joy, one of the era's most celebrated leading ladies. This placed Beavers in contact with some of the most powerful and influential figures in Hollywood. Captivated by show business (Beavers reportedly had a beautiful singing voice), in 1926, she left Joy to join an all-female touring "minstrel troupe." A year later, she returned to Los Angeles and signed up with Butler at Central Casting, shortly afterward winning a role in *Uncle Tom's Cabin*. She secured several other small parts, including one that led her to a job as the personal maid to actress Lillian Tashman. Eventually, however, her film career took off. With the advent of talking pictures, Beavers became a favorite choice among white movie directors and producers, and she was able to quit being a maid—ironically, like so many other black actresses, to play a maid on the screen. As she later told one interviewer, she would have much preferred to do more serious parts, but with the Depression on, "money was scarce so Hollywood won."[37]

Beavers was an articulate and serious-minded young woman. She was also hardworking, affable, and, as white movie people quickly discerned, very willing to accept direction. Like McDaniel and Howard, she was heavyset and dark-skinned, fitting the "type" demanded by white directors for domestic characterizations. Beavers's silver-screen roles were distinguished by her gentle, even timid, manner, and her light, almost

high-pitched voice, which masked an almost thoroughly ordinary middle-American accent. She quickly developed a deferential screen presence that projected a nonthreatening bewilderment. Like Howard's, her style was distinctive, aptly described within the pages of the *California Eagle* as "soft." Yet despite Beavers's careful reification of black stereotypes, she also had a rebellious streak. On movie sets, she made clear her disdain for cooking and cleaning and refused to participate in any kind of preparation whatsoever for kitchen scenes.[38]

While each of the era's leading black film actresses created a unique approach to the characters they played, Hattie McDaniel's style was the hardest fit for white Hollywood's fantasy world. McDaniel bellowed out her lines with bossy gruffness. In *Boiling Point* (1932), featuring cowboy star Hoot Gibson as the hotheaded Jimmy Duncan, McDaniel played a western ranch cook named Caroline. Unknowingly, the scriptwriter provided McDaniel with some choice lines. In an effort to downplay Gibson's middle age, betrayed by his paunchiness, Caroline refers to Jimmy Duncan as "boy." Aware of the insult carried by "boy," commonly used by whites to degrade black men, McDaniel made the most of it. Each time she could, she emphasized the word "boy" in her lines. "That's it, boy," she roars in one scene. "My goodness, boy, don't get so mad," she admonishes him, "cause you're liable to boil over and bust yourself wide open." The wise Caroline gives him lucky voodoo buttons and instructs him to count them each time he gets angry. Although the reference to voodoo and Caroline's nurturing impulse recalled the qualities of the stereotyped, superstitious mammy, McDaniel played her scenes with verve, boldness, and a commanding confidence in her character's superiority.[39]

Lawless and outspoken, McDaniel's particular style made her an unlikely choice for most black female roles, which strictly demanded complete submissiveness and uncomplicated simplemindedness. As a result, when not working as a silent extra, McDaniel became locked into comedic roles. Her persona was simply too dangerous to cast her in a drama; it was only tolerable in situations where humor deflected her clever bluntness. Often she was placed in speaking roles where she was unable to exert any kind of editorialism. In 1933, she landed a part alongside Gertrude Howard, in Mae West's *I'm No Angel*. McDaniel had only one line and it

was a setup for a Westian joke. "I was under the depression [sic]," her character obliviously observed while buffing West's nails, "that you was a one-man woman." "I am," West responds. "One man at a time."[40]

Although Hattie McDaniel remained a minor film player, Sam McDaniel's movie career was booming. In 1932, Sam McDaniel had nine-teen speaking roles and he continued to work steadily throughout 1933. Although a careful careerist, he was secure enough with his position in Hollywood to refuse Friday night studio calls that interfered with his radio show. Almost always, the studio assented, perhaps, in exchange for McDaniel's constant on-the-air plugs for the motion pictures he appeared in. In addition to film and radio, Sam McDaniel continued to play local clubs with his band, tutoring several rising white Hollywood singers and musicians, including crooner Bing Crosby whom he had taken under his wing while both were still troupers. Indeed, Sam McDaniel's primary identity, as revealed by his early listings in the *Los Angeles City Directory*, remained that of musician, not movie actor.[41]

Yet Sam McDaniel was fast becoming a film celebrity and was build-ing a very promising movie career. He insisted he could not complain. "I ain't kickin'," brothers and sisters," he told the *California Eagle* in an interview. Described as humble and "unassuming," Sam McDaniel was nonetheless a shrewd showman. When working along with Hattie on the set of *Operator Thirteen*, starring Marion Davies, newspaper magnate William Randolph Hearst's lover, he gave the starlet several copies of the *California Eagle*, encouraging her to become more familiar with the black community. In turn, Davies pledged to do whatever she could to help him. Sam McDaniel also became a close friend of Charles and Sara Butler. And his long association with Harry Levette paid off. Sam McDaniel under-stood the power of press and, with Levette's help, enjoyed continual plugs in the *California Eagle*.[42]

While African Americans almost exclusively comprised the readership of the nation's black newspapers, white Hollywood did at least somewhat monitor the black press, especially the *California Eagle*. During the 1930s, the *Eagle*'s Harry Levette was one of several journalists covering the Tinsel-town beat. The *New York Age*, the *Baltimore Afro-American*, the *Chicago*

Defender, and the *Pittsburgh Courier* all ran columns dedicated to Hollywood happenings, specifically focusing on black accomplishments. Filmmakers, eyeing black box-office receipts, flooded African-American newspapers with press releases and photos, almost all promoting white Hollywood stars. Although the studios commonly excluded black reporters from Hollywood premieres and often movie lots as well, the African-American community continued to demand more film news. Of all of these papers, the *California Eagle* offered the most comprehensive coverage, and Levette, who worked frequently in film, had an insider's access to the studios. He made a careful effort to document the participation of blacks in all capacities in films and credit the names of as many African-American players as possible in his columns.[43]

During the early 1930s, Levette was extremely optimistic regarding the future of African Americans in the film industry. He boasted of the large number of black players who received regular studio calls from Butler. He highlighted not only the talent but also the untapped diversity of black entertainers. In promoting Sam McDaniel, Levette insisted: "his long experience in stage and night club circles stood him in good stead . . . although heretofore insufficient attention has been brought to the fact that he is one of the most versatile actors in the profession." Levette cited Sam McDaniel's success as one of the most hopeful signs for blacks in Hollywood. In 1932, Sam McDaniel was cast as a western outlaw, Whistlin' Six, in the movie *The Vanishing Frontier*. It was a rare cinematic achievement, one of the few times a black man was seen on the screen as something other than a servant. Although it was a minor part and that of a villain, it allowed McDaniel to exhibit another side of his talents. Levette predicted that with Whistlin' Six, "the way will no doubt open" for variations in black cinematic roles.[44]

But Levette was wrong. Better and varied roles were not forthcoming, and black film images remained virtually unchanged. Black men opened doors, hauled luggage off and on trains, and waited tables. Black women served dinner and drinks, obediently attended their mistresses, and fussed over white children. For the most part, Sam McDaniel and his sister Hattie remained relegated to such roles. But the multitalented McDaniels

stuck with Hollywood. It allowed the McDaniel siblings to earn enough money to support the other, less well-paying, aspects of their entertainment careers.[45]

Actually, Hattie McDaniel had not fully committed herself to Hollywood. In the fall of 1933, she auditioned and won the role of Queenie in a stage revival of *Show Boat* mounted by famous Broadway producer David Belasco and theater owner Homer Curran. Belasco booked the extravagant production, which included a cast of over one hundred, for an opening at Curran's San Francisco Theater, with the intention of eventually turning it into a road show. In October 1933, Hattie McDaniel packed her bags and left Los Angeles for what was planned to be an extended run of one of the nation's most popular stage musicals.[46]

Belasco and Curran's *Show Boat* premiered on Monday, October 31, 1933, to a large audience. Immediately, the revival proved to be a hit. *Variety* reported that in the first week alone it grossed $18,000 in ticket sales. Langston Hughes, one of the most celebrated writers of the Harlem Renaissance, caught the show's debut and sent a glowing report to the *California Eagle*. He hailed Belasco's new discovery, Kenneth Spencer, who played Joe, as "a new Negro talent of importance," and praised, among others, "Hattie McDaniel, colored artist of Hollywood fame" for contributing to an extraordinary opening night. *Show Boat* held strong in San Francisco throughout most of November, generating well over $10,000 a week for its investors, an impressive sum during the Great Depression.[47]

From the beginning, however, problems plagued the *Show Boat* revival. Despite lucrative receipts, Belasco and Curran abruptly sold all of their interest in the show to Seattle businessman Howard Lang and his partner, movie agent Ivan Kahn. Owing over $9,000 in back taxes, Belasco had bailed out, fearing that the federal government would attach the production's proceeds. Then, on November 28, the production's treasurer, Hewlett "Hughie" Tarr, was killed during a box-office robbery. No doubt the incident was unsettling for everyone associated with the show, including Hattie McDaniel.[48]

Shortly afterward, Lang and Kahn closed *Show Boat* and took it to Los Angeles, where it debuted downtown at Curran's Mayan Theater on December 5. The reviews were good; Edwin Schallert of the *Los Angeles*

Times rated it "a gem of a production." There, *Show Boat* generated $7,500 in its first week, a respectable take for Los Angeles. But the show was still besieged with bad luck. After a week's run, federal agents showed up at the Mayan to collect on Belasco's overdue tax bill. After a heated argument with Lang that lasted over two hours, the officers left, reportedly convinced that Belasco had surrendered his interest in the show. Nonetheless, Lang closed *Show Boat* that night and rebooked it at Hollywood's Pantages Theater. When it opened again on December 14, it was a decidedly scaled-down version. Lang released most of the cast, retaining only the principals, including Hattie McDaniel and a small choir. He also cut the production's running time to under two hours so he could cram in three shows daily. After a short run, Franchon and Marco, a variety theater circuit, began negotiating with Lang to take over *Show Boat* and send it out on a national tour.[49]

Although the 1933 revival of *Show Boat* was Hattie McDaniel's first major stage role, the pace of the Pantages shows was exhausting. In January 1934, before the production hit the road, she bowed out. "Hattie McDaniels," reported Harry Levette, "almost overworked in the recent run of *Show Boat,* is taking a much needed rest." Although McDaniel was only forty years old and a veteran trouper, she found the almost six hours of daily live performances to be grueling. Additionally, McDaniel must have been weighing out the costs of continuing with such a troubled production. As she well knew, touring was tiresome, lonely, and financially uncertain. At this point, she had to make a choice. She would devote herself to the silver screen.[50]

5

. . .

Prominence

. . .

Hattie McDaniels, who is predicted to surpass Louise Beavers
in prominence within the year, got her first real break in Judge
Priest *when Will [Rogers] had songs written for him and*
Hattie to sing together.

Harry Levette, *California Eagle,* August 23, 1935

O N FEBRUARY 9, 1934, Harry Levette announced in his column
that Hattie McDaniel had "interviewed Monday and is said to
have passed for an important part." The role was that of Aunt
Dilcy in Fox's *Judge Priest* starring Will Rogers, and this character, a
housekeeper, was a part of the story from beginning to end. McDaniel,
who had won the part by ad libbing during her screen test, would have
several scenes with dialogue, and even the chance to sing. On May 25,
1934, Hattie McDaniel signed her first real studio contract. It was a one-
picture deal and promised her $300 for only eleven days of work. In terms
of speaking roles available to black actresses, this one was significant and
marked a turning point in Hattie McDaniel's career. Fox even accorded
her on-screen credit, although the studio, like so many others had in the
past, misspelled her last name as McDaniels. The job came just in time.
McDaniel insisted that she was so down on her luck that she had actually
prayed for this part.[1]

Playing Dilcy could not have been easy for the independent and satir-
ical Hattie McDaniel. *Judge Priest* presented a dreamy, romanticized de-

piction of a blissful post-Reconstruction South, the region her parents had fled to find a better life. In the film, Rogers appeared as a wise jurist, representative of what the opening prologue proclaimed was the "vanished generation" of honorable white Southerners. In Ford's depiction of the supposedly easygoing, simpler Dixie, black Americans like Dilcy and Priest's personal servant Jeff Poindexter (played by Stepin Fetchit) existed only to serve white people. Ironically for McDaniel, the daughter of the proud Union soldier who took up arms against the Southern cause, the film pivoted around a reunion of Rebel veterans who were congregating to celebrate the Confederate cause.

While providing McDaniel with generous screen time, *Judge Priest* placed her in an extremely restrained role. McDaniel was forced to wear demeaning makeup (a dark foundation with a high luster). Although she had gained weight, she was padded to look even larger, and her wardrobe consisted of cotton dresses, aprons, and kerchiefs. Dilcy is simplemindedly deferential to her employer, completely committed to pleasing and anticipating his every whim. She literally rejoices in her subservience. "I've got to take down the judge's clothes," she sings happily with almost a sense of religious duty while gathering laundry from the line. "Got to take them in the house, yes Lord." Dilcy contentedly hums and even dances a step while she works. She not only enjoys her servility, she despises any threat to the Southern order. Upon discovering that the judge's nephew, home from a Northern college, has been eating "Yankee" food, she exclaims with horror, "Lord help you, white child!"

Although the part was stamped with all the hallmarks of negative black stereotypes, McDaniel endeavored to brand it with her unique style and subtle commentary. She literally shouted her lines, as well as her songs, at a volume drowning out the other players. Dilcy's sassing is directed solely at the lazy and dimwitted Jeff, but McDaniel used it to send a message. The efficient, skilled, and hardworking Dilcy stood in contrast to Jeff, a bumbling, lazy former chicken thief. When Jeff tries to steal freshly baked doughnuts, Dilcy stops him short. As he whines, she shoots him a look that conveys not only reproach but also an undercurrent of contempt for his ridiculous behavior in general. Dilcy's disgust is obvious: Jeff is embarrassing and offensive.[2]

Yet McDaniel had very little room to subvert the baseline stereotyping in this role. In part, this derived from the firm directorial hand of John Ford, considered to be one of cinema's greatest artists. Best known for westerns that celebrated common white Americans as citizen-heroes, he applied a similar approach to his films set in the south. Like many film-makers of his generation, Ford was strongly influenced by D. W. Griffith and, as a young actor, had even appeared as a hooded Klansman in *The Birth of a Nation*. In fact, he was able to work that film's star, Henry B. Walthall, into *Judge Priest*. But Ford also shot a scene where Priest saves Jeff from a lynching and denounces the murderous practice. Fox ulti-mately cut it, citing possible complaints from whites below the Mason-Dixon Line as the reason.[3]

While Ford shaped Hattie McDaniel's performance, it was also guided by Will Rogers. One of the nation's most beloved stars, Rogers was known for his homespun brand of improvised, populist cowboy humor. Ironically, he had Cherokee ancestry but was raised in a household that identified more with the white Southern mindset. His father, an Oklahoma rancher, had fought for the Confederacy during the Civil War. Although by the 1930s Rogers had established a national reputation as a political liberal, critical of wealth and big business, he was also a man of prejudices. In early 1934, Rogers used the term "nigger" during his popular radio show. Immediately, an outcry went up from the black community. He defensively responded that anyone offended by his remarks could just turn him off. But that did little to allay African Americans' concerns. Rogers finally apologized, first through his secretary, who insisted that he had "always been sympathetic with the struggle of the Negro" and much later, when he spoke to the African-American congregation at Los Angeles's Second Bap-tist Church. But in another instance, he was dismissive. "I want my col-ored friends to know that nothing is further from my intention than offending any people at any time . . ." he stated. "I never crack jokes with the intent to offend races, creeds, or mother-in-laws."[4]

Although Rogers's stance on race was, at best, ambivalent, many in the black film colony regarded him as an ally. While his films remained en-trenched in black stereotyping, they also contained numerous roles for

African Americans. Unlike other white stars, he was not afraid to share the screen with and even be upstaged by black performers whose comedic characters often drew the biggest laughs from white audiences. As several have pointed out, Rogers projected a friendly rapport with black characters on screen. And, as John Ford remembered, Rogers's diatribe against lynching in *Judge Priest*, purely ad libbed, was "one of the most scorching things you ever heard." Within the industry, Rogers was a widely acknowledged champion of Stepin Fetchit. He interceded when Fox attempted to banish Fetchit for his recalcitrant behavior and misdeeds.[5]

Still, Fetchit remained a difficult personality. On her first day on the *Judge Priest* set, Hattie McDaniel ran head-on into his notorious temperament. The veteran actor immediately snubbed her, dismissing her as a neophyte. (It is likely that he feared she would be a potential competitor for on-screen laughs.) After working in a few scenes with McDaniel, Fetchit warmed up—a little bit. The *California Eagle* chortled over his egotism and reported, "If Hattie should have felt any resentment at Step's cool welcome," as the berating Dilcy, "she had an opportunity to take it out on him in the play."[6]

While Fetchit may have initially offered McDaniel a chilly reception, Ford and Rogers were extremely welcoming. Both men were delighted by her performance. The *California Eagle* reported that Ford, an exacting director, was "elated" to discover that she was a quick study and that Rogers had remarked that they were "sure lucky" to have McDaniel on the project. In fact, Rogers was so pleased, he requested an expansion of her part so she could improvise a song with him. Word of McDaniel's impressive work began to spread and brought out Fox's head casting director who personally showed up on the set one day to observe the studio's latest discovery.[7]

With *Judge Priest*'s release in August of 1934, Hattie McDaniel won her first real professional recognition within white Hollywood. The film's notices were overwhelmingly positive, and while in the past reviewers had all but ignored Hattie McDaniel, this time she received not only mention but also praise from one of the most powerful figures in Hollywood, the nationally syndicated columnist Louella Parsons. "There is a colored

woman, Hattie McDaniels, who sings Negro spirituals as I have seldom heard them sung," Parsons raved in her endorsement of the film. "Rogers himself joins in with her and you'll love it."[8]

Once McDaniel's contract with Fox ended, RKO moved quickly in early July to sign her for a film that was shooting on location in Arizona. Throughout the summer and into the fall, McDaniel worked steadily. By the end of 1934, she had racked up significant roles in eight feature productions, including *Babbitt*, *Little Men*, *Lost in the Stratosphere*, and *The Merry Wives of Reno*. Over the next two years, McDaniel solidified her claim to her special brazen style. "Give me back my blanket," she bellows as the white hired man rips it from her bed to put out a raging fire in *Little Men*. For the Hal Roach comedy, *Fate's Fathead*, she fiercely levels a shotgun at her white employer, played by Charley Chase, whom she mistakes for an intruder. Her unconventional approach continued to receive acclaim. *Variety* praised McDaniel in *Little Men* as a standout in what it considered a lukewarm film overall. The nation's most respected show-business trade paper also cited her contributions to *Babbitt*. "The part of Rosalie, the colored maid," the *Variety* reviewer insisted, "is ample with comedy." Hattie McDaniel was well on her way to becoming a familiar cinematic presence.[9]

During the course of this banner year, Hattie McDaniel also scored a small part in Universal Studio's *Imitation of Life*, which would become one of the era's most significant films. *Imitation of Life* was the story of Bea Pullman, a white widow who supports her daughter, Jessie, by selling maple syrup. Circumstances bring her together with an African-American woman, a domestic named Delilah Johnson, whose young daughter, Peola, is extremely light-skinned. The two women conquer destitution by marketing a boxed version of Delilah's special pancake recipe and building a financial empire. Despite their success, neither woman finds true happiness. Bea's attempts at love fail; she is married to her career. And Delilah's heart is broken when Peola rejects her to pass for white. Devastated by her loss, Delilah dies with Bea by her bedside.[10]

Universal planned *Imitation of Life* to be a major release and early on poured resources into the film. The studio assigned its leading director of women's films, John Stahl, to the project, hoping his special touch would

bring in female fans, the most stalwart of moviegoers. But with the sensi-
tive nature of the racial subplot, Universal knew that it would have to fight
to get *Imitation of Life* to the screen. From the beginning, the studio ma-
neuvered carefully. First, they tackled the issue of proper casting. Most
likely Hattie McDaniel, like many other African-American actresses, hun-
grily eyed the role of Delilah. It was the first dramatic, starring role ever
created by a white studio for an African-American actress. But McDaniel's
confident, proud, and blunt style would have transformed Delilah into a
far too bold and realistic character. Rather, the part went decidedly to
Louise Beavers, whose willingness to follow direction and project self-
effacing humility was highly prized by white Hollywood. Beavers's "soft"
manner on screen was much less threatening than McDaniel's command-
ing presence. Instead, McDaniel was cast as a mourner at Delilah's funeral,
a scene that eventually ended up on the cutting-room floor.[11]

Although McDaniel's involvement in *Imitation of Life* was limited, the
controversies surrounding the film would eventually impact her career.
The film's planning stages offered a window into the prejudices of the stu-
dios, evidencing the grip that racism had on American filmmaking. Just
the process of selecting Peola revealed how bigotry influenced Holly-
wood's decisions. Stahl rejected the idea of using a white actress, not to
give a black performer a break but rather because the role implied and re-
quired contact between Delilah and Peola that would violate white Amer-
ican segregationist traditions. "Such a thing, so to speak," he remarked in
an interview, "would simply not 'go down' with theater audiences." Stahl
rejected all local African-American actresses, insisting that the passing
theme would only be believable if played by a "newcomer" to the screen.
In the end, after auditioning over three hundred women, he recruited
Harlem's sensational singer and dancer Fredi Washington to play Peola.
Thin, extremely light-skinned, and possessing a deep, elegant voice, Wash-
ington was regarded as a highly talented performer and great beauty.[12]

Despite the careful casting of the film, the studio still had to battle the
Hays Office. At the beginning of March 1934, Universal sent a draft of *Im-
itation of Life* to Joseph Breen, the Hays Office's chief film censor. Breen's
response laid bare the decisive role that censors played in shaping black
images and upholding white racism on the silver screen. While Breen ap-

plauded the "beautiful mother-daughter love running through the story," he balked at the film's racial content. "The main theme is founded upon the results of sex association between the white and black race," he wrote to Universal, "and as such, in our opinion, it not only violates the production code but is very dangerous from the standpoint both of industry and public policy." If filmed, Breen made clear, the censors would block the release of *Imitation of Life*.[13]

The studio pressed on. Yet, despite a direct plea from Carl Laemmle Jr., the son of Universal's founder, Breen's position remained unchanged. "We pointed out that not only from the picture point of view . . . but from the point of view from the industry as a whole," he noted in his files, "this was an extremely dangerous subject and surely to prove troublesome not only in the south where it would be universally condemned but everywhere else." Universal refused to ditch the project, even offering to sidestep the issue of miscegenation by explaining away Peola's light complexion as a genetic defect. Breen did not buy it and continued his campaign to force Universal to abandon the project.[14] He had an assistant scour office files for past cases where the censors had dealt with interracial relationships between blacks and whites. This proved futile; since the formation of the censorship office, Hollywood had steered clear of black and white miscegenation–related stories. But there had been one edict issued by Will Hays that had regulated interracial interactions. In 1928, Hays had prohibited "white women" and "Negroes" not only from romantic attachments but also from engaging in any kind of "social relationship," period.[15]

Breen also sought feedback from other members of the Hays Office. One staffer, Alice Field, found *Imitation of Life* "moving" but advised avoidance. "The spot touched is such a sore one, that it would seem the kindest thing of all to do as little probing thereabouts as possible," she insisted.[16] J. B. Lewis, another reader, also weighed in against the production. Lewis argued that the film, which used the racial slur "nigger" in the dialogue, would also offend African Americans. But even in its attempts to uphold racial status quo, he argued, the script failed. Tellingly, his critique revealed the conscious efforts made by both studios and censors to perpetuate second-class citizenship for African Americans. "It may have been the

author's intent to show that Negroes were happiest as servants in the house," Lewis conjectured, "but this is not clearly brought out."[17]

Despite the censors' refusal to approve the production, Universal began filming *Imitation of Life* during the summer of 1934. Two weeks into the shooting, Breen shrilly warned the studio, "This story is definitely a dangerous one." Now, only receiving portions of the script from Universal, he continued to issue rejections but also began editing dialogue and mandating deletions. He sliced out an entire scene where a young black man barely escapes being lynched. Additionally, Breen insisted that Stahl remove the term "nigger" from the script. When it had been used in a previous film, Lionel Barrymore's *House of Connelly*, the result had been protests and near uprisings at black theaters. Stahl initially refused to cut the epitaph, but after objections from the normally compliant Louise Beavers, it and several other offensive lines were deleted from the script. "I know I didn't want to say them," Beavers told one reporter discussing the film's dialogue, "and I knew Negroes would not want to hear them."[18]

Eventually, after considerable wrangling both off and on the set, *Imitation of Life* received the censors' approval. Universal's insistence on proceeding with the project had called Breen's bluff. The relationship between the studios and the censors, whose salaries were paid by film bosses, was fragile. If Breen had attempted to block the film upon its completion, the studio may have released it anyway, and that would have signaled a wholesale abandonment of the industry's attempts at self-censorship. The next step may have led to external interference, perhaps even by a government agency. Essentially, the Hays Office settled for compromises over *Imitation of Life*, as it had done with numerous films before. Within the first few minutes of the movie, any concerns regarding miscegenation were quelled with Delilah's explanation that Peola's father was a "very light-skinned black man." Although Peola desires, even demands, the privileges of white people, her mother contentedly accepts her place. Delilah smiles on command and gladly listens from the floor below as Bea Pullman throws an elaborate party, with white guests only, to celebrate the success of their enterprises. Delilah even refuses her portion of the fortune derived from the massive sales of her pancake mix. "You'll

have your own car, your own house," Bea explains slowly. "My own house!" Delilah exclaims. "You gonna send me away, Miss Bea? . . . Don't do that to me. How I gonna take care of you and Miss Jessie? . . . I's yo cook and I want to stay your cook. I gives it to you, honey. I makes you a present of it." Universal had successfully created a cinematic, nonthreatening Delilah who, in contrast to her anguished daughter, communicated that black Americans were happiest, to use J. B. Lewis's expression, as "servants in the house."[19]

Still, the film contained stunning dramatic opportunities for Beavers and Washington. Despite the filmmakers' attempts to sustain white racial assumptions, Beavers and Washington brought new dimensions to black women's roles. Delilah and Peola were not simply props, nor did they exist exclusively for comedic relief. They laughed and cried, expressed joy and agony. These characters had lives independent (if only slightly) of white people, and conveyed an emotional world that was complex and varied.

In November 1934, *Imitation of Life* made a much-heralded debut. On both coasts, it drew capacity crowds and was held over in several places for a record-breaking second week. The film also scored similar successes across the country and immediately became a box-office hit. Ticket sales quickly proved that Breen's fears were wrong. In January 1935, at his insistence, Universal sent him a report on the film's reception in the South. In a number of Southern cities, including Memphis, Richmond, and Little Rock, *Imitation of Life* rang in at number one at theater cash registers. Los Angeles's African-American citizens turned out in droves for the film. In part, they were drawn by the inclusion of literally hundreds of black locals as extras attending Delilah's funeral. Rather than cast professionals, Charles Butler recruited ten local lodges to march in the procession and the popular Reverend N. P. Gregg of People's Independent Church to lead the onscreen rites.[20]

Although *Imitation of Life* proved popular and profitable, critics were divided on the merits of the film. Some rejected its sentimentalism, and many others denounced Universal for wasting an opportunity to take a bold stand against racism. The *Literary Digest* protested that "the real story"—the racial discrimination that was the root of Peola's angst—"is merely hinted at, never really contemplated." Still, other white reviewers

contended that *Imitation of Life* was path-breaking, heralding it as a pioneering effort that at least acknowledged American racism. The usually conservative *Variety* warned that "exhibitors below the Mason-Dixie line" would find the film objectionable, but rated Washington as "arresting" and predicted that "the picture may make some slight contribution to the cause of greater tolerance and humanity in the racial question." Among Hollywood's elite, *Imitation of Life* was so admired that the film was nominated for an Academy Award in the Best Picture Category for 1934.[21]

Within the African-American community, this film ignited a passionate debate over black cinematic images, one that would ultimately and intimately affect black actors such as Hattie McDaniel. Many African-American critics separated the performances offered by Beavers and Washington from the film's content. La Vera White of the *California Eagle* hailed Beavers and Washington as "super-glorious."[22] The *Pittsburgh Courier's* Bernice Patton predicted that their skillful acting would open new doors for African Americans in film. But, at the same time, the racialist undercurrent that flowed throughout the film offended most black reviewers. A number of African-American critics objected to the implication that Peola passed not because she yearned for social equality and economic advancement but because she carried a deep streak of racial self-hatred. Howard University's Sterling Brown, writing in the Urban League's *Opportunity*, joined others who insisted that the film only perpetuated racism, segregation, and the most degrading black stereotypes. Its treatment of race "hardly seems anything to cheer about," he insisted.[23] "These are not real Negroes, Delilah and Peola," read a letter to the editor of the NAACP's magazine *The Crisis*. "They are what white people want us to be."[24] La Vera White's reaction summed up the major failing of *Imitation of Life*: "Some may praise the picture on the grounds that it will create 'sympathy' for Negroes. As for me—I say who in the _____ wants their condescending sympathy? I'll take respect and equality or nothing!"[25]

The heated public debate over *Imitation of Life* fueled a shift in the African-American press. Previously, a number of African-American publications, especially newspapers, had functioned as public-relations tools for black stars and Hollywood films. But the controversy over *Imitation of*

Life led many to demand more critical appraisal of the movie industry and the cinematic depiction of black Americans. "[African-American movie-goers] must be taught to recognize and resent anti-Negro sentiment in such a manner that their feelings can reach the box office . . . ," wrote black Los Angeles attorney Loren Miller in *The Crisis*. "The Negro masses will adopt a critical attitude only if the organs of opinion and Negro leadership establish an adequate critique for their guidance." While Hattie McDaniel remained a relatively minor figure among black film players, she would soon be directly drawn into these discussions. Despite often competing with her for the same roles, she had a close friendship with Louise Beavers. As *Imitation of Life* thrust Beavers into the limelight as Hollywood's only African-American female star, she became the first black woman to navigate through the waters of Hollywood fame and public criticism. Hattie McDaniel watched and learned as her friend confronted the challenges of stardom.[26]

Beavers certainly attracted a large number of devoted fans both in the black and white communities. Tapping into her popularity, in 1935, the studio sent her on the first of several personal-appearance tours throughout the country. And with the announcements of the nominations for the 1934 Academy Awards, several voices went up in protest when she was bypassed for an Oscar nomination. "But of course, the Academy could not recognize Miss Beavers," the Associated Negro Press wire service remarked. "She is black."[27]

Beavers also drew harsh criticism. Many viewed her performance as demeaning. Some insisted that Beavers had brought nothing new to the screen: Sterling Brown dismissed her characterization, asserting, "Delilah is straight out of southern fiction."[28] The *Pittsburgh Courier* went even further. Smarting from what it felt was a snub by the actress at the film's premiere, it depicted her as arrogant and ungrateful, alleging that she had begun ignoring the black press. The paper insisted that she had brushed them off, telling them, "I'm getting a lot of publicity and I'm not worried about it." The *Courier*'s report implied that Beavers cared more about her career than she did about her race.[29]

Beavers, who felt that she had brought a special humanity and pathos to the role of Delilah, did not silently accept the criticism. Instead, she

fired back publicly. In an interview with the *California Eagle*, she took on the *Courier*, dismissing their allegations. "I cannot account for the cause of such an attack," she insisted, maintaining that African-American journalists had all been welcome at the premiere and on the set throughout the filming. Hollywood booster, Harry Levette defended her as "race-proud" and underscored her consistent support for the black press.[30] "Why not regard the picture as it was intended? As a story—a story about human beings?" Beavers asked in an interview with the *New York Amsterdam News*. She highlighted the importance of the black presence in Hollywood, insisting that she had persuaded the studio to delete the most offensive elements of the film. "I have always tried to protect my people," she insisted, "and to show directors that they are just as sensitive and particular about their race as whites are about theirs. I wouldn't sell my race for a dollar." Regardless, Beavers's outspoken defense of herself and her film career ultimately placed her in the position where she became a champion of the movie industry and its stereotypes. Beavers remained vocally optimistic that blacks in Hollywood would progress. "In almost every successful picture now," she claimed, "you see one or more Negro characters. True, they may have only a maid or servant's part but even that shows advancement over the slapstick and African Zulu parts to which they were once confined in *Trader Horn* and *Tarzan of the Apes* type drama." The actress argued that *Imitation of Life* would be the beginning of a transformation in black cinematic images.[31]

It became rapidly apparent, however, that the significant changes that Beavers and her colleagues were hoping for were not at all forthcoming. As predicted, roles for African Americans did begin to proliferate. Charles Butler reported to the *California Eagle* that the demand for black players had immediately escalated with *Imitation of Life*'s demonstrated box-office success. Studios rushed to write more black characters into their scripts. These were not just parts for extras but included a number of substantial speaking roles. Throughout 1935 and into 1936, studio calls for black players increased. Still, the substance of black roles did not improve, and it would be years before Hollywood attempted another exploration, no matter how inept, of racism on the screen. Instead, moviemakers faithfully recycled the same old, demeaning stereotypes. Beavers returned to

playing childlike, usually humorous servants, with no further opportunities to exercise her dramatic skills in white Hollywood pictures. As an "off-type," Fredi Washington was unable to find suitable follow-up roles and eventually abandoned Hollywood altogether. She returned to New York and emerged as an outspoken critic of white show business in general. But she had always been skeptical of Hollywood. "There is also less of this so-called race prejudice and more of real art in the drama [of the stage]," she told the *Pittsburgh Courier* soon after she first arrived in Los Angeles. "Then I guess, I am what you call 'too independent' to fool around with your producers here."[32]

As Fredi Washington had learned, and an old hand like Hattie McDaniel knew, the white studios' back lots were simply microcosms of the racism that dominated American society at large. Although Hollywood was home to a number of progressive whites, the studio system perpetuated American racism both before and behind the cameras. In many ways, the discrimination that African-American actors and actresses endured in Hollywood during this golden age of filmmaking was of the most insidious nature. Although Clarence Muse occasionally doctored scripts, African-American composer William Grant Still scored musical accompaniment for a few films, and Langston Hughes even worked on some screenplays, African Americans were basically excluded from the studios' creative ranks. There were no black directors, producers, or crewmembers. Outside of black performers, who were usually relegated to small roles, African Americans who worked on the lots were confined to jobs as bootblacks, studio commissary waiters, gofers, and personal servants to the stars. In many ways, African-American performers who attempted to break down the studio's segregationist atmosphere bore the brunt of racism. Wonderful Smith, an African-American comedian who got his start in films in 1935, recalled that the attitude toward blacks on the movie lots was "cold." Fredi Washington was repulsed to discover that studio crewmembers used racial slurs with impunity. Even African-American performers who broke into speaking roles and began receiving widespread recognition, like Stepin Fetchit and Louise Beavers, were consigned to second-class citizenship. Although the studio cafeterias were integrated, until the 1940s black stars were barred from eating in the exclusive dining

rooms reserved for Hollywood's elite performers. Reminders of racism came in all forms. Mae West, the controversial film actress who was a supporter of African-American performers, caused a stir when she lunched alone in her dressing room with her old friend, musician Louis Armstrong. Even during filming, this attitude was reinforced. White comedian Martha Raye, who appeared with Armstrong in *Artists and Models*, insisted that "Hollywood rules called for a stipulated distance separating the white performers from the Negroes while they were before the cameras." Hattie McDaniel remembered this as a rough period for blacks in Hollywood, a time when "no Negro was given a dressing room, when there were no hairdressers on the sets for Negro actresses, [and] when no studio hired a Negro wardrobe girl."[33]

Hollywood bigotry also remained vigilantly protected within Central Casting's walls, where typecasting completely dictated the careers of African-American film players. Central Casting and Charles Butler, both representatives of the producers, controlled almost all African-American movie players. Since most white talent agencies refused to represent black performers, Butler not only made casting decisions but also conducted contract negotiations with the same studios that paid his salary. This conflict of interest became increasingly obvious; Charles Butler was more invested in doing the industry's bidding than protecting African-American artists.[34]

In response, a number of black film players began discussing strategies to improve their position within the motion picture industry. In part, they were spurred on by the formation in 1933 of the Screen Actors Guild (SAG). Although Clarence Muse was a charter member of SAG, the union had failed to recruit any other African-American performers. In part, the guild's dues were prohibitive for black performers, who were significantly underpaid. Other African Americans remained distrustful of the overwhelmingly white organization, believing that it would use them to achieve its more general goals and then do little to address their particular grievances. Several black film actors worried that industry leaders, who opposed unionization, would retaliate against SAG members by having Butler strike their names from his registry.[35]

By 1934, SAG had compelled the motion picture bosses to recognize

the union and had made significant gains for its members. During that year, Clarence Muse emerged as a respected and active SAG member, a vigorous advocate of unionization. On October 1, 1934, he joined Hattie McDaniel and thirty-three other black screen actors to discuss their position within the film industry. Muse made a passionate plea on behalf of SAG. "The pathway to the solution to your problems," he contended, "leads through the Screen Actors Guild and that alone." A growing disillusionment with the studios and Butler had set in, and the group agreed to break into several committees to reach out to other black players. At a subsequent meeting, after white guild representative Aubrey Blair pledged equal treatment for all members, Hattie McDaniel and a number of other black screen actors officially joined SAG. Although membership in the union may have seemed like a risky step for this early group, McDaniel and the others discovered that it paid off, especially since many of the most sought-after black players signed up at the same time. Guild protection provided stable working hours, improved conditions (like proper food and adequate toilet facilities) on the set, and a standard contract with a salary that would from now on always be equal to that of white actors in comparable roles.[36]

Shortly after joining SAG, Hattie McDaniel won her biggest role yet. In late 1934, Fox put her under contract (this time a standard union agreement) to appear as the loyal servant Mom Beck in *The Little Colonel*. A starring vehicle for America's sweetheart, Shirley Temple, the film also featured Bill "Bojangles" Robinson. For years, Robinson had been revered as a master of tap dance in both black and white entertainment worlds. *The Little Colonel* was his first feature-film role and had been designed to showcase his talents. It must have been difficult for Robinson to accept such a part—he was cast as the long-suffering manservant, Walker, subjected to constant verbal haranguing by his cranky and abusive white employer. However, Robinson countered the submissiveness of his role with his bold yet elegant footwork, as well as pronounced frowns and even sneers at on-screen white insults. Not surprisingly, he forged a strong and lasting friendship with his costar Hattie McDaniel.[37]

McDaniel's role as Mom Beck, a faithful servant, would be a test of her acting abilities and of her willingness to play a more traditionally stereo-

typed role. Set primarily in the south during Reconstruction, *The Little Colonel* echoed the sentimentalism found in *Judge Priest*. The film's atmosphere is lushly embellished with romanticized pro-Confederate longings and the sense that no one in the region, black or white, wanted or accepted slavery's end. Mom Beck carries portions of the plot and remains content to serve just as she had before emancipation. She is permitted to scold Shirley Temple—her duty is to properly nurture white children. But there was little room to back-talk anyone else. The studio used Mom Beck to provide humor but also constructed her to be, for white film fans, a lovable tribute to the black stereotypical mammy image. She fiercely protected her white employers, unconditionally loving them more than any biological mother could. She possessed wisdom when it came to dealing with her little charge but otherwise was ignorant and quaintly foolish. Locked in a closet by unscrupulous swindlers, Mom Beck resorts to ramming the door with her rear end. While white audiences roared and critics hailed McDaniel, the scene was chillingly reminiscent of the purported comedic relief enacted by the mammy in *The Birth of a Nation*.[38]

The parallels between *The Little Colonel* and *The Birth of a Nation* were not accidental. The film's director, David Butler, as a teenager, had worked for D. W. Griffith and maintained deep racial prejudices that were apparent on the set. Even little Shirley Temple was aware that something was wrong, although at age six, she was too young to understand it fully. She remembered Butler, in an attempt to embarrass her rather overbearing father, paying an African-American child to jump into her father's lap and cry out, "Daddy, Daddy." The director chortled with delight as the child continued to follow her father around the set, calling him "Daddy." In her memoirs, she recounted her later realization of the depth of racial bigotry it revealed. This was the atmosphere that Hattie McDaniel endured as she struggled to make her way in the film industry.[39]

Still, in the face of Hollywood's discrimination, Hattie McDaniel pushed on, now thoroughly committed to her film career. She became one of the first in the black film colony to reap the benefits from the boom in black roles. Throughout 1935 and 1936, she was selected for more and more speaking roles. While she was almost completely restricted to comedic parts as maids and mammies, she did find that several allowed

her to inject a little defiance into her performance. And the more humorous, the more uncontrollable she was. For *The Postal Inspector*, she was cast as Deborah, the happy but superstitious maid who offered up an unmistakable parody of some of the sex goddess Mae West's trademark sultry moves.[40] Better still was McDaniel's role as Isabelle McCarthy, in *China Seas*, starring the scintillating Jean Harlow and the handsome Clark Gable. Harlow's character, the hardboiled, déclassé Dolly Portland, cruises the Pacific, picking up lovers along the way. Her maid, Isabelle, reflects her complete lack of refinement; no respectable white woman would employ such an outrageous servant. It was a device similar to the one von Sternberg had used in *Blonde Venus*, only now it had a decisively comedic slant. Isabelle lounges in a garish dressing gown, feet up, reading gossip magazines, oblivious to Dolly's orders. She angles for the gaudiest pieces of her mistress's wardrobe. And she speaks uninhibitedly. "Would you say that I look like a lady?" Harlow asks. "No'se Miss Dolly," Isabelle replies directly. "I've been with you too long to insult you that way." Isabelle even dares to point out their similar tastes in fashion. Later, as Dolly is led away to face criminal charges, Isabelle proclaims (with very little sympathy), "You sure been mighty good to me, even if they does hang you." In Isabelle McCarthy, McDaniel created the antithesis of Mom Beck—she was completely self-interested and refused to know her place or hold her tongue.[41]

By 1935, Hattie McDaniel had gained enough notoriety that when RKO signed her for *Alice Adams*, press releases promoted her as "one of the most prominent performers of her race on the screen." For this film, which starred Katharine Hepburn in the title role, Hattie McDaniel played Malena Burns, a less-than-enthusiastic maid hired by the financially strapped Adamses who hope to project a facade of affluence. McDaniel used a new approach to this part. Her previous characterizations carried verve; she delivered her lines with punch sometimes accompanied by an artificial laugh that revealed the effort it took to find her dialogue even remotely amusing. Her typical pace was quick and her body language crisp. But she performed Malena Burns with a lumbering slowness, mumbling her lines in a weary monotone. At the insistence of Alice Adams (Hep-

burn), Malena prepares and serves a heavy dinner on a sweltering summer night. Plodding through her scenes, chomping on a piece of gum, McDaniel conveyed both the oppressiveness of the summer's heat as well as the oppressiveness of working for white people. Malena has neither enthusiasm for her job nor any respect for the fraudulent Adams family. She expresses her disapproval of the menu and, when Mr. Adams refuses to take a hors d'oeuvre, shoves the tray forcefully in his face. She enters the dining room by kicking open the door and rolls her eyes in disgust at Alice Adams's embarrassing attempts to impress her wealthy suitor by speaking French. McDaniel played Malena thoroughly consumed with disdain.[42]

RKO's publicists highlighted McDaniel's performance as "one of the high comedy notes," and a number of reviewers agreed.[43] *Motion Picture Daily* reported that McDaniel drew "howls" from the first-night audience. *Variety* rated her "a wow." And best of all, the *New York Times*'s respected film reviewer Andre Sennwald gave McDaniel special mention. "The recital would be incomplete," he wrote, "if it neglected to applaud Hattie McDaniel for her hilarious bit as the hired maid during the classic dinner scene." No doubt, those who saw this film left with vivid memories of McDaniel struggling to push open the dining room's sliding doors, pausing, and with complete revulsion announcing, "Dinner is served."[44]

By late 1935, Hattie McDaniel had become thoroughly involved in cinema. She now regularly received speaking roles with screen credit and favorable mention in the white press. She had worked for almost all of the major motion picture studios and with many of Hollywood's most popular white stars. Matinee idol Clark Gable had become a special friend and an ardent advocate for her within the industry. She was, despite the lingering Depression, making very good money, signing a number of picture-by-picture contracts with Fox with salaries in the range of $250 a week. She had left her apartment and rented a house on West Twenty-eighth Street, about four miles from Central Avenue. Despite her success, she remained firmly grounded and down-to-earth. Instead of the rowdy, off-hours high life commonly associated with show-business personalities, she claimed to prefer to entertain at home, cooking meals for family and friends like Libby Taylor, a former fellow trouper who had come to Hollywood as Mae

West's maid and shortly afterward landed in the movies. Indeed, Hattie McDaniel was far from basking in Tinseltown glamour; she relied on the streetcar to get to and from the studio.[45]

One day in 1935, Wonderful Smith caught a Los Angeles streetcar and, to his surprise, found himself riding along with filmdom's Hattie McDaniel. "Before I sat down, I told her how glad I was to see her in person," he recalled, ". . . I told her I enjoyed her work." McDaniel thanked him, and the two began to chat. Smith had arrived in Los Angeles in 1930 at the age of sixteen, leaving his native Arkansas and hoping to find more opportunities in the west. Since then, he had worked a number of jobs, including one as a parking lot attendant at a local nightclub. (He got his break in films later, in 1935, when he parked a car for an assistant director who invited him to the studio to test for a part in a Mae West film *Klondike Annie*.) During his conversation with McDaniel, she revealed that she was looking into buying a used car that she hoped would make her trips to the studio easier. The problem was, she confided, that she did not know how to drive. She offered to pay Smith in his off-hours if he would become her driver. Smith eagerly accepted and soon was occasionally running her to and from work and other engagements as well as helping her out with errands. Before long, they became close friends. "She was a fine lady," Smith remembered.[46]

Among the places Smith took McDaniel was to church. While she now occasionally worshipped at People's Independent Baptist Church, she often had Smith drive her over to the services held at Father Divine's Peace Mission. It is not surprising that McDaniel would be drawn to the charismatic Father Divine, whose East Coast ministry had spread rapidly throughout the nation during the 1930s. Divine, whose mother had been enslaved in pre–Civil War Maryland, had grown up in poverty and knew Southern racism firsthand. By the time he reached adulthood, he had forged a unique, syncretic religious ideology that blended African-American Christianity with Eastern Mysticism and the mind-power philosophy known as New Thought. Divine preached the notion that God's spirit dwelled within all people and that through positive thinking, followers could tap into God's internal presence and achieve health, wealth, and happiness, as well as eternal life on earth. The minister's unique ideology

and practices, which included celibacy, temperance, and extravagant worship services in the form of banquets overflowing with food and drink, captured significant media attention during the 1930s. Many marveled at his ability to feed the poor and help the unemployed find jobs. But the followers' insistence that Father Divine was God, and his requirement that faithful disciples cut family ties and move into gender-segregated hostels, compelled many to regard his leadership as dangerous and cultlike. Nonetheless, he attracted acolytes of all races who set up "extensions" of his Peace Mission Movement throughout the world. Some of these consisted of cooperative businesses like stores, restaurants, and hotels. (For a time, the movement owned and operated Los Angeles's Dunbar Hotel.) Others opened churches, which attempted to replicate the massive celebratory feasts and social outreach that Father Divine had modeled at his east coast headquarters.[47]

While McDaniel, never willing to surrender her family ties or secular existence, did not become a thoroughly dedicated apostle, she remained interested in and supportive of Divine. His was one of the few genuinely interracial religious movements of the era—he insisted that race was a social construction used to unnecessarily divide Americans. In his opinion, like any other adversity, racism could be conquered by mind power. He demanded that followers cease identifying people by the color of their skin. Additionally, McDaniel must have found inspiration in Divine's trademark emphasis on hard work and positive thinking as the keys to success. Within his philosophy, anything was possible; no problem was insurmountable. All one had to do was channel God's energy and maintain the right attitude. While this spoke to Americans from all walks of life, it resonated especially with those who had suffered or were experiencing economic dislocation and racism. For Hattie McDaniel, who had struggled so long and hard to succeed, Divine's theology must have been affirming. As she continued her climb in Hollywood, she became ever more an advocate of this positive-thinking version of self-help. It was empowering and held out the possibility that individuals could take control and guide their own destinies regardless of the obstacles and hardships they faced. Furthermore, it resonated perfectly with her own evolving philosophy of life. "She believed that if you worked hard enough, you could achieve anything,"

Wonderful Smith remembered. That, combined with faith—"I just go to God for it, and He gives it to me," she told black journalist Bernice Patton—drove McDaniel on.[48]

In some ways, Hattie McDaniel had tangible evidence that hard work, determination, and a positive attitude paid off. In August 1935, Harry Levette announced that Hollywood insiders agreed that Hattie McDaniel would "surpass Louise Beavers in prominence within a year."[49] This sunny forecast was based, in part, on a rumor that had been circulating since January. Universal Studios had acquired the film rights to *Show Boat,* and many believed they would cast Hattie McDaniel as Queenie. Undoubtedly, McDaniel wanted this role and may have opportunistically participated in planting the word in the black press that she was first choice for Queenie. (It was, after all, her pal Harry Levette who first broke the news.) This would be a major role for any black actress who landed it. Universal planned *Show Boat* to be a big-budget, splashy feature and began pouring resources into it even during the preproduction phase. For the cast, it recruited several veterans of the Broadway version—Irene Dunne, Helen Morgan, and Charles Winninger. But Universal's biggest triumph came when it convinced African-American actor, singer, and activist Paul Robeson to reprise the role of Joe, which he had played in New York to tremendous critical acclaim. A graduate of Rutgers, who held a Columbia law degree, Robeson had, like Clarence Muse, turned to the stage after facing discrimination in the legal profession. He had a powerful baritone voice and, on stage, a commanding presence. A proud man and uncompromising critic of American racism, when Universal approached him with an offer of a part in *Show Boat,* he tried in vain to bargain for final say on his scenes. "I'm afraid of Hollywood . . ." he told a reporter earlier. "Hollywood can only realize the plantation type of Negro—the Negro of 'poor old Joe' and 'Swanee River.' " Despite his reluctance and the studio's refusal to give him creative control, he signed on, perhaps believing that his powerful delivery would overwhelm Hollywood's attempts to depict the character disparagingly. Nonetheless, Universal's advance publicity identified Joe as "the lazy, easygoing husband" of Queenie.[50]

As *Show Boat*'s cast came together in fall 1935, the role of Queenie curiously remained unfilled. What Hollywood wags did not know was that

Universal was not considering Hattie McDaniel for the part at all. Rather, they intended to use Tess "Aunt Jemima" Gardella, the white actress who played Queenie in blackface in *Show Boat* stage productions. This did indeed prove that the studios had not progressed much since the era of D. W. Griffith and still believed that whites in blackface were perfectly acceptable in black roles. Interestingly, it was the Hays Office that eventually prevailed upon Universal to abandon the idea. But it was not because blackface was offensive, nor was it to make way for African Americans in film. Actually, the censors insisted that if Queenie were played by a white woman, even if she was in blackface, any depiction of intimacy between Queenie and Joe would be a violation of the office's restrictions on miscegenation. Breen had interpreted censors' production codes in the broadest manner. "I think you should be extremely careful however not to indicate any physical contact between the white woman and the Negro man," Breen warned Universal. "Many people know Aunt Jemima is a white woman and might be repulsed by the sight of her being fondled by a man who is a Negro."[51]

Universal chose not to fight Breen and discarded the idea of using Gardella and hired McDaniel to play Queenie, but next they tried to slip the term "nigger" into the script. (It had been featured prominently in the original stage version.) After acquiescing, once again, to the Hays Office's demands to delete the term, Universal finally started the cameras rolling in early January 1936. McDaniel's work commenced quickly; Robeson was under contract to appear in London in mid-January, which left only two weeks to film his scenes. After Robeson dashed off to Europe, McDaniel and the rest of the company continued to film for two-and-a-half more months. It was a long shoot but, for McDaniel, a symbolic milestone. She got to work with Paul Robeson, one of the black community's most acclaimed actors, and became a part of one of the era's most elaborate and spectacular movie musicals.[52]

Show Boat made a grand debut in May 1936 and was an immediate box-office smash. The *New York Times* raved, "We have reason to be grateful to Hollywood this morning for it has restored to us Edna Ferber's Mississippi River classic *Show Boat*." White reviewers praised Robeson's performance, especially his powerful rendition of the film's theme song,

"Old Man River." Clarence Muse reported that at one Hollywood screening, the predominantly white audience cheered Robeson's gripping delivery of his songs and wailed with laughter at Hattie McDaniel's flashes of comedy. The actress again elicited special mention from Hollywood's top columnist, Louella Parsons. "Hattie McDaniel, who is the perfect foil for Paul Robeson's characterizations," the reporter wrote, "is one of my favorite actresses. She is always sure of getting a laugh."[53]

As Queenie, McDaniel had several key scenes. Again, she played a devoted servant with a broad smile and hearty (although purely synthetic) laugh. She participated in several musical numbers, including, "Can't Help Lovin' Dat Man of Mine" and "Ah Still Suits Me," a duet with Robeson. Additionally, this role was particularly choice and allowed McDaniel to sneak in flashes of recalcitrance. "Outta my way," growls a white riverside roustabout. "Who wants to get in your way?" she barks back. Spying her beautiful brooch, he bellows, "Where'd you get that?" Head up, with a tone of defiance, Queenie responds, "It is mine; it was given to me." Refusing to be intimidated by this white man's belligerence, she exits the scene with "Ask me no questions, I'll tell you no lies." It was a classic McDaniel moment. As scholar Donald Bogle pointed out, "Hattie McDaniel was talking back to whitey, and there was nothing subtle about it." It is not surprising that Paul Robeson complimented McDaniel, telling the *California Eagle* that she "was one of the best actresses he ever met."[54]

With *Show Boat*, Hattie McDaniel did overtake Louise Beavers as Hollywood's most sought-after black actress, appearing in eleven major features in 1936 and fourteen in 1937. But *Show Boat* opened up another, even more important door in her life. While working on the production, she met African-American writer and journalist Ruby Berkley Goodwin. Sent to the *Show Boat* set to interview Paul Robeson, Goodwin struck up a friendship with Hattie McDaniel. It would last for life.[55]

Ruby Berkley Goodwin was born in 1903 in Du Quoin, Illinois. Raised in a deeply spiritual household (both of her grandfathers were ministers), she came from an activist background. Her father, Braxton Berkley, was a miner and labor leader, fighting for the rights of working men. In 1920, he took his family to California, where he eventually rented a ranch in Fullerton, a small, predominantly white, farming community twenty miles south

of Los Angeles. His daughter, Ruby, had completed high school in Illinois and then went on to earn a teaching degree from State Normal School (now known as San Diego State University). While in San Diego, she married Lee Goodwin and they began a family, which eventually grew to include five sons and one daughter. The couple later settled in Fullerton, where Ruby Berkley Goodwin secured a teaching job.[56]

While Ruby Berkley Goodwin was a dedicated teacher, she was also committed to bettering society through a vigorous pursuit of equality. She became active in a number of local Civil Rights organizations and popular as a local speaker on race relations. A prolific writer, she published poetry that dealt with varied subjects, including the daily struggle of women and American racism. Goodwin broke into journalism during the 1920s and served for a time as an editor on the *California Eagle*'s staff. In 1929 she was assigned to cover MGM's all-black musical *Hallelujah* and became the first African-American woman on the Tinseltown beat. Her resulting column, "Hollywood in Bronze," ran in various African-American papers nationwide for years. While Goodwin was generally supportive of most members of the black film colony, she did not hesitate to point out the white studio system's shortcomings. In 1936, she expressed skepticism regarding the movie industry's ability to effectively stage *Green Pastures*, an all-black production that focused on God's attempts to save humankind from sin. Urging the studio to reach beyond its traditional shallow, passive black stereotypes, she advocated a respectful and multidimensional depiction of the Lord as a black man—a God "at times angry, meting out vengeance to a reckless, ruthless world," as well as "kindly, forgiving, all wise, omnipresent."[57]

It is not surprising that Goodwin would develop a fast friendship with Hattie McDaniel, now the screen's most sought-after African-American actress. Although the two women—the schoolteacher and the movie comedienne—seemed to share little, they had much in common. Both maintained a deep spiritual faith. Goodwin was profoundly devout; she experimented with Quakerism and Eastern religions and later wrote a master's thesis on comparative world religions. Goodwin's poems on topics ranging from women's experiences to lynching appealed to Hattie McDaniel, who had a great love of verse. But, equally important, Hattie

McDaniel and Ruby Berkley Goodwin had both come to know and experience the inner realities of the film industry. Goodwin had a realistic understanding of the underside of the movie business: that it was fueled not by creativity or social consciousness but by ticket sales and profit margins. McDaniel not only appreciated but also benefited from such insights as well as from Goodwin's journalistic savvy. The actress came to rely on Goodwin for advice on topics ranging from public relations to the selection of film roles. Before long, McDaniel, who was receiving more and more attention and an increasingly large volume of fan mail, hired Goodwin as a part-time publicist and secretary. It was a strategic move on the actress's part. Louise Beavers had received criticism for not hiring a black press agent and putting herself in the hands of the white studios. McDaniel would not make this same mistake. Additionally, Goodwin's selection was especially important because she had a well-established reputation as a community leader and activist. As the two women became closer, so did their families. Ruby Berkley Goodwin's oldest son, James, remembered first meeting Hattie McDaniel when she visited Fullerton. James Goodwin was shocked—she was not at all the clown that he had seen on the screen. "She was a really substantial person, very sophisticated," he recalled. "She was very different in person—thoughtful, animated, beautiful with a quick smile."[58]

Ruby Berkley Goodwin and her family came into Hattie McDaniel's life at an important time. McDaniel was enjoying increasing success in the film industry and, in turn, she was becoming more of a public figure. With stardom, came more attention, both positive and negative. She turned to Goodwin for personal and professional support. Hattie McDaniel was going to need that friendship, for with her escalating fame, her life was about to become very complicated.

6

. . .

And I've Only
Begun to Fight

. . .

Trained upon pain and punishment,
I've groped my way through the night,
But the flag still flies from my tent,
And I've only begun to fight.

Hattie McDaniel, Christmas 1937

I N SO MANY WAYS, Hattie McDaniel seemed to have reached a peak in her life and career. Even though Hollywood's post–*Imitation of Life* obsession with black characters quickly passed and roles for black cinema artists significantly declined in 1937 and 1938, Hattie McDaniel continued to work steadily. In 1937, she was cast in fourteen films, and the following year, while she only scored six roles, they were all substantial. For some shoots she was able to command up to $150 a day. The resulting financial security allowed her to help out family members. She lent a hand to her sister Etta Goff, who quit domestic service to forge her own path in films, and her brother, Sam McDaniel, who had watched Hattie's career eclipse his own. Hattie McDaniel managed to coax her oldest sister, Lena Gary, along with her children and grandchildren, to leave Colorado for California. Settling in a small house near Central Avenue, Lena found work as a maid. For the first time in almost twenty years, all of the remaining McDaniel siblings were together again in the same town. At Christmas, Hattie McDaniel showered her great-nieces and -nephews with presents, toys that as a child she never had a chance to enjoy.[1]

McDaniel also spent on herself. She purchased her first home, a small house in the same neighborhood where she had been renting. Like most other members of the black community, she shopped for her furniture at Gold's on Central Avenue. She placed her mother's picture prominently on the mantel of her fireplace. The front and back yards were redone, a project, McDaniel proudly announced, overseen by an African-American woman landscaper. While the actress had achieved a little prosperity, remarkable in the midst of the Depression, in a broader context it was really a solidly middle-class existence far removed from the glamour and excess enjoyed by her white Hollywood costars. Still, the actress did splurge on a couple of indulgences—a white baby grand piano for her living room and a Packard, previously owned by Nelson Eddy; it was green, her lucky color.[2]

Word of McDaniel's success spread throughout the community, and as her fame grew, a number of individuals and organizations began to seek her support for various causes. In winter 1937, she joined Clarence Muse for an NBC radio broadcast to raise funds for Red Cross relief programs for Americans, many of them black, who had been displaced by the year's devastating floods. She made frequent personal appearances at Central Avenue functions and benefits, including one to aid Los Angeles's black American Legion Post and another for Delta Sigma Theta's scholarship fund for young, college-bound black women. It was not uncommon, in fact, for McDaniel to support black endeavors, to lend her name to efforts designed to advance the African-American people. She joined actress Theresa Harris, who also played Hollywood domestic roles, for an afternoon of "midget car" races, organized by a black sponsor with laps dedicated to the *California Eagle*, the African-American owned Golden State Life Insurance Company, Clarence Muse, and of course, Hattie McDaniel. The cameras for the Colored American Cavalcade newsreels caught McDaniel and Louise Beavers at the black United Golfers Association's tournament. McDaniel turned out for a celebrity softball tournament to benefit the black community's American Legion Post.[3]

McDaniel's modest wealth also allowed her to contribute monetarily to various causes. Within the black community, she gained a reputation for generous giving, often without question feeding and lending money to friends and strangers alike. "She was generous to a fault," Wonderful

Smith recalled. She backed an effort to stage a pageant celebrating African-American achievements at San Francisco's World's Fair. (It never came off and her money disappeared.) Once she had the resources, she made underprivileged children her cause. In 1938, she helped buy musical instruments for students at a public school in Watts. Haunted by a childhood spent in poverty, each Christmas she purchased an enormous number of toys and gifts to be distributed to poor families. She began throwing an annual Christmas party at her home, with packages under the tree for needy children selected to attend. These good works filled the pages of the *California Eagle*. While at one level this operated as a smart publicity move, McDaniel had also long been a supporter of community endeavors. Even during her early years in Denver, she had loaned her talents to such causes. Only now the name of Hattie McDaniel had a new meaning. She was a Hollywood star, a black celebrity, and she was guaranteed to draw attention as well as comment.[4]

Confirmed in her star status, McDaniel found her life under increased scrutiny. But anyone digging dirt on the star went away disappointed. While McDaniel appeared at the requisite social functions and was an avid baseball fan, she insisted that she shunned the high life. "I save my money," she told a reporter a few years later. "No hot spots or night spots or wild living for me. I got friends that I love and I need like I hope they love and need me and I follow God all the way." McDaniel still claimed her social life focused on entertaining family and friends at home. But with her celebrity, even these affairs had grown into events. One Thanksgiving, after preparing a twenty-pound turkey for Etta Goff and her companion, Joseph Spaulding; Madame Sul-Te-Wan, a black Hollywood veteran whose career dated back to *The Birth of a Nation;* and a few others, McDaniel found herself deluged by fans who dropped in to join the festivities. It was not hard to find her—Hattie McDaniel was still listed in the telephone book.[5]

Among the invited guests at that holiday dinner was jazz pianist John Erby. A musical prodigy, Erby was playing and composing music by the age of nine. After graduating from Wilberforce and working briefly as a public school teacher, he made his way to Chicago in the 1920s where he broke into show business as "The Singing Pianist." He was a popular figure in the black entertainment community, playing with local blues stars

like Victoria Spivey and scouting talent for OKeh records. While it was probably the Chicago scene that first drew Erby and McDaniel together, they had a second chance to meet in Milwaukee where they both became featured performers in local nightclubs in the early 1930s. By 1936, Erby made his way to Los Angeles and teamed up with McDaniel as her song-writer and accompanist for what had become, because of her film obligations, now-rare live appearances. It was a dynamic pairing. When they played Los Angeles's Orpheum Theater, McDaniel's rendition of "Longing for the Folks Down Home" scored thunderous applause that, according to one reviewer, "shook the rafters." Soon, Hattie McDaniel was frequently appearing on John Erby's arm at social events. They became, in true Hollywood fashion, an item.[6]

Most were surprised when, in February of 1938, *California Eagle* correspondent Fay Jackson reported that Hattie McDaniel had filed for a divorce. Jackson, who knew McDaniel fairly well, revealed her own shock upon discovering that the actress had not only been married once but twice. To add to the intrigue, rumors that McDaniel and Erby would tie the knot had been circulating for some time. When Jackson queried McDaniel about her reasons for ending her marriage to Nym Lankford, Hattie curtly replied, "I just don't want to be bothered anymore."[7]

McDaniel's decision to finally divorce Nym Lankford after over ten years of separation indicates that her relationship with John Erby was probably quite serious. By taking that final legal step, she would be free to marry again. But McDaniel and Erby never made it down the aisle, and before long, the talented pianist drifted out of her life. It is possible that Hattie McDaniel was in part, if not totally, responsible for the split. She had a hardboiled attitude, at least in public, toward romance. "I guess with me it's hydrant love—I can turn it off and on," she later remarked to the *Los Angeles Times*. There were also hints the relationship ended on a bitter note and involved professional competitiveness between the two entertainers. "Men are jealous of a woman when she gets ahead," she insisted in 1940. "I wouldn't have anybody in the acting line—we'd fight ourselves crazy."

Erby must have realized, as did others, that Hattie McDaniel was really married to her career. When he became a part of her life in the mid-thirties, she was busier than ever. In addition to her film work, in July

1937, she signed on to reprise her role as Queenie on Maxwell House's *Show Boat* variety radio series. For several years, *Show Boat* had been the nation's number one musical program on the air. But by 1937, its ratings had dropped significantly. In an attempt to revive it, sponsors sought out popular performers like McDaniel who had been associated with previous stage or movie versions. It was a perfect opportunity for the actress; the show broadcast one evening a week and fit in well with her full shooting schedule. Each episode gave her an opportunity to do something a little different as she and her foil, costar and former black Broadway comedian Eddie Green, performed skits based on historical romantic couples like Queen Elizabeth and Sir Walter Raleigh, and Pocahontas and John Smith. During this period, she also appeared on L.A. radio's early-morning *Breakfast Club*. "That dynamic personality is just stopping the show," Clarence Muse raved in his column about the actress's return to broadcasting. Although *Show Boat* was canceled in October and her stint on the *Breakfast Club* was only brief, Hattie McDaniel remained a very busy woman.[8]

It was very likely that McDaniel was able to secure these radio gigs with the help of her new white agent, William Meiklejohn. Now a relatively hot property, in 1937, she signed on with Meiklejohn, who had an office on Sunset Boulevard and usually handled newcomers like Judy Garland, Mickey Rooney, and Lucille Ball, and second- and third-tier film players such as William Demarest (later *My Three Sons*' Uncle Charlie) and the then virtually unknown Ronald Reagan. Although he had started out small, Meiklejohn was savvy and not afraid to take some risks; he later earned the nickname "starmaker." (He was also one of the first white agents to represent black artists.) Meiklejohn's Hollywood "smarts" and studio ties no doubt helped McDaniel's career to blossom even further.[9]

As McDaniel continued to be a familiar presence on silver screens throughout this period, she held firm to her unique style. The servants she played remained confident, assertive, and sassy. She had developed a trademark disdainful glare, and several directors made use of her ability to convey complete and utter disapproval with one look. In *Stella Dallas*, starring Barbara Stanwyck, McDaniel disapprovingly glowered at the rowdy behavior of the film's white characters, effectively highlighting their debasement. McDaniel's character condescendingly looked over and

sneered at a white woman in *The Shining Hour*. (It was safely packaged—the woman was disparaging her employer.) While most of McDaniel's scenes were intended as comic relief, it was these moments that really allowed her to continue her attempts at bending expectations of black women. For Jean Harlow's last film, *Saratoga,* McDaniel played Rosetta, a brassy, self-assured maid who does little to hide her attraction to Duke Bradley, played by Clark Gable. "If he was only the right color," Rosetta brazenly and eagerly confides, "I'd marry him." McDaniel's bold delivery indicated that Rosetta had definitely considered defying the boundaries of America's color line but also acknowledged that racism prevented it.[10]

McDaniel's biggest parts in 1938 were in *Shopworn Angel* and *The Mad Miss Manton*. In *Shopworn Angel*, she played Martha, the maid of a celebrated and sophisticated Broadway singing star Daisy Heath (Margaret Sullavan). Each time Daisy hollered for her, Martha bellowed right back. McDaniel's worldly delivery implied that Martha, who like her employer slept in and stayed out all night, had her own extremely lively existence. She was her own person with her own life.[11]

Even more audacious was McDaniel's interpretation of the maid Hilda in another Stanwyck film, *The Mad Miss Manton*. Stanwyck was cast as a socialite Melsa Manton, pursued by a persistent newspaper editor Peter Ames (Henry Fonda). Conceived of as obstinate and blunt, Hilda created controversy even before she made it to the screen. "The characterization of Hilda, the colored maid," Joseph Breen of the Hays Office warned RKO, the producing studio, "may be found objectionable in the south where the showing of Negroes on terms of familiarity and social equality is resented."[12] Hilda was far too comfortable and outspoken with white people, and under Breen's pressure to put Hilda in her "place," the writers toned down McDaniel's part. But still, in McDaniel's skillful hands, Hilda remained defiant and even resentful, back-talking whites throughout the film. "I heard it," she mutters when Manton summons her to answer the door. "I ain't deaf—sometimes I wish I was." "The kitchen is closed," she barks at one of Manton's friends. When her employer admonishes Hilda, exclaiming, "She's our guest," the briskly exiting maid snaps back, "I didn't invite her." Following Manton's orders, Hilda boldly throws a pitcher of cold water in an annoyingly persistent Peter Ames's

face. It was outrageous behavior that no African-American maid could have gotten away with in reality. McDaniel had created a fantasy servant that she knew would be fired in an instant in any real-life situation.[13]

The studios mediated (and discounted) Hattie McDaniel's rebelliousness by continually confining her to what even she admitted were "incidental comedy roles." Within Hollywood circles she continued to gain respect as a cooperative and hardworking professional with a special comedic flair. And, by this point, the usually cautious McDaniel felt secure enough to object to offensive material in Fox's 1937 film *Can This Be Dixie?*, which she had signed up to do for $350 a week. It is unclear what McDaniel objected to—the film's final cut contained a disparaging lampoon of a black revival meeting, with a blackface number titled "Pick Pick Pickanninny, Pick Dat Cotton." (The *Hollywood Reporter* rated it the movie's high point.) But, according to one report, McDaniel protested and ultimately Fox removed from the film some content that she insisted was unacceptable.[14]

McDaniel's impact on redirecting black film images was ultimately negligible as she continued to play to Hollywood racism by accepting the stereotyped roles of humorous maids and mammies. Ultimately, she gained more and more recognition within the film industry. She not only was commonly accorded screen credit, her name was increasingly identified with black cinematic female servants. "Hattie McDaniel gives her usual positive performance as the maid," *Variety* commented on her appearance in *The First Baby*.[15] In the 1938 film *Carefree,* starring Fred Astaire and Ginger Rogers, the scriptwriter simply named her character Hattie, merging McDaniel even more closely in American imaginations with her screen roles. When one white character, Cora, orders mayonnaise for breakfast, "Hattie" expresses complete disapproval, returning with a bowl and slamming it down on the table with unmistakable disgust. Later, Cora asks, "Hattie, have you even been married?"

"No ma'am," she answers. "But I've been engaged."

"Oh, just as good," Cora replies.

"No ma'am," Hattie McDaniel, coincidentally in the midst of her divorce, gloomily responds. "It's a lot better."[16]

But as Hollywood increasingly linked her to her screen image,

McDaniel fought to distance herself from those maids and mammies clad in kerchiefs, aprons, and cotton dresses. Off-screen, she always dressed beautifully, cultivating an image of refinement and elegance. "Orchids and ermine are her favvies when she goes out a-sparkin'," reported the *California Eagle* spying her at a number of Central Avenue functions.[17] "Although Hattie is large, she is a very fashionable dresser," the *Baltimore Afro-American* reported. "She prefers smart tailored gowns and jaunty hats." Her favorite colors were sedate navy blue and gray. Although she had continued to gain weight throughout the years, Hattie McDaniel, many agreed, remained a strikingly attractive woman.[18] Further, she was, as many were surprised to discover, articulate, well-spoken, and gracious. McDaniel constantly underscored the differences between her true self and the fantasized black stereotype that was making her famous. "I'm a fine Black mammy [on the screen]," she observed to actress Lena Horne. "But I'm Hattie McDaniel in my house."[19] McDaniel's attempts to separate herself from her characterizations indicated that she recognized, and even, at some level, resented her imprisonment in the typecast roles derived from the film industry's racist vision of black America.

Yet, Hattie McDaniel continued on her climb, still winning acclaim from filmmakers and in the white press. ("Top notch," the powerful Louella Parsons pronounced McDaniel's appearance with Carole Lombard in *True Confession*.[20]) Such accolades were extremely helpful to her career, but the actress discovered the price of success in Hollywood was exceptionally high. Increasingly, as she became more visible, she became more directly drawn into the debate over black film images. Much of McDaniel's work replayed the worst of stereotypes, endangering the African-American struggle for equality. For all of her attempts at talking back, speaking in a voice that countered the subservient roles she accepted, McDaniel found it difficult to sustain a convincing and effective rebellion. Unlike her early years on stage as a satirist when she wrote and directed her own productions, the highly controlled medium of film had constrained her performances. The silver screen muted her boldness and her attempts at overriding the Mammy image she had parodied for so long. In the past, she played to black audiences, and that context allowed her material to serve as biting commentary. But in front of white Holly-

wood's cameras and before predominantly white film audiences, McDaniel's scripted characters, no matter how much they deviated from the norm, only seemed to uphold racist status quo. One of the first to criticize McDaniel and her performances was Earl Morris of the *Pittsburgh Courier*. In a long article, he denounced Hollywood for its treatment of African-American actresses, citing its practice of bypassing pretty and light-skinned actresses and denying the talented Louise Beavers better parts. While he praised almost everyone else, when it came to Hattie McDaniel, he had nothing good to say. Morris flatly dismissed her performances as "handkerchief head roles."[21]

Overall, condemnation of Hollywood's dependence on disparaging black stereotypes was escalating and coming from a variety of sectors. In spring 1937, the Urban League's Lester Granger issued a forceful statement scolding the film industry for disparaging African Americans. "One of the greatest handicaps that the Negro has to face in his fight for complete integration into the American social scene is the persistent American stereotype which portrays him as a criminal, potential or actual, or as a stupid, doltish, clown," he passionately insisted. "No opinion forming agency in America does so much to perpetuate this stereotype as the films produced in Hollywood with the roles played by Stepin Fetchit, 'Bojangles' Robinson, Louise Beavers, and Clarence Muse." Granger called for "a new type of film," one that showed the complexities and realities of the African-American experience. While he acknowledged that there was room for comedians and fun-makers, he pointed to the desperate need for blacks to be portrayed with dignity. With fascism and Hitler's notions of Aryan supremacy threatening freedom around the world, a domestic anti-lynching bill stymied in Congress, and the continuation of segregation, disenfranchisement, and lynchings throughout the United States, Granger's call assumed a particular urgency. He argued that American democracy rested on the recognition of the humanity and equality of all its citizens and that Hollywood film was directly threatening this, one of the country's most sacred cornerstones.[22]

Granger was not alone in demanding that Hollywood surrender its practice of perpetuating derogatory stereotypes. The brief growth of black roles between 1934 and 1936 had also resulted in a heightened presence

of demeaning images on the screen. In turn, criticism from both African-American leaders and journalists escalated; their denunciations of Hollywood's tenacious grip on black stereotypes became more strident. Earl Morris, the most vocal of the group, lashed out against filmdom's repeated insults. "Hollywood ignores the Negro," he asserted, "[and] tells the world he is only a clown, a buffoon, a trespasser in the world of 'make-believe.' "[23] He called for African Americans to boycott Hollywood films. African-American journalist Marion Marshall implored America to recognize the dangers inherent in black stereotypes: "Can't you see that in emphasizing these objectionable characters that we, who are struggling for advancement, are put to a great disadvantage because only ONE type of Negro is placed before the eyes of the public?"[24] Earl Dancer, a former Harlem producer who briefly edited the *California Eagle*'s theatrical page, branded Hollywood's depiction of black characters as "vicious propaganda" that was "as vile and contemptible as Nazism."[25]

Many critics were fast becoming impatient with the African-American artists who accepted white Hollywood film roles, blaming them, in large part, for the perpetuation of stereotypes. In February 1937, the *New Age Dispatch*, a black Angeleno newspaper, denounced Louise Beavers for her loyalty to the film industry and continued portrayal of stereotypical servants. It dismissed Beavers's persistent defense of moviedom: "We would naturally expect that to be colored by the fact that she is directly concerned because of her livelihood."[26] Other performers, in addition to Beavers and now McDaniel, felt the sting of disapproving pens. Marion Marshall took respected musician Louis Armstrong to task for his role in Bing Crosby's *Pennies from Heaven*: "Why did he [Armstrong] have to take the part he did, risking the possibility of instilling deeper in the hearts of present-day people that the colored man is ignorant and notorious for stealing chickens?"[27] Some black journalists labeled Bill Robinson an "Uncle Tom," as he continued to accept subservient role after role. Upon word that the dancer would be paired with a white woman in blackface in a film, Earl Morris retorted, "Bill Robinson, evidently, believes the phrase, 'when you're white, you're right,' " and accused the star of selling out for "just a little filthy lucre."[28] Consistent themes emerged; members of the black film colony were selfish, willing to put their careers and bank ac-

counts ahead of the greater good of the African-American people. By collaborating with Hollywood, black stars were only hindering campaigns against American racism.[29]

Members of the black film colony were both hurt and outraged by the mounting criticism of their careers. Although they were blatant careerists and determined to make the best salaries possible, they insisted that their presence in Hollywood was a significant step forward in the African-American struggle and that they were hardly in pictures solely for economic gain. Determined to formulate a response to the criticism and negative press, a group of some of the most prominent black picture players, including Hattie McDaniel, Louise Beavers, Bill Robinson, Clarence Muse, and *Green Pastures'* star Ernest Whitman, gathered formally in early April 1937. McDaniel dominated the meeting. For over thirty minutes, she recounted what Clarence Muse described as a "dramatic story of injustice." While Muse remained unspecific about her exact grievances, he did allege that some of her woes had resulted in her refusal to pay off an unnamed journalist. "If your check fails to arrive on time," Muse contended, "your art immediately goes to the cleaners and is saturated in uncalled for scandal or ridicule."[30]

This was a rare public outburst from McDaniel. Certainly the actress must have recognized she was in a tight spot. To join with forces crusading against Hollywood would end her film career. But to side with the studios would undermine her position within the black community, something that she held dear. At this point, she decided to handle criticism less openly than had Louise Beavers, whose outspoken defensiveness only succeeded in making her the focus of more negative publicity. McDaniel curbed what could be a hot temper and cautiously avoided making any public statements against either the black press or Hollywood filmmakers. While many remembered Hattie McDaniel as generous, kind-hearted, and fiercely loyal to family and friends, others described her as competitive, aggressive, and even manipulative. Intensely proud of her accomplishments built upon almost thirty years in show business, the actress became determined to protect both her film career and her status within the black community. But such an ambition threw her, and other black performers like her, into a nearly schizophrenic existence as they tried to walk a line be-

tween Hollywood's demands and the black struggle. It was a contradictory and virtually impossible goal—making good in the white film industry required compromises that almost always in some way contradicted the African-American campaigns for equality. "We took a lot from both sides," recalled black actor Eugene Jackson who appeared as "Pineapple" in the *Our Gang* series. "It was hard to please both sides when you had to eat." The ever-determined Hattie McDaniel became convinced, nonetheless, that she could please both sides—that it was possible to preserve both her career and her reputation as a race woman.[31]

For the time being, Hattie McDaniel, who viewed the criticism she received as purely unfair personal attacks, generally confined herself to fuming about her black opponents behind closed doors and allowed others to carry on her cause. Clarence Muse and Ruby Berkley Goodwin, who both understood the issue of black representation in films in broader terms, took up that banner. In their opinion, it was imperative that black Hollywood form a united front to address the charges against African-American actors, that black performers' presence within the industry was vital to the goal of eventually achieving better roles. But organizing the black performers proved to be a frustrating and virtually impossible task. Impeded by what Goodwin described as "petty jealousy, rivalry, and bum sport tactics," many fought each other for parts, vigilantly guarding their careers, sometimes regardless of the cost. "The competition was keen," recalled Wonderful Smith. "I didn't think it was necessary." But despite the divisions, Muse and Goodwin pushed on and, working together, hammered out a strategy to counter the criticism aimed at the black film colony. They agreed that they must harness space within the nation's black newspapers to answer the critics and champion the cause of blacks in Hollywood.[32]

Muse immediately tackled the brewing controversy in his regular column in the *California Eagle*. "Every week, some Negro writer or citizen takes a crack at our Negro actors in pictures," he wrote in early spring 1937. "They seldom praise these artists for good performances but invariably accuse ninety per cent of our actors as 'Uncle Toms.' " He called on the African-American community to rally behind black film stars. While he acknowledged that the studios perpetuated traditional black stereotypes, he maintained that African-American performers skillfully over-

came such restrictive parts with their great "artistry" and a dedication to seeing that their characterizations were "truthfully played."[33] From his perspective, African-American actors and actresses were to be celebrated, not vilified. They were pioneers integrating an industry that was run by white people for white people. He also defended studio heads, insisting they were not bigots. "I don't think the neglect [to offer alternative black images] is due to prejudice," he stated, emphatically insisting that moviemakers had to serve their audiences to sustain their industry.[34] It really was the white moviegoing public that presented the problem. "These writers [black journalists] seem to think that commercial picture makers are interested in bitter propaganda," Muse wrote. "That is not so. They are ever alert to play in their stories, romance, humor [and] ... at times slap stick comedy to reach the millions of unlearned ticket buyers."[35]

However, Muse's own noncinematic projects belied his generous assessment of the goodwill of motion picture producers. When not working in pictures, the actor poured his creative energies into Los Angeles's black theater community. Just as he was emerging as white Hollywood's most vocal black champion, he also became instrumental in staging *Run Little Chillun*, an all-black musical sponsored by the Federal Theater program and authored by African-American musician and choral director Hall Johnson. "Mr. Muse says the only hope for the young Negro actor is the loyal support of colored audiences," the *California Eagle* reported. And it was not on the silver screen, where stereotypes proliferated, but on the stage where the "dilemma of the Negro actor" could be addressed. "If [African-American patrons] fail to come to the theater," the paper summarized Muse's stance, "the young Negro artist is doomed."[36]

Furthermore, Muse's energetic participation in SAG also indicated that privately he did not have such an optimistic view of studio bosses. Although his columns defended those patrons who paid him and other select black film stars, such as Hattie McDaniel, comfortable salaries, they also served as a promotional tool for the union, the exact organization that was at odds with movie producers. He frequently heralded what he maintained was the open atmosphere of the Screen Actors Guild as well as the generous support that white film stars, including Mae West, James Cagney, and Wallace Beery, offered to black causes. Muse believed that if African-American per-

formers persevered in Hollywood, eventually the industry would turn the corner. Continued attacks on African-American film stars in the black press and by the public impeded not only their careers but the future progress of black film images. "I am sure that this group of artists are making it possible for our young artists to come," Muse steadfastly insisted.[37]

Many in the African-American community were not so sure. Black images on the screen had shown very little improvement during the course of cinema's now almost forty-year history; they remained chained to offensive stereotypes. Fay Jackson wrote off Muse as a "Dixie salesman of film productions."[38] Earl Dancer found the actor's assertions that the studios exhibited no race prejudice absurd. "We know when [MGM] had a member of our race under contract at $1250 a week," he countered, "she was ushered to the lunch counter [in the commissary] and told that was the only place she could eat."[39] After he visited all of the studios, Earl Morris's impression was distinctly different from that of Muse. He was certain: "Hollywood doesn't give a tinker's damn about the Negro."[40]

The split in the African-American community over blacks in film actually developed from deep and long-standing ideological differences. Most African-American picture players insisted on defining success as the integration of the racially restrictive white show-business world. But for advocates of immediate equality, just being present, even with subtle defiance, was no longer sufficient. Many now considered the performance and its context as equally, if not more, important than getting a foot in the door. Motion pictures were a powerful tool that shaped public attitudes and opinions. All that the filmgoing public saw of black America consisted of goofy servants with rolling eyes and wide grins—images that continually reinforced the idea that somehow African Americans were different and lesser people that merited second-class citizenship. Those black performers who continued to accept and play Hollywood's stereotypes became part of the problem rather than part of the solution.

Black Hollywood stars like Hattie McDaniel, who insisted that they were "race men" and "race women," were caught in a generational shift. Many had entertainment careers long before they landed in Hollywood, and a number had started in show business around the turn of the twentieth century, sharing the stage with Bert Williams, George Walker, and

Aida Overton Walker, as well as some of the pioneers of black minstrelsy. Although that era was long over, a number of the senior members of the black film colony, to a degree, still subscribed to Booker T. Washington's philosophy of accommodating racism and striving for economic success. (McDaniel's own ties went so far as to include her very close relationship with Booker T. Washington's nephew, Roscoe Conkling Simmons.) In terms of their film careers, many black movie stars insisted that through hard work and by patiently proving themselves within Hollywood's racist environment, they would eventually bring about positive change. In their opinion, there was nothing incompatible between their careers as players in white films and their commitment to uplifting the race. In part, this was because they subscribed to Washington's gradualist ideology selectively. Outside the studio gates, most black performers were in agreement: in society at large, civil rights for African Americans could no longer be deferred. They believed that as the country changed, so would black film images, reflecting the advancement of African Americans.

In the meantime, black film stars contended movies were not really about activism and transformation; they were a business, and the mark of success in that realm was earnings. Although Hattie McDaniel considered herself an artist, in her mind, her film career was a job. Throughout her formative years, she had witnessed sacrifices and compromises made by good and proud people like her parents to put food on the table. Into adulthood, Hattie McDaniel remained perpetually preoccupied with making a living, never forgetting her years in poverty. In cinema, as in other workplaces controlled by white employers, self-expression took a back seat to making a living. McDaniel's own observations regarding her film career indicated that essentially she viewed working for white Hollywood movie bosses as no different from working for other white employers. The distinction was only in salary, and the choice for someone who had been poor was clear. "I can be a maid for $7 a week," she reportedly later remarked, "or I can play a maid for $700 a week."[41]

"Just a passing thought," wrote Harry Levette in the *California Eagle* in 1937. "If we are tired of seeing Stepin Fetchit, Clarence Muse, Bill Robinson, Hattie McDaniels, Louise Beavers, Theresa Harris, and other featured players doing maids, washwomen, butlers and stable boys in pictures, let's

put our money in one big pool and BUILD A STUDIO TO DEPICT THE OTHER PHASES OF NEGRO LIFE." As Hollywood clung ever tighter to black stereotypes, many community leaders called for the formation of independent African-American film companies. It was certainly not a new idea. In the mid-1910s, just after the release of *The Birth of a Nation*, several members of the black community had established their own film studios. In particular, the Johnson brothers' Lincoln Motion Pictures Corporation and Oscar Micheaux's Film Corporation successfully made and distributed films to black audiences throughout the country. But the increased cost of moviemaking in the 1920s and the subsequent Depression forced most autonomous black film producers out of business. The African-American community simply did not have the resources, especially in hard times, to sustain independent black film enterprises.[42]

With the debate over African-American images in film came a renewed determination to create an independent cinema that treated black life with respect and dignity. The most notable effort came from two African-American performers, Ralph Cooper and George Randol, who teamed up to form Renaldo Films. While the company's first release, *Dark Manhattan*, recycled elements of traditional black stereotypes, it attempted to show African-American people in all walks of life. Sam McDaniel joined the company to play a gangster, a departure from his now-commonplace butlers and servants. It is not surprising that Sam McDaniel would become deeply involved in black cinema. His commitment to independent black creative endeavors dated back to the 1910s, when he organized Denver's first black-owned theater, the Five Points Theater.[43]

But Cooper and Randol quickly ran into the same obstacle that their predecessors experienced—a lack of funds to sustain their company. By late 1937, Cooper had joined the Million Dollar Production Company, dedicated to making all-black pictures for black audiences and financed by two white producers, brothers Leo and Harry Popkin. The Popkins assembled a staff that included Harry Levette as publicist as well as a cast list of many experienced African-American actors. Sam McDaniel signed up for their first picture, a crime drama called *Bargain With Bullets*. Million Dollar went all out for the film's debut, a glamorous affair held on Central Avenue. It was a star-studded evening broadcast over a local radio

station with host Clarence Muse bantering with dignitaries as they strolled up the red carpet in classic Hollywood style. Hattie McDaniel arrived in furs and a stunning evening gown. Autograph seekers immediately engulfed her.[44]

While Sam McDaniel accepted several roles in all-black productions, his famous sister Hattie remained on the sidelines. At some point, most of the black film colony appeared in independent black films. Louise Beavers became especially visible, playing the lead in two Million Dollar productions—*Life Goes On* and *Reform School*. Her participation in these films allowed her to combat some of the allegations that she had turned her back on the race. But even more compelling, these films, despite shoestring budgets and lack of big studio production slickness, did furnish Beavers with the chance to break away from typecasting and play proud and intelligent black female characters. Theresa Harris, who had starred in *Dark Manhattan*, explained the tremendous appeal of working in black productions. "The opportunity of playing roles otherwise denied one in white pictures is a great relief to the aspiring Negro Motion Picture Artist," she told the *California Eagle*. "I never felt the chance to rise above the role of a maid in Hollywood movies. My color was against me any way you looked at it."[45]

Hattie McDaniel remained conspicuously absent from independent black films. She appeared in only one all-black film, and it was a white-produced RKO musical short titled *Mississippi Moods*. In the late 1930s, it was rumored that Million Dollar Productions was planning to use her in a film, but it never happened. "[Million Dollars' *One Dark Night*] is a perfect vehicle for Hattie McDaniel and Mantan Moreland but Miss McDaniel is being saved for another feature," reported the *New York Amsterdam News*.[46]

It may have been true that the company was holding off for just the right film, but there were other factors responsible for Hattie McDaniel's absence from sepia screens. Since she worked so steadily in Hollywood pictures, she remained tied down by contracts with white studios that held her services exclusively during filming. Once released from a picture, she was quickly picked up again for another white film. McDaniel made a critical choice at this point in her career—rather than turning down an assign-

ment with a white studio to appear in black independent productions, she elected to confine herself to white Hollywood. She may have been encouraged in her decision by white producers and her agent, who probably feared that if McDaniel took on black film projects, her popularity would be undermined by overexposure. By 1937, studios had begun promoting her films in African-American neighborhoods more aggressively, with her name splashed across the marquees of black theaters. Films marketed in African-American newspapers frequently highlighted her name in cast lists. When *Star for a Night*, featuring white leading lady Claire Trevor, came to Central Avenue's Rosebud Theater, Fox took out an ad in the *Los Angeles Sentinel*, which read in bold type: "HATTIE MCDANIEL, she's in it too." Despite the increasing criticism, Hattie McDaniel still seemed to have drawing power in the black community.[47]

Yet, McDaniel's continued rise in Hollywood was a mixed bag of elation and disappointment for the actress. On the one hand, her career was booming, and in tribute to her agent, William Meiklejohn, she ran a large Christmas greeting in the *California Eagle* in December 1937, praising him. "Yes, I Believe In Santa Claus," it read with a list of ten of her most recent film triumphs and Meiklejohn's name prominently featured. But McDaniel's holiday message, which contained a bluntly worded poem, also indicated that with success came frustration and even some simmering anger.

> *I have learned something worth far more,*
> *Than victory brings to men,*
> *Battered and beaten, bruised and sore,*
> *I can still come back again.*
>
> . . .
>
> *Trained upon pain and punishment,*
> *I've groped my way through the night,*
> *But the flag still flies from my tent,*
> *And I've only begun to fight.*[48]

This statement of testy resolve served as McDaniel's thinly veiled response to her critics. Regardless of those who were questioning her career, she re-

mained determined to pursue her own path through white Hollywood, as much as possible on her own terms.

As this Christmas greeting revealed, Hattie McDaniel had a prickly temperament, one that sometimes overpowered her professed faith in optimism. She certainly realized this, and as she confronted the rising tide of criticism and the frustrations of Hollywood's entrenched racism, she immersed herself further in mind-power philosophy. McDaniel became drawn to the teachings of the power-of-positive-thinking advocate Norman Vincent Peale. Trained as a Methodist minister, Peale had drawn deeply from New Thought to preach what he described as "Practical Christianity," which emphasized each individual's potential to channel God's omnipresence to achieve personal happiness, physical well-being, and professional success. Similar to Father Divine, Peale preached that through faith and prayer, anything was possible. The key was a hopeful and confident outlook. "Life averages well," Peale wrote in his 1937 tract *The Art of Living*, "which means that most of the troubles we are worrying about now will never happen." McDaniel became an early and avid fan of Peale's philosophy, no doubt studying *The Art of Living* and Peale's follow-up book, *You Can Win*. These were formulas for success in a fast-paced, modern-day world, promising that God, who was always at hand, was there to assure victory to those who believed and approached life with an upbeat attitude.[49]

Hattie McDaniel was so drawn to Peale's philosophy that she somehow arranged not only to meet him but ultimately to befriend the minister. Perhaps it was through Hollywood circles; Peale was just starting to gain national attention in the late 1930s, and he likely sought connections with film industry leaders and stars. Or maybe it was through Ruby Berkley Goodwin. She had begun acting as a buffer, checking McDaniel's outspoken nature and sometimes brash reactions. A student of religions, Goodwin, recognizing McDaniel's hotheaded streak, may have steered the actress toward affirming ideologies. McDaniel and Peale's friendship would last for years, and the minister, whose name became synonymous with the power of positive thinking, never saw McDaniel's cantankerous side. In fact, the woman he knew possessed a "rare quality of personal magnetism" and "exuded vibrancy." He later described her as a testimony

to the effectiveness of positive thinking. Despite hardships and poverty in her life, she had achieved remarkable success that she credited to optimism and devotion to Christ. She insisted to Peale that every morning, regardless of weather, she would go outside, breathe deeply, "throw out her arms in a gesture of joy," and shout, " 'Hello there, good morning.' " "And," she confided, "that good morning just smiles right back at me. Then I go about my job of making people happy. And I'm happy doing it." But Hattie McDaniel was an actress. While she may very well have begun each day with such a ritual, she also had an image to uphold. By her own admission, she was always performing. (Borrowing from Sam McDaniel's earlier fictionalized family history, she ingratiated herself with Peale with the claim that her father had been a Baptist minister.) It was clear that as Hattie McDaniel dealt with the cost of success in white Hollywood, she continually sought ways to ease her increasing anxieties. No matter how conflicted the inner Hattie McDaniel was, the public persona she projected won over Peale. "She was alive to her fingertips," the positive-thinking advocate recalled.[50]

As Hattie McDaniel confronted the challenges of stardom, she relied more and more on Ruby Berkley Goodwin for guidance not only in spiritual matters but also in the delicate political situation in which she found herself. McDaniel's politics had been fairly casual and reflexive. For party affiliation, she listed herself as an independent, and while she supported black organizations and causes, she had never joined any local or national activist group. However, Ruby Berkley Goodwin was an intensely political person, active in the NAACP and eventually serving as the Los Angeles Urban League's public relations chairperson. In general, Goodwin held firm to the notion that through the power of regular people, black and white Americans could conquer racism together. And Goodwin believed that Hollywood could and would change, even over the short term.[51]

It was this grassroots strategy that Goodwin relied on as she helped McDaniel plot a course between the growing criticism of black film images and Hollywood's tenacious grip on black stereotypes. In fall 1938, for the *Pittsburgh Courier*, Goodwin pounded out a firm response to Earl Morris's call for a boycott of white Hollywood motion pictures. Goodwin argued that his strategy would do little to sway filmmakers. Rather, she insisted that

African Americans needed to "talk to Hollywood in a language she understands." That language, she maintained, was one of economics. "We must face the facts," Goodwin wrote. "Hollywood is in business to make money through entertainment." In her opinion, motion picture producers had to be persuaded that more and better roles for African Americans would sell movie tickets. That, she believed, could be accomplished by rank-and-file filmgoers. She urged African-American movie patrons to flood studio mailboxes with fan mail praising black film stars and telling producers what they wanted to see in films. "Hollywood will talk back to you by putting more Negro players in super productions," she insisted. Of course, she added a plug for her friend Hattie McDaniel. "Write to Hattie McDaniel," Goodwin urged, "and tell her she was a riot in *Shopworn Angel*."[52]

Hollywood did respond to fan letters, using them not only to predict the popularity of stars but to gauge the demand for particular types of films. But ticket sales spoke much louder to producers. As the pressure to improve black images soared, Hollywood bosses increasingly responded by deferring to what they identified as "the Southern box office." Studio heads contended that Southern film audiences were the movie world's most faithful fans and that Hollywood's real profits came from theaters below the Mason-Dixon Line. Any violations of Southern racism or challenges to their strict racial practices, the studios insisted, meant disaster for Hollywood productions. Many African-American observers were suspicious of the film industry's assertions. (According to one study, as late as 1947, Southern ticket buyers provided movie producers with only 8 percent of a film's total profit.) Black columnist Earl Dancer branded the studios' insistence on the overwhelming power of Southerners to make or break a film as "the most vicious lie ever perpetuated," intimating that it was a ploy to cover up Hollywood's own racist proclivities.[53] "The Southern Box Office, claimed by the studios to be their chief source of income, [which] stood in the way of major Negro features or the actual building of real Negro stars," wrote Fay Jackson, "is no longer an excuse for ignoring one of the richest sources of motion picture material."[54]

In an effort to debunk Hollywood's claims, the black press also responded with polls demonstrating the benefits of catering to the African-American box office. In 1937, one survey showed that in urban areas

throughout the nation, where films generated healthy revenues, blacks were just as loyal movie patrons as their white counterparts. The same poll indicated that African-American film fans, lacking substantial stars of their own, were more attracted to a film's plot than to its white stars. When pressed to name their two favorite cinema figures, they chose two unconventional white stars, the sultry Mae West and tough-guy gangster George Raft. The study concluded that if black performers were placed in dignified roles with respectable plots, such films would ring in profitable returns, drawing both black and white movie fans.[35]

Despite the statistics, Hollywood's industry leaders remained unmoved by both letters from black fans and polls demonstrating the potential economic benefits of improving the black cinema presence. Although many Hollywood producers were Jewish and knew bigotry and persecution firsthand, most identified with the dominant culture's racial ideology. Even those sympathetic to the African-American struggle found their hands tied by the Hays Office. Joseph Breen was virulently anti-Semitic, regarding Jewish filmmakers with disdain and distrust, reading their challenges to the code as confirmation of a vast Hollywood Jewish conspiracy to undermine American morals and values. Although motion picture producers paid Breen's salary, they constantly battled with him and the rest of the Hays Office to retain control of their films. But movie bosses were in a jam. Dismantling the Hays Office would place the industry in jeopardy of external censorship and scrutiny, an alternative potentially worse than placating Joseph Breen.[36] In the end, the producers, working in concert with the censors, continued to alter scripts to uphold racist ideology. The powerful studio heads, many blind to their own racism, all extremely protective of the industry, refused to relinquish offensive black stereotypes and offer alternative images that might be more positive or realistic. They consistently defaulted to the same refrain: the Southern box office would abandon them, and financial disaster would certainly follow.

Although the Southern box office became a convenient excuse for filmmakers to rationalize their perpetuation of negative black stereotypes on the screen, the reality was that racism was prevalent throughout white American communities in all regions. Nothing demonstrated this more than the immense popularity of a novel that captivated white readers from

coast to coast. Published in 1936 and written by an obscure white Southern journalist named Margaret Mitchell, it was titled *Gone With the Wind*. Mitchell was born and raised in Atlanta, Georgia, and her ambitious story, which chronicled the life of a white Southern family from the eve of the Civil War through Reconstruction, ran over a thousand pages. It was a success unlike that of any other book of its era; in its first six months it sold over one million copies. *Gone With the Wind* appeared on the bestseller list and was awarded the Pulitzer Prize for fiction in 1937.[57]

Mitchell, who had worked on her manuscript for years, conceived of *Gone With the Wind* as an epic historical novel, one that told the purported "truth" of the white South as it suffered through the Civil War and fought to reclaim its power and dignity during Reconstruction. The novel opens with the frivolous flirtations of a Georgian belle, the desirable Scarlett O'Hara. A daughter of a successful planter and slaveholder, Scarlett is a strong-minded, selfish young woman whose main interest is in winning the heart of the remote and unobtainable Ashley Wilkes. But her comfortable, posh world of girlhood romances changes dramatically with the outbreak of the war and its subsequent aftermath of confusion, desperation, and poverty. Although her love for Wilkes never dims, she falls for and eventually marries the roguish but good-hearted Rhett Butler.

After the war, Scarlett faces utter destitution. As in *The Birth of a Nation*, the Ku Klux Klan emerges during the postbellum years as the noble defender of the white South and its women. In the novel's pages, the black characters appeared as loyal, devoted servants who were glad to be enslaved, or sly, cunning criminals who sought to victimize the white population. In Mitchell's view, the antebellum South was an era of greatness, when honorable gentlemen ruled their plantations like gentle aristocrats and blacks happily accepted their place as slaves fulfilling all of the wants and needs of white people. That kinder, happier era was swept away by an unjust war, one that tested and proved the greatness of the white South and its people.[58]

While other novels had attempted to rally sympathy for the Confederate past and the field of history had become increasingly overtaken by a pro-Southern tone, nothing had ever matched the impact of *Gone With the Wind*. Before the novel's release, it created such a stir that it even piqued

Hollywood's interest. Kay Brown, the New York aide to film producer David O. Selznick, was so enthusiastic that she secured an advance copy of Mitchell's novel. Stunned by what she perceived as the novel's deep emotional grandeur, she urged Selznick, the son-in-law of MGM's Louis B. Mayer, to option it as quickly as possible. The novel's size and enormous number of characters made it a daunting prospect for film, but Selznick was a maverick and a risk-taker. In the summer of 1936, Selznick purchased the film rights for a remarkable price for that era, a whopping $50,000, and began preparing to bring *Gone With the Wind* to the screen.[59]

When it became public that Selznick had optioned *Gone With the Wind*, African Americans throughout the nation reacted with alarm. "Unless the propaganda is CUT from the *Wind* opus (and that comprises four-fifths of the story)," insisted the *California Eagle*, "it could just as well be a forgotten foul breeze anyway."[60] The *Pittsburgh Courier* opined that translating Mitchell's story to the screen would be a challenge since the Hays Office commonly expunged the term "nigger" from all scripts. "Margaret Mitchell in her *Gone With the Wind* knew few other words to refer to the Negro characters and so she used it a 'million times,' " reported Earl Morris. "I'm afraid that S.O.B. will kick plenty of fuss about [the film censor's deletion of the word in] *Gone With the Wind*."[61] Fay Jackson pointed to *Gone With the Wind* as simply a part of another predictable Hollywood cycle, reflecting a recent Tinseltown obsession with films set in the South. Although she had reservations about the project, she urged African-American film players to seize the opportunity in the film's roles to challenge conventional racial images. "Everyone sympathizes with Uncle Tom," she warned. "Few LOVE him, but NO ONE RESPECTS HIM."[62]

David O. Selznick's reaction to the brewing controversy surrounding *Gone With the Wind* was to pledge to the black press that the story would receive careful treatment and that he would seek "the best possible cast."[63]

Hattie McDaniel's reaction was to buy the novel and read it carefully.[64]

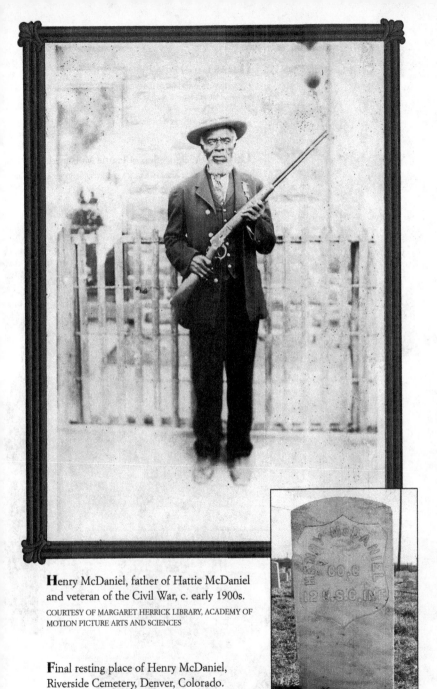

Henry McDaniel, father of Hattie McDaniel and veteran of the Civil War, c. early 1900s.

COURTESY OF MARGARET HERRICK LIBRARY, ACADEMY OF MOTION PICTURE ARTS AND SCIENCES

Final resting place of Henry McDaniel, Riverside Cemetery, Denver, Colorado.

COURTESY OF DONALD WOO

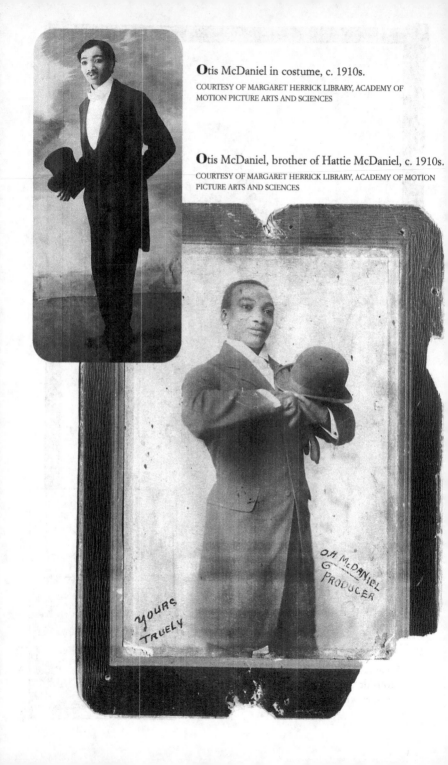

Otis McDaniel in costume, c. 1910s.
COURTESY OF MARGARET HERRICK LIBRARY, ACADEMY OF
MOTION PICTURE ARTS AND SCIENCES

Otis McDaniel, brother of Hattie McDaniel, c. 1910s.
COURTESY OF MARGARET HERRICK LIBRARY, ACADEMY OF MOTION
PICTURE ARTS AND SCIENCES

YOURS
TRUELY

O.H. McDANIEL
PRODUCER

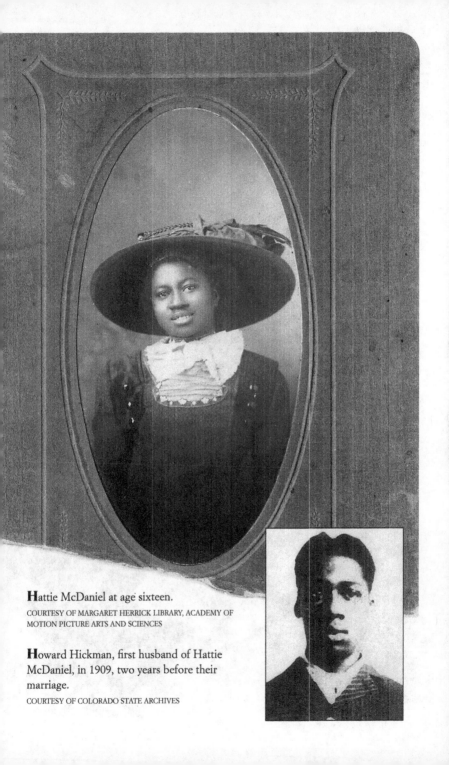

Hattie McDaniel at age sixteen.
COURTESY OF MARGARET HERRICK LIBRARY, ACADEMY OF
MOTION PICTURE ARTS AND SCIENCES

Howard Hickman, first husband of Hattie
McDaniel, in 1909, two years before their
marriage.
COURTESY OF COLORADO STATE ARCHIVES

From right to left, Hattie McDaniel, Sam McDaniel, and Etta (Goff) McDaniel at train depot, c. 1930s.

CALIFORNIA EAGLE COLLECTION, SOUTHERN CALIFORNIA LIBRARY FOR SOCIAL STUDIES AND RESEARCH

From left to right, George Morrison, Marion Morrison (Robinson), Willa May Morrison, and Hattie McDaniel (seated). c. 1940s.

COURTESY OF THE DENVER PUBLIC LIBRARY

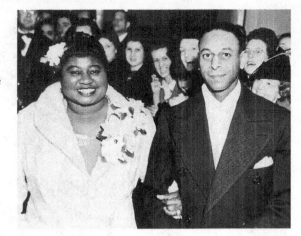

Hattie McDaniel and escort B. P. Yoder on February 29, 1940, the night she became the first African American to win an Academy Award.

COURTESY OF MARGARET HERRICK LIBRARY, ACADEMY OF MOTION PICTURE ARTS AND SCIENCES

Hattie McDaniel with her third husband, James Lloyd Crawford, during their Los Angeles wedding reception, May 1941. A photograph of McDaniel's mother, Susan McDaniel, stands on the mantel to her left.

CALIFORNIA EAGLE COLLECTION, SOUTHERN CALIFORNIA LIBRARY FOR SOCIAL STUDIES AND RESEARCH

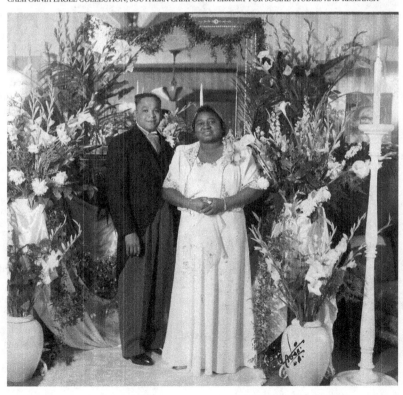

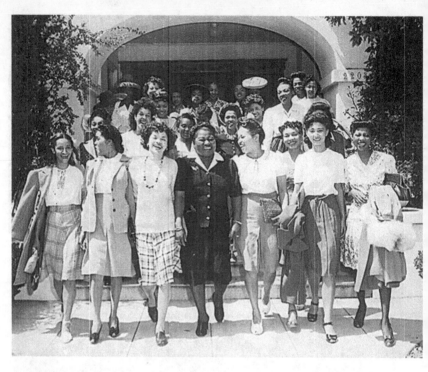

Hattie McDaniel, as chair of the Negro Division of the Hollywood Victory Committee, leaving her home on South Harvard in Los Angeles with a group of young volunteers and performers to entertain the troops stateside during World War II.

NATIONAL ARCHIVES AND RECORDS ADMINISTRATION

Hattie McDaniel celebrating the success of the *Beulah* show at a party in her home in 1948. Pictured left to right are: bottom row, Janet Blair, Greg Belcher, Esther Williams; top row, unidentified neighbor, Louise Beavers, Hattie McDaniel.

COURTESY OF MARGARET HERRICK LIBRARY, ACADEMY OF MOTION PICTURE ARTS AND SCIENCES

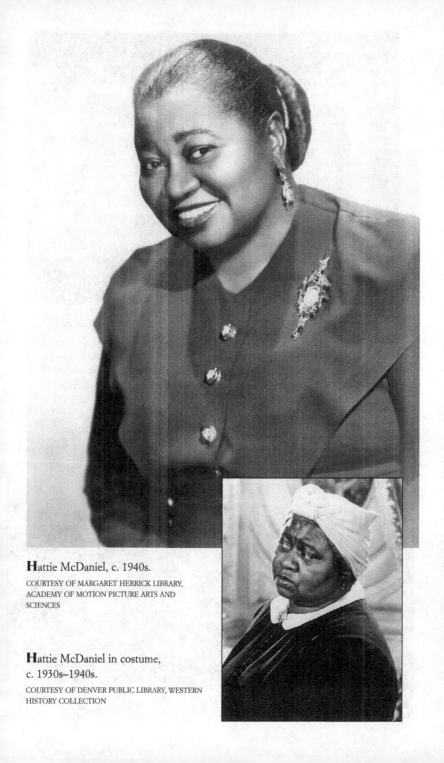

Hattie McDaniel, c. 1940s.

COURTESY OF MARGARET HERRICK LIBRARY,
ACADEMY OF MOTION PICTURE ARTS AND
SCIENCES

Hattie McDaniel in costume,
c. 1930s–1940s.

COURTESY OF DENVER PUBLIC LIBRARY, WESTERN
HISTORY COLLECTION

Final resting place of Hattie McDaniel, Rosedale Cemetery, Los Angeles, California. COURTESY DORIS WATTS

Gates of Rosedale Cemetery and grave of Hattie McDaniel (second row, fifth marker), Rosedale Cemetery, Los Angeles, California. COURTESY DORIS WATTS

Something Distinctive
and Unique

. . .

When I read the book Gone With the Wind, *I was fascinated
by the role of "Mammy," and like everyone in the position to
give it professional consideration, I naturally felt I could create
in it something distinctive and unique.*

Hattie McDaniel, *New York Amsterdam News*,
May 20, 1939

"SCARLETT HEARD Mammy's lumbering tread shaking the floor of
the hall" was the line that introduced the O'Hara's head servant to
Gone With the Wind's readers. "A huge old woman, with the small,
shrewd eyes of an elephant" was Mitchell's vision of Mammy. "She was
shining black, pure African, devoted to her last drop of blood to the
O'Haras." Mammy had been the nursemaid of Scarlett's mother, Ellen Ro-
billard, and had absorbed the aloof, rigid aristocracy of her original elite
French owners. Upon her mistress's marriage, she followed Ellen to Tara,
the O'Hara plantation, and brought along with her a "code of conduct
and her sense of pride that were as high or higher than her owners."
Mammy raised all of the O'Hara daughters, devoting considerable atten-
tion to shaping the willful Scarlett. Still, Mitchell conceived of Mammy in
the simplest terms—as an inferior who mimicked her owners and accepted
her place, never aspiring to anything more than to lovingly serve white
people. The loyal Mammy, never quite comprehending the standards she

upheld, despised Yankees and those blacks who challenged traditional Southern social order. She existed to validate slavery and the fantasy of white superiority.[1]

Yet Mitchell did allow Mammy some limited authority. A formidable woman, Mammy managed Tara's household affairs with a commanding presence. "Whom Mammy loved," the author insisted, "she chastened." And since Mammy loved her owners so much, she spent a considerable amount of time chastening them. Mitchell's Mammy expressed, mostly in an extremely circumspect fashion, "disapproval" and "indignation." She was unafraid of confrontation with the headstrong Scarlett O'Hara. (Of course, it was all for Scarlett's benefit—a necessary component in raising a proper young Southern lady.)[2] Fay Jackson spotted the possibilities immediately. She believed, as revised for cinema, the role of Mammy could "call for much more dignity than hitherto allowed for the bandannaed ruler of the big house." But this would only happen with just the right actress in the role.[3]

Indeed, Selznick sought the perfect fit for all of Gone With the Wind's characters and did so by launching a nationwide talent search. This was, to some extent, a publicity stunt, but it also functioned as a stalling tactic while he struggled to secure funding and a studio to host the production. At the core, however, Selznick was truly obsessed with finding ideal players who could make Mitchell's story as vivid on screen as it apparently was in the literary imaginations of white American readers. The producer's quest for the perfect cast extended to the black characters of the film; particularly important was his search for Mammy. The California Eagle reported that Gone With the Wind's original director, George Cukor, was determined to find "an especially versatile actress who must be able to express all of the emotions from pathos and sorrow, humor and broad comedy to the dignified, commanding character who eventually takes charge of the white family after the death of its head." One of the first names floated around was that of Georgette Harvey, who had won acclaim in George Gershwin's Porgy and Bess. In early 1938, Harvey interviewed for Mammy, confidently proclaiming, "If it is acting they want, I am certain I can deliver."[4]

Several other candidates for Mammy also surfaced quickly. These in-

cluded silent-film pioneer Madam Sul-Te-Wan, singer and up-and-coming actress Hattie Noel, and the most popular contender, the veteran Louise Beavers. In Atlanta, Margaret Mitchell suffered through one agonizing visit from a white woman determined to play Mammy in blackface. Other white Atlantans showed up with their black help, who, they demanded, be selected as Mammy. Although she had no professional acting experience, Elizabeth McDuffie, the personal maid of Eleanor Roosevelt, requested consideration; she supplied a letter of recommendation from the first lady. McDuffie was a Georgia native who had been the nanny of one of Mitchell's closest friends, qualifications that alone endeared her to the author.[5]

In early 1937, a coy suggestion came from Sam McDaniel's good friend Bing Crosby. Why not, Crosby asked Selznick, use that woman who had played Queenie in the recent film version of *Show Boat*? The famous crooner claimed he did not know her name but thought she would be a good choice.

About the same time, several members of the black press, no doubt with some urging from the actress herself, began to push Hattie McDaniel as their favorite for Mammy. Although the renowned comedienne seemed like an odd choice for a major dramatic role, she received the *California Eagle*'s endorsement. The paper made it clear that, in their opinion, Harvey's style was best suited for the stage and Beavers was simply too much of the "melodramatic, tearful, softer type of Negro mother." McDaniel possessed the strong and assertive presence that would counter any cinematic attempt to marginalize Mammy as a secondary, doltish, servile character. Although McDaniel was confident that she could play the role, and was lobbying for it hard, even she believed that she was a long shot for Mammy. "She never thought the part of Mammy in *Gone With the Wind* would be hers," Clarence Muse recalled, "because she had played a number of comic parts."[6]

The debate over who would play Mammy, as well as the other characters, went on for over a year as Selznick struggled to get *Gone With the Wind* off the ground. He screen-tested numerous players, worked and reworked the script, and trolled about Hollywood looking for sponsorship. Eventually, his father-in-law, Louis B. Mayer, offered MGM's help and,

with that, launched the project into its final planning stages. But even as late as December 1938, Selznick had yet to fill the roles of both Scarlett and Mammy. In a cost-cutting move, he decided to team up his finalists for screen tests. Of these pairings, the one that clicked was that of a Hollywood newcomer, British actress Vivien Leigh, and the well-known comedienne of the screen, Hattie McDaniel.[7]

Although Leigh immediately became Selznick's pick as leading lady, even by early January 1939, the role of Mammy remained up in the air. The producer had verbally offered the part to Hattie McDaniel but ran into resistance from journalist Susan Myrick. Born in Georgia and a descendant of a Confederate general, Myrick was a close friend of Margaret Mitchell and had been hired as the film's consultant on Southern culture and practices. Myrick immediately disapproved of McDaniel. "She lacks dignity, age, nobility, and so on," Myrick wrote of McDaniel in a letter to Mitchell. "She just hasn't the right face for it." George Cukor agreed with her.[8]

In mid-January, Selznick wrote to Cukor, dismissing all objections raised about McDaniel and insisting that it was "inconceivable that we can get anyone better for the role in view of our previous search." The producer, known for his controlling style, prevailed, and on January 27, 1939, Hattie McDaniel signed her biggest movie contract yet. (Her negotiations were probably greatly aided by William Meiklejohn's absorption into Jules Stein's powerhouse agency MCA.) McDaniel's agreement tied her exclusively to Selznick for $450 a week. Although slated to run only fifteen weeks, the terms were renewable, promising McDaniel a potentially long run as a player for Selznick International Pictures Incorporated.[9]

Hattie McDaniel was forty-five years old. She had a new movie contract and a major part in Hollywood's most talked-about film, which inched her up yet another notch of prominence in Tinseltown. But all this success also placed her even closer to the center of controversy over African-American images in film. That winter, McDaniel hired Ruby Berkley Goodwin to handle public relations full-time. For Goodwin, it became a consuming job. Monday through Friday, she and her two youngest sons lived in McDaniel's home, driving back to Fullerton on the weekends. Hattie McDaniel needed Goodwin's help now more than ever, for agitation

against *Gone With the Wind* was growing. The actress may have reached a pinnacle in white show business, but she would pay dearly for it.[10]

Throughout the preproduction phase, protests against *Gone With the Wind* increased. Seeing direct parallels between Mitchell's novel and *The Birth of a Nation,* various sources demanded Selznick abandon the project, arguing that it would only increase racial animosity against African Americans.[11] While opposition came from many sources, the most persistent of *Gone With the Wind*'s early critics was Walter White, the executive secretary of the NAACP. Light-skinned and well educated, White was an uncompromising advocate and tireless worker for African-American equality. He was fearless in his campaigns against racism. As a young man, he had passed for white and infiltrated white supremacist groups to gather information for the NAACP. He had also participated in the early protests against *The Birth of a Nation.* Ambitious, confident, and tenacious, White had climbed to the head of the NAACP's leadership ranks by 1931. But despite his dedication, according to his biographer Kenneth Robert Janken, he could also be an egotist and a micromanager. He often insisted on personally coordinating the most important and visible campaigns directly from the NAACP's national headquarters in New York City.[12]

In early June 1938, White wrote Selznick, expressing the NAACP's deep concern over *Gone With the Wind* and insisting that "we have found among both white and colored Americans a very definite apprehension as to the effect this picture will have." But White suggested that Selznick not drop the project, and instead hire a consultant, "preferably a Negro," to oversee the production and to eliminate the offensive and historically inaccurate elements of Mitchell's novel. White also encouraged Selznick to look to W. E. B. Du Bois's scholarly study *Black Reconstruction* for a more balanced treatment of the post–Civil War South.[13] Du Bois's account, which sought to counter the pro-Confederate and antiblack histories of the Civil War and its aftermath, documented the horrors of slavery, the brutalities of the Ku Klux Klan, and the concerted efforts by Southern whites to deny African Americans human rights. Selznick passed White's recommendation on to Sidney Howard, a Pulitzer Prize–winning playwright who was adapting *Gone With the Wind* for the screen. "There's

nothing like Hollywood advancing your education," Selznick remarked to Howard. The playwright was unimpressed, stating flatly in a letter to White, "I had already read Du Bois' *Black Reconstruction*."[14]

Throughout the summer of 1938, White and the NAACP continued a stiffly cordial correspondence with Selznick. The producer and his assistants repeatedly promised White that the film would be free of offensive material. As a Jewish-American deeply concerned with the violent anti-Semitism of Hitler's regime, Selznick struggled with the implications of bringing Mitchell's pro-Confederate story to the screen. "I, for one, have no desire to produce any anti-Negro film," Selznick declared to Howard. "In our picture I think we have to be awfully careful that the Negroes come out decidedly on the right side of the ledger, which I do not think should be difficult."[15] In early planning stages, Selznick had excised the novel's valorization of the Ku Klux Klan and lynching. Additionally, he instructed Howard to transform the novel's black villains into white characters. With these alterations, the producer believed that the film would be devoid of Mitchell's "anti-Negro" material that seemed uncomfortably similar to *The Birth of a Nation*. (He had earlier turned down an opportunity to remake that film.) "I hasten to assure you," Selznick wrote to White, "that as a member of a race that is suffering very keenly from persecution these days, I am most sensitive to the feelings of minority peoples."[16]

While Selznick believed he was sympathetic, his creative vision remained harnessed to the racism of his era. He fundamentally lacked insight into the substantial problems that *Gone With the Wind* presented as a whole—that the core of the story and construction of black characters defended slavery and promoted notions of black inferiority. Selznick's simple fixes did not alter Mitchell's basic message, one that conveyed the impression that the South was a better place before Emancipation. One indication of Selznick's blindness surfaced when, despite his professed abhorrence of *The Birth of a Nation*, he briefly considered hiring D. W. Griffith to assist with the project. (He later dispensed with the idea.) Even more telling was that despite censors' warnings, which began as early as September 1937, the racial slur "nigger" remained in *Gone With the Wind*'s script. Selznick argued that it provided historical authenticity and that it would be acceptable if used by those whom he identified as "the

better Negroes" in the film. While at one point, Joe Breen agreed to allow the term if it was strictly confined to the dialogue of black characters, he eventually reversed his decision and demanded the word be completely deleted. Even though the Hays Office believed that Selznick had complied with their orders, and the producer repeatedly assured Walter White that the film would be perfectly satisfactory, the term remained in the script.[17]

Although Selznick had promised White he would recruit a respected African-American leader or scholar to oversee the project, once filming began, the producer got cold feet. After adding Wilbur Kurtz, a white expert on Confederate history, to the staff, Selznick decided there was no need for more consultants, especially any who might challenge the production's content. "[David O. Selznick] is very anxious to avoid having a Negro advisor," wrote his secretary, Marcella Rabwin, to Selznick's New York assistant Kay Brown. "Such a man would probably want to remove what comedy we have built around [the black characters] however lovable the characters may be." At Selznick's orders, Rabwin instructed Brown to pay a visit to Walter White in an effort to court him and allay any remaining apprehensions he had over the production. "We're so concerned about White," Rabwin confided, "because he is a very important man and his ill-will could rouse a swarm of bad editorials in Negro journals throughout the country."[18]

The Selznick organization's attempts to manipulate White revealed the depth of Hollywood's racial prejudices and ignorance. Selznick's staff was not even entirely certain of the name of the now well-established, high-profile organization that White headed, referring to the NAACP as the "Society for the Advancement of Colored People." They believed that their revisions of Mitchell's original story had certainly gone far enough and portrayed blacks in the most flattering light possible. But their basic conceptions of what was a positive image echoed the old condescending stereotypes of simple, childlike, loyal slaves. "Mammy . . . is treated very lovably and with great dignity," Rabwin wrote to Brown. Prissy, the O'Haras' young female slave, was innocently "an amusing comedy character," and Pork, Tara's devoted valet, according to Rabwin, had the qualities of "an angel." Charged with attending to what the Selznick organization identified as "the Negro problem," Rabwin was so badly informed that

when she briefed Kay Brown, she identified Walter White as "a white man sincerely interested in the Negro cause."[19]

"Mr. White, honey chile," Kay Brown wrote glibly to Rabwin after meeting with the NAACP leader, "is a Negro . . . and promptly told me he was one during the first five minutes of the interview." Despite an awkward start, Brown claimed she had successfully dispelled White's concerns over *Gone With the Wind*. She believed that their mutual admiration for African-American soprano Marian Anderson, as well as shared dislike for Paul Robeson's wife, Eslanda, had opened a door for trust and communication. White was so taken with Brown that he invited her to dinner, clearly a test of her racial attitudes, and to be his guest at an upcoming Anderson recital. Brown, who found him overbearing and self-absorbed but sensed his powerful influence, accepted. "I think we're buddies," she told Rabwin, "and anticipate nothing but a great cooperative spirit from Brother White."[20]

However, wooing Walter White did little to address the broader African-American community's concerns. And their worries only increased in February when the *Pittsburgh Courier*'s Earl Morris published a piece contending that *Gone With the Wind* would prove "worse than *The Birth of a Nation*." He revealed that the film not only perpetuated derogatory images but also contained the despised term "nigger." "Write! Write! Write to Will Hays," he advised his readers. The journalist believed that with the rise of Nazism and the growth of white supremacy in Europe, white Americans would be forced to reevaluate their own bigotry. "Negro movie audiences now have the best opportunity to fight against such pictures," he insisted. He also demanded that black Hollywood reject any further roles in such films. In his opinion, *Gone With the Wind*'s black cast members were little more than "economic slaves" whose participation in the film amounted to "racial suicide." Most of his condemnation was directed at the film's lead black star. "We feel proud over the fact that Hattie McDaniel won the coveted role of 'Mammy,' " he wrote in his column. "It means about $2,000 for Miss McDaniel in individual advancement . . . [and] nothing in racial advancement."[21]

Although McDaniel refrained from any open response, her association with *Gone With the Wind* finally sealed her public image as a key agent in

the perpetuation of Hollywood racism. Public-relations plans hatched by Selznick's staffer Russell Birdwell and designed to court African-American film fans with press releases highlighting the careers of *Gone With the Wind*'s black cast members only furthered such an impression. McDaniel and the other African-American players would become instrumental in Selznick International's attempts to head off more black criticism. "In other words," Rabwin reported on Birdwell's strategy, "he would let our [black] actors in 'GWTW' do our work for us in the Colored newspapers across the country."[22]

Prompted by Selznick's press releases, Oscar Polk, an experienced stage actor cast as the loyal Pork, and newcomer Butterfly McQueen, selected to play the foolish Prissy, received featured treatments in black newspapers. But most of the hype surrounded the well-recognized Hollywood figure Hattie McDaniel. The production company composed a press packet that included a lengthy biography of the actress's climb from obscurity to fame. She made an appearance on *Southern Serenade*, a local Los Angeles radio show targeting black audiences. On another broadcast, a coast-to-coast NBC radio hookup, McDaniel recounted her early years as a maid-turned-show-business-trouper. Reports on the actress's career began to appear in both black and white newspapers throughout the country. Hattie McDaniel had reached the true status of celebrity. But while she was receiving more exposure than ever, with each appearance and every mention, her reputation as an apologist for the film industry grew.[23]

McDaniel's radio appearances and Selznick's press releases did little to arrest the black community's worries. By February 1939, the studio had received hundreds of letters demanding that the producer shelve the project. That winter, forty-four more protest letters, one signed by seventeen people, arrived at Selznick International's offices. Additionally, a number of organizations addressed the Hays Office directly, demanding that censors step in and halt the production.[24]

In the face of mounting opposition, Selznick and his staff strategized on how to cut off the attacks. The producer briefly considered appealing to Walter White to intercede, but he discarded that plan after assistants pointed out that the NAACP chief's support was not a sure thing. Next,

Selznick toyed with the idea of placing a respected black newspaper editor or scholar on the payroll to handle public relations with the African-American community. After considerable fretting, he also abandoned this idea. Instead, Selznick finally decided to first court his harshest critic—Earl Morris.[25]

It started with a mid-February telegram from the production company's publicity head Victor Shapiro to Morris, which read: "OBJECTIONABLE EPITHETS ARE NOT IN THE SCRIPT GONE WITH THE WIND ALSO NO KU KLUX KLAN SEQUENCE APPEARS AND NOTHING IN FILM WILL BE OBJECTIONABLE TO NEGRO PEOPLE."[26] Next, Selznick International invited Morris to observe the filming and meet with members of the production staff. The reporter accepted and upon arrival he was treated like royalty. He toured the set, shook hands with some of the film company's most important executives, and had his picture taken discussing the script with Selznick's highest-ranking advisors. It worked. In late February, Morris reported to his readers that Selznick had given his word that the film would not disparage the African-American people. He also pledged that he would continue a vigilant watch over the filming.[27]

Selznick International followed up by targeting other key black journalists to head off further criticism. Leon Washington, the *Los Angeles Sentinel*'s editor, had been particularly critical of *Gone With the Wind* and urged black domestics to gather signatures on petitions denouncing it. In this case, Selznick's staff enlisted select black Los Angeles civic organizations to convince Washington that the film would be acceptable. The editor remained suspicious but called off his campaign, offering terse assurance to his readers that his "justifiable but premature" concern over the use of racial slurs had been assuaged. George Cukor took Ruby Berkley Goodwin aside and pledged to her that everything offensive had been deleted. "It is with decided relief that I can report, from no higher authority than George Cukor . . . ," Goodwin wrote in a story for the Associated Negro Press, "that the objectionable term 'n_____' . . . has been cut entirely from the script of *Gone With the Wind*." Internally, the Selznick staff congratulated themselves on successfully wooing the black press and heading off any further controversy.[28]

In an effort to waylay other complaints, the Selznick team composed a form letter that went out in response to further protests against the film. It cited Morris's endorsement and claimed that Walter White had been fully consulted on the production. That spring, in their continued attempts at derailing any more opposition, Selznick International released a publicity photo of Hattie McDaniel and three purported representatives of the black community. (At least two of those pictured with McDaniel were film-industry employees.) "Don't worry," the *Pittsburgh Courier* quoted McDaniel saying. "There is nothing in this picture that will injure colored people. If there were, I wouldn't be in it."[29]

While McDaniel clearly was fronting for the Selznick organization, it is probable that she thought, like others, that the dialogue had been cleaned up. Selznick ran through numerous screenwriters and himself made continual revisions of the script. Often players received their dialogue for the day as they arrived on the set in the morning. The constantly shifting content of the production made it difficult for the censors to keep tabs on it, and even they were under the impression that Selznick had deleted the banned language. But internally, a debate raged. Despite his staff's warnings, he determinedly fought to retain dialogue containing the term "nigger." "I can't believe that we were sound in having such a blanket rule of this kind," he wrote of the censors' prohibition of the racial slur, "nor can I believe that we would offend any Negroes if we used the word 'nigger' with care." By early June, it remained in the script, primarily in the lines of black characters, including that of Mammy who used it deridingly against blacks pictured as tramps flooding into postwar Atlanta.[30]

Hoping to validate his position, Selznick dispatched his story editor, Val Lewton, to consult with local African-American leaders. On June 9, Lewton reported that after meeting with noted black architect Paul Williams (who later designed several Los Angeles city landmarks) and other prominent black leaders, he was convinced that it was completely inappropriate to use the term. It was impossible to include it in a nonoffensive way, Williams had insisted. "They abhor it," Lewton reported, "and resent it as they resent no other word." Additionally, Lewton reminded Selznick, the production company had repeatedly promised it would

refrain from using this racial slur. Almost immediately upon receiving Lewton's report, Selznick, after so tenaciously fighting to retain the term, instructed that it be completely cut from the script. Perhaps it was finally clear to him that it would so enrage the black community that it was not worth the cost of inciting more criticism. He may have also realized that the censors would shear those sequences where it was used anyway. But it is possible that he may have been pressured by Hattie McDaniel. Just a few days before Selznick suddenly abandoned his fight, McDaniel had filmed the scenes that would have required her to use the term. It was clearly absent in the final cut. Long after the filming of *Gone With the Wind* was complete, it was widely reported that McDaniel had refused to deliver lines containing the offensive epithet.[31]

However, whether or not McDaniel played a part in having the slur removed from the script is unclear. The actress, always with an eye on her career, was protectively discreet regarding her relationships with her white film-industry employers and colleagues. She never specifically claimed responsibility for changes in *Gone With the Wind*—regardless of the significance such an accomplishment may have represented to the African-American community. McDaniel had continued her rise within the industry by being pleasant and compliant, collaborating with white racism to advance her career. Even early on, McDaniel was not averse to doing whatever she could to promote herself with white Hollywood power brokers. Clarence Muse recalled her networking on movie sets and studio lots, bragging about her experiences as a cook in white kitchens and plying film bosses with home-baked goodies. The disappointing reality was that McDaniel played to white racist expectations both in front of and behind the camera. As she had admitted, she was always acting, always obscuring the divide between fiction and reality. While she often reminded those in the black press that she was hardly like the image she played on screen, she did little to make such a distinction for the white people she worked for and with. Hattie McDaniel rationalized that her actions were necessary to support herself and her family and a reasonable sacrifice made to pave the way for future black performers. But the truth was she helped perpetuate Hollywood's racism by not only refusing to directly challenge the bigotry she faced in the studio system but actually upholding it. Surviving in

Tinseltown became paramount. By this point, McDaniel was so solidly entrenched in her Hollywood career, it would now override almost everything else in her life.[32]

On the set of *Gone With the Wind*, McDaniel decided it was essential to court the dubious Susan Myrick, who, as a close friend of Margaret Mitchell, wielded considerable influence over the film. McDaniel quickly succeeded in winning her over. Assigned to tutor African-American cast members on what she believed was a genuine black Georgian dialect, the journalist was pleased to find McDaniel a quick and receptive student. "She says Yassum and No'm to me in a way that makes me mighty homesick for my Mary Brown back in Macon," Myrick wrote in one of her many columns that appeared in the *Macon Telegraph* during the filming.[33]

While Myrick's columns recorded the day-to-day operations on *Gone With the Wind,* they were also part of Selznick's attempts to blur the lines between what remained of the real Hattie McDaniel and Mitchell's fantasy Mammy. The production company's star machine kicked in and, to court white fans, reconstructed McDaniel's early years, underscoring her career as a domestic and downplaying other aspects of her life (like her blues career) that evidenced any challenge to white racist expectations. In the hands of Selznick's publicity people, Henry McDaniel became a zealous itinerant Baptist preacher, which exaggerated the story originally concocted by Sam McDaniel. Of course, no mention was made of Henry McDaniel's decision to leave slavery and take up arms against the very people *Gone With the Wind* sought to heroize. Likewise, Susan McDaniel, who had also fled slavery, was depicted as an efficient maid and cook who imparted her devotion to serving white people to her daughter. Readers were assured that "when slack days hit [McDaniel's] theatrical career, she has not been too proud to become a domestic in a private home to tide her over." Although studio publicity acknowledged her appearances with Morrison's Orchestra and at Sam Pick's, it emphasized her career as a maid and housekeeper. According to press releases, McDaniel arrived in Hollywood with only modest ambitions, patiently working her way up from an extra to a featured player. The actress emerged as a cheerful, hardworking, and completely nonthreatening figure that accepted her place within the prescribed racial order. According to one press release,

McDaniel's grandmother, a woman the actress could never have possibly known, served on a plantation just like Tara. "[McDaniel's grandmother] would be proud," it claimed, "to see her granddaughter become the servant of 'quality folks' on the motion picture screen." The message was clear. McDaniel's achievements must not be gauged by her talents as a performer but by the status of the white people she served on the screen.[34]

Myrick's columns were even more distorted. She regaled readers with accounts of McDaniel's purported nurturing, deferential, and occasionally quaintly foolish behavior. "I think that Hattie McDaniel has played Mammy so long in the picture *Gone With the Wind* that she is being a Mammy in real life," Myrick declared after the actress insisted on treating the journalist's cold with what she claimed was an old-fashioned concoction of linseed oil, lemon juice, and bourbon. Myrick also implied that on the set McDaniel was known simply to everyone, including Clark Gable, as "Mammy." In another instance, Myrick condescendingly reported that several members of the production staff had "laughed themselves sick." Waiting between scenes, McDaniel had retreated to work on some of her own material. "What on earth are you up to?" Myrick demanded, finding McDaniel writing and humming along. She claimed McDaniel arose to her feet and did a quick rendition of "Swanee River" accompanied by a tap dance, kicks, and "rolling eyes."[35]

Myrick's anecdotes were calculated to appeal to her white Southern readership and emerged certainly from her racist presumptions. Still, McDaniel did little to discourage these reports. In Myrick's autograph book, the actress signed in as both "Mammy" and "Hattie McDaniel," yet another acquiescence to the journalist's delusions. As painful as it must have been to confront Myrick's racism and to participate in a movie that so misrepresented the black experience, the actress remained cooperative. This was a steady job with incredible wages, a major step up in white Hollywood. Playing to white expectations was a strategy of deception and self-preservation that black laborers had practiced dating back to the days of slavery, and McDaniel liberally used such a tactic to promote and protect her Hollywood aspirations.

The two other black principals, Oscar Polk and Butterfly McQueen, pursued their own coping tactics. Like McDaniel, Polk was amiable and

nonconfrontational. At the studio's request (or possibly demand), he wrote a defense of *Gone With the Wind* for the *Chicago Defender*. "I am from the South, and am as familiar with Southern traditions as any member of my race," he insisted. "The characters that appear in the picture—Pork, Mammy, Prissy, Uncle Peter, Big Sam and Jeems, are all true to life—all of them could have, and in fact, actually have lived." On the other hand, McQueen, whose shrill Prissy was probably the movie's most degrading character, proved to be the most recalcitrant. She manipulated directors by playing the daffy Prissy both on screen and off, muffing her scenes and forcing retakes. In one instance, she refused to redo a scene where she was slapped, until Cukor agreed to fake it and to force Vivien Leigh to apologize for an earlier, stinging strike. In another, the actress balked when told to eat watermelon. McQueen later claimed McDaniel took her aside and warned her, "You'll never come back to Hollywood; you complain too much."[36]

Butterfly McQueen later labeled Hattie McDaniel a sellout for her refusal to take a forceful stand against studio racism. In part, this derived from McQueen's defensiveness over her own performance. But McQueen was not alone in her condemnation of McDaniel, as it became increasingly obvious that the veteran actress was willing to accept whatever fiction about her the studio manufactured. However, many Hollywood performers found their private lives rewritten by film-industry press agents. For example, Bing Crosby, whose relationship with his wife and children was dysfunctional, was repackaged as a doting husband and father. But the reconstruction of Hattie McDaniel carried a much greater significance and maintained broader, more dire consequences. Rather than emerging as an intelligent woman and accomplished artist, McDaniel allowed the studios to recast her as a mammy playing a mammy. Most film performers of any race had little say over the studio's depictions of their lives; those who complained or publicly contradicted studio hype usually found themselves out of work. But in McDaniel's case, Hollywood's fabrication more than distorted the life of one individual; it disparaged an entire race. McDaniel's willingness not only to permit but even to encourage such lies perpetuated white racist ideology. McDaniel would make very subtle attempts at countering Hollywood's tales, always vigorously insisting her

aim was the betterment of the African-American people. Regardless, at this stage in her life, most of her actions promoted her position in white films and, no matter what her private feelings were, betrayed, in some form, the larger fight for civil and human rights.[37]

Yet the reality was that McDaniel operated in a harsh, unforgiving, and racist industry. Rarely did blacks take on the studios from within, and those who did paid the price. Fredi Washington had been one of the few black performers to quit rather than compromise, and her post–film career appeals to Hollywood for change had fallen on deaf ears. (Later, in 1942, Paul Robeson announced his plans to abandon Hollywood.) Any actor, black or white, who emerged as too much of a troublemaker was banished. This was especially true for African-American performers. Stepin Fetchit's recalcitrant off-screen antics and lifestyle eventually led to his exile. During the filming of *The Heat's On,* talented singer and pianist Hazel Scott refused to proceed with a musical number until the studio agreed to provide the film's black actresses, who were all dressed in Mammy-style clothes, with more dignified costumes. The film's producer yielded, but Scott was branded difficult and struggled to get other roles. Ethel Waters challenged studio authorities with a number of demands, including her insistence that her part in *Cabin in the Sky* be revised. "I won all my battles on that picture," the forceful Waters recalled. "But like many other performers, I was to discover that winning arguments in Hollywood is costly. Six years were to pass before I could get another job." The only options were to comply or get out. Hattie McDaniel chose to comply.[38]

The situation on *Gone With the Wind*'s set was not much better than on others that Hattie McDaniel had worked on. According to film historian Thomas Cripps, someone at MGM had hung signs designating certain restrooms as either "white only" or "black only." Only after a group of African-American performers threatened a work slowdown did the studio remove the signs. There was other evidence of persistent racism. While the studio sent individual cars to pick up the film's white stars, the black principals were forced to ride together in a single limousine that made rounds of their homes in the mornings. Hattie McDaniel was accorded her own chair with her name on it and, along with several other black players, made

considerably more than some white featured actors in the cast. Nonetheless, the higher pay for those black players achievement was understood within racist terms. Actress Evelyn Keyes, who played Suellen O'Hara, later characterized the racial climate as appalling. She observed that studio heads viewed the higher salaries of black performers as justifiable not because they deserved them but because "they were playing slaves," which "kept them in their place."[39] Confronting the demeaning atmosphere, black players pulled together. When a black cast member shot a scene, they gathered to watch and applauded after the director cried, "Cut."[40]

In many ways, working on *Gone With the Wind* was such an enormous, exhausting, and chaotic undertaking that it bred camaraderie within the cast and across racial lines. In fact, it was one of the few times that such a large number of black and white performers had come together to work over a long period on a film. Evelyn Keyes noted that black and white performers often mingled comfortably; photos taken behind the scenes show them relaxing and eating side by side. And the entire cast suffered together under constant uncertainty. Striving for perfection, the controlling Selznick fired George Cukor and finally hired Victor Fleming to complete the bulk of the filming. The project shifted daily; players were unexpectedly called back to reshoot scenes and dialogue. The ever-changing script even caught experienced troupers like Hattie McDaniel off-guard. "What is that rustling noise I hear, Mammy?" Gable asked as the cameras rolled and McDaniel forgot to exit. After a long pause, Gable teasingly tried again, "What is that rustling noise I was supposed to hear if you had walked away, Mammy?"[41]

There was enormous pressure for everyone involved with *Gone With the Wind,* and to relieve anxiety, the film's cast sometimes resorted to high jinks. It was Gable who emerged as the production's biggest practical joker. Myrick reported that during a break in a shooting of a scene with McDaniel, he switched the iced tea that she was drinking with straight scotch. When filming resumed, McDaniel took a mouthful and, caught off-guard, could barely sputter out her lines. Although Gable intended it as good-natured fun between close friends, Myrick seized on it as yet another example of the enchantingly foolish Hattie McDaniel. "The cast and

crew had a ten minute laugh," chortled Myrick. Although *Gone With the Wind* was intended as high drama, blacks still functioned, even in public relations, as comic relief.[42]

Hattie McDaniel still pursued this part with a determined seriousness and resolutely took ownership of the role. "When I read the book *Gone With the Wind*, I was fascinated by the role of 'Mammy,' and like everyone in the position to give it professional consideration, I naturally felt I could create in it something distinctive and unique," she told the nation's premier black newspaper, the *New York Amsterdam News*. Selznick's constant changes and overnight revisions left directors little time to set up shots and gave performers like Hattie McDaniel a chance to improvise more than normal. Wilber Kurtz remembered with astonishment how McDaniel virtually directed herself. "Selznick could hand her a part of the script and count on her to know exactly what to do with it, which she proceeded to do," Kurtz commented. "She even threw in certain *business* without any direction from the script or from the director." As a result, Mammy emerged as a fusion of McDaniel's past fictional personae. The actress constructed the character by drawing from her early dramatic experiences in Denver reciting Shakespeare and Dunbar, her rebellious satire of minstrel stereotypes, and her independent blueswoman defiance. If her character in *Gone With the Wind* did succeed in breaking new cinematic ground, as some have argued, then it was due to Hattie McDaniel's reinterpretation of the role.[43]

By early July 1939, most of the principal filming of *Gone With the Wind* had been completed, and the cast went on hiatus. Hattie McDaniel first attended to several obligations within the black community. She was on hand at the Santa Fe depot in downtown Los Angeles to greet Eddie "Rochester" Anderson, Jack Benny's sidekick, who was returning from his latest out-of-town film premiere. She also put in an appearance at a breakfast held in the home of African-American social figure Pauline Slater. Finally, in mid-July, McDaniel departed on a vacation. Unlike those of her white *Gone With the Wind* costars, who were enjoying exclusive hotels and fine restaurants, McDaniel's options were limited by segregation. So she booked a cottage at a resort catering to African Americans in Lake Elsinore, a desert town southeast of Los Angeles. There she hoped to com-

bat the effects of a lingering cold. Indeed, she did not seem to be as hearty as she had once been. According to a press release, she had ballooned to over 290 pounds. While that was an overstatement, exaggerated on screen by generous padding, McDaniel had put on considerable weight and struggled to shake off even slight infirmities. It was likely that she was already suffering the early symptoms of diabetes, a disease that would plague her in the years to come.[44]

After some late-summer retakes, by October *Gone With the Wind* was completed. As Selznick reviewed the final cut, he discovered something unexpected. While he was pleased with the performances of all of his featured players, that of Hattie McDaniel astonished him. Rather than sinking into the background, Mammy, as interpreted by McDaniel, emerged as one of the film's strongest characters. He telegrammed his New York publicity man, Howard Dietz, raving that Hattie McDaniel delivered "a performance that, if merit alone rules, would entitle her practically to co-starring." In another memo, to Daniel O'Shea, his vice president of production, Selznick predicted that the actress's contributions would leave a "sensational impression" on film audiences. He also fired off a congratulatory telegram to McDaniel; he decided to quickly sign her to an exclusive long-term contract before someone else did. "I think she is going to be hailed as the great Negro performer of the decade," the producer confided in another memo.[45]

Rumors began to circulate that Hattie McDaniel had turned in a spectacular performance. And a sneak preview in Los Angeles for the press confirmed it. At the end of one of McDaniel's scenes, the crowd broke into hearty applause. "Hollywood almost cheered her every entrance," reported the *Chicago Defender*. While Hattie McDaniel had accepted the part of Mammy knowing the grave reservations that many in the black community had about *Gone With the Wind*, she was confident that once they saw her work, their worries would cease and she would put her critics' fears to rest. Hattie McDaniel was satisfied; her biggest role so far was her best. "Hattie is the happiest person around these parts," reported the *California Eagle*, "for she knows she turned in her very finest performance to date."[46]

Selznick exploited this prerelease praise for his performers to hype

Gone With the Wind among moviegoers. Anxious to get the film into theaters—the holidays were fast approaching and were a flush time for Hollywood ticket sales—Selznick and his company worked quickly to organize a gala premiere. With an eye toward taking advantage of all promotional opportunities, Selznick International selected Atlanta for the film's opening. As part of the movie's setting, and Mitchell's hometown, Atlanta offered not only a receptive audience but promised to underscore the film's authenticity. Throughout November and into December 1939, Selznick's staff worked feverishly. It was a daunting undertaking—reassembling the now-scattered stars, preparing activities for notables from Atlanta and Hollywood, and planning a tribute to the few, very elderly, surviving Confederate veterans. It would be extravagant and glamorous. Vivien Leigh and Olivia de Havilland would fly in with Selznick. Gable would arrive with his beautiful wife, Carole Lombard, on a specially chartered flight, a DC-3 with *Gone With the Wind* emblazoned on its hull.[47]

But Selznick's plans ran into a snag. While Atlanta was abuzz about the arrival of Leigh, de Havilland, Gable, and Lombard, city officials proved extremely touchy on the the inclusion of black cast members. The presence of the African-American performers at the premiere or any of its attendant functions posed a threat to their long-standing Jim Crow traditions. Atlanta's leaders, in particular the mayor's office, made it clear: the black players, including Hattie McDaniel, were not welcome.[48]

Selznick was clearly disappointed. He intended to schedule black cast members for appearances in Atlanta's African-American community, hoping to win endorsements that would sidetrack further protests from the black press. Although he easily capitulated to the Atlanta officials' demands, he was dumbfounded to discover that the exclusion went even further. The city fathers also objected to the appearance of McDaniel's photograph alongside those of her white costars in the film's souvenir program. It left Selznick outraged. "In these increasingly liberal days (thank goodness) I hate to be personally on the spot for seeming ungrateful for what I honestly feel is one of the great supporting performances of all time, which is that of Mammy," Selznick wrote to Howard Dietz. "Everyone who has ever seen the picture is unanimous in agreement that one of her scenes which is very close to the end of the picture is easily the high emotional

point of the film." But Kay Brown cautioned the producer: "The inclusion might cause comment and might be a handle that someone could seize and use as a club." Eventually, convinced that pressing the matter may jeopardize the entire project, Selznick bowed to Southern expectations and removed Hattie McDaniel's picture from Atlanta's program.[49]

McDaniel took the safe, careerist route and never commented on the Atlanta snub. But, on December 11, she sent a letter to Selznick as he prepared to depart for his premiere. It may have been William Meiklejohn's idea, since he was in the final phases of negotiating a long-term deal for McDaniel with Selznick International. In her note, she thanked the producer for the chance "to play Mammy in the epochal drama of the old South." "I hope that Mammy," McDaniel wrote, "when viewed by the masses will be the exact replica of what Miss Mitchell intended her to be." The next day, Selznick reported to staffers that the deal with McDaniel had been closed.[50]

On late Wednesday afternoon, December 13, 1939, David O. Selznick's plane touched down in Atlanta, and the newsreel cameras began to grind. The following day, three hundred thousand spectators filled the city's downtown streets for a grand parade with the production's white stars rolling past. The night climaxed with a grand ball sponsored by Atlanta's Junior League. After the usual acknowledgments, the master of ceremonies introduced the evening's program:

> We have all been thinking and talking a lot about the Old South lately. . . . Tonight we want to give you a glimpse into the past—and visit an old plantation on a warm, fragrant June evening. Can you smell the wisteria? Can't you hear those darkies singing? They're coming up to the Big House.[51]

The curtain rose, revealing an elaborate re-creation of Tara. On the steps stood the choir of the Ebenezer Baptist Church costumed as slaves and singing spirituals. Years later, one of those teenagers in the choir, in a different time and a different place, would go on to lead the challenge to the racism and segregation that the evening celebrated. His name was Martin Luther King Jr.[52]

Friday, the premiere day, had been declared a state holiday in honor of the film. That evening, cameras recorded a beaming Selznick, a dashing Gable, a stunning Leigh, and a shy Margaret Mitchell as they traversed the red carpet that ran between the enormous white faux columns that lined the front of Atlanta's Loews theater. Hollywood luminaries and Atlanta's elite filled the choice seats in the theater as an all-white crowd of over two thousand packed the rest of the theater. Evelyn Keyes later commented on the unquestioned rigid segregation. "It never occurred to me," she remarked as she reflected on the era, "that there was anything unnatural in there not being a single black face at the big premiere."[53]

Finally, the house lights dimmed, the music swelled, and the curtains lifted. For the next four hours, the audience was whisked into a Technicolor re-creation of the Old South and the Confederate struggle. The Southern spectators responded accordingly—cheering the Rebels, booing the Yankees, and sitting morose at the sight of the hundreds of wounded and dying Rebel soldiers after the battle of Atlanta. The film was for these white Southerners, as one reviewer commented, "four soul stirring hours."[54]

"Missy Scarlett, you come back here," Hattie McDaniel as Mammy roared out of an upper-story window of Tara's mansion. "You ain't got no more manners than a field hand."[55] This was the film audience's introduction to McDaniel's version of Mammy, and, despite the actress's assurances to the contrary, it was hardly the slow, elderly, and "lumbering" character of Mitchell's imagination. McDaniel played the role with an astute quickness and vigor absent in Mitchell's pages. McDaniel's Mammy was loyal and devoted, but she was also bossy, intelligent, loud, and opinionated. And anyone watching closely would have seen that in some scenes Mammy wore a large, expensive-looking ring and had nicely manicured nails, subtle signals that the character was a fabrication. From the beginning to almost the end, McDaniel's Mammy was a key figure and, as film scholar Donald Bogle notes, "not once does she bite her tongue."[56] For McDaniel's Mammy, serving Scarlett is not a labor of love but a constant annoyance; her patience runs blatantly thin. Mammy primps Scarlett but constantly scolds her, and even berates her spirited charge, sometimes with unmistakable pleasure.

"Come on now and eat," Mammy demands.

"Ashley Wilkes says he likes girls with good appetites," Scarlett retorts.

"What a gentleman says and what they thinks is two different things. And I ain't noticin' Mr. Ashley askin' for you to marry him," Mammy responds, boldly flashing a shrewd and victorious smile.

Indeed, Hattie McDaniel played Mammy as feisty and nervy, back-talking most of the white characters throughout the film. In addition to Scarlett, she fusses at various members of the O'Hara family and, visibly disgusted, orders returning Confederate soldiers to bathe. Her initial disdain for Rhett Butler is unconcealed. In part, this was a commentary on Butler's degenerate status: he was an ostracized member of an elite Southern family who cavorted with prostitutes and only discovered his loyalty to the Rebel cause late in the war. But it also furnished McDaniel with the opportunity to play a character that rejected white male authority. "You don't like me Mammy," Butler states teasingly. "Humph," she snorts with revulsion, looking him directly in the eye. But it is really her approval he seeks. "She is one of the few people I know whose respect I'd like to have," Butler confesses to Scarlett. His tenderness in his marriage to Scarlett and his tremendous love for their child, Bonnie Blue, eventually win Mammy over. And despite the on-screen chemistry between McDaniel and Gable, derived in part from their close friendship, the specter of white domination haunted their cinematic relationship. "Pull up your skirt," Butler demands, realizing that Mammy is wearing the red silk petticoat that he has given her as a present. It harkened to the reality of the physical exploitation of black women by white men. But McDaniel, so familiar with Gable, attempted to reverse it boldly remarking "Mr. Rhett, you is bad." It intimated that Mammy was willing to comment on a white man's inappropriate demands, even if it was done with a dose of deflective humor.[57]

Yet the one scene that stood out in the movie, referred to by Selznick as the unexpected "high emotional point of the film," was not played with McDaniel's good friend Clark Gable but with Olivia de Havilland. In it, Mammy ascends a staircase, pleading tearfully with Melanie Wilkes to comfort Rhett Butler, insane with grief over the sudden death of his daughter. In the scene, Mammy emerges as the only person with an insight

into the deeper psychological world of the other characters. Scarlett is strong, Mammy assures Melanie; it is really Rhett who is weak. He has locked himself in his room alone with his daughter's body, threatening to kill Scarlett if she takes the child from him. "He ain't going to let us bury that child," she tells Melanie through her tears.[58]

This was the first time since *Imitation of Life* that an African-American actress had been permitted to show any range of real dramatic emotion on the screen. Although the scene with Melanie Wilkes implied that a black woman's existence centered only on the well-being of her white employers, McDaniel attempted to tweak the old stereotype. She wept, but not frenziedly, conveying a restraint and pride that contested the notion that black women were outrageously emotional and irrational. At the film's opening, when the mayor of Atlanta, a key player in blocking McDaniel's inclusion in the premiere and the souvenir program, acknowledged the actress's performance, the crowd exploded with an ovation. In a congratulatory telegram, Margaret Mitchell wrote to McDaniel with praise that must have been bittersweet. It read: "Wish you could have heard the applause."[59]

Later, when questioned how she was able to execute such a powerful performance, McDaniel explained that it was quite simple. The scene with Olivia de Havilland had not evolved from any kind of past experience with the white people she had served. Rather, McDaniel drew from the real memory of enduring the life of poverty as an African-American woman. "They are honest to goodness tears; no skinned onion comes near me, nor any other inducer," she told a white reporter in 1941. "If tears are slow to come I get to thinkin' of the meals I missed in my early struggles and believe you me, they come a gushin'."[60]

While Jim Crow kept McDaniel from the Atlanta premiere, she did attend *Gone With the Wind*'s Hollywood debut on December 28, 1939. This time, at Selznick's insistence, her picture was featured prominently in the program. (It would also be included in programs for all areas outside of the South.) Although nowhere near as elaborate as the Atlanta bash, the Hollywood premiere was even more important. Observers rated it the most impressive assemblage of Tinseltown personalities ever. In the audience that night were the very members of the Academy of Motion Picture

Arts and Sciences who within weeks would begin voting on the season's upcoming Oscar nominations. Their reaction boded well for the film, and they showered the producer and cast with applause. The critics were equally impressed. The *Los Angeles Times*'s Edwin Schallart declared *Gone With the Wind* one of the best films ever made. "It is the ultimate realization of the dreams of what might be done in every phase of film wizardry" was the *Hollywood Reporter*'s assessment. *Variety* was equally effusive, endorsing *Gone With the Wind* as "in some ways, the most Herculean film task ever undertaken" that would be certainly acknowledged "as one of the screen's major achievements, meriting highest respect and plaudits."[61]

With these endorsements, the outlook for *Gone With the Wind* seemed extremely promising. Throughout the country, it received an enthusiastic reception from the white community. Most in the white press agreed its cast had turned in remarkable performances. This included Hattie McDaniel, praised by many reviewers as superior. The *New York Times* rated her as the "best of all, perhaps next to Miss Leigh." (Although it did warn that McDaniel's opening scene, where she forcefully scolds Scarlett from an upstairs window, was inappropriate—"unfittin'" as they put it.) *Variety* was even more positive. "It is she who contributes the most moving scene in the film," their critic insisted. "Time will set a mark on this moment in the picture as one of those inspirational bits of histrionics long remembered." Edward Schallert agreed, comparing McDaniel's performance to that of a "Greek chorus" interpreting the true meaning of the story for the audience.[62] McDaniel had drawn on her strengths as an outsider to create a character that many found compelling. But McDaniel's Mammy, who so pleased white critics, also conveyed a pathos. Not too far beneath the smiling and nurturing surface lay a simmering rage with the white people that she loyally but often grudgingly served. The *Hollywood Reporter* unwittingly captured the dualism in McDaniel's performance, hailing her as "unforgettable as the faithful, obstreperous Mammy."

Despite these accolades, McDaniel remained isolated in Hollywood by racism. Although the Tinseltown premiere crowd was racially integrated, even on this big night, she still confronted patronizing white attitudes toward her and her place in moviedom. White Hollywood gossip colum-

nist Bill Henry, sitting two seats away from the actress, heard someone in the row ahead of them ask, "Hattie, do you like acting in pictures?" Underlying such a question was the condescending implication that rather than use her creative talents, Hattie McDaniel might actually prefer to remain an overworked and underpaid maid. No such query would have been made of a white actress. But McDaniel continued the act, revealing subtly how she really felt. "Yes, honey," she responded, "I sure do."[63]

The popular columnist and radio personality Jimmie Fidler joined with those who celebrated McDaniel's contributions to *Gone With the Wind* and attempted to bring attention to Hollywood's egregious realities. "Long after I have forgotten [the other stars'] work, I'll still see the emotion-wracked ebony face of Hattie, tears coursing down her cheeks," he wrote. Yet something about all of the hoopla bothered him. "Where does this Negro artist go from here?" he asked. "Why back to playing incidental comedy maids, of course." With the film factory's rock-solid racial barriers, Hattie McDaniel's future, he believed, was bleak. Hollywood had no intentions of providing her with any real opportunities to use her talents. "I don't think it will be easy for me to laugh at Hattie's comedy in the future," he stated. "For I'll never be able to overlook the tragic fact that a very great artist is being wasted."[64]

For black critics, Fidler's revelation was no surprise. However, their reaction to McDaniel's performance was mixed. A number of black reviewers agreed—McDaniel had delivered an impressive performance. Most in this camp argued that her contributions to the film had to be separated from *Gone With the Wind*'s overall content. As the *California Eagle* put it, McDaniel had done "brilliant work" in a "difficult vehicle." The *Washington Tribune*'s Melvin B. Tolson applauded the actress for playing "the nuances of emotion, from tragedy to comedy, with the sincerity and artistry of a great actor."[65] Even Earl Morris came around: "While this writer has found many objections to the story as written by Margaret Mitchell . . . Miss McDaniels as an actress certainly has won her laurels."[66]

Overwhelmingly, however, the vast majority of African Americans objected to *Gone With the Wind* as a whole. Tolson echoed Morris's prediction of a year earlier: Selznick's film was "more dangerous than *The Birth of a Nation*." In his opinion, "*The Birth of a Nation* was such a barefaced

lie that a moron could see through it . . . , [but] *Gone With the Wind* is such a subtle lie that it will be swallowed as truth by millions of whites and blacks alike."[67] Many were outraged at the film's warped interpretation of slavery and sympathy for the Confederate cause. In a letter to David O. Selznick published in the *Daily Worker*, the young black playwright Carlton Moss blasted *Gone With the Wind* for promoting the notion that slaves neither desired nor made the best of Emancipation. Many of the same black weeklies that had praised McDaniel condemned the film. The *Pittsburgh Courier* protested that Selznick's film depicted a world in which "Negroes are ignorant, incapable, and superstitious." The *Chicago Defender* branded it a "weapon of terror against black America" and reported that over one hundred picketers gathered at one movie house featuring the film.[68] Even McDaniel's good friend Clarence Muse was appalled by *Gone With the Wind*'s insulting tone. In response, he announced his intentions to film his script *Son of Thunder*, designed to set the record straight on slavery and the Old South. Letters of protest arrived in the mailboxes of both Selznick International and the NAACP. Surprisingly, the NAACP's reaction was tepid. While they agreed the production was historically flawed and unflattering to African Americans, they contended that it was not egregious enough to campaign against it.[69]

Yet at the same time, Walter White was making Selznick very aware of the negative consequences of the movie. White reported that its release had already induced all kinds of baneful consequences, including a decline in support among a number of white women's organizations for antilynching legislation, a renewed animosity for the Union's cause, and a growth in membership of the Klan. One studio, he reported, was preparing to remake *The Birth of a Nation*. Selznick was incensed. "We leaned over backward," he wrote to White in April 1940. "On these matters and feeling as keenly as we do in the problems involving racial prejudices, I feel it is unfair we should be attacked as being on the other side." White reverted to an uncharacteristically light-handed approach with the now-testy Selznick. The NAACP leader had a plan. He hoped that by treating Selznick gently, he could open a dialogue between himself and movie producers that would eventually result in better film roles for African Americans.[70]

White's behind-the-scenes maneuvers did little to ease the growing

outrage within the African-American community over *Gone With the Wind*. And Hattie McDaniel, so central to the production, was on the receiving end of much of the criticism. Several black reviewers argued that it was impossible to disassociate McDaniel from the film's dangerous story. Although Earl Morris had praised the actress, another *Pittsburgh Courier* critic condemned her and the film's other black performers for playing degrading "happy house servants" and "unthinking hapless clods."[71] Carlton Moss contended that there was nothing innovative about McDaniel's characterization; it was just another iteration of "the timeworn" demeaning cinematic black images. He objected to "Mammy with her constant haranguing and doting on every wish of Scarlett" and the film's message that "she loves this degrading position in the service of a family that has helped to keep her people enchained for centuries."[72]

At the time, Hattie McDaniel said very little publicly in response to her critics, who were growing in number. But the year before, she made clear why she had decided not only to play but pursue the part of Mammy. During her interview with the *New York Amsterdam News*, McDaniel began with a description of the role that would have pleased Selznick as well as Margaret Mitchell: "I visualized myself as loving Miss Ellen, worrying over the willful Scarlett, respecting Gerald O'Hara, pinching and scolding the irrepressible Prissy." But, in a slight departure from Selznick's promotional campaign, McDaniel also envisioned Mammy as possessing significant power; the actress conceived of the character as having considerable influence over all of Tara's affairs. McDaniel insisted to her interviewer that her version of Mammy was not based on Mitchell's fantasy servant. Rather, McDaniel insisted, she had based the character on Harriet Tubman, Sojourner Truth, and Charity Still—confident black women abolitionists who had themselves been born in slavery. And, she stressed, Mammy's legacy was not determined by the white people she served (as Selznick's publicity insisted) but rather the young people of the black community that she raised. Mammy, McDaniel argued, was "the brave efficient type of womanhood which, building a race, mothered Booker T. Washington, George Carver, Robert Moton, and Mary McLeod Bethune." After freedom, it was the earnings of working-class black women that provided the financial foundation for independent black churches, businesses, and charities, as

well as the NAACP and Marcus Garvey's Universal Negro Improvement Association. (An interesting example of a black nationalist and separatist organization that no doubt went right over Selznick's publicity people's heads.) Why did McDaniel, the daughter of slaves, agree to play the kerchiefed Mammy? "This is an opportunity to glorify Negro womanhood," Hattie McDaniel maintained. "I am proud that I am a Negro woman because members of that class have given so much."[73]

One day, in early February 1940, Hattie McDaniel showed up at David O. Selznick's office with a file of clippings on *Gone With the Wind* from black newspapers. While she may have intended to educate the producer on the black response to his film, no doubt, among these articles were those that pressed for her nomination for an Academy Award. Objections to her participation in the film were mounting, but several supportive black journalists had urged their readers to write Selznick demanding he place McDaniel in the running for an Oscar. One such letter came from the leadership of the Sigma Gamma Rho, an African-American sorority that argued that an Academy Award for Hattie McDaniel promised "discrimination and prejudice will be wiped away." (Ruby Berkley Goodwin was a member of the organization.)[74] The pressure to nominate McDaniel was not confined to the black community. Back in December, the *Los Angeles Times*'s Edwin Schallert heralded her performance as a "remarkable achievement" that was "worthy of Academy supporting awards."[75] Thrilled at the response, Selznick made certain that McDaniel secured a spot on the ballot for Best Supporting Actress. Even though he also nominated Olivia de Havilland in the same category, he assured Sigma Gamma Rho that "we hope, as you do, that Miss McDaniel may be the recipient of an Award."[76]

With Selznick's support, Hattie McDaniel became the first African-American to be nominated for an Oscar. And her competition was tough. In addition to de Havilland, who had a hefty part in *Gone With the Wind,* the field included Geraldine Fitzgerald for *Wuthering Heights,* Edna Mae Oliver for *Drums Along the Mohawk*, and Maria Ouspenskaya for *Love Affair.* Either way, it looked good for Selznick overall. In total, *Gone With the Wind* had scored an extraordinary thirteen nominations. Balloting began on February 15, 1940, and a favorite for Best Supporting Actress

immediately emerged. While describing it as a "neck and neck race" between the *Gone With the Wind* stars, *Variety* wagered that there was "a good chance, however, that the colored Hattie McDaniel will capture another victory for the Selznick International stable."[77]

According to later reports, on the evening of February 29, 1940, a group of picketers protesting *Gone With the Wind* lined up outside of the lavish grounds of Los Angeles's Ambassador Hotel. Inside, Hollywood's elite had begun to gather in the hotel's famous Coconut Grove for the Academy of Motion Picture Arts and Sciences' Twelfth Annual Awards ceremony. It was thoroughly Tinseltown—a lavish, black-tie affair with everyone arriving fashionably late. Moviemakers and stars rolled up outside in limousines and expensive automobiles determined that nothing would spoil this party. As the Nazi regime moved through Europe, filmland was congratulating itself for its democratic egalitarianism. For the first time, black members were admitted to the Motion Picture Academy and accorded voting rights; Clarence Muse, Harry Levette, and even Earl Morris all cast ballots. (Journalists covering film were often admitted as voting members.) Additionally, Hattie McDaniel, as the guest of David O. Selznick, became the first African-American to attend the awards ceremony. But there was another first in store. The word was out. The *Los Angeles Times*, privy to advance information, had leaked the names of the winners in its late edition. Many of those gathering already knew what the ceremony would only make formal—Hattie McDaniel would be the first African American to win an Oscar.[78]

Hattie McDaniel arrived with her handsome escort for the evening, identified by the *California Eagle* as F. P. Yober. She looked stunning. Cameras flashed as she made her way to the ballroom, exquisitely dressed in a tasteful, rhinestone-studded aqua blue evening gown, white ermine jacket, and a bountiful corsage of white gardenias. As she entered the Coconut Grove and made her way to her table, the crowd of almost 1,700 members of the Hollywood film colony broke into a resounding applause. She and Yoder were seated, along with a white man (possibly William Meiklejohn or one of his representatives), at their own table, placed at the periphery of the room but near the stage where the awards would be given. Even on this evening of Hollywood firsts, segregation remained the rule.[79]

When Fay Bainter, the previous year's Best Supporting Actress, took the podium, Hattie McDaniel must have felt a surge of nerves and excitement. This daughter of ex-slaves, who had struggled with poverty and racial oppression, had finally broken into the highest ranks in Hollywood, ascending further than any African American had in the world of white show business. When Fay Bainter began, the room fell silent. "It is with the knowledge that this entire nation will stand and salute the presentation of this plaque," she announced, "that I present the Academy Award for the best performance of an actress in a supporting role during 1939 to Hattie McDaniel."[80]

The Coconut Grove rocked with applause as McDaniel briskly made her way to the stage. According to some sources, the Selznick organization had prepared a speech for her. But, *Variety* reported, she was so "overcome" that she left the speech at her seat. This oversight allowed McDaniel to speak on her own. Instead of delivering a speech prepared by Selznick's staff praising the producer, the actress, with the help of Ruby Berkley Goodwin, had worked up her own remarks. Although they were hardly revolutionary, they did not belong to a white writer. She began with customary thanks to the Motion Picture Academy, her colleagues, Selznick, and Meiklejohn for supporting her for the Oscar. "It makes me feel very humble, and I shall always hold it as a beacon for anything I may be able to do in the future," she continued. "I sincerely hope that I shall always be a credit to my race and the motion-picture industry." With that, she had summed up her central dilemma, her entrapment between two opposite poles—the struggle of the African-American people and the racism of the white movie world. "My heart is too full to express just how I feel," McDaniel, now sobbing, told the crowd, "so may I say thank you and God Bless you." And with that, Hattie McDaniel exited.[81]

8

. . .

Eighteen Inches

. . .

I know that in my business popularity is a weedy growth—
here today, gone tomorrow. I've learned by livin' and watchin'
that there is only eighteen inches between a pat on the back
and a kick in the seat of the pants.

Hattie McDaniel, *Denver Post*, April 15, 1941

FTER ALL THE OSCARS were handed out and the evening came
to a close, at the request of the management, Hattie McDaniel
greeted hundreds of the Ambassador's guests gathered to see
her on the hotel's mezzanine. As she exited, she told reporters clamoring
for a comment, "Well, all I have to say is I did my best and God did the
rest." She arrived home that night to a bundle of congratulatory tele-
grams and messages from around the country. The following morn-
ing, the nation's newspapers, big and small, carried the story of McDaniel's
triumphant win. The black press also joined in the celebration. The *Los
Angeles Sentinel*'s front page bore a photo of McDaniel with a large
caption reading "Winner." A headline on the *California Eagle*'s theatri-
cal page proclaimed, "Hollywood Applauds Hattie McDaniel as She Re-
ceives Award." That spring, her portrait appeared on the cover of the
NAACP's *Crisis*. "I realize that this is another hurdle that has gone down
before the Negro and his art," McDaniel told the *Pittsburgh Courier*. "I
consider this recognition a step further for the race, rather than personal
progress."[1]

McDaniel was not the only one who interpreted her award as having much broader significance. Many heralded it as proof of America's greatness; the actress refilmed her acceptance speech for newsreels to be shown throughout the country. "This is more than an occasion," Fay Bainter, who had presented the actress with her award, declared. McDaniel's Oscar, she said, was a testimony to the truly democratic nature of a society where "people are free to honor noteworthy achievements regardless of creed, race, or color." Hattie McDaniel's Academy Award was not just an acknowledgment of her talents. During such uncertain times, it became a symbol of the difference between the egalitarian ideal of the United States and the totalitarian threat of Nazi Germany.[2]

These were heady days for Hattie McDaniel. In April, she threw a big party to celebrate, inviting her closest friends, including Ruby Berkley Goodwin and a number of black film-colony colleagues. During the festivities, a telegram from Washington, D.C., arrived, bearing the names of five thousand admirers who congratulated her on her "brilliant work." Ernest Whitman entertained the crowd with his impression of Paul Robeson singing "Old Man River." The hostess herself stepped in and performed devastating impressions of white comedienne Fanny Brice and actress Helen Morgan, who had played the mixed-race Julie in *Show Boat*. Hattie McDaniel may have moved closer to becoming a part of the Hollywood establishment, but she remained unable to resist the impulse to offer up a little satirical commentary. Despite years in the film industry, she had not entirely lost her edge.[3]

Hattie McDaniel was also growing increasingly hopeful. Criticism of her in the black press abated somewhat as attention shifted toward her breakthrough award. With her long-term contract with Selznick and the accolades for her performance as Mammy still pouring in, McDaniel was certain that her film career was on the upswing and that it all portended a brighter future in Hollywood for African Americans. She anticipated that moviemakers would finally see the wisdom of creating a wider range of roles for black performers. The actress's camp reported that Selznick International had "intimated that it plans to give Miss McDaniel outstanding parts" specifically crafted for the actress. McDaniel also made public her aspirations to play "a modern" part, one of a "courageous, lovable

Negro mother." These were, as Ruby Berkley Goodwin recalled, "joyous sun-lit days" for Hattie McDaniel.[4]

Although times were good, Hattie McDaniel knew well that she still faced an uphill battle as a black woman in the film industry. While her comments to the press were attempts to apply a little pressure on Selznick, she continued to deal with white Hollywood cautiously. After the Academy Awards, William Meiklejohn suggested that they negotiate for a higher salary, but the actress refused. Almost immediately some black journalists charged her with "Tomism," alleging that she was only echoing the deferential behavior of *Imitation of Life*'s Delilah who turned down her portion of the pancake-mix sales. McDaniel countered that a post-Oscar raise would not necessarily translate into more earnings. As a Hollywood insider, she had watched other actresses, black and white alike, including Louise Beavers, Greta Garbo, and Hedy Lamarr, receive salary boosts only to be laid off for long periods by the same studios ultimately reluctant to really pay out the higher wages. It was more important to remain before the public eye. "Big salaries and little work don't interest me," she told a reporter. "I don't want more money, I want more work."[5]

Despite proceeding with care (and relying on a small amount of manipulation), McDaniel found that Jimmie Fidler's gloomy predictions were coming true. Selznick was hardly planning to place her in better roles. The producer focused on cashing in as quickly as possible on Hattie McDaniel and was convinced that her value was far greater on the radio than on the screen. He was determined to develop a radio series around the actress, one in which she would play some iteration of the Mammy character, possibly even Aunt Jemima.[6]

In January 1940, even before McDaniel had won the Academy Award, Selznick pitched his proposal to CBS's William Paley. As a demonstration of McDaniel's radio potential, the producer booked her to plug *Gone With the Wind* and sing on NBC's *Good News of 1940*. He urged Paley to tune in. Immediately lukewarm to the idea, the radio giant passed the task on to an assistant and, after receiving his report, turned Selznick down flat. Paley insisted that the actress's singing talents were at best modest and dismissed the series idea as completely untenable. No black woman had ever starred in her own radio show, Paley asserted, contending that attitudes of

Southern audiences would preclude such a venture from succeeding anyway.[7]

Selznick remained confident that McDaniel could successfully headline a very lucrative show. At his insistence, his staff compiled a list of all potential Mammy vehicles, mostly stories written by white Southern writers. Selznick also secured all the rights to the title "Mammy" for use both on radio and in film. "I think we might sell the combination of this title and McDaniel to some independent producer for a lot of dough," he wrote to Val Lewton.[8]

Like other film actors under long-term contracts, Hattie McDaniel soon discovered that she had amazingly little control over her career. Such agreements gave studio heads complete power over performers. McDaniel now could only work for Selznick, and he made all decisions regarding her future. Finding his radio idea stalled, he loaned Hattie McDaniel out to Fox studios for a Walter Brennan and Fay Bainter film *Maryland*. McDaniel rapidly realized that her part as a cook named "Aunt Carrie" was hardly an improvement. In fact, it forced her back into a secondary role as a comic-relief character. Additionally, Selznick, fearing the project might compete with *Gone With the Wind*, insisted on dictating her approach to the part, hemming her in even further. He so jealously guarded McDaniel's interpretation of Mammy he actually asserted that he owned her specific style. The actress received a stern warning not to replicate any of her "tricks of characterization" that had distinguished her portrayal of Mammy. Selznick eventually began rejecting potential roles for McDaniel. At one point, when offered a major part for the actress, he sent Hattie Noel to test instead. Selznick's possessiveness stifled the actress's career, robbing her even further of her most powerful tool, that unique ability to signify and back-talk that had so empowered her earlier characterizations.[9]

McDaniel's assignment to *Maryland* was nothing short of a letdown. Although she managed to work a little crankiness into the role and she was allowed to sing, she was forced to mute many of her trademark signals of resistance. Gone was the spark, those unhidden grimaces and the stinging comedic undercurrents along with the important dramatic moments. McDaniel's character reverted to the most degrading simplemindedness. She ogles a large ring, exclaiming, "My, my, just wait 'til I strut down the

church aisle with this." McDaniel's delivery now seemed far more mindlessly happy than intentionally haughty. Even worse were the other black characters that she had to play against. McDaniel's sassing is confined to the foolish, dice-throwing, deceitful Shaddrack, her cinematic husband played by Ben Carter. The black WWI-veteran-turned-lazy-stable-hand Aleck, played by the lanky Darby Jones, emerged as a reincarnation of Stepin Fetchit. Clarence Muse, cast as a minister, provided gripping musical sermonizing, but nonetheless, the black church appeared silly and overly emotional. *Maryland* was proof positive that Hollywood was hardly ready to surrender its grip on black stereotypes.[10] When the film was released in the summer of 1940, white reviewers praised it and McDaniel's contributions. "It isn't the white folks who steal the show," wrote Louella Parsons of the *Maryland*'s premiere, "but Hattie McDaniel and Ben Carter who were so funny that the audience last night applauded them."[11] But the black press was hardly impressed. While the *California Eagle* acknowledged McDaniel's performance, it rated the production as "mediocre" overall. Earl Morris maintained that while the actress "[came] through with flying colors," the part was far beneath her. "Many actresses of her magnitude . . . would not have taken a subordinate role," he noted.[12]

Although she had made clear her aspirations for better parts, Hattie McDaniel found she had little choice—she was under contract and had to accept what she was given. It was a dilemma faced by even the most popular stars, both black and white, under long-term agreements. They played the roles they were assigned or they were forced from the business. Even the biggest stars resorted to desperate tactics to compel the studios to accede to their wishes. James Cagney walked out. Bette Davis tried to escape to Europe to do films there, but a court, at the studio's behest, slapped her with an injunction for violating her contract. When Olivia de Havilland tried to buck the system, she received similar treatment. (It was de Havilland who, in 1947, won a suit against Warner Bros. that broke the all-consuming grip of studio contracts over players.) Katherine Hepburn, Eddie Cantor, and Carole Lombard fought losing battles with their studios. A long-term studio contract was like "bed and board in jail," Bette Davis recalled. "I had not one whit of freedom as an artist." Film performers discovered that even their agents had little influence over their specific

situations, other than to plead or cajole producers. Hattie McDaniel was no exception and probably had even fewer avenues of recourse. During important negotiations, even her own agency, MCA, referred to her disparagingly as "this girl."[13]

As the filming of *Maryland* wrapped up in early spring 1940, it became apparent that there was no radio deal in the offing for McDaniel. With nothing for the actress on the horizon, Selznick was becoming increasingly anxious. Despite the producer's plans, McDaniel had her own ideas and was pressuring him to send her out on a personal-appearance tour to promote both her talents and his film. It was common for Hollywood producers to market their films by sending their stars out to play in vaudeville-type revues in movie houses nationwide. And, even before *Gone With the Wind* had finished shooting, McDaniel was wagering that MCA would easily secure engagements for her. On the film's set, she had begun working up her act, as Susan Myrick had discovered. After completing *Gone With the Wind*, she hired a singing coach and commissioned a seamstress to make replicas of several of her costumes from the film. MCA reported that even before the film was released they received an avalanche of requests for her to make personal appearances.[14]

Selznick resisted the personal-appearance-tour proposal. Such arrangements required a sizable initial financial outlay and tendered unpredictable returns. But facing few other alternatives and McDaniel's continued insistence, the producer eventually capitulated. In March, when *Gone With the Wind* was being released for the first time to black movie houses, he decided McDaniel could be used to promote the film with African-American audiences. He sketched out an arduous itinerary and insisted to his assistants (who were immediately skeptical) that "in the smallest and worst of these theaters, particularly if we had one or more personal appearances per theater of Hattie, the advanced admission would, if anything, make them treat it as even more of an event."[15]

Hattie McDaniel balked at Selznick's plans. Politely but resolutely, she responded through William Meiklejohn, who telegrammed the producer: "HATTIE MCDANIEL ALSO ANXIOUS TO PLAY COLORED HOUSES BUT PREFERS PLAYING WHITE HOUSES FIRST."[16]

Hattie McDaniel again found herself in a struggle to break down an-

other racial barrier. She was determined to become one of the first African-American actresses to embark on a major tour of the nation's most prominent movie palaces. Louise Beavers and Fredi Washington were the only black actresses who had previously been sent out for such tours, and they had played both black and white theaters. Personal appearances were the benchmark of making the big time; McDaniel was insistent that she be booked in the same theaters as any other Best Supporting Actress honoree. She resisted what really must have seemed like an attempt to Jim Crow her, to segregate her into black theaters only. Additionally, Hattie McDaniel had already worked hard on her act; it was subtle but it was targeted at white audiences.[17]

Despite McDaniel's objections, it was Selznick insiders who compelled the producer to back away from his plans. They convinced him that most African Americans could not afford the higher ticket prices that had to be charged to cover personal appearances, and that profits would be minimal. So Selznick worked out a compromise with McDaniel. He agreed to pay her $125 a week bonus while on tour, to pay for her maid, and to cover all traveling expenses. McDaniel would play mostly white theaters but also make appearances at two African-American movie houses, both major black venues on the East Coast.[18]

On April 11, Hattie McDaniel tried out her act at Glendale's Roxy Theater. The crowd that night was sparse—only a quarter of the seats were filled. But in the audience sat Ray Klune, Selznick's production manager, who had been dispatched there to report on McDaniel's act and secure a copy of the script. Selznick had an early draft, but the actress had neglected to submit a final version for his approval. That evening, Klune first approached Meiklejohn, who claimed he had never seen any script. Next he tried McDaniel. She assured him that she barely deviated from the original draft and ad libbed all new material. All Klune could do was provide Selznick with a written summary of what he saw that evening.[19]

The curtains parted, a piano struck up Al Jolson's hit "Mammy," and Hattie McDaniel, costumed as her character from *Gone With the Wind,* greeted the crowd: "Oh, how do folks? I didn't know you all was out here. You know, I just about forgot I had a real honest-to-goodness audience, after lookin' at you all from the silver screen so long." She followed with

a little veiled sarcasm. "I don't know it just does something to me (in here)—just to see your happy faces, or should I say—smilin' faces?" She announced with a large grin, exaggerated to convey its insincerity, "Yes, sir, there ain't nothin' like a real honest-to-goodness smile—that is when you mean it."[20]

She then launched into a re-creation of two scenes from *Gone With the Wind*. Surprisingly, neither was the sentimental staircase scene with Melanie Wilkes, the one that reportedly won her the Oscar. Rather she chose two spicier examples—Mammy's confrontation with Scarlett over Ashley Wilkes and the petticoat scene that ended with "My goodness, Mr. Butler, you is bad." This gave her a chance not only to rework Mammy a little but also to parody the white characters now so firmly enshrined in the white-American imagination.[21]

She followed with two original songs, tellingly titled "Mammy's Meditation #1" and "Mammy's Meditation #2." "You can talk about your Mammy, dear ole Mammy, yes of yore," McDaniel began in "Meditation #1," ". . . but things is changin' nowadays, an' Mammy's gettin' bored." With McDaniel's revision, Mammy casts off her household duties for some "swingy music" and a little fun. "Mammy must have some rejuvenation, razzmatazz and syncopation," she sang out. There was certainly more to her life than serving white people and raising their children. Unlike cinema's slow-moving, traditionally asexual figure, this rebellious Mammy was a woman full of energy and sensuality. "I saw you last night and got that ole' feelin'," McDaniel belted out. "The moment you danced by I felt a thrill." Still, despite Mammy's attempts to break out, McDaniel's number ended on a note of resignation. "Oh well, what's the use," she sighed. "I guess she'll always be, always of yore, people singin' songs about her around their cabin door."[22]

McDaniel's second meditation was a satire on old-time Mammy songs popular since blackface minstrelsy's heyday. Now Mammy was returned to her proper place, complacent and elderly, sitting with her corncob pipe on her porch. She apologizes for even contemplating rejecting her place, satisfied "just to think about that Swanee shore." She also fondly recalls her days of loyal service: "I want my chillun I nestled to me breast, black an' white with so much zest." Although emotionally over the top, McDaniel's

lyrics alluded to the exploitation of black women in slavery, making a concealed reference to one of the most difficult demands on African-American women in bondage—that of wet nurse. These women fed and nurtured white children, while their own often went hungry and without their mothers' comfort. The song's plaintive cry, "Give me back my babies—my babies of yore," conveyed more than just the standard sentiment of Mammy songs. It was also a remembrance of those black women separated by bondage from their children—those grandmothers Hattie McDaniel never knew.[23]

McDaniel had another surprise in store. "Well folks, I've changed my mind; I guess I'll have one more fling before I go home," she announced as the act came to a close. And with that, she belted out a contemporary bluesy ballad, "Comes Love—Nothin' Can Be Done." This allowed McDaniel to harken back to her earlier days of cunning double entendre, for the song was rife with potentially suggestive lyrics: "Comes a rainstorm—Put rubbers on your feet/Comes a snow storm—You can get a little heat." While it was all a little ambiguous for audiences ignorant of her torchy stage performances, Hattie McDaniel, at least for the moment, resurrected her defiantly bold blues queen persona.[24]

The predominantly white Glendale audience gave McDaniel a warm round of applause. Indeed, as the crowd reveled in seeing Hollywood's recently crowned Best Supporting Actress, McDaniel was stealthily deploying a rejection of Mammyism and of the stereotyped mask Hollywood had forced her to wear for so long. While her deeper messages went over the heads of her admiring white fans, the *California Eagle*, which had had a sneak preview of the act, immediately recognized McDaniel's intentions, hailing it as a "burlesk on Mammy" that had "all the earmarks of a 10 karat wow." Although McDaniel had remained publicly silent on her opinions of *Gone With the Wind*, she used the act, composed in part on the film's set, to speak out. As the *Denver Star* had pointed out in her youth, comedy could be used to respond when all other channels appeared closed. For those who really listened, McDaniel made clear that she found Selznick's historical dramatization of slavery, the Civil War, and Reconstruction ridiculous.[25]

It was apparent why McDaniel wanted to play this act to white audi-

ences. While the more serious implications of her performance would escape most whites, it was her one chance to look white people in the eye and undermine their racist fantasies with a confusing and unexpected alternative to the Mammy stereotype. And if whites missed the point, it was all the more powerful. For the joke really was on them. They were laughing at an image that reflected back their own weaknesses and foibles, ultimately a mockery of themselves.

Selznick's production manager Klune certainly was duped. His only criticism was that McDaniel's routine was a little short—it ran only ten minutes. But he heartily endorsed it to Selznick, reporting that "the act went over big" and predicting it would "be very successful," especially with a full orchestra. However, Selznick was not convinced. He found the whole thing puzzling, complaining that in some places it was too "sloppy and sentimental" and in others it veered into material that was inappropriately "sexy." While he could accept the former, the latter had to go. He reminded his vice president of production, Daniel O'Shea, of an earlier controversy over McDaniel's performance in one of his previous films, *Nothing Sacred*, indicating that she had added something during filming he considered improper. (What happened remained unclear, for in the final cut, McDaniel made only a brief, innocuous appearance as a jilted wife.) Selznick was determined that nothing would jeopardize his investment in the actress and viewed her in a strictly patronizing way. "She will, if we don't watch out," Selznick warned O'Shea, "rob herself of stature as a performer by stooping to cheap things."[26]

It was April 25, 1940, and Hattie McDaniel was already in a Chicago dressing room, preparing for her personal-appearance tour's debut, when she received a letter from O'Shea. He bid her good luck and assured her that the Selznick company was confident that her act would be a smash. But he also strongly urged her to make some changes in the act, to delete a few lines from "Mammy's Meditations #1." It is not entirely certain that McDaniel complied either in Chicago or anywhere else on the road, because ad libbing allowed her to alter her material to fit her mood and her audience. But regardless, she did incorporate a dance routine, described by *Variety* as "low down strutting," that may have countered Selznick's attempts at defusing the act's suggestiveness. Chicago's fans did

not mind seeing McDaniel's saucy side, offering her a big hand on open-ing night.[27]

For two weeks, Hattie McDaniel held forth on stage at the Chicago Theater, sharing the bill with the Andrews Sisters and Red Skelton. But it was hardly a smooth start to the planned twelve-week, nine-city tour. McDaniel arrived in town sick and spent the first few days convalescing in seclusion. When she did emerge, to attend a tribute to her at the Swing-land Café and to pay a visit to *Chicago Defender* columnist Bob Hayes, she was still ailing. To add to it all, ticket sales for her first week were satisfac-tory but less than expected. The second week, the box office sagged, leav-ing the overall take good but hardly spectacular.[28]

The third week, McDaniel was supposed to play Pittsburgh. But Fox abruptly demanded she return to Los Angeles by plane for retakes on the yet unreleased *Maryland*. She initially resisted, claiming that she was afraid to fly. But Selznick's staff insisted, and McDaniel was forced to cancel Pittsburgh to make her way back to Hollywood. Fox protested when they saw that she charged them not only for her expenses but for those of her maid as well.[29]

By May 17, McDaniel was back on the road, opening at Baltimore's Royal Theater, a movie house catering to the African-American commu-nity. The following week took her to another black theater, the Lincoln, in Washington, D.C., where, according to the *Baltimore Afro-American*, McDaniel "[took] the town by storm." The theater owners there threw her a special breakfast and invited reporters. The Sigma Gamma Rho sorority honored her at the last show, presenting her with flowers. In turn, she answered questions from the audience and treated them to her impres-sions of Sophie Tucker and Mae West.[30]

On the surface, McDaniel's stint in Washington, D.C., looked success-ful. However, the box office told a different story. Washington's black au-diences proved cool to McDaniel's appearance, and ticket sales were sluggish. It was hardly a welcoming environment. The previous March, when the Lincoln had staged an elaborate opening of *Gone With the Wind* for black audiences, picketers lined up outside of the theater carrying signs reading YOU'D BE SWEET TOO UNDER A WHIP and GONE WITH THE WIND HANGS THE FREE NEGRO. Despite her Academy Award, Hat-

tie McDaniel's performance as Mammy remained an insult to many African Americans. By now, most had only seen McDaniel in white films. It had been many years since she trouped black theaters, and most African Americans had no exposure to the early, satirical McDaniel. Without this context, it was hard to read McDaniel as representing anything other than the traditional, demeaning stereotype. As a result, by the week's end, the Lincoln had lost money. Angrily, the theater demanded reimbursement from Selznick. It was flatly denied. "Perhaps it may be that Miss McDaniel, despite her color, is better suited to the white theaters," MCA's Phil Bloom speculated to the theater's management, copying Selznick on the correspondence. "At least this was mentioned to us by a couple of people who have seen her work on stage."[31]

On May 31, 1940, McDaniel arrived in Manhattan to prepare for a grand opening at the Paramount Theater. Before beginning rehearsals for her show, she first attended services at Adam Clayton Powell's Abyssinian Baptist Church and gave a lengthy interview to the *New York Amsterdam News*. "If you keep trying, something is bound to happen," she insisted was her key to success. "Whether or not it is in your favor is a matter only you can decide." She was optimistic about the future of African Americans in Hollywood cinema. It was just a matter of time before "color will become incidental." While she acknowledged that there was discrimination in the industry and that change would be gradual, it was coming. "Success in the industry is based almost entirely on ideas . . . ," she contended. "And even though we're sometimes handicapped because of color, I am firmly convinced that real and original ideas know no color lines."[32]

McDaniel's upbeat tone was probably due in part to the fact that the Paramount Theater was one of the nation's largest and most impressive movie houses. Backed by the Harry James Orchestra and sharing the bill with the dancing team of Buddy and Vilma Ebsen, her act received glowing reviews. "She can entertain and plenty," remarked *Variety*. "She even tops 'em off with a dance and they keep howling her back for more." But no matter how dazzling McDaniel was, she could not overcome being billed with a weak Paramount feature, *The Way of All Flesh*. The first week's receipts were rated by *Variety* as "disappointing," and the second week's were the worst in five years.[33]

The tour's final leg brought McDaniel back to the Midwest, with her first stop in Milwaukee, the town where she had been stranded penniless just over a decade earlier. Selznick's publicity people made the most of it and dug up Sam Pick for a press release. He confirmed that McDaniel had started as a bathroom attendant and recounted how, by accident, he discovered her latent talents and put her on stage to perform. His interview, picked up by journalists around the country, offered a classic rags-to-riches story—one that reminded everyone of McDaniel's humble and nonthreatening origins. But it also served as a beacon of hope for working-class black Americans. "Left a Maid, Returns a Star," read a headline in the *Baltimore Afro-American*.[34]

The next week came Cleveland, where McDaniel opened on the Fourth of July. For eight days, she hit the boards there, this time bringing in, by *Variety*'s estimate, "good coin." She also received an invitation to appear on the popular Sunday-morning devotional radio show *Wings Over Jordan*. Created by Reverend Glenn T. Settle, pastor of Cleveland's Gethsemane Baptist Church, *Wings Over Jordan* was the first national radio show completely written and produced by an African-American team. Each week, listeners from around the country tuned in to hear Settle's stirring sermons, the soaring melodies of the acclaimed *Wings Over Jordan* Choir, and an uplifting message from a respected African-American leader or role model. The show's goals were twofold—to provide spiritual meditation as well as promote racial harmony. McDaniel had been a fan herself; she claimed she had listened to it on Sunday morning for years.[35]

Since the invitation offered no compensation, it presented some problems with McDaniel's contract. However, Selznick's staffers figured out a way to squeeze in an appearance while she was playing Cleveland so that it did not interfere with her obligations to the producer. On Sunday morning, July 7, she arrived at Cleveland's WGAR early, with a prepared script. Surprisingly, the usually confident McDaniel sounded anxious as she began to read. The actress's unease was understandable: to find herself as an invited guest on *Wings Over Jordan* was a special honor. Even more unsettling was that Selznick's assistants had insisted on reviewing and approving what she was going to say. McDaniel still tried to use it as a chance

to speak directly to the public and, although filtered by Selznick, to offer at least some of her own thoughts and opinions.[36]

Hattie McDaniel began her message contending that her achievements were not individual but representative of the collective potential of the African-American community. "I feel no great personal pride for my contribution to the world of art," she stated in a shaky voice. "Rather, I feel that the entire fourteen million or more Negroes have all been raised a few notches higher in the estimation of the world." She also addressed the topic of blacks in Hollywood, answering those who criticized her for taking the role of Mammy, vehemently denying that she was "selfish" in pursuing it. McDaniel insisted to *Wings Over Jordan*'s listeners that her true goal was to give her own interpretation to the role, to make Mammy "a living, breathing character, the way she appeared to me in the book," again underscoring it as a tribute to those women who had struggled in and against slavery. She also offered encouragement to the younger generation, based on her personal philosophy, a blend of Booker T. Washingtonian principles of hard work, self-help, and the power of positive thinking. "Do not become discouraged if the world does not accept your offering at first," she advised, no doubt remembering her own struggles. "Remember—success is word and thought put into action—GO ONWARD AND UPWARD."[37]

By Friday, July 12, Hattie McDaniel was back in Chicago for one more week, this time opening at a matinee at the State Theater for MGM's *Strange Cargo*. The ticket sales this time were strong and, as a result, the tour overall proved profitable for Selznick. Although he paid McDaniel $625 weekly, he charged most theaters $1,500 plus a portion of the box-office proceeds for her appearances. While it hardly generated a windfall, it was much better than letting her remain inactive.[38]

Once back in Chicago, McDaniel received another pro bono request. This one came from Claude A. Barnett, founder of the Associated Negro Press wire service, who invited her to participate in Chicago's American Negro Exposition, a celebration of the seventy-fifth anniversary of Emancipation. Barnett hoped to include McDaniel in the *Cavalcade of Negro Theater*, written by Harlem Renaissance authors Langston Hughes and

Arna Bontemps. Although Selznick stood to make virtually nothing out of the deal, he permitted McDaniel to accept the engagement, preferably during the layoff period that was about to commence once her week at the State Theater was completed. That way, it was all on McDaniel's dime.[39]

But the actress was hardly enthusiastic about the arrangement. By the end of the tour, she was exhausted. Even during her *Wings Over Jordan* broadcast, it was apparent that she was ill again; her voice, stretched thin over almost three months of nonstop performing, was hoarse. It had been over eleven years since McDaniel had toured, and Selznick's schedule, which often required her to do several shows a day over the three-month period, had eroded her health. Furthermore, her inclusion in the American Negro Exposition was quickly turning out to be a major fiasco. The event was riddled with financial and organizational problems. Barnett first scissored and then completely cut the *Cavalcade of Negro Theater*. By this point, McDaniel had become acquainted with both Hughes and Bontemps and certainly must have been aware of their subsequent disenchantment. Instead, Barnett planned for McDaniel to appear during the intermission of *Chimes of Normandy,* a musical scheduled to open July 20.[40]

On July 17, with her Chicago dates coming to a close, Hattie McDaniel telegraphed Daniel O'Shea. "I'm ill and I want to come home for a rest," she wrote. "I'm positive there will be no hard feelings with my race—as I understand them." With that, she canceled her appearance at the Exposition and boarded a train bound for Los Angeles.[41]

McDaniel's sudden decision to head home may have had been motivated in part by a desire to be present when she, along with Ben Carter, Clarence Muse, and Louise Beavers, was honored with a special award from the Motion Picture Division of the NAACP at the San Francisco World's Fair in late July. By early August, she was back in Los Angeles; the *California Eagle* described the returning McDaniel as "tired but still smiling." But she arrived to find that Selznick had failed to line up anything for her. By then, she had been under contract to him for almost nine months and had done only one picture. Selznick's staffers had begun working on yet another possible radio series—this one titled *Hattie and Hambone.* McDaniel would be paired with an African-American actor

who would play Hambone, a black cartoon character created by white Southerner J. P. Alley and known for his simple, homespun wisdom. (She may have triggered the idea herself with her "Mammy's Meditations" during her personal appearance tours; Alley's cartoons were called "Hambone's Meditations.") Popular for years, Hambone had a particular perceptiveness but still reinforced many elements of black stereotypes. Selznick's staff worked hard on the concept—there were no takers for this idea either.[42]

Like many under contract to Selznick, McDaniel discovered that involvement with the producer could be stifling. Selznick's own output was small, and he signed up actors, directors, and other studio employees not so much intending to use them in his films but rather hoping to loan them out for lucrative fees. (Several players with Selznick contracts never even worked on one of his pictures.) This placed performers in particularly precarious positions, basing their value more on his ability to market them than on their usefulness to him as artists. Selznick drove hard bargains, asking outrageously high fees for his array of rentable employees, including Joan Fontaine, Ingrid Bergman, and director Alfred Hitchcock. That also operated to the actors' detriment, often precluding them from securing the best roles. It was an uncertain existence, and many in his stable became, like Hitchcock, openly resentful of Selznick's practices and micromanagement. Some felt that accepting a contract with the producer did much more to hinder than help their careers.[43]

Although Hattie McDaniel still had MCA, her contract basically put Selznick in complete control of her destiny. And it was not a happy situation. As fall 1940 rolled around, her career was virtually at a standstill. Growing more dissatisfied with the relationship, Selznick remained determined to wring as much profit from her as possible. When she informed him that she was headed to New York City to be honored by Eleanor Roosevelt as the "Outstanding Member of the Colored Race in the Theatrical Field" at the World's Fair, he instructed his Manhattan office to schedule her for a couple of weeks of personal appearances at the Loews Theater. Kay Brown reported back that Loews had brusquely declined to book the actress, insisting that they could not accommodate his last-minute requests. But Brown actually believed that Loews's response derived from

something deeper than inconvenience, that the management had become "chary of Negro acts prior to the election." Indeed, the presidential race, with incumbent Democrat Franklin Delano Roosevelt pitted against Republican Wendell Willkie, increased racial tensions in the city. Brown implied that Loews's real fears were that McDaniel would draw integrated audiences to their theater and that violent clashes would ensue. Such overblown concerns echoed the racist tenor of the era, the impediments that McDaniel faced despite having become one of Hollywood's most recognizable performers. Certainly, no fights had broken out among multiracial crowds at the World's Fair, where McDaniel accepted her award along with a special block of stamps commemorating the seventy-fifth anniversary of Emancipation.[44]

Shortly afterward, the actress received an urgent request from Selznick International, still looking for ways to benefit from their commitment to her. One of their greatest hurdles in promoting the actress was securing all-important coverage in fan magazines, the mainstay of movie consumers. These publications targeted white women and, in doing so, devoted their coverage to white stars, especially white actresses who often offered advice on fashion, beauty, and love. Such counsel from a black woman, even a Best Supporting Actress, was deemed inappropriate. Yet, Selznick's publicity people hit on what they thought was an ingenious plan, deciding that there was one area where advice from a black woman would be most welcomed—cooking tips. They demanded that the actress promptly send them copies of her favorite recipes, those that she had perfected working for white families over the years. McDaniel was cool to the idea, responding that she could not immediately provide any recipes since she cooked without them. But, after a noticeable delay, she submitted a commonplace selection of recipes for corn bread, greens, icebox cake, and one called "Mammy's Fried Chicken à la *Maryland*," a plug for her most recent film. They hardly contained any culinary secrets. And it was no wonder. Ironically, the woman who had worked so hard to escape a career as a maid, only found herself, an Academy Award–winning actress, ordered back into the kitchen by her white employer. Success for Hattie McDaniel was indeed bittersweet.[45]

By that fall, Selznick's staff had calculated that McDaniel was losing

money for the studio—that the producer was far from breaking even on his investment. Although Selznick fretted over McDaniel's lack of profitability, the only prospect that had come along was an offer from the Warner Bros., a studio that he had found difficult to negotiate with in the past. Believing that Selznick was missing a tremendous opportunity by leaving McDaniel idle, Warner Bros. had created a part for her as Violet, a black maid in a Bette Davis vehicle *The Great Lie*. After moving along sluggishly, Selznick eventually assigned Val Lewton to review the script. The story editor returned with a ringing endorsement, contending that it was a significant improvement over McDaniel's role in *Maryland* and assuring the producer that in no way would it compete with her characterization in *Gone With the Wind*, which still held strong in theaters throughout the country. "She has opportunity for comedy, pathos, display of screen loyalty, and several minor dramatic scenes," Lewton reported. Desperate to recoup his losses on McDaniel, Selznick gave the project the go-ahead.[46]

In late October, Daniel O'Shea opened talks with Warner Bros. by demanding an extraordinary $12,000 for McDaniel. Warner Bros. recoiled at the amount. But the studio wanted McDaniel so badly that Jack Warner personally called Selznick to bargain for a lower fee. After some tense exchanges, the Warners agreed to pay Selznick $9,640 and to take over McDaniel's contract, allowing the producer the option of having her back for one film a year.[47]

In November, almost immediately after Hattie McDaniel returned from New York, she was called to the Warners' lot to begin work on *The Great Lie*. In addition to Bette Davis, the cast included Mary Astor and George Brent, as well as Hattie's brother, Sam McDaniel. From the onset, the production was plagued with problems. Davis clashed with the studio and told the press that she did not anticipate this would be one of her particularly significant movies. (It was her subtle way of protesting against what she considered a grossly inferior role.) Fearing that the outspoken actress might sabotage the film before it even hit the screen, the Warners barred journalists from the set and made efforts at blocking Davis from doing any more interviews. Once filming began, flu spread through the cast, at one point almost bringing filming to a halt. That delay forced Hat-

tie McDaniel to decline an invitation from the city of Atlanta to join them—on stage only, of course—for a one-year anniversary celebration of *Gone With the Wind*'s premiere.[48]

At least some of the production's setbacks were actually McDaniel's fault. Rushed into the part with no consultation, she had little time to prepare and seemed unsure of herself. On her first day on the set, she was handed two new pages of dialogue cold. But rather than rapidly learn the part, as she normally did, McDaniel simply could not remember her lines. It cost the company almost an entire day of filming.[49]

It is possible that McDaniel was either consciously or unconsciously resisting this role. She had been thrust into the film with little deliberation and summarily passed off to the Warners. The treatment must have both discouraged and hurt the actress whose contribution to *Gone With the Wind* was widely acknowledged as helping the film already gain the status of celebrated classic. Despite Val Lewton's enthusiasm, the role of Violet was not at all what McDaniel had in mind. The character was yet another devoted and emotionally overwrought servant who lived only for and through her white employer, hardly an improved image of African-American womanhood. (The studio had cut the only progressive element from the script—portions of a scene critical of the Ku Klux Klan. They feared the KKK would sue them for libel.) Although when the picture was released in April 1941, *Variety* praised McDaniel's performance, their critic complained that Violet's "unfettered emotions" were "oddly utilized to express what was in her mistress's apprehensive heart."[50]

Although she received good notices for *The Great Lie,* McDaniel was facing an increasingly discouraging reality. The film industry was a fast-paced business, and movie fans had incredibly short memories. As each day passed, her cinematic worth rapidly declined. In some ways, she was now fighting on two fronts. First, she continued the battle as a black actress whose selection of parts was already limited. But second, she now suffered from what some called the "Oscar curse." A number of Academy Award winners found that the honor actually impeded rather than promoted their careers. "Nothing worse could have happened to me," remarked two-time Best Actress winner Luise Rainer. The coveted Oscars changed the industry's perception of those who won them; these perform-

ers with their ultrastar status were presumed too expensive or too de-
manding to hire. Although McDaniel had attempted to circumvent this
impression by turning down a higher salary, she still could not completely
counter the Academy Award jinx. Often players like McDaniel found
themselves consigned to weaker films, studios hoping that their presence
would give such productions a little box-office jolt. For Hattie McDaniel,
her work following *Gone With the Wind* was purely disappointing as she
found herself thrust into substantially inferior vehicles and struggled to get
even those few roles. In assessing the achievements of black players dur-
ing 1940, the *California Eagle* named Louise Beavers, Leigh Whipper, and
Eddie Anderson top players of the year. In their opinion, despite her
Oscar, McDaniel's absence from the screen had "lost her 1940 race by for-
feit."[51]

McDaniel may have hoped that her new arrangement with Warner
Bros. might improve her situation. On the positive side, Warner Bros., un-
like Selznick International, was a large studio and much better equipped
to create internal opportunities for its contract players. There McDaniel
might have more opportunities to build her reputation within the studio.
Additionally, the company's founders Jack and Harry Warner produced
some of the period's most socially aware films. Although they had never
dealt with American racism, they had made such feature films as *Public
Enemy* with James Cagney and *Dead End* starring Humphrey Bogart, ex-
ploring poverty, crime, and working-class life. They often elevated com-
mon Americans to the status of cinematic heroes with films like *Meet John
Doe*, featuring a compelling, humble performance by Gary Cooper. Fur-
thermore, the Warners were outspokenly anti-Nazi and made concerted
efforts to turn out films that underscored the greatness of American dem-
ocratic institutions. There was the possibility, although seemingly remote,
that the Warners might offer her the role she had been seeking.[52]

Nonetheless, there were definite downsides to being sold out to the
Warners. Within industry hierarchy, they ranked near the bottom. The stu-
dio struggled in the shadow of more prestigious companies, perpetually
fighting to shake its image as a cut-rate venture specializing in B movies.
Moreover, its galaxy of stars, which included Bette Davis, James Cagney,
and Olivia de Havilland, was highly dissatisfied with the bosses. The

Warners worked their players long and hard hours. They often laid performers off for long periods and then enforced lengthy extensions of their contracts to make up for lost time. Although most movie bosses were autocratic, Harry and Jack Warner were regarded as the most extreme. The studio environment was laden with disputes; the most powerful performers often resorted to absenteeism in an effort to leverage fairer treatment or better roles. Although she could negotiate with Selznick on a very restricted basis, McDaniel would find it almost impossible to assert influence here.[53]

As McDaniel would soon find out, although the Warners could be overall more liberal than their Hollywood counterparts, their racial attitudes were not much more enlightened. Like Selznick, Warner Bros. viewed McDaniel's talents in rigid and limited terms. Jack Warner professed admiration for Hattie McDaniel's talents—not as a film artist in general but, more narrowly, as the "best colored actress in the world." By early 1941, it was apparent that the Warners were also going to do little to advance her career. Although they assigned her to appear in *Affectionately Yours*, a comedy starring Merle Oberon, Dennis Morgan, and Rita Hayworth, it was yet another disappointingly small role, diverging little from her past characterizations. After finishing that film, McDaniel found herself sitting and waiting for the studio to call.[54]

While her career had gone dormant, her personal life had picked up. In early January 1941, McDaniel received a visit from an old friend, James "Lloyd" Crawford. Short and stocky, yet with a gentle smile, Crawford was described as "genial" and "dignified." Reports of his occupation varied. Some sources listed him as in real estate; others claimed he was a prosperous rancher from Montana or Wyoming. There was also talk that he held investments in western mining interests. Regardless, his friendship with McDaniel dated back to her days in Chicago during the Roaring Twenties.[55]

What brought Lloyd Crawford to Los Angeles is not clear. But he decided to stay awhile. It was not long before he became McDaniel's very visible public escort. She appeared with him at social functions, including concerts given by Marian Anderson and Dorothy Maynor. Rumors rapidly spread, intimating that Crawford was more than just a pal. And what the

wags suspected was true. Sometime in March, Crawford presented McDaniel with a large, impressive diamond ring and asked the actress to marry him. Hattie McDaniel said yes.[56]

On March 21, 1941, Hattie McDaniel and Lloyd Crawford took a flight to Tucson, Arizona, where the two had arranged to be married. Upon arrival, McDaniel postponed the ceremony several hours until the bridal bouquet she had accidentally left behind in Los Angeles was flown in. She made the most of public relations opportunities resulting from the delay, touring Tucson's Dunbar Negro School and addressing the students as well as treating them to ice cream and candy. Finally, at five-thirty in the evening, with her bouquet in hand and smartly attired in navy blue, Hattie McDaniel said her vows at the Union Baptist Church. (The couple had planned a quick civil ceremony, but during their wait, they were talked into a church wedding by friends.) On the marriage license, Crawford gave his age as forty-five; McDaniel shaved almost five years off and gave hers as forty-three. "I, personally," she told the press, "intend to stay married forever this time."[57]

The whirlwind that followed was far beyond any normal romantic honeymoon. The day after the wedding, McDaniel and her new husband boarded an eastbound train for New York City. They stopped briefly in Kansas City, where a welcoming committee headed by Chester A. Franklin, a black newspaper editor, and Lee Davis, an old friend from the Morrison Orchestra, greeted the couple. At a brief stop in Chicago, the actress granted an interview to the *Chicago Defender*, insisting that she had never been happier. Then the newlyweds were off to Manhattan. But there was little privacy there. According to a *Baltimore Afro-American* correspondent, as the couple checked into Harlem's Hotel Teresa, they were engulfed by a crowd of admirers. A *New York Amsterdam News* photographer later snapped them "enjoying a waffle breakfast in their suite." McDaniel then put in one guest appearance on the Eddie Cantor show and another on behalf of war relief for Greece. She also paid a well-publicized visit to the Riverdale Colored Orphan Asylum, where she spoke before two hundred children encouraging them "to find out what you can do and then do it well." She then announced to reporters her intention to adopt a child in the near future.[58]

The couple rushed back to Chicago, where she performed at a fund-raiser for war-torn Great Britain. After a few days in the Windy City, she was off again, this time headed home to Denver for the first time in almost ten years. She arrived Saturday night, checked in at the home of her nephew Lorenzo Lawrence, and by the next morning was up and on her way to worship at Shorter AME. It was Easter Sunday, and a large crowd, including her former collaborator George Morrison and his wife, Willa, packed the church to wish her well. "She was overwhelmed with showers of praise and blessings from her former friends and school boys and girls of yesteryear," the *Denver Star* reported. The actress wept when speaking to the congregation about her parents. The afternoon brought a reception at Lawrence's home. Well into the evening, the actress received old friends, local black leaders, white lawmakers, and the Colorado governor, Ralph I. Carr, who came bearing a present—an autographed picture of himself.[59]

The next day was just as hectic. It started with breakfast at the Morrisons and a visit to the mayor's office, where McDaniel received the keys to the city. She was then whisked off on a specially guided tour of Denver. At noon, a group of black women, all state government employees, honored her at the upscale Tea Room of the Blue Parrot Inn. She stopped by the governor's office to drop off a photo of herself, personally inscribed to him, before heading off for a press conference with local journalists. During the press conference, McDaniel was gracious and cordial but endeavored to resist the media's attempts to link her with her screen characters. The *Denver Post*'s Frances Wayne, who covered the event, insisted that the actress not only appeared similar to her fictional persona but also possessed the "blurred drawl of the old deep south" and a "laugh as elemental as the sunrise or thunderstorm." What she missed was McDaniel's efforts at countering her film images. Arriving in mink, the actress did not hesitate to let white Denver readers know that she was financially quite comfortable, hardly anyone's housekeeper. "My pa's there [in Riverside Cemetery] in the Circle of Veterans of the Civil War," she told reporters— a reminder that her father had fought against the same Confederates lionized in *Gone With the Wind*. She spoke thoughtfully of her craft and also acknowledged that celebrity was fleeting and uncertain, involving compro-

mises that made both friends and enemies. "I've learned by livin' and watchin' that there's only eighteen inches between a pat on the back and a kick in the seat of the pants," she observed. As the gathering ended, she did something that some whites in pre-WWII America would consider radical. "This is an affectionate goodbye," she said, shaking Frances Wayne's hand, "because I believe in carin' for folks, even those I just met." Although the journalist accepted it as a gesture of friendliness, for a black woman to insist on taking the hand of a white person was a bold move in an era where customs, even in Denver, prohibited such familiarity.[60]

At four p.m. Monday, Hattie McDaniel and Lloyd Crawford climbed back on the train and steamed toward home. After three weeks on the road, the couple was ready to move in together in her modest house on West Thirty-first Street. But the homecoming proved almost as hectic as the honeymoon. Well-wishers began to appear at their door. McDaniel's old flame, Roscoe Conkling Simons, with a small entourage, dropped in for a visit. (He was a bit distraught over the marriage, later writing to McDaniel: "I love you, Hattie, and love your husband for having sense enough to fall in love with you.") Furthermore, the couple was almost immediately consumed with preparations for an elaborate Los Angeles wedding reception. They would greet guests on a white lambskin rug in a living room overflowing with white flowers and lush green plants. An elegant three-tiered wedding cake was ordered, and the dining room would be trimmed in white gardenias. McDaniel selected a white wedding gown for herself and a stately morning coat for her groom.[61]

Sunday afternoon, May 4, 1941, Ruby Berkley Goodwin formally presented Mr. and Mrs. James Crawford to over five hundred guests who gathered to celebrate their marriage. Members of the Sigma Gamma Rho sorority served cake and refreshments to the crowd, an interracial mix of famous Hollywood figures, friends, family, neighbors, and a smattering of fans. The *California Eagle* marveled at the affair and at McDaniel's ability to bring together such a diverse group. At eight o'clock the reception ended, and the day wrapped up with a dinner party for one hundred of Hattie McDaniel's closest friends.[62]

Lloyd Crawford had been Hattie McDaniel's husband for only six weeks, and no doubt, he already realized that this was not going to be a

traditional marriage. The actress would be no submissive, self-sacrificing wife. During her interview in Denver, McDaniel had made clear that she was the one in charge and intended to mold Crawford to her liking. This was her third marriage and his first; she knew what to expect. "The inner man doesn't come out until you've got him," she remarked to reporters. "It's my business, like in the Bible, to bend the twig to incline the branch." To add to McDaniel's take-charge attitude toward the relationship, her career continued to take precedence over everything else. She certainly had no plans of becoming a stay-at-home wife. It seemed that the veteran show-woman and her determined lifestyle early on overwhelmed her new husband. "He has the happy faculty of allowing his wife all the spotlight she so well deserves and maintaining his own individual charm without the least desire to 'steal the show,' " the *California Eagle* observed. At the wedding reception in Los Angeles, reporters ribbed McDaniel, who had vowed to never marry again. Her response indicated that an awkward distance already existed within her marriage. "It won't be long," she remarked about Crawford, "before he'll be just like one in the family."[63]

Crawford was entering McDaniel's life at a difficult time. Not long after returning to Los Angeles, she had high hopes of being loaned out to Paramount to work with Cecil B. DeMille in *Reap the Wild Wind*. But the Warners eventually pulled out of the deal. "They seem to have other plans for me that will keep me at the home studio," she wrote to Roscoe Conkling Simmons, sounding just a little dejected. She did not seem quite sure what those plans were. Hers was a frustrating position. After having enjoyed the status of an Academy Award winner for over a year, McDaniel was anxious about her future in Hollywood. She became increasingly restless, remaining essentially out of work for one of the first lengthy periods in years.[64]

Hattie McDaniel was not the only member of the black film-colony who faced a career slump. Over the previous year, cinema work for African Americans had dried up, and the number of black SAG members had declined significantly. To some degree, this was a reflection of a broader crisis in the industry. The war in Europe had cut off critical international markets and forced American studios to downsize their output. But, as the *California Eagle* argued, the problem for black performers

reached much deeper. Filmmakers remained dependent on typecasting, refusing to acknowledge the complexity of the black experience. The paper urged movie moguls to tap into the richness of the African-American experience—to create realistic roles reflecting true black life and use African-American extras in crowd scenes to reflect American diversity. The *Eagle* even asserted that McDaniel's achievement was a testimony to the benefits of abandoning typecasting and developing more complicated roles. "Hattie McDaniel won the Academy Award on her wonderful talent and trained ability, not her type," the paper declared. "If she had only weighed 100 pounds and have been four shades lighter in complexion, she would have earned the Oscar just the same." While that may have been true, the *Eagle* well knew that McDaniel would have never won the part if she had not fit the type. And now, despite her success at demonstrating that it was talent, not type, that mattered, it was type that dominated her career.[65]

This had been true not only with Selznick but also in her relationship with the Warners. Actually, Warner Bros. made even fewer attempts than Selznick at securing assignments for McDaniel and put very little effort into developing projects for the actress. Rather, the Warners had planned to plug her into features formulated for their white stars. Soon they were claiming that McDaniel just did not fit their needs and, by early June, had terminated her contract. However, within weeks, Warner Bros. did a rapid about-face and renewed it, a maneuver they commonly used with stars to force them to accept lower salaries. Internal Warner memos revealed that their specific problem in using the actress was rooted in their blind reliance on typecasting. Although McDaniel had proven her dramatic abilities in *Gone With the Wind*, she was still overwhelmingly regarded as a black comic actress. In summer 1941, Warners assigned her a bit part as a superstitious, rabbit's foot–carrying servant in Raoul Walsh's *They Died With Their Boots On*. Despite her Oscar-winning performance, McDaniel found herself entrapped by the image of the laughable female servant that had initiated her rise in the 1930s.[66]

In the fall of 1941, McDaniel came up against this label when she tested for what portended to be one of the most significant black female roles of the era—that of Minerva Clay in the Warners' drama titled *In This*

Our Life. The role had a serious angle, and studio advisors objected to using Hattie McDaniel, who they felt was suited only for comedy. After an evening spent reviewing screen tests of another contender for the role, Jack Warner rejected their apprehensions. "I am not worried about her getting laughs for they played her serious in GWTW," he wrote to his production head, Hal Wallis, "and I remember her part vividly." At his insistence, McDaniel was hired. It was an encouraging sign. Although a small role, Minerva Clay was just the character McDaniel had longed to play.[67]

In This Our Life focused on the tormented and deceitful Stanley Timberlake (Bette Davis), who steals the husband of her sister, Roy (Olivia de Havilland). Embedded within this tale of divided sisters is Minerva Clay, the Timberlakes' modest, hardworking housekeeper. Her son, Parry Clay, is a talented and determined young man; he plans a career in law and, to put himself through the university, also works for the Timberlake family. But Parry's ambitions are foiled. After a hit-and-run accident in which she kills a little girl, Stanley successfully convinces authorities that Parry is to blame. The police arrest and incarcerate him.

McDaniel had only three scenes. The first two, she delivered with her old verve and even sneaked in a couple of disapproving glances. But McDaniel took a decidedly different approach to the third scene, where Roy Timberlake visits Minerva in her home after the accident. McDaniel played Minerva with a dramatic flair she had never before had the opportunity to use on screen. With a quiet dignity, the clearly worried yet proud Minerva confronts the white woman with the truth not only about her scheming sister but also about the fate of African Americans in the justice system. Polite yet frank, Minerva proclaims her son's innocence. Authorities ignored Parry's protestations. "The police just come and took him off," she reveals to Roy, "and he tried to tell them but they don't listen to no colored boy." From behind bars, Parry Clay confirms that Stanley is guilty of the manslaughter charges she now faces. The film ends with his exoneration and with the selfish Stanley Timberlake dying in a fiery car crash.[68]

Certainly, McDaniel must have felt encouraged as she finished *In This Our Life* in early December 1941. To add to her hopefulness, Warner Bros. had arranged for her to immediately depart for two weeks of personal appearances with Count Basie's Orchestra at Manhattan's Strand Theater.

But before she could open, on December 7, she, like other Americans, had to grapple with a new reality. Japan had bombed Pearl Harbor and propelled the United States into WWII. As the country entered the conflict, the landscape of American culture began to shift. Back home in Hollywood, the studios now had the task of discerning not only what filmgoers would demand but what the government, concerned about rallying Americans behind the war, would allow. Although *In This Our Life* was ready by early 1942, Warners placed its release on hold. For the time being, McDaniel's only truly serious film role, the one she had longed to play, remained shelved.[69]

9

. . .

Quarrel

. . .

*I have no quarrel with the NAACP or colored fans who object
to the roles some of us play but I naturally resent being
completely ignored at the convention after I have struggled for
eleven years to open up opportunities for our group in the
industry and have tried to reflect credit upon my race, in
exemplary conduct both on and off the screen.*

Hattie McDaniel, *Pittsburgh Courier*, January 9, 1943

OUBLE V—VICTORY at home and victory abroad—became the
battle cry of the black community as the nation plunged into
the largest and deadliest war in the history of humankind. From
the African-American perspective, winning went far beyond protecting
the nation. Italy's invasion of Ethiopia, the last remaining independent
African state, and Hitler's philosophy of Aryan supremacy threatened peo-
ple of African descent everywhere. Furthermore, many African Americans
believed that victory abroad would only be meaningful with a victory at
home in the long, ongoing domestic struggle for civil rights. Seemingly, the
United States could not hypocritically continue to brag about its superior
democratic institutions while sustaining widespread Jim Crow laws and
disenfranchisement of black Americans.[1]

Although the majority of African Americans lived in segregation and
poverty and were denied equal education and employment, there was
hope that the war, which required the country to unite, would foster an en-
vironment favorable to the African-American cause. The Roosevelt admin-

istration concentrated significant efforts on easing, at least superficially, the nation's internal divisions, especially any racial unrest that might distract from fighting the enemy. And while FDR hardly intended to enact sweeping reforms to ensure racial equality, he was eager to court African-American citizens. Even before the U.S. entered the war, after considerable pressure, he had signed an executive order ending discrimination in defense hiring. After Pearl Harbor, the president and his advisors focused on public relations efforts aimed at cultivating black support. Most of this task eventually fell to the Office of War Information (OWI), which oversaw the dissemination of war news as well as the development of campaigns to rally Americans behind the long, hard fight. Through the OWI, the administration attempted to appeal to blacks with propaganda promoting the illusion of American racial inclusiveness.[2]

Early on, Hattie McDaniel became a part of this crusade and emerged as a highly visible presence in the war drive. It was not hard to recruit the actress, she was a proud veteran's daughter. Her involvement promised much—Hattie McDaniel was also a Hollywood star whose Academy Award was hailed as a national symbol of America's egalitarian promise. At the onset, the OWI began pressuring filmmakers to produce movies, documentaries, and newsreels supporting the war and to provide the services of popular actors to promote the effort. In turn, the industry organized the Hollywood Victory Committee, dedicated to coordinating the stars and their appearances supporting the war. Hattie McDaniel was unanimously elected to the committee and, in May 1942, was assigned to form a separate Negro Division aimed at bolstering black morale and providing entertainment for black troops. She selected Eddie Anderson, Leigh Whipper, Ben Carter, Fayard Nicholas, Louise Beavers, Lillian Randolph, Nicodemus Stewart, Mantan Moreland, and Wonderful Smith to serve as her steering committee. Shortly afterward, they convened at her home to hear an address from SAG's president, Edward Arnold. "The [Hollywood Victory] committee gives us in the motion picture industry the opportunity to translate into action our love of country and our desire to help win the war," Arnold told those assembled. "Good entertainment is vital to the morale of our men in the camps and army posts, and without morale we

can't win the war." Immediately, the Negro Division began planning tours of military bases as well as activities directed at assuring that African-American citizens backed the war.[3]

Hattie McDaniel not only poured considerable time and energy into running the Negro Division during the war years, she also put in numerous personal appearances on behalf of the Victory Committee. She performed at USO shows and war bond rallies. She toured military camps to entertain the troops, visited injured soldiers in veterans' hospitals, and threw parties to raise funds to support the war. She made a number of appearances for War Department radio broadcasts, some transmitted overseas to the fighting men. She joined Clarence Muse, Rex Ingram, and a number of other black stars for an NBC tribute to the heroic sacrifices of African-American servicemen. In one skit, Hattie McDaniel defended black support for the war despite the persistent inequalities stateside. "I've been fighting this battle for democracy for years," she responded to one character reluctant to join the war effort, "and I'm going to keep on fighting it." When she appeared at a camp in San Bernardino, she delivered an old-time jazz song and dance. "Needless to say, the troops and visitors alike almost tore down the house with applause," the *California Eagle* observed. "At the close the soldiers crowded around her, begging for autographs even forgetting for the time the fifty pretty debutantes who had been escorted there as hostesses."[4]

McDaniel also served in other ways. She won an appointment as a captain in the American Women's Volunteer Service Organization and often posed proudly in her smartly tailored uniform for publicity photos for black newspapers. One shot showed her in a crisp salute, and, for another, she played hostess to a group of black soldiers touring the Warner Bros. lot. In a different set of press materials, geared toward white audiences, she dressed as Mammy, and served meals to actor Edward G. Robinson and white GIs. The Twenty-eighth Infantry made her an honorary first lieutenant. She received citations from the WACS and the Red Cross. A number of black servicemen in Los Angeles on layovers stayed in her home; the city still had very few hotels that welcomed African-American patronage.[5]

McDaniel could now entertain houseguests in style. By early 1942, she had purchased a stately seventeen-room mansion in the West Adams dis-

trict, the same area where her sister Etta Goff had worked as the Kelsey family's housekeeper. The neighborhood, populated by white, old-money Angelenos, was a very distinguished address. McDaniel's new home was impressive—a white two-story structure perched on the hill at a corner of South Harvard and West Twenty-second Streets. Its grounds were filled with flowers, shade trees, and neatly sculpted shrubs. The house had a large dining room, butler's pantry, kitchen, service porch, library, living room, lounge, drawing room, den, four bedrooms, and basement. McDaniel redecorated in light colors with beige carpets and ivory furniture, some of it French Provincial. Lee Goodwin, Ruby Berkley Goodwin's husband, repainted the house's interior alone, using a variety of uniquely contrasting colors. McDaniel had plenty of room for her white grand piano and to display her growing collection of figurines as well as the numerous autographed photographs she had received from Hollywood colleagues and other dignitaries. Her Oscar stood in a special place on the fireplace mantel. Conscious of the wartime emergency, McDaniel had the basement converted into an air-raid shelter, complete with a kitchenette, beds, and well-stocked cupboards.[6]

South Harvard represented Hattie McDaniel's complete break from the poverty that she had endured during her earlier life. "She had the most exquisite house I had ever seen in my life, the best of everything," recalled actress Lena Horne. Despite her success McDaniel remained unpretentious and shared what she had with friends and family. (A society figure advised: "Hattie, you're getting too prominent to continue mingling with so many common people. You'd better begin eliminating them." McDaniel retorted, "That's a good idea. I'll start by eliminating you.") Ruby Berkley Goodwin's son Paul, who lived in the house while his mother worked for the actress, remembered its enormous and lush backyard where he played with McDaniel's relatives and the children of Hollywood celebrities like Bing Crosby. When black attorney and *Denver Star* correspondent George Ross arrived in Los Angeles, McDaniel invited him over. A chauffeur picked him up and he was greeted at the door by a butler in formal dress. After a tour of the home, he visited only briefly with the actress and her husband; she was headed out for a NAACP benefit for China relief. (Ross declined her invitation to come along.) He lauded

McDaniel for retaining a "simple, sincere graciousness" and for treading a "humble path beginning as a teen age girl in Denver . . . over many hard obstacles to the top most rung of fame." McDaniel remained deeply conscious of her impoverished roots. When one reporter marveled at the twenty-five pairs of shoes in her closet, she insisted that footwear was a tool of a performer's trade, especially one so involved in entertaining the troops. And, she added, "I haven't forgotten when I had only one pair of shoes and one pair of stockings to my name."[7]

For Hattie McDaniel, South Harvard became more than just a home; it was a sign of success—this was the land that her father had left Tennessee in search of over sixty years before. It also became a place where she could entertain in proper Tinseltown fashion. To claim her place as a member of cinema's elite, McDaniel staged the requisite yearly Hollywood party. While she could count on her African-American colleagues to attend, bringing out white stars, directors, and other Hollywood movers and shakers was a different matter. Only within the past few years, at the Academy Awards and SAG functions, had blacks and whites in the industry begun to mix socially. But McDaniel had an irresistible drawing card. Everyone knew that the king of Hollywood, Clark Gable, would be faithfully present at all of Hattie McDaniel's Movieland bashes.[8]

While Hattie McDaniel became legendary as a hostess, it was not for her Tinseltown gatherings. Rather, she would be long remembered for those parties that she threw for members of the black entertainment community. Frequently, black cinema figures, musicians, and artists gathered in her home to relax, practice their craft, and exchange information on their progress in their careers. The best of black show business performed within the walls of 2203 South Harvard. Duke Ellington, Cab Calloway, and Count Basie all played there. Ethel Waters sang and Butterfly McQueen did dramatic recitations. On many evenings, McDaniel herself joined in. It was private and intimate, but it was also independent and unfettered, free of white interference. South Harvard became a salon where black artists, including the hostess herself, could resist white domination of their talents. In many ways, these creative moments recalled the original and independent productions staged by the McDaniel siblings for black audiences back home in Denver. Maybe most important, they re-

vealed McDaniel's private restlessness with the limitations imposed on her by the film industry—that *she* desired an autonomous outlet for her own creative drives.[9]

Still, no matter how stifling Hollywood was, Hattie McDaniel grew more anxious as her movie career continued in a tailspin. She made only two films in 1942, *George Washington Slept Here* and *The Male Animal*. In both, she played her standard comic maid role. However, since they had modern settings, she persuaded the studio to dispense with the traditional, demeaning Hollywood black dialect. She also attempted to imbue both roles with as much back-talking as possible—easier to do because their contemporary plots distanced them from Selznick's coveted Mammy. In *George Washington Slept Here*, her character, Hester, does not suppress her discontent. After moving with her employer (played by Jack Benny) to a dilapidated country home, she bellows, "I'm quitting." Although she's convinced to stay on, when a family member demands iced tea, Hester delivers only an angry glare. McDaniel's interpretation of Cleota in *The Male Animal* was also blunt. An offbeat tale starring Henry Fonda and Olivia de Havilland, this film's love-struck white characters gave McDaniel plenty of opportunity to play a grumpy, outspoken domestic who mutters disdainful asides. Although she "yassums," it is with a tone of complete disagreement. But these two parts were far from anything even approaching what McDaniel had envisioned after the Oscar. Both Hester and Cleota are consigned to demeaning eye-rolling and embarrassing gaps in their knowledge, only reinforcing major elements of traditional black stereotypes.[10]

Still under contract to the Warners, Hattie McDaniel had only two options—either play the parts the studio gave her or leave the industry altogether. Although McDaniel still maintained that the industry would improve for black Americans, she was having a harder and harder time adhering to her own positive-thinking philosophy. It was not only the movie producers' stubborn reliance on formulaic stereotypes that discouraged her; she was also becoming convinced that there was another force holding her back. More and more Hattie McDaniel angrily blamed her inability to secure roles and her lack of progress on the NAACP's Walter White.

Since beginning his correspondence with David O. Selznick in 1938,

Walter White had become a more central player in the discussion over African-American film images. White's strategy was to establish cordial relationships with Hollywood's upper echelons and, on his own, make an appeal for the betterment of black roles directly to industry leaders. In addition to Selznick, who now made an annual contribution to the NAACP (of only $100—a modest sum for a big-time producer), White had succeeded in courting a number of other influential film-industry figures, including producer and Motion Picture Academy president Walter Wanger. In late 1940, it was Wanger who arranged for White to make a brief stop in Hollywood to talk to a few movie bosses.[11]

For White these early encounters were civil but fundamentally ineffectual. Like others before him, he received the standard Hollywood excuse that a film's success was determined by its popularity at the Southern box office. But once the United States entered WWII, White recognized that the government's attentiveness to black morale would provide him with the opportunity to override filmdom's repeated brush-offs. In February 1942, he returned to Hollywood, this time well-armed. He carried with him a War Department request that he press studio heads to include African-American military contributions in newsreels. Even more important, Walter White arrived with a letter of introduction from Eleanor Roosevelt. "I am sincerely interested in this problem [of black stereotyping] and hope that Mr. White will meet with success," the first lady wrote in support of improving black film roles. Those in Washington were wagering that the NAACP chief could be an important tool in a larger propaganda campaign targeting African Americans and assuring their support for the war.[12]

White also had another heavyweight in his corner—Wendell Willkie. After losing to Roosevelt in 1940, Willkie had represented Hollywood during a dicey Senate probe of the film industry, and this had won him many friends in Movieland. Willkie, a progressive on racial issues, was sincerely disturbed by cinema's perpetuation of negative black stereotypes. With solid Hollywood ties, Willkie offered to use his influence and open doors for White with film-industry leaders.[13]

Thanks to Willkie, White received a first-class welcome from Tinseltown. Hollywood wined and dined him, treated him to tours of movie lots,

and arranged for him to rub elbows with stars like James Cagney, Melvyn Douglas, and Jean Muir. White thoroughly enjoyed the flattery and glamour. Yet, despite all the fanfare, movie bosses evaded his requests for appointments. The NAACP's leader grew impatient as he found himself sidetracked from his mission. During his stay, he granted an interview to the *California Eagle*, objecting to Hollywood's black cinematic "caricaturing" and pointing out that "Hollywood's treatment of the American Negro has stamped an indelible false impression upon the minds of people in every corner of the globe."[14]

One day before White was to depart Los Angeles, Willkie finally succeeded in arranging for him to speak at a meeting of several Hollywood producers at the Biltmore Hotel. It was a select gathering of the industry's most powerful figures, including Walter Wanger, Twentieth Century Fox's Darryl F. Zanuck, and David O. Selznick. White made his case regarding the degrading state of black film images, he believed, persuasively. He reported that Zanuck "marched up and down puffing a cigar and stopped to declaim, 'I make one-sixth of the pictures made in Hollywood and I never thought of this until you presented the facts.' " Selznick was the first to offer a solution, suggesting that the Motion Picture Producers Association hire an official censor to oversee all black film roles for the Hays Office. The rest immediately vetoed that idea; there was little enthusiasm for giving Hays any more power. Walter White sighed with relief; he worried that a censor would only erase the black presence entirely. "The problem with the Negro in the cinema is not now so much that of deletion," he wrote to a friend, "as it is of getting the moving pictures to present the Negro as a normal human being and an integral part of human life and activity."[15]

In the end, all that came of the meeting was an agreement to meet again—sometime soon. Wanger and Zanuck convinced White that more could be accomplished if the NAACP chief brought his case before a larger body of industry leaders. They all parted as hearty friends.[16]

Although the producers were obviously stalling, they were truly anxious about the issue of black representation. However, their concern arose not so much over the derogatory effects of cinematic racism. Rather, this group feared that the war emergency would allow the government to med-

dle in filmmaking. Some feared that Willkie was planted in Hollywood to report back to Washington on the movie industry and its loyalty to the war effort. Additionally, it was rumored that White was visiting Hollywood at the request of the Selective Service, that his presence was part of a larger effort to ward off any antidraft activity that might arise within the black community. Willkie and White both denied the allegations. Yet the producers' suspicions only deepened when Zanuck, who enjoyed a warm relationship with FDR, appointed Willkie to head Twentieth Century Fox's board of directors. From White's perspective, it was an excellent sign. Willkie's influence surely would force movie bosses to finally break away from the old, negative stereotypes.[17]

Shortly after White returned to New York, he received a letter and article from Almena Davis, editor of the African-American newspaper the *Los Angeles Tribune*. The piece, which quoted an unnamed African-American actor, indicated that the black film colony was fuming over White's visit but was also smugly contending that his campaign had already fizzled. Davis's source insisted that the producers had "licked" the NAACP chairman with "facts and figures [that] had told him things he didn't know and couldn't refute." The journalist was troubled; she suspected that black performers were deriding White out of a selfish desire to protect their jobs. But she also feared that these insiders were right— that the studios had no intention of improving black roles. In her letter to White, she invited him to comment.[18]

White responded to Davis privately, insisting that the "prospect of definite progress is bright." In his opinion, these anonymous black performers were ingrates; his hard work would produce better roles and better pay for those already in the industry. Would she be willing to reveal the identities of these unnamed critics? White asked. Davis politely declined.[19]

Black film veterans had a hard time buying White's protestations that he had their best interests at heart, and they bristled at insinuations that they owed him any appreciation. They also wanted better roles but were offended by the NAACP chief's refusal to consult with them. From White's viewpoint, it was unnecessary—he only wanted to deal with studio power brokers. In his mind, the willingness of these black performers

to play stereotypes made their race pride and commitment to the African-American struggle suspect. They had little pull and would hardly be useful allies in the struggle. Since 1940, he had called for the industry to stop portraying the black American as a "buffoon" or "humble servant." Black Hollywood interpreted his remarks as criticism of their artistic skills and a statement of his intention to exile them from Hollywood.[20]

By July 1942, Walter White was back in Los Angeles to preside over the NAACP's annual national convention. Simultaneously, he had arranged to meet with the larger community of white filmmakers. He timed his return to coincide with the escalating wartime push for unity, which, in turn, put tremendous pressure on the producers to appear to be responsive to White's cause. So they planned their meeting with the NAACP chief in glitzy Hollywood fashion. It would be an extravagant luncheon to honor both White and Willkie at Twentieth Century Fox's swanky Café de Paris.[21]

Although the meeting was closed-door, someone later mailed out a press release to African-American newspapers detailing the proceedings. Reportedly, the luncheon began with Walter Wanger's testimonial introduction of the NAACP leader as "one of the great representatives of the new day." White took the podium and laid out Hollywood's responsibility not only to the African-American people but also to the war effort. "I want you to know the tremendous eagerness of the Negro Soldier to win this war for democracy," he told the crowd of seventy, which included Zanuck, Selznick, Willkie, SAG's Edward Arnold, Hal Wallis, director Frank Capra, Will Hays, Louis B. Mayer, Will Rogers Jr., and John Stahl. But that commitment, he maintained, could only be sustained by boosting the "morale of Negroes of this country and throughout the world." The key to uplifting the black spirit was in the persuasive hands of moviemakers. "Restriction of Negroes to roles with rolling eyes, chattering teeth, always scared of ghosts or to portrayals of none-too-bright servants," White scolded the assembly, "perpetuates a stereotype which is doing the Negro infinite harm." He called upon filmmakers "to have the courage to shake off [their] fears and taboos and to depict the Negro in films as a normal human being and an integral part of the life of America and the world."

The *Pittsburgh Courier* reported that the meeting ended with film bosses collectively pledging to improve the black cinematic presence and create characters that reflected the reality of black life.[22]

Not one member of the black film community had been invited to the Café de Paris luncheon. While White (and the producers) had ignored them in the negotiations over movie representation, he could not avoid encountering at least some of them at the annual conference. Clarence Muse remained a very active participant in Los Angeles's NAACP, and several other black motion-picture personalities attended portions of the convention. It is almost certain that most were present for its climax, a mass meeting held at the Shrine Auditorium. Hattie McDaniel was definitely there. A photographer caught a shot of the actress with White and Los Angeles mayor Fletcher Bowron, all beaming and all shaking hands. McDaniel's smile would not last long.[23]

In a speech before ten thousand delegates and guests, which included Walter Huston, Walter Wanger and his wife, who was actress Joan Bennett, and Wendell Willkie, White not only condemned the deplorable state of race relations worldwide but plunged into the issue of blacks in American cinema. He reported that his discussions with the studio heads had been successful and that he anticipated that in the near future black cinematic characters would receive significantly more respectful and realistic treatment.[24]

African-American film players were furious. It was not the idea that black roles would improve that upset Hattie McDaniel and other black film veterans. Rather it was White's high-handed approach and their conviction that he was determined to end their careers—that these new roles were hardly intended for them. Accompanying the NAACP's chief on the platform for the Shrine's mass meeting was Hollywood newcomer Lena Horne; he made no secret that in his opinion she was the perfect image of the New Cinematic Negro. Thin, light-skinned, and extraordinarily beautiful, Lena Horne was articulate and sophisticated. She was also well-connected, not only within Manhattan's show-business circles, where she had gotten her start at Harlem's Cotton Club, but also among the black leadership elite. Walter White was a close family friend, and he was one of the first to urge her to try Hollywood. "Walter White felt, and I agreed

with him," Horne later recalled, "that since I had no history in the movies and therefore had not been typecast as anything so far, it would be essential for me to try to establish a different kind of image for Negro women." With White's support, Lena Horne arrived in Hollywood determined to break down Hollywood's racist barriers. Her visible inclusion in the convention's climactic meeting was his way of promoting her career.[25]

White left Hollywood feeling that he had conquered filmdom. Almost immediately Zanuck circulated a letter urging industry insiders to address the crisis that the NAACP's chief had illuminated in such a "simple and direct" fashion. Other Hollywood power brokers stepped forward with encouraging public statements. Fred Beetson, vice president of the Motion Picture Producers Association, testified: "I feel every producer who was at the meeting was greatly impressed and will undoubtedly find ways and means of helping to put into effect some of the suggestions offered." On behalf of the Screenwriters Guild, Sidney Buchman insisted that he had "taken the matter deeply to heart," pledging to "act in every way possible to further this vital education." The NAACP gathered these comments and released them to the press. White viewed these endorsements as evidence that his labors would soon bear fruit.[26]

Soon after White's departure, the African-American press began seeking black Hollywood's reaction to the NAACP's chairman's drive. Although some commended him for doing "a fine job," others were much less enthusiastic. Ben Carter, Hattie McDaniel's costar in *Maryland* who also ran a black talent agency, praised the idea of more dramatic parts but cited a continuing "need" to provide roles to comedians. Clarence Muse was much less diplomatic. He blasted Walter White as a "committee of one" and contended that the black film stars "have been more conscious than Walter White that Negroes should have better roles." In Muse's opinion, White's lone-wolf approach would do nothing more than throw the studios into a panic that would, in turn, compel them to delete darker-skinned, working-class, and comic characters from the screen.[27]

Even Hattie McDaniel agreed to speak on the record, probably restrained with some coaching from Ruby Berkley Goodwin. "I have no quarrel with the NAACP or colored fans who object to the roles some of us play," she told the *Baltimore Afro-American*. In her view, it was not the

organization itself or black moviegoers that were the problem. It was White and his leadership style. "I naturally resent being completely ignored at the convention after I have struggled for eleven years to open up opportunities for our group in the industry," she continued. "You can imagine my chagrin when the only person called to the platform was a young woman from New York who had just arrived in Hollywood and had not yet made her first picture," she insisted, referring to Lena Horne. While McDaniel conceded that "there is much room for improvement," at the same time, she argued that advances had been made in the industry. She cited what she claimed was an evolution of some black roles from incidental to central characters, as well as the better treatment of black players on the studio lots. She argued that the "battle must be fought out right here by the actors and it cannot be won if outside pressure groups shut the doors of opportunity against us." She now articulated a bleak assessment of the industry's potential for change. "It takes time and I don't believe that we will gain by rushing or attempting to force studios to do anything they are not readily inclined to do," she told the *Pittsburgh Courier*.[28]

McDaniel's gloomy realism may have resulted from her recent experiences with the Warners and *In This Our Life*. Coincidentally (of course), the studio scheduled the film's release in May 1942, just as White began bearing down on Hollywood. While *In This Our Life* overall was problematic, it did represent a departure in filmmaking. Here was a somber Hattie McDaniel, openly commenting on the grave inequalities of the justice system. Her cinematic son, played by newcomer Ernest Anderson, conveyed a brilliant, hardworking, and serious-minded young man, frustrated by the racism that prevented him from achieving his dreams. This was exactly the type of film that Walter White had envisioned for American screens, and Warner Bros. cited it as evidence of their commitment to creating better black roles.[29]

In This Our Life was enthusiastically hailed in a variety of sectors. Several white film critics praised its attempt to address racial inequality. Although the *New York Times* panned it as a run-of-the-mill romance story, it heralded the racial discrimination theme as a brave and much-needed departure from the usual Hollywood fare. P. L. Prattis, executive editor of the *Pittsburgh Courier*, congratulated Warner Bros. for its "contribution to

better Americanism" and raved that "in this picture a very grievous side of the life of almost every colored American is exposed in the role of Parry Clay." The studio received fan letters praising the film. "For the first time in the history of the cinema, a Negro is depicted as a normal, intelligent, clean living, human being," wrote Edith Peacock McDougald. "Please give us more pictures like this one which depicts Negroes as flesh and blood human beings and not as clowns," requested Private James Samuels who added, "Thank God that you see the light."[30]

Even Walter White, who saw *In This Our Life* before his July trip to Hollywood, was pleased. In a letter to Harry Warner, he declared the film a "magnificent achievement" and "a high water mark to date of the honest treatment of the Negro." He never acknowledged Hattie McDaniel's participation in this path-breaking project, although he did congratulate the studio for crafting black roles that were a "refreshing change." White also sent off a letter thanking Olivia de Havilland. An outspoken young woman, de Havilland informed the NAACP's leader that she and others were actually disappointed. "Several of us who were associated with the film felt that it would have been a much more interesting picture if it had been a less conventional story of romance and trouble," she wrote, "and had dealt more deeply and extensively with the story of Parry and Minerva and their relationship to the principal characters."[31]

Although the film really made only a mild pass at tackling racism, not everyone welcomed its open discussion of American inequalities. Quickly, the dreaded Southern box office reared its head. Alonzo Richardson, the head of Atlanta's film censorship board, deleted all mention of racism from their copies and then sent off a stinging letter to Joseph Breen. *In This Our Life*, he claimed, insulted Southern whites everywhere. He was shocked that Warner Bros. even dared film scenes where McDaniel and Anderson objected to racial status quo. Additionally, Richardson claimed there was a growing animosity among white Southerners for what they perceived as the film industry's unwarranted sympathy for African Americans and an "increased impertinence of the Negroes in spite of things done for their own good." In discussions of race, he warned Hollywood to stay away. "It is still our problem; we KNOW how to handle it," Richardson insisted. White Southerners, he claimed, revealing the depth of the

era's and region's racism, "love the Negro as others can never love him; appreciate his ability as none other CAN and put up with his frailties as none others do or would." Breen thanked Richardson for his "very, very interesting" insights and conveyed his acceptance of Atlanta's decision to cut the film.[32]

Dixie was not the only place that sheared scenes in which McDaniel and Anderson protested racial discrimination. While the film was screened in its entirety in uptown Manhattan, it ran in Harlem and other black New York communities with Atlanta's deletions. Once it was discovered, many decried the action. "Try as I might, I can't get the picture of any Negro inciting a race riot or joining hands with the Axis powers because of having seen *In This Our Life* as originally presented," reporter Peter Suskind wrote. "It stirs genuine pride, not race hatred." The *Pittsburgh Courier* protested the censorship of McDaniel's and Anderson's scenes and declared, "It is the greatest irony to know that such a step forward in securing equality should be withheld from the Negro people themselves." Outraged Harlem residents and other local figures lodged complaints with the NAACP and Warners. Walter White gingerly queried Warner Bros. and they vaguely promised to investigate the matter. In the end, no one could really say who had ordered the cuts.[33]

Regardless of who made the decision to censor *In This Our Life* in Harlem and other black communities, it denied many the chance to see Hattie McDaniel in what would be scenes from her most significant role. This was no soft-peddled *Imitation of Life*. As Minerva Clay, Hattie McDaniel had become the first black actress to voice direct criticism of American racism on the Hollywood screen. But almost no one made mention of her contribution. In the end, McDaniel remained trapped behind Hollywood's stereotype. One way or another, Hattie McDaniel was consigned to remain the symbol of Hollywood's Old Cinematic Negro—the simplistic, comic, and loyal servant.

This was apparent in Warner's press releases, which actually reinforced the stereotypes that the film purportedly challenged. Although several versions revealed Ernest Anderson was a graduate of Northwestern University's theater department, they also played up his position as a service attendant on the Warner Bros. lot. (It was said that he was a "favorite" of

Bette Davis, who reportedly got him the part in the film.) McDaniel's image suffered just as much. Rather than highlighting her Oscar credentials, Warner Bros. attempted to link the actress to her Mammy image. One studio release insisted that during a scene in which McDaniel delivered a tray carrying a bottle of Scarlet's Special Reserve, a popular whisky, she remarked, "Land sakes, I jes' can't get away from that gal." McDaniel may have dispensed with Hollywood dialect on the screen, but she could not stop public relations copywriters from putting the words in her mouth anyway.[34]

Certainly, McDaniel must have been disheartened. And her dissatisfaction with the Warners surfaced shortly after the *In This Our Life* fiasco. In July 1942, she demanded to be let out of her contract. In addition to probably feeling let down by the studio, she had come to believe that her long-term relationship with it had only impeded her career, preventing her from accepting not only better film roles but also more radio and stage engagements. Warner Bros., which had continued to struggle to cash in on her, agreed to terminate the contract but held her for three more films.[35]

By late summer 1942, Hattie McDaniel had taken as much action as she could with the studio and now she set her sights on Walter White. Following through on her contention that the actors themselves best waged the struggle for improved representation, the actress, along with several other black film stars, formed the Hollywood Fair Play Committee. The group did little to hide their determination to force White out of the film debate. This would, they claimed, not only preserve their livelihoods but also further the march, even if gradual, toward more dignified roles. Convinced that the best route for actors' grievances lay with SAG, in September 1942, the Fair Play Committee attempted to schedule a formal meeting with their union representatives. Reluctant to get involved in what was becoming an increasingly acrimonious dispute, SAG refused the black actors' request. It is likely that this spurred on McDaniel's push for more inclusion within the union's leadership. She had already, along with Ethel Waters, taken a seat on SAG's nominating board. In this position, McDaniel was able to open doors for African-American representation within the upper ranks of SAG's leadership; for example, with her support, Lena Horne was appointed in 1943 to a vacated seat on the union's

board of directors. The following year, Horne was formally elected to the board with McDaniel's endorsement.[36]

It may have seemed odd that McDaniel was so encouraging of the Hollywood newcomer. Horne's grand entrance into Hollywood had garnered animosity from the majority of the black film-colony members, who regarded her as an interloper and immediately snubbed the young performer. Shortly after arriving in Tinseltown, Horne received a summons to Hattie McDaniel's home. Apprehensively, she arrived for her appointment only to discover that McDaniel bore her no ill will whatsoever. "She was an extremely gracious, intelligent, and gentle lady," Horne remembered. The veteran actress was frank, Horne recalled; the journey for African Americans in the studio system was not easy. "She explained how difficult it had been for Negroes in the movies, which helped give me some perspective on the whole situation," Horne wrote in her autobiography. "She was extremely realistic and had no misconceptions of the role she was allowed to play in the white movie world."[37]

Hattie McDaniel encouraged the newcomer to push ahead. The Hollywood veteran advised Horne, who had two young children, to always put her family's welfare first, that the bottom line was the need to earn a living. "You've got two babies. And you've got to work," Horne recalled Hattie McDaniel telling her. "Just do what you have to do." The young performer insisted that McDaniel's "act of grace helped tide me over a very awkward and difficult moment." Although she was never fully accepted in black Hollywood, her friendship with and respect for Hattie McDaniel endured. Horne's daughter, Gail Buckley, recalled that when a number of black film players publicly lashed out at her mother, McDaniel forcefully rose to the young actress's defense.[38]

While Hattie McDaniel may have made her peace with Lena Horne quickly, her life was only becoming filled with more disappointments. October 1942 was a dismal month; on the third, her oldest sister, Lena Gary, passed away after suffering from heart problems. To add to her woes, her marriage to Lloyd Crawford had begun to fall apart. Despite all the rumors of Crawford's wealth and success, it turned out that "he didn't do anything," as Wonderful Smith recalled. McDaniel paid for him to attend real estate school. He briefly held a government job in San Francisco and

even worked for the studios. But he did not stick with anything for long. Crawford had a decidedly more casual outlook on life; he just was not as driven as his ambitious wife. In an attempt to protect the increasingly frustrated McDaniel, he tried to convince her to retire from the screen and to move with him to Chicago. She refused. She was not going to sacrifice what she had fought so hard to create to follow a man. As the strain of the marriage began to affect McDaniel's career, she found it hard to concentrate and memorize dialogue. For the next several years, the couple grew further and further apart as Crawford spent less and less time at home. Lonely and discouraged, McDaniel lavished attention on her spaniel, Frisky. After the dog delivered nine puppies, she spent hours feeding each one with an eyedropper.[39]

To make life even more difficult, McDaniel, like other black performers, faced mounting resentment. In response to their open opposition, Walter White dismissed the black actors as "jealous" of his efforts and Hollywood connections.[40] And he had a number of supporters within the African-American community who had grown weary of Hollywood racism and the black actors' accommodationism. In the *People's Voice,* published by her brother-in-law Adam Clayton Powell, Fredi Washington charged the Fair Play Committee with obstructionism and called on them to back White's efforts. She pointed out that change would only come through a united effort. Norman O. Houston, a respected leader in the Los Angeles black community and head of the Golden State Life Insurance Company, cautioned White about the black film players' "crudeness" and relayed his wife's assessment that "most of them are ignorant and can only fit in the parts they have been playing anyway."[41] In a letter to White, Langston Hughes reported, "What I gather from the cullud [sic] actors . . . is that they are afraid they will be all wiped off the screen if you-all get too hard on the producers." And he added, "Almost any Negro—except those who play them—can spot an Uncle Tom." The criticism devolved into personal attacks. White received one anonymous letter warning him that Hattie McDaniel was "mean and vicious and resentful."[42]

While the division between the African-American film community and Walter White rose, in part, out of a disagreement over liberation strategies and was underscored by class and generational differences, the outcome

was the development of a virtually impassable gulf. The real tragedy rested in the fact that the two sides were fighting the same enemy. The heart of the problem rested with the white producers who remained so resistant to change and so completely invested in black stereotyping. Langston Hughes recognized it. "Knowing those producers out there, they can't visualize any decent roles being given to them [the black movie players] anyhow," he observed to White.[43]

What remained unsaid was that it was to the producers' advantage that black Hollywood and Walter White were battling each other. Throughout the debate, moviemakers occasionally responded with a statement defending the industry but never their black employees nor their newfound friend Walter White. For the most part, they remained mum as the two sides fought it out. Much to the NAACP's dismay, at least one studio attempted to circumvent White's campaign by putting the *Pittsburgh Courier*'s theatrical columnist Billy Rowe on the payroll to plug Hollywood pictures and black stars.[44]

Still, both black Hollywood and Walter White continually refused to take on movie moguls with any force. McDaniel's desire was to protect her fragile career. She knew that too much public criticism would only alienate her bosses and ultimately drive her from the industry. On the other hand, Walter White was also reluctant; if he appeared too antagonistic, the studios would cut him off, ending all discussions about bettering African-American images. Instead of pushing for an all-out public campaign, he spent considerable energy cozying up to and even defending Hollywood notables. Corresponding with black press representative Neil Scott, who had attacked David O. Selznick, White argued in favor of *Gone With the Wind*'s creator. "I . . . have always found him friendly and cooperative," White wrote of the producer. "I believe he wants to do the right thing."[45]

By mid-1943, however, White had grown increasingly frustrated with the obvious lack of significant progress in transforming black film images. "I believe that all of the producers who made promises to Willkie and me were sincere . . . ," he wrote to journalist Peter Furst. "But I am equally certain that the stereotypes about the Negro are so indelibly fixed in their minds as well as a lot of other American white people that it is going to take a long time to eradicate them." In May 1943, he attempted to rattle

moviemakers slightly with an editorial in the *Chicago Defender*. In it, he praised Hollywood for beginning "to deliver on its promises to broaden the treatment of Negroes in films." Citing small black roles in *Crash Dive*, *The Ox Bow Incident*, *Casablanca*, *Sahara*, and *Bataan*, as steps in the right direction, White urged filmmakers to make "a complete break with the tradition of showing Negroes as menials." Such characters were nothing more than "cretinish, grinning, Uncle Tom[s]." He ended with a direct message to black Hollywood veterans regarding their responsibilities in the struggle. "One of the most important elements in that progress," the NAACP chief wrote, "will be the behavior of Negro actors themselves in playing their roles with sincerity and dignity instead of mugging and playing the clown before the camera."[46]

Seeing that White now publicly blamed them for the perpetuation of stereotyping and racism, Hattie McDaniel and other African-American film performers were enraged as well as panicked. Shortly after White's editorial appeared, the Fair Play Committee finally compelled SAG to meet with them. Before an all-white committee of union representatives, McDaniel, joined by Clarence Muse, assailed Walter White insisting that he had inappropriately usurped the role of the union by negotiating directly with movie bosses over work-related issues. His activities had hindered their careers, they contended, and undermined their standing in Hollywood. SAG disagreed, declaring that the clash was not a labor issue and refusing to take sides in what had become a political fireball both within Hollywood and the black community.[47]

Indeed, the result of White's campaign was what McDaniel and others had feared. Established members of the black film colony struggled harder than ever to get parts. Hollywood had been jolted into action more by the demands of the OWI than by White's persistent cajoling. African-American faces began to appear, sporadically, in crowd scenes. On occasion, a newsreel acknowledged black contributions in battle. Director Frank Capra filmed *The Negro Soldier* (1944), a docudrama celebrating the history of African Americans in the military from the American Revolution through WWII. Designed to be uplifting, it was rich with dignified images of courageous, young black fighting men and their proud families. Although there was hardly an upheaval in black cinematic representation, by

the end of WWII, as historian Thomas Cripps argues, the Washington propaganda machine had made a lasting mark on Hollywood filmmaking.[48]

This was mostly true for black male images. Wartime public relations primarily targeted African-American men; they were the ones headed off to battle. Many of the better images were of black male military characters. Kenneth Spencer, McDaniel's costar in Belasco's *Show Boat*, appeared as a loyal soldier in *Bataan*. Ben Carter played a Dorie Miller–type character in *Crash Dive* and Rex Ingram scored a part as a courageous African leader in *Sahara*. But virtually none of the established black actresses benefited much from the new, albeit sparse, roles that Hollywood had created in response to demands for improved representation. Even newcomer Lena Horne found her endeavors at breaking new ground blocked. Her two biggest projects, *Cabin in the Sky* and *Stormy Weather*, were all-black musicals. And in *Cabin in the Sky*, she played a scheming temptress, an image not too far removed from the disparaging mixed-race seductresses found commonly in white literature and early film. Horne grew quickly disillusioned as she hunted for better parts. "They didn't make me into a maid," she commented. "But they didn't make me anything else either."[49]

For McDaniel, unable to escape typecasting, the situation only worsened. Her film career continued to plummet. In 1943, she had only two minor roles. (One was in *Thank Your Lucky Stars* during which she developed severe respiratory problems after numerous takes of a scene involving fake clouds generated by dry ice.) Despite the downturn, at the same time, a survey of the Lichtman chain, which owned theaters playing to African-American audiences, showed that Hattie McDaniel's pictures were among the top ten in box-office grosses. The following year, 1944, was a little better—she scored four parts.[50] But none were particularly choice. In one of these, *Three Is a Family*, McDaniel played a goofy, tippling maid. In 1945, when it was screened for the troops in Australia, African-American GIs were so offended and humiliated by her performance that they marched out in protest. Hattie McDaniel insisted that she was doing her best in the few roles that were offered her. She railed at what she perceived as a double standard: "Now no one has ever accused Zazu Pitts, Gracie Allen, Joan Davis, Vera Vague, Martha Raye, and many others too numerous to mention as being ignoramuses because they play silly parts."[51]

McDaniel's biggest role of 1944 was in Selznick's blockbuster drama *Since You Went Away*. The producer cast her as Fidelia, who, as the character's name implied, was yet another devoted maid. This was a complicated tale of the struggles of Anne Hilton (Claudette Colbert), whose husband goes missing in action while fighting in the war. Throughout the film, Selznick incorporated shots of African Americans in various scenes, including a wounded black soldier in a military hospital and black students at a high school graduation. Fidelia's costuming went beyond the standard apron and maid's uniform; McDaniel's wardrobe included a snappy hat, a coat with fur collar, and several nicely tailored dresses. But Fidelia was still constructed to reinforce a completely nonthreatening image of black women. When economic hardships force Anne to lay her off, Fidelia protests. Although she quickly finds another job and admits that the "wages is mighty good," Fidelia insists, "I ain't going to be contentment like I been right here all these years." Her desire is to come back and serve the Hiltons. Eventually, she does, working nights and on her days off for the family in exchange for her old room until finally they can rehire her. Any revisions in this film to Hollywood's traditional black characterizations were overridden by the loud message that black Americans really still preferred to work for white people in menial capacities even if it meant earning a significantly smaller salary and giving up a large amount of independence. And even though McDaniel had abandoned the distorted enunciations of the old-style black Hollywood dialect, her dialogue still conveyed the notion that somehow blacks were less intelligent and capable.[52]

As McDaniel's film roles became scarcer, she actually found herself spending more time on her war work and entertaining the troops than she did on movie sets. She cobbled together some radio dates, returning to the *Eddie Cantor Show*, appearing on the *Billie Burke Show*, and guest-starring on *Amos 'n' Andy*. (She played a cranky landlady, romanced by Andy, portrayed by a white actor, Freeman Gosdon, using black dialect. On radio, the two crossed a color line and that would have never been allowed in film, even if Gosdon had worn blackface.) Although she kept busy, McDaniel's hopefulness seemed to dim further. Ruby Berkley Goodwin recalled that for Hattie McDaniel, these were "bitter years of loneliness

and disillusionment when she thought her race did not appreciate her artistry."[53]

The strain of her many personal and professional disappointments really began to show in the spring of 1944. On April 23, at the black community's Second Baptist Church, the NAACP's Youth Council held its First Annual Motion Picture Award Assembly. The program was to honor several Hollywood figures, including actors Bette Davis, Lena Horne, Rex Ingram, Dooley Wilson, Carlton Moss, Ben Carter, and screenwriter John Howard Lawson, for their contributions to interracial unity during 1943. The NAACP's Youth Council selected Hattie McDaniel to deliver the keynote address. Before an integrated crowd of over three thousand and a number of white Hollywood dignitaries such as actors Olivia de Havilland, Anita Louise, George Murphy, and writer and producer Carey Wilson, McDaniel read for thirty minutes from a prepared text on the history of blacks in Hollywood. She began with an acknowledgment of black film pioneers, including Louise Beavers, Madame Sul-Te-Wan, and Clarence Muse. Endeavoring to outline the progress that African Americans had seen in the industry, she contended that the treatment of black entertainers had improved significantly. She also defended the film-colony veterans. "We are ever on the alert to keep our roles free from objectionable material," she told the assembly. "Yet as artists we reserve the right to accept the parts that we can portray with sincere artistry." Objecting to the push to delete menial roles, McDaniel insisted that they were not demeaning but a tribute to "our foreparents," who "had to start from somewhere." "I don't doubt it that running in some of your minds is the reason Hattie McDaniel is speaking on the subject of cooking, washing, and ironing is because she has done so much of it herself," she told the crowd, underscoring that entertainment had always been her primary profession but that she did not shy from relying on domestic work to get by. She concluded with a tribute to those young black GIs fighting abroad by reciting Paul Lawrence Dunbar's "The Colored Soldiers," originally homage to those of an earlier generation who had, like her father, taken up arms to protect the country.[54]

This speech, which was probably cowritten by Ruby Berkley Goodwin, was McDaniel's opportunity to rally back, to make her case before

both the black community and white Hollywood. And a strong piece it was. But it hardly had the effect that the actress had hoped. As Robert J. Smith, editor of the *Los Angeles Sentinel*, reported, when she came to the section acknowledging Lena Horne, she praised her as "a representative of the new type of n——r womanhood." The editor insisted that the crowd sat in stunned silence and McDaniel attempted to backtrack by emphasizing, "I said Negro womanhood." Smith claimed that after the ceremony when he asked McDaniel for comment, she "smilingly said, 'I have no statement to make.' "[55]

Smith ran an account of McDaniel's horrific gaffe on the front page of his paper with a banner headline reading "A Slip of the Lip May Sink a Ship." Lena Horne, the editor claimed, reacted with embarrassment and shock, she "drip[ped] with great beads of sweat" and wrung her hands. The story made its way into the *Baltimore Afro-American*, which reached a national readership; its title read, "Miss McDaniel Accused of Using Offensive Epithet." It was exactly what Hattie McDaniel, who had been battling the charges of "Tomism" and racial self-hatred, did not need.[56]

Had McDaniel revealed a profound animosity toward Walter White's protégée Lena Horne? (Horne did not seem to think so and only expressed admiration for McDaniel, whom she always regarded as one of her few friends among black film players.) Was the slip an unintentional comment on the cinematic glass ceiling that restricted the careers of all black actresses, including even Horne? The audience that day contained a number of white representatives from the studios, many of whom had actually done very little to promote a new image of "Negro womanhood." Or did this indicate the depth to which racism had warped Hattie McDaniel's own sense of self, and pride? What really haunted the actress in the recesses of her mind was not clear, then or now.

Even McDaniel, flustered by her ghastly mistake, was at a loss to explain it. But she was furious with Smith for publishing an account of the horrifically embarrassing event. She lashed out at the editor in a long, rambling, and clearly self-authored letter that was published in the *California Eagle*. McDaniel admitted that she committed a "regrettable error" and insisted that she had already apologized "to those who are worthy of such consideration." She maintained it was an accident and, in a swipe at the

Sentinel's editor, compared it to "those countless typographical errors which the columns of your paper constantly and continually contain." In blazing language, she condemned Smith's article as "unauthentic" and "falsely exaggerated," insisting that he had threatened wartime unity by "sowing seeds of discord and malicious antagonism." She maintained that she had barely uttered the offensive term before she corrected herself and that she immediately apologized before an understanding crowd that was "tittering with laughter." Her good friend, Lena Horne, had quickly forgiven her and had hardly broken out in a sweat. "In truth, Mr. Smith," McDaniel wrote, "Miss Horne confidentially told us, she just does not 'sweat.' "

Branding him among the "Judases" and as an "unscrupulous Pharisee," McDaniel actually blamed Smith for her mistake, linking it to her belief in the power of the mind:

> If account for my error I could, it would be only to truthfully state that the radiotronic mental reflections of minds such as yours . . . like ether waves of mental telepathy, electrically lodged in my subconscious "reception box" the instance you released them.
>
> And in answer to the telepathic atmosphere of your unholy and prejudiced mind, my friend, Miss Horne, became the victim of my subconscious mind. And she in turn most unjustly received what I undoubtly and unquestionably must have meant for you. And I am now quite sure and fully convinced—I did!!![57]

McDaniel's tirade hardly helped her cause as she refused to take responsibility for her appalling faux pas and backhandedly used the horrendous term against the editor. Many of those willing to wade through McDaniel's vitriolic response, which covered an entire half-page of the *California Eagle*, probably came away even more offended. It certainly sounded spiteful and, indeed, troubling. It suggested that McDaniel not only harbored an intense anger but also was a deeply conflicted woman. Increasingly bitter and insecure, Hattie McDaniel grew more desperate. She now watched helplessly as both her Hollywood career and her reputation within the black community slipped away.

Obsolete?

· · ·

*How can one in your profession not know that the millions of
Negroes in this country, the majority of them are employed in
domestic roles? Why do we as a race deny our heritage? Surely
you don't think the roles I portray are obsolete?*

Hattie McDaniel, *Kansas City Call*, March 25, 1949

ALMOST RIGHT on the heels of McDaniel's outrageous blunder
came a surprise. In May 1944, she announced to Louella Parsons
that she was expecting her first child. "Betty Grable, Lana
Turner, Maureen O'Hara, Gene Tierney, and the rest of those glamour
girls have nothing on me," she remarked, sounding just a little resentful of
the era's leading white actresses. McDaniel told the *California Eagle* that
she was busy decorating a nursery in both blues and pinks. If it were a boy,
she would name him Otis, after her brother; a girl would be called "Hat-
tie McDaniel Jr." She wrote to friends excitedly about the pending arrival.
She told reporters that she was due sometime in the fall.[1]

When September rolled around, the actress bowed out of a film role,
insisting that the "stork was too near." But autumn passed and no baby ar-
rived. In December, just after Christmas, the *California Eagle* announced,
"Sorry to hear that it won't be a baby in the Hattie McDaniel's home; it
was a misconception." It was the era's tactful way of reporting that the ac-
tress had suffered a false pregnancy. Later it was speculated that her con-
dition could be attributed to her worsening health. Certainly years of

considerable weight gain, encouraged by the studios, were starting to wear down the once-energetic actress.[2]

At fifty-one, McDaniel must have known that it was unlikely that she was pregnant. It is possible that the actress was entering menopause and, because she commonly shaved a few years off her age, was misdiagnosed by her physician. Perhaps the actress, who had such a fondness for children, had deluded herself. It was even possible that she was trying everything to keep her failing marriage from collapsing. But, interestingly enough, McDaniel first went public with her pregnancy while she was in the midst of filming *Three Is a Family*. This farcical comedy centered on the mishaps surrounding a set of infants—as the film's press-promotional material put it, the results of a "careless stork." The film's advance publicity made the most of the baby theme. In addition to highlighting McDaniel's pregnancy, it revealed that the wife of co-star Arthur Lake was also expecting and that the married couple that had authored the play on which the film was based had recently had their first child. "Then Cindy the studio cat gave birth to three kittens," columnist Erskine Johnson reported, adding that the film's press agent's goldfish had also given birth to "twins." "After all that's happened . . . who's going to believe me?" the publicist stated to Johnson. "Even we don't believe him," the columnist wrote.[3]

Could Hattie McDaniel's pregnancy have begun as a publicity stunt that got out of control? The studio certainly eagerly used it to promote the film. For McDaniel, it was extremely advantageous; it was such a shock to the public that it immediately drew attention away from her awful slip at the Motion Picture Awards Assembly. For the rest of the summer and into the fall, the press focused on her pregnancy and not her terrible faux pas.

Yet it was uncharacteristic for McDaniel, so deeply committed to her career, to pass up a movie role. Under such extreme duress and always wanting children of her own, she may have convinced herself the pregnancy was real. According to Carlton Jackson, who interviewed McDaniel's acquaintances still alive in the 1980s, after learning there would be no baby, Hattie McDaniel fell into deep despair; she withdrew from the public eye and even spoke of ending her life. Paul Goodwin remembered that while McDaniel was indeed depressed and exhausted, she was hardly

suicidal. She did, however, retreat for a short time, leaving South Harvard for the quiet solitude of the Goodwin family's Fullerton ranch.[4]

McDaniel's self-imposed isolation did not last long. On New Year's Day, 1945, she hosted a party in her South Harvard home, where each guest gave, according to the *California Eagle*, an "impromptu performance." In February, she appeared along with Louise Beavers and Ben Carter in two floor shows for a fund-raiser for the American Women's Volunteer Service Organization held at the Gayety Swing Club on Central Avenue. Regardless of her attempts at bouncing back, in the coming months, her life was not going to get any easier.[5] During the winter of 1944–45, Hattie McDaniel began to receive an unusually large volume of letters from young black GIs, some signed individually but others carrying the names of up to fifteen men. While McDaniel was accustomed to fan mail, these were different. They all came from the Pacific theater and, in similar language, criticized the actress for continuing to accept domestic roles, insisting her characterizations were a demoralizing embarrassment to the African-American people. Using a battery of secretaries, McDaniel responded to all the letters, assuring the writers that she would "never disgrace them" but insisting that she could not "afford to forsake my life profession which is my means of livlihood [sic]."[6]

McDaniel became certain that Walter White, who was touring military outposts in the Pacific at the time, was responsible for this hailstorm of negative mail. In turn, she wrote a clearly self-composed letter to the War Department and several other branches of the United States government, implicating the NAACP chief and requesting that they intercede on her behalf. McDaniel insisted that she accepted that success had its drawbacks. Once she won the Oscar, she declared, "I soon learned that I was a public target, criticism [was] all around me . . ." But White, she alleged, had gone beyond what was normal or fair. She complained that he had consistently singled her out and that she was the only one he referred to by name in his criticism of black Hollywood. Her letters revealed a willingness to do whatever she could, regardless of how malicious or desperate it was, when it came to stopping or even seeking revenge against Walter White. She did not shrink from manipulating whites by playing on their racist fears for her own advantage. McDaniel purposefully exagger-

ated the potential results that White's campaign posed, painting a picture of angry black GIs returning home and threatening domestic tranquility. "I'm a serviceman overseas and I sort of have a grudge against the world," she quoted one letter that she claimed was signed by thirteen black GIs. "You can bet that I and many boys like me upon returning home will strive to make life a bit happier . . . There is no telling of what extent we'll have to go but we'll try regardless of the opposition." Even if she believed this was true, she also knew that the specter of black violence only triggered the worst kind of white repression and that such an allegation only threatened to betray the larger struggle.[7]

But as frantic as McDaniel's response may have seemed, it originated out of some very real, deep-seated fears. She had known the worst of poverty firsthand, and she believed White's campaigns threatened not only her stature in Hollywood but her ability to support herself and her family. Revealingly, only a few years before, she had told an interviewer that her first memory was at the age of three and was of feeding locusts to a kitten. While on the surface it served to reinforce the image of the nurturing mammy, on a much more intimate level, it hinted at a childhood marked by hunger. Little Hattie McDaniel's family struggled for food for their children and, in her early years, there were plenty of instances when she went without. The terror of hard times haunted McDaniel; it fueled her success but it also drove her to extremes. She would not go back to starvation and to barely making ends meet. She would fight with all she had against any threat, real or perceived. That even included someone as powerful and respected as Walter White.

Of course, McDaniel's attempt to enlist the government in her campaign against Walter White failed. Her pleas went ignored, and eventually her letter made its way back to the NAACP's chairman. When he learned of her allegations, he defended himself. Yes, he had told the GIs to write—but to the studios, not to the actress.[8]

During late 1944 and throughout 1945, Hattie McDaniel's film career came to a halt, and she was completely out of work. Although she would continue to blame White for her woes, she was also distracted by serious personal problems. Her marriage to Lloyd Crawford had become increasingly acrimonious and, in April 1945, he left her permanently. It took

McDaniel several months to accept that their marriage really was beyond repair. In August, she finally filed for divorce.[9]

At the same time, Hattie McDaniel was facing yet another adversity. By the summer of 1945, she had become embroiled in a legal battle to save her home. The West Adams district was governed by restrictive covenants prohibiting the purchase of property in the area by nonwhites. In various parts of Los Angeles, African Americans like Hattie McDaniel had challenged these homeowner agreements and bought real estate in these areas anyway. In some places they were successful, but in many others they became targets of vicious attacks or were subjected to legal action and eviction. Since 1941 Sam McDaniel, who had moved into a white neighborhood on Van Ness Avenue, had been fighting an attempt to take his home under a restrictive covenant. The ACLU and the NAACP, which were pushing such cases as a step toward ending residential segregation in the United States, were providing him with representation.[10]

When Hattie McDaniel signed the deed to South Harvard, she must have known that it might evolve into a clash with her white neighbors. Shortly before she bought her home, Ben Carter had settled in West Adams. And soon after the actress moved in, Louise Beavers, Ethel Waters, musician Noble Sissle, and noted black dentist and builder of the Dunbar Hotel, Dr. J. A. Somerville, also purchased houses in the area. Although many of the white residents initially cold-shouldered their new neighbors—some even moved—most of those that remained were rapidly won over by the black stars who generously enhanced their properties. By 1945, fifty-seven black families, some of the black community's most respected elite, had settled in West Adams, which became known as Los Angeles's Sugar Hill.[11]

Although some whites in the community had begun protesting in 1943, it was not until the summer of 1945 that eight white area homeowners decided to try to oust their black neighbors by filing suit against them. The white West Adams plaintiffs disparagingly insisted that if restrictive covenants were not enforced, their property would lose value and racial clashes would inevitably ensue. In the past, local courts had commonly upheld such neighborhood agreements. In one case, a judge even ruled that while African Americans could not be prevented from buying real estate

in an area, they could be forbidden to live in homes on their property if the deeds contained restrictive clauses.[12]

Despite the frustration it presented, the suit did not send the emotionally wracked McDaniel spiraling further into despair. Rather, it revitalized the actress. While she had acquiesced to Hollywood racism on movie lots, she refused to accept it outside of the studio walls. It was Hattie McDaniel, the most famous of the black homeowners, who helped to organize the black West Adams residents in a fight not only to preserve their homes but also to end restrictive covenants. In her efforts, she joined forces with Loren Miller, a local black attorney, NAACP activist, and political radical. Miller had traveled to the USSR with Langston Hughes, published articles attacking racism in *The Crisis* and *The New Masses*, and had led the fight against housing discrimination in Los Angeles. It was Miller who represented Sam McDaniel in his restrictive-covenant case and, in 1944's *Fairchild v. Raines,* won a decision for a black Pasadena family that had bought a nonrestricted lot but was sued by white neighbors anyway. Although the attorney had been a critic of the film industry and black cinematic images, he developed tremendous respect for Hattie McDaniel. In 1944, when he ran for a congressional seat on the Democratic Party ticket, McDaniel turned out to support him. Miller knew that McDaniel would make this a high-profile case and that her involvement presented a major opportunity to strike a blow against housing discrimination. Ironically, while Hattie McDaniel was fighting the NAACP's national chairman, Walter White, she was working closely with the Los Angeles branch and Miller to end restrictive covenants.[13]

In defying restrictive covenants, McDaniel had chosen a tough and dangerous battle. In other parts of Los Angeles, whites used terrorism as they endeavored to preserve neighborhood segregation. The Ku Klux Klan burned crosses on the front lawns of black Angelenos fighting restrictive covenants. Several African-American families fled other white neighborhoods after enduring constant insults and threats. One family found themselves in jail, another was bombed out of their home. It was this atmosphere of racial hostility and violence that McDaniel confronted as she waited for her day in court.[14]

On December 5, 1945, the "Sugar Hill Case," as McDaniel's restrictive-

covenant fight became known, came to trial before Superior Court Judge Thurmond Clarke. On that day, McDaniel led her codefendants along with two hundred and fifty supporters into the courtroom. In opening arguments, the attorney for the white plaintiffs insisted that the black West Adams residents were in violation of the law, that restrictive covenants were protected under the Constitution, and that black property-owners must be required to surrender their homes immediately. Loren Miller countered with a shocker. He immediately moved to bar any testimony by or on behalf of the plaintiffs, arguing that restrictive covenants violated both the Fourteenth Amendment, which mandated equal protection under the law, and the California State Constitution. Judge Clarke's response was earth-shattering. He immediately granted Miller's motion and followed up with a ruling. "It is time that the members of the Negro race are accorded without reservations and evasion, the full rights guaranteed under the 14th Amendment of the Federal Constitution," Clarke insisted. "Certainly, there was no discrimination against the Negro race when it came to calling upon its members to die on the battlefields in defense of this country in the war that just ended." This set a precedent. By ruling restrictive covenants unconstitutional, Clarke opened the door for the end of such residential segregation throughout the United States.[15]

As Miller and his clients expected, the white West Adams residents immediately appealed. Thurgood Marshall, head of the NAACP's legal division, cabled the national office's support for the ensuing battle. Despite the additional help, the case dragged on through the courts. As Miller built his case, the defendants emerged with a radical demand. Hattie McDaniel, Louise Beavers, and Ethel Waters publicly called for the court to find in their favor under the just-ratified United Nations Charter's guarantee of human rights, which protected citizens of the United States, as well as the world, against racial discrimination. As the case was pending, black Angelenos, joined by the AFL-CIO and other black and white church and community groups, held a massive rally to call for an end to restrictive covenants.[16]

McDaniel's restrictive convenant suit was not the only legal battle she was fighting. On December 19, 1945, she was back in court, this time to testify against Lloyd Crawford in her divorce trial. Outfitted in a smart

plaid blazer and dark skirt, McDaniel looked fresh and trim. But once on the stand, she told a sad story of a marriage that had been filled with unhappiness. She alleged that Crawford had contributed little to the household income and refused to find steady work. When he did, she testified, he took a job purposefully embarrassing to her (she did not elaborate what it was) and, even worse, she claimed, threatened to kill her if she complained. Additionally, McDaniel maintained that Crawford constantly interfered with her career, demanding that she abandon it.

"Was he jealous of your motion picture fame?" the presiding judge, Goodwin J. Knight, asked.

"Yes," McDaniel insisted.

"I guess fame doesn't bring happiness, does it," the judge commented.

"No, *sir*," McDaniel answered firmly.[17]

Judge Knight, who later became governor of California, promptly granted McDaniel's divorce. Since there was no community property involved—McDaniel had purchased the South Harvard property in her name only—the separation was a clean break. The rumor mill kicked in and immediately linked Hattie McDaniel with a young, unnamed serviceman. She vigorously denied it. Several weeks later, she attended the Academy Awards, the first ever broadcast over the radio, on the arm of Wonderful Smith. She insisted that there was no romance between them either. "We are just friends," she told the press.[18]

Although she had terminated her stormy marriage to Lloyd Crawford, McDaniel still found herself adrift in a sea of personal and professional troubles. That winter, her sister Etta had fallen seriously ill. It must have shaken Hattie McDaniel; the two had always shared an intense bond. With Hattie's help, Etta had carved out a successful film career and, by the 1940s, had appeared in small parts in over forty-five films. Although described by some as "unassuming," Etta McDaniel shared her sister's drive. In 1942, she proudly described herself in an interview as a "self-made woman." While she did not enjoy the tremendous fame and recognition of her sister, Etta McDaniel did find happiness in a grandson, Edgar Goff Jr., and a second marriage, to Joseph Spaulding, a Los Angeles building contractor. She worked up until she became too ill to go on (her last picture was *The Thin Man Goes Home*). In early January 1946, Etta McDaniel was

hospitalized, and on January 13, at the age of only fifty-five, passed away. She had earlier converted to Catholicism, and on January 15, her grieving family held her funeral at Holy Name Catholic Church and buried her in Los Angeles's Calvary Cemetery. Her death left a considerable void in her sister's life; it counted as one of the biggest losses Hattie McDaniel had ever endured.[19]

Hattie McDaniel's despair was transformed into pure rage when, shortly after her sister's death, she learned that Walter White had finally consented to meet with members of the black film colony. Since the beginning of his Hollywood crusade, various voices had urged White to consult with Hollywood's African-American entertainers. One of the first was Lena Horne, who early on recognized the danger posed by the breach between White and the black cinema community. Even Norman O. Houston, despite his disdain for the black actors, advised White to meet with them. Respected black composer William Grant Still, who had worked in Hollywood, counseled White to use more diplomacy with black film artists. "You may, of course, not agree with what they say," he wrote to White in 1943. "But on the other hand, it is very possible that someone will have something of genuine value to offer."[20]

White's decision to meet with the black performers did not result from a change of heart or a desire to seek their counsel. Rather, he had become more disenchanted with white Hollywood's recalcitrance, as well as alarmed at the direction filmmakers appeared to be headed. At the war's end, the government had abandoned its commitment to improving black images, ultimately shutting down one of the major sources of pressure on the film industry. With Wendell Willkie's death in 1944, there was no one to hold producers accountable, and cinema bosses, thinking they were off the hook, were quickly reverting to prewar racial status quo. But Walter White had a plan. He decided to publicly unveil it before the members of the black film colony in Los Angeles.[21]

The duty of setting up the meeting between Walter White and the black performers fell to Los Angeles's NAACP branch president and local attorney Thomas Griffith. Hoping to defuse what promised to be a tense encounter, Griffith decided to schedule it over a meal plentiful with drink. He sent personal invitations to all of black Hollywood, inviting them to

meet Walter White at the elegant Crystal Tea Room on January 21, 1946. RSVPs flooded in. Louise Beavers, radio actress Lillian Randolph, Clarence Muse, Ben Carter, Carlton Moss, Lena Horne, Sam McDaniel, and almost everybody who was anybody in black Hollywood would be there.[22]

Yet, outstanding among these acknowledgments was one from Hattie McDaniel. On January 20, she sent Griffith a searing letter. "No, Atty Griffith, I cannot accept your invitation to break bread with Walter White," she wrote with ringing hostility for the NAACP chief, "for he has openly insulted my intelligence, playing me as he thinks all dark skinned Negroes to be played." She claimed that during one of their encounters White addressed her "with the tone and manner that a Southern Colonel would use to his favorite slave." She believed that he had somehow implied that her only talents were for domestic work, and also insisted that sources had informed her that White was prejudiced against those with darker complexions. "There is none of us that would not welcome better parts," she declared, arguing that filmmakers would continue to restrict blacks to servile roles until African Americans moved further up the real world's occupational ladder. "Although Walter White has tried to imply that I would accept any role just to be working, this is not true," she maintained. "I am trying each day to lift the position of my people and to create a deeper respect from the other side for us." In her estimation, White's crusade had only amounted to a decline in employment for all black actors as studios gave roles formerly played by African Americans to whites. All of this could have been prevented if White had worked with black performers. By cooperating, the two sides could have effected more change, more quickly. Hattie McDaniel was deeply hurt and embittered. "If I never make another picture I am able to live," she roared, "for God has endowed me with other talents which Walter White and no other persons know nothing of, and they are not menial as he said."[23]

The meeting between Walter White and the African-American film colony went ahead without Hattie McDaniel. "Virtually all of them came," White reported in a letter to the home office, "—with hatchets." And the NAACP's chief did little to help the situation. He opened the meeting not with a discussion but rather an announcement. The NAACP, White re-

vealed, planned to open a Hollywood office solely dedicated to improving black cinematic representation.[24]

When White finished outlining his plan, the black performers exploded in protest. Clarence Muse angrily disputed the need for another branch in the region, one that would, in terms of the relationship with the film industry, supersede the NAACP's long-established Los Angeles office. (Like Muse, other members of the black film colony continued to be actively involved with the local division, which was probably one of the factors motivating White to set up a separate Hollywood NAACP.) Louise Beavers, speaking on behalf of both herself and Hattie McDaniel, objected to White's continued circumvention of black performers and complained about the disparaging letters sent by black GIs in the Pacific to her good friend. (White vociferously denied all responsibility for the mail.) Like McDaniel, Beavers angrily accused White of harboring biases against darker members of the race. Other performers joined in, complaining about the loss of work. Several assailed Lena Horne as "an Eastern upstart" and "a tool of the NAACP." Horne stood her ground, defending her career and, joined by Carlton Moss, refuting the charges that White was prejudiced. But her remarks, and her well-known status as an NAACP insider, did little to quell the crowd's escalating hostility. It became clear that neither side was truly willing to compromise or publicly unite for an all-out assault on their real foes, the white studio system. After three solid hours of berating the NAACP leader, the black film players left the meeting more incensed than ever. Louise Beavers later told a *Pittsburgh Courier* reporter: "This latest NAACP brain child is a new type of streamlined gangsterism."[25]

"Fortunately, I was in a non-belligerent mood and laughed at their cracks, some of which were to say the least slightly less than in good taste," White told his staff members regarding the meeting. From his view, all it accomplished was to verify that the black actors were motivated solely by selfishness. He stormed ahead with the Hollywood bureau, dismissing any further opposition from the black film colony as "not terribly important however much some of them may squawk now."[26]

In part, White's assessment was correct. Public opinion within the African-American community had swung decidedly against the black film

veterans. Vocal champions of old black Hollywood were declining in number. The *Chicago Defender* weighed in with hearty support for an NAACP Hollywood bureau; it criticized the black film stars for continuing to "play the despicable, disgusting Uncle Tom roles" and caring only about their own incomes.[27] Fredi Washington called on her former Hollywood colleagues to put aside their differences and close ranks with White. "What all concerned are overlooking is the fact that to accomplish these aims, there must be mass organization," she wrote. "Such organization the NAACP has." She reprimanded black film stars for stooping to "distasteful" charges of color bias against the NAACP leader. For years White had worked for and with darker-complected members of the race, and the idea that he harbored such bigotry appeared outlandish and embarrassingly petty, only further undermining the credibility of the black film colony.[28] The *Pittsburgh Courier* also ran articles supporting White and his plan. One, "White Answers Stars Blast At Interference," was written by black journalist Alfred A. Duckett, who before publication sent the piece to the NAACP leader for approval. The final version quoted White placing a significant amount of blame for "lynching, disenfranchisement, unequal educational opportunities, and job discrimination" on the movie actors. "What is more important?" asked White. "Jobs for a handful of Negroes playing so-called Uncle Tom roles or the welfare of Negroes as a whole? If the choice has to be made the NAACP will fight for the welfare of all Negroes instead of a few."[29]

Black film stars such as Hattie McDaniel resented White's accusations that the vicious manifestations of racism were in any way their fault. But, as they clung to outdated notions of gradual racial uplift, they found it increasingly hard to exert much influence both inside and outside Hollywood. Their status within the African-American community suffered greatly while any clout they had managed to wrestle within the studio system declined. The problem was that, indeed, most of their careers were almost over. Postwar filmmaking had taken a decidedly different turn. The conflict had left Hollywood world-weary; many of the films of this period reflected the gloom and anxieties of the Cold War America. In the years just after the war, filmmakers made less use of black characters. Even in terms of comedy, the post-1945 cinematic world was virtually all-white. As

McDaniel and others alleged, studios and the censorship office, hoping to evade the race issue, had become wary of using African Americans in film. In the later forties and early fifties, when the egalitarian legacy of wartime filmmaking kicked in, Dorothy Dandridge and Sidney Poitier began to forge new characterizations. But parts for black players did not multiply to any great extent. This was especially true for black cinema veterans. They had become a liability. Black Hollywood old-timers had come to symbolize the racial stereotypes in everything they did, no matter what it was. When they did appear on screen, their images only served as reminders of the disparagement of racial stereotyping and dire effects of racism.[30]

For McDaniel, 1946 was the last year she would make a significant number of films and, even so, it was only a paltry four. Three of these, *Janie Gets Married*, *Margie*, and *Never Say Goodbye*, were run-of-the-mill women's films in which McDaniel appeared as yet another maid. But she did score a role in a project that promised to be an innovation in filmmaking. It was a Walt Disney production called *Song of the South*.[31]

The Disney project carried with it a major drawback—it was based on white Southerner Joel Chandler Harris's collection of black folktales, which were popularly known as "Uncle Remus Stories." These tales in their original form had been told for generations within the black community and offered subtle messages of resistance. However, in Chandler's hands, they were greatly stripped of their power and transformed into only another pop-culture extension of racist ideology. Disney blended these tales with a story of a young white boy in post–Civil War Georgia who, after his parents separate, is sent to live on his grandmother's plantation. His sadness is eased by his friendship with Uncle Remus, who delights him for hours with Brer Rabbit tales. The film was punctuated with music and, for the first time in cinematic history, blended live action with animation.[32]

Despite the ingenuity of Disney's idea, early on, word that he intended to make a film based on Uncle Remus tales aroused grave concern among African Americans and others sympathetic to the black struggle. In 1944, just after Hedda Hopper announced Disney's intentions in her column, Walter White wrote to the producer inquiring about the project. Disney cordially responded, inviting White to consult with him personally on the

project but insisting that it would be too cumbersome to work with the NAACP as a whole. Although White agreed to read the film's script, Disney subsequently forged ahead without the NAACP leader.[33]

Several months later, the Hays Office reviewed a draft of *Song of the South* and rated the black characters all acceptably sympathetic. But Joseph Breen did warn Disney that the film might induce some opposition within the black community. "Our Negro friends," Breen wrote, "appear to be a bit critical of all motion picture stories which treat their people and it may be that they will find in this story some material which may not be acceptable to them." Breen urged Disney to establish a relationship with some "responsible Negro authorities" to head off protests against the production.[34] Additionally, the censor forwarded the advice from Francis Harmon, a white Southerner who worked for the Motion Picture Producers Association. Despite his regional biases, Harmon was strongly critical of Disney's project. He warned of the offensiveness carried by the script's liberal use of "darky," the disrespectful scenes of "Negroes singing happily," and the stereotyped "funny business." But, in sum, his recommendations only reflected how fundamentally insensitive film industry insiders were to the black community's concerns. With slight alterations and a clarification that Uncle Remus, as a character from the past, bore no reflection on modern times, he felt the film would be acceptable.[35] For Disney, the censorship office's feedback served as a green light. He deleted the term "darky" and slapped on a prologue that read: "Out of the humble cabin, out of the heart of the Old South, have come the tales of Uncle Remus, rich in simple truths, forever fresh and new."[36] Still, the American Council on Race Relations urged Disney to abandon the project. The producer ignored them. He compared *Song of the South* to *Gone With the Wind* and insisted that it would serve as a "monument to the Negro race." It indicated the depth of his unwillingness to hear or understand the position of those struggling for better and more accurate representation.[37]

In terms of the mechanics of filmmaking, *Song of the South* was a technologically ambitious, pioneering project. It took almost two years of planning and filming until finally, in 1946, the picture was ready. And if there were any hopes that Disney would address the objections raised about the

film, they were dashed when his studio announced that *Song of the South* would be premiered in Atlanta. It only further signaled that Disney's tale would promote a romanticized vision of the Old South.[38]

In *Song of the South*, Hattie McDaniel, as Aunt Tempy, came the closest she had in years to echoing the parts she had played earlier in her film career. Now completely freed from Selznick, she could resurrect at least some of the elements of Mammy of *Gone With the Wind*. Actually, it is likely that the Disney studios, attempting to ride on that film's success, probably encouraged her to draw as much from her characterization of Mammy as possible. Aunt Tempy rides into the first scene with her head held high, looking the white people she serves in the eye. Still, her attempts at reviving the boldness of her early performances were limited by Disney's conservative attitudes. Tempy was blustery and could be irritable, but only with her white charge and other black characters. Bandannaed, in servant's wear, McDaniel used a dialect that she insisted was drawn from slave times but sounded more like the old Hollywood version of black speak. And unlike Selznick's opus, as lacking as it was, *Song of the South* gave her no dramatic opportunities or any chance to draw more deeply from her talents. Tempy is one-dimensional and has absolutely no power. Like the film's other black characters, she is content to stay on the plantation despite Emancipation. One of the film's musical numbers, sung by black field hands in tattered clothes, exposed the real underlying message. "Goin' to stay right here in the home I know," the song goes, several lines later declaring, "Thankful that he let you stay."[39]

Song of the South made Disney some money and received some positive appraisals from white reviewers. *Variety* celebrated its pioneering mixture of live action and animation.[40] The *Atlanta Journal* proclaimed the film superb entertainment. Many, including a number of African-American critics, praised James Baskette, the forty-two-year-old actor aged by makeup artists to play Uncle Remus. In fact, the following year, the Motion Picture Academy honored him with a special award for his performance. (It was posthumously awarded; Baskette had died of a sudden heart attack.) But Hattie McDaniel's performance received little notice. Although *Variety* hailed her delivery of a song, an oddly modern tune

"Sooner or Later," *Time* magazine, which overall found the film turgid, lumped her in with the rest of the cast, which it labeled "bores."[41]

Some Americans, both black and white, maintained that *Song of the South* was more than dull; it was dangerously flawed. Bosley Crowther of the *New York Times* denounced Disney for producing a sanguine version of "a sublimely unreconstructed" South. "The master and slave relation is so lovingly regarded in your yarn . . . one might almost imagine that you figure Abe Lincoln made a mistake," he wrote. "Put down that mint julep, Mr. Disney. It doesn't become your youthful face."[42] Hope Spingarn, wife of educator and NAACP leader Joel Spingarn, immediately identified what she considered the film's greatest problem. She noted that Disney had slyly incorporated most of the timeworn, offensive black stereotypes into the animated animals. The cartoon characters spoke in traditional de-grading black Hollywood dialect and were drawn to evoke minstrelsy. The result was a devastating animalization of black images that only perpetu-ated racism's most harmful and disparaging elements. Pickets went up protesting *Song of the South* in Manhattan and other parts of the nation. Several black theaters refused to screen the film. Some cited Hattie McDaniel's mammy role as particularly objectionable, and she received a barrage of letters protesting her appearance in the film.[43] Walter White quickly issued a statement, condemning the film as insulting and distorted, "a dangerously glorified picture of slavery."[44]

McDaniel went on the defensive. In an interview that ran nationwide, she fired back:

> The story of Uncle Remus . . . is a warm, moving tale of the creative ge-nius of a Negro slave who brought understanding and happiness into the lives of all those he met. To the entire countryside he stood for wis-dom, kindness, and faith. He understood human nature, whether shrouded in a white or black skin.[45]

For many, Hattie McDaniel's association with and her protectiveness of such a controversial film confirmed that she was a puppet of white studios and interested only in her own career. Not too long after the film's release, in the fall of 1946, she was invited to address a youth group dedicated to

bettering black cinematic characterizations. As the actress finished, the angered young people showered her with what the California Eagle's editor Charlotta Bass described as "verbal brickbats."46

Following *Song of the South*, Hattie McDaniel worked only two weeks in 1947, in a small role in a minor picture for Republic Studios, titled *The Flame*. For the actress, unemployment was not only depressing but, as she battled the haunting fears of poverty, also alarming. Seething, she blamed White for the collapse of her film career. She continued her attack on him through private channels. "Here I am without a job," she wrote to Communist-hunter California state senator Jack B. Tenney (who was in the process of holding his own antisubversive hearings). "Would you please speak with someone?"47 When her friend Dr. Stanley Bates, a NAACP insider, telephoned her for a "friendly chat," McDaniel launched into a rant. White was both jealous and bigoted, she raved, insisting that someone had overheard the NAACP chief remarking, "I'm going out there and see how those black n——— can live so fine." Although Bates did what he could to convince the actress that White would never make such a statement, it did little to placate the thoroughly livid McDaniel. She was certain that White held her in contempt for the color of her skin and her working-class origins, that he could not accept that a woman of her background could become a success. Her resentment had gotten the best of her and she had deluded herself into believing the worst of the NAACP leader.48

In late 1947, angry and resentful, McDaniel took her case to the white press. First, came an article for the *Hollywood Reporter*, authored by the actress no doubt with considerable assistance from the publication's editors. In the piece, titled "What Hollywood Means to Me," McDaniel maintained that blacks in Hollywood had made some progress, recalling earlier times when black players were denied dressing rooms and proper wardrobe assistance. She also cited black inclusion in SAG as evidence of the changing environment of the film industry. To those who continued to criticize her, McDaniel offered this: "I believe my critics think the public more naïve than it actually is. Arthur Treacher is indelibly stamped as a Hollywood butler, but I am sure no one would go to his home and expect him to meet them at the door with a napkin across his arm." Her critics

were taken in by the Hollywood fantasy as much as any film fan, she insisted, and they needed to comprehend the distinction between "farce" and "factual." Comedy, she argued, was supposed to be unreal—that was exactly its appeal. While the article read as a defense of white Hollywood and her career, it was an admission that she believed her comedy signified something much more complex than appeared on the surface. "I have never apologized for the roles I play," she emphatically stated.[49]

McDaniel followed this with an interview with Hedda Hopper. Ruby Berkley Goodwin, who now worked only sporadically for the actress after assuming the duties of secretary and publicist to Ethel Waters, accompanied McDaniel to her appointment to act as a check on her friend's outspokenness. But McDaniel was boiling, and there was probably little Goodwin could do to keep her from caustically assailing her opponents. A champion of the white film industry and hardly sympathetic to the African-American struggle, Hopper printed as much of it as she could. "What do you want me to do?" McDaniel rhetorically asked her critics. "Play a glamour girl and sit on Clark Gable's knee? When you ask me not to play the parts, what have you got in return?" If the naysayers, like Walter White, really wanted to improve black images in film, she suggested they finance independent black studios. She steadfastly maintained that she would gladly accept any role in an independent black production that resulted from such an effort, although the reality was she had passed up similar opportunities previously. Hopper declared that it was not white moviemakers standing in Hattie McDaniel's way but rather black leaders and journalists. The article was filled with Hopper's racist perspective, one that promoted the film industry and demeaned not only McDaniel—who, according to the gossip columnist, was on the verge of opening a fried chicken restaurant to survive—but the campaign for better black representation in American cinema.[50] In the *California Eagle*, Charlotta Bass exposed Hopper's piece as pro-racist, pro-studio propaganda. "I again repeat that neither the N.A.A.C.P., the Negro newspapers, nor individuals are fighting Miss Hattie McDaniel," she wrote in a column addressed directly to Hopper. "For your enlightenment, we are fighting a damnable system that keeps Miss McDaniel and the rest of us second class citizens."[51]

Although McDaniel's burning animosity for Walter White consumed

her, she still recognized, like Bass, that the bigger problem rested with white film moguls. (In the *Hollywood Reporter*, McDaniel implied that despite her years in the movie capital, she remained an outsider. "At heart, I suppose I am still a tourist from Milwaukee," she ended the piece.) In the summer of 1947, as a loyal and active SAG member and the film community's most heralded black performer, she must have played some role in compelling the union to finally meet with Hollywood producers to discuss the problem of black cinematic representation and the loss of jobs for African Americans. After the meeting, SAG reported back that the Motion Picture Producers Association had agreed to stop casting white actors in parts originally calling for black characters, to halt the use of traditional stereotypes, and to increase the number of African-American players in crowd scenes or bit parts. But it was hardly the step forward that many had anticipated. The agreement was composed in conciliatory language: "some thought will be given," read one section, and in another, the examples of inclusive extra work included "gas station attendants, elevator operators, etc." It did little to encourage truly improved representation. Furthermore, it was virtually unenforceable.[52]

It was not long before it was obvious: the agreement between SAG and the producers was a dead letter. As never before, Hollywood power brokers were either excising the celluloid black presence or stubbornly refusing to relinquish their customary racist images. That fall, one studio altered a script, calling for a black character to be referred to by her first name rather than as "Mrs. Bigby," as designated in the original dialogue. Another deleted lines where a black male character protested the disparaging white assumptions that all blacks were addicted to gambling. An industry insider leaked information to the NAACP's Thurgood Marshall that the studios were in turmoil—not over black images but rather over the actions of the House Un-American Activities Committee (HUAC). Probing into moviedom's affairs, HUAC had accused a variety of high-profile Hollywood figures of Communism. Just an allegation of Leftist sympathies was enough to end a public career in many fields. Marshall reported to Roy Wilkins that "the producers are scared to death," and to save themselves and the industry, they were moving expeditiously to demonstrate their loyalty by excising any cinematic content that might be

interpreted by conservatives as Left-leaning. Since Red-baiters often linked civil-rights activism with Communism, the studios began deleting sympathetic or progressive black images. Marshall discovered that the studios had internally agreed that "Negro and other minorities" would "revert to the old line treatment."[53]

In a frantic effort to escape the dire consequences of the post-WWII Red Scare, Hattie McDaniel and many in the black film community adopted staunch anti-Communist positions. These African-American performers had reason to worry. Despite their images as sellouts to white racism, almost all had supported various campaigns for equal rights, some spearheaded by organizations or individuals now suspected of having disloyal Leftist ties. Loren Miller, Paul Robeson, Charlotta Bass, Lena Horne, and a number of other members of the black community were victims of Red-baiting. (Bass had been called before a commission chaired by state senator Jack B. Tenney and was bravely outspoken against what she termed his "reign of terror.") Additionally, Hattie McDaniel, Clarence Muse, Louise Beavers, and several other black film veterans had been active SAG members, and such union involvement definitely provided the anti-Communist forces with supposed evidence of subversivism. The rise of HUAC and its attacks on Hollywood complicated McDaniel's life even further. She now not only faced white racism both inside and outside of the studios and animosity from within the black community but also the possibility of being targeted in the anti-Communist sweep of Tinseltown. In one interview, she issued a strong denial that she maintained any Communist sympathies. She appeared in a photo opportunity alongside Jack B. Tenney. (Charlotta Bass was outraged and, in a strident editorial in the *California Eagle*, called on McDaniel to repudiate her association with the reactionary politician.) Additionally, she joined with seventeen other black Hollywood figures in signing a petition denouncing Communism and declaring it a threat to the liberties of African Americans. "The solution [to the civil rights struggle] cannot be found through Communism which would destroy the advances Negroes have made in the United States," it read, further comparing such ideologies to slavery. Hattie McDaniel also benefited from the support of Lela Rogers, the mother of Ginger Rogers, who helped organize the Motion Picture Alliance for the Preservation of

American Ideals. After emerging from HUAC testimony in 1947, Lela Rogers assured a reporter from the *Baltimore Afro-American* that both Hattie McDaniel and Louise Beavers were "truly good Americans and grand persons." If McDaniel's politics appeared to make a hard right turn in the later forties, it was yet another desperate effort to preserve her dying career.[54]

However, Hattie McDaniel soon—and surprisingly—found her position within show business on the upswing again. In fall 1947, CBS radio began a talent search for someone to play the lead role in its hit series *Beulah*. For several years, a Southern white actor Marlin Hurt had played Beulah, a black domestic who expended most of her energy trying to extract a marriage proposal from her boyfriend, Bill. When Hurt died suddenly of a heart attack in 1946, the show's sponsor, Procter & Gamble, replaced him with another white male actor, Bob Corley, who was an immediate flop. Desperate to revive what had been a lucrative show, they held auditions for a replacement. Among those who turned out was the Academy Award–winning Hattie McDaniel. Although no black woman had ever headlined her own radio show, Procter & Gamble decided to try her out. With McDaniel's debut on *Beulah* in mid-November of 1947, the show became more popular than ever.[55]

Not only was McDaniel a smash on the air, as Selznick had predicted years before, she brought to the role entirely new commercial possibilities. Now Beulah could be more than just a voice; she could be used visually in commercial endorsements. Procter & Gamble moved swiftly to exploit the actress, hawking their soap Dreft in ads that ran in magazines and newspapers nationwide. In one, dressed in a housekeeper's uniform, a smiling Hattie McDaniel testified, "When I wash dishes with Dreft, they sparkle like diamonds, even without wiping! Love that Dreft." (One of Beulah's most famous lines, originated by Hurt, was "Love that man.") In the late 1940s, the company even supplied McDaniel with personalized greeting cards that pitched Dreft and read "Merry Xmas, Happy New Year, and *thanks* for listening, Beulah." Over the next five years, McDaniel became thoroughly enmeshed with the image of Beulah. Procter & Gamble was so convinced of the success of radio's first black female star that they boosted the show from one to five days a week. For fifteen minutes, every Monday

through Friday at four o'clock Pacific Standard Time, broadcasting live from Hollywood's Sunset Playhouse, McDaniel dominated the nation's airwaves. According to one report, McDaniel's contract promised her $1,500 each week during the broadcast season, which ran fall through spring. She would have summers off to pursue movie roles.[56]

Although it hardly had the prestige of cinematic work, and the demands of radio made it hard for McDaniel to accept other engagements during most of the year, *Beulah* was a big comeback and offered her the steadiest salary that she had ever earned. Additionally, the character provided McDaniel with an interesting challenge. Radio ruled out all possibilities of the backhanded visual techniques that McDaniel had so long used in film to undermine the more disparaging elements of her parts. Now all she had was her voice. McDaniel immediately took an adamant stand. If she were to play the part, then it would be without Hollywood's contrived and humiliating black dialect. Additionally, she requested that Ruby Berkley Goodwin write some of the show's scripts. Anxious to appease McDaniel, CBS agreed.[57]

With the addition of McDaniel and a new staff, which included Sherwood Schwartz and Hal Kanter, *Beulah* was headed in a new direction. (Schwartz went on to develop some of television's most popular sitcoms, such as *Gilligan's Island* and *The Brady Bunch*, and Kanter later produced the path-breaking series *Julia*, starring Diahann Carroll, and *All in the Family*.) Under Hurt, who conceived of the character as "man-crazy, weighs about 140 pounds, has good teeth, wears her hair in bangs and a pageboy bob," the show had remained solidly entrenched in demeaning stereotypes. In a high falsetto, Hurt had delivered Beulah's lines in traditional Hollywood black dialect, and she emerged as dopey and foolishly ignorant. When she finds a wedding ring, she thinks the 24k inscribed inside of it refers to the apartment number of the owner. Bill, the object of her affection and also played by Hurt, is not only commitment-shy but fundamentally lazy and is called "boy" by the white characters.[58]

In an attempt to counter *Beulah*'s tremendous failings, McDaniel, for one of the first times, flexed some star muscle and immediately set out to overhaul the show. "I've been using up an extra share of nervous energy creating a new interpretation of Beulah," she later told the *New York*

Times. "I'm the third Beulah on the air and I was what you might call plenty concerned about this new series when we started last November." McDaniel transformed Beulah into a wisecracking, all-knowing character who was much more sensible and intelligent than the Hendersons, the family she served. The stories focused on Beulah's life and, as before, her endless attempts to get Bill, her boyfriend of seven years, to the altar. McDaniel played the character with an astuteness that Hurt's interpretation had lacked. She transformed Beulah from a man-hungry, lightweight giggler into an intelligent and mature woman who knew what she wanted and was going to get it one way or another. Unlike Hurt's interpretation, McDaniel's Beulah confessed to gaps in her knowledge not because she was ignorant but rather as clever setups that transformed her white employers into the foils for her constant string of witticisms. When she asks Harry Henderson, the family's patriarch, who is on a campaign to stop Halloween pranks, to define vandalism, he says he means "boys' mischief." Beulah saucily retorts, "Why put a stop to that? I've always found it fun." Beulah was bold and, although always mild-mannered with the Hendersons, confronts the rest of the world with feistiness. Each show opened with a new quip from the actress. "Beulah, one gal who needs some advice on how to get them to throw that rice," began one episode. Often Beulah and Alice Henderson conspire together to trick Bill or Harry. In one episode, Alice advises Beulah to write herself a love letter and sign it with a male name to make Bill jealous. In another, Beulah concocts a plan to help Alice lure her husband into taking her on vacation to Mexico. Although the gender messages were clearly traditional—Beulah and Alice are constantly seeking their men's approval—both women emerge as crafty and controlling. With McDaniel on the show, this became a battle of the sexes that united women across racial lines. Bill asks Beulah if she would question him if she found lipstick on his collar. She replies, no: "How could you answer after I hit you on the head with that baseball bat?"[59]

Although overall Beulah came off quicker and more knowledgeable than the Hendersons, the show also reentrenched many traditional aspects of black stereotypes. With McDaniel on the series came innumerable jokes about weight. "If anyone was drowning and they saw me coming, they think a whale was after them and they'd die of fright," she remarks when

asked if she could be a lifeguard. (This kind of gag was one way the show's creators could link the radio voice to the stereotyped Mammy.) CBS played up McDaniel's size, and in one press story insisted that both the actress and her pet Dalmatian, Dannie, were trying to reduce. Additionally, Beulah was restricted to life as a loyal black servant to a white family, always fussing over the Hendersons' needs, cooking and cleaning for them. While, as Sherwood Schwartz remembered, the show's new staff "made sure that no blacks were unemployed on the show," and Bill, played by Ernest Whitman, was hardworking and, as Alice Henderson observes, "honest and conscientious," all of the black characters were confined to menial positions. With the exception of McDaniel, many used inflections of the traditional Hollywood black dialect. Beulah's daffy sidekick was Oriole, played by Ruby Dandridge, the mother of the young path-breaking black actress Dorothy Dandridge. While her daughter was challenging black stereotyping, Ruby Dandridge was confined to a silly and dimwitted character, the maid next door with a screechy voice, whose antics and ignorance leave Beulah exasperated. ("Shut up, Oriole," Beulah bellows, "you sound like a seagull.") Entrenching the stereotypes even further, the white Hendersons have a very sterile and almost unromantic relationship while Beulah and Bill, despite his reluctance to take the plunge, are filled with passion. Whenever he enters, and just before he ambles over to the refrigerator for free food (another stereotype), Bill introduces himself with some kind of reference to his abilities as a lover. "It's Bill, baby, your great big live wire," he announces in one episode. Beulah is equally amorous. "Well, step right in and let's start sparking," she responds. The two often kiss, signaled by a loud, obnoxious smack over the air. The contrasting relationships between the two couples asserted that blacks were simply lustier than whites; it only degraded African-American people further. Despite Beulah's wisdom and inventiveness, her sassiness and bossiness were always countered by these reminders of American racist ideology. CBS's publicity announcements that proclaimed Beulah "that bubbling, chuckling, ever-happy domestic" and "the kitchen queen" did not help much either.[60]

McDaniel received voluminous fan mail for *Beulah*, mostly from white listeners, and again found herself at the center of controversy. Walter

White had also campaigned against black stereotypes on the radio, a place where whites commonly played black characters using demeaning Hollywood dialect. McDaniel, the most noted black woman on the air, rapidly became the focus of much of the protest against radio's promotion of racism. In an effort to bolster black support for the show, Procter & Gamble gave away free tickets to the show at the offices of the *Los Angeles Sentinel.* Although black publications reported on McDaniel's newfound success on the air, at least some African Americans remained dissatisfied. "Hattie is a disgrace on the radio," wrote one listener to Walter White. In 1949, the *Kansas City Call,* an influential midwestern African-American newspaper, published a list of things that "Must Go." Prominently featured was the name of Hattie McDaniel.[61]

McDaniel was furious. She answered the *Call*'s article with a scathing letter to the editor, defending her portrayal of Beulah as both dignified and responsible. Objecting to the erasure of images of black domestics from mass culture, she argued that for many African Americans they did reflect a reality. "How can one in your profession not know that the millions of Negroes in this country, the majority of them are employed in domestic roles?" she thundered. "Why do we as a race deny our heritage? Surely you don't think that the role I portray is obsolete?" She insisted that the money she earned went to helping others. Indeed, McDaniel had established her own charity, Les Femmes Aujour d'hui (Women of Today), an outgrowth of her work with other black women during WWII and dedicated to raising money for a variety of philanthropic causes. She had also contributed to charitable activities as an honorary member of Sigma Gamma Rho and the Jewish Women's Auxiliary. But despite such endeavors at maintaining a positive public profile, she remained the focal point of criticism within the black community. "She and others who would degrade us in the eyes of the peoples of the world, should be kept from the Screen, Radio, and Television," insisted one anonymous writer to Walter White. McDaniel ended her letter to the *Call* with an ominous threat: "I'm giving fair warning to each and to all, that should further articles of this nature continue to appear, I shall be forced to bring the matter to the attention of my lawyers, in order to protect my interests."[62]

Although McDaniel's visceral responses made her look petty and thin-

skinned, she still had supporters. She had always maintained a great deal of respect among black film players. Willie Best, a black actor promoted in Hollywood as "Sleep 'n' Eat" or "Little Stepin Fetchit," hailed McDaniel for being "soft and kind to everybody. No put on."[63] While those who had experienced just a little of the McDaniel temper would disagree with him, a number still regarded her as a trailblazer who sacrificed and compromised with the overall goal of creating opportunities for African Americans. *Our World,* a black monthly publication with a nationwide circulation commented, "If in personifying a role which exists she makes a couple of thousand a week too, good! Especially when she takes the money to fight pressures which cause Negroes to find most of their employment in white folks' kitchens."[64]

Ebony magazine also hailed McDaniel's radio debut as an important accomplishment. A reporter from this publication, the *Life* magazine of the black community, covered an extravagant, star-studded party McDaniel threw in 1949 to celebrate *Beulah*'s success. Two years after she had taken over the role, the show attracted over ten million listeners each night and for the next couple of seasons was consistently rated in radio's top twenty. *Ebony*'s spread showed a smiling McDaniel entertaining a house full of guests both black and white, including Hollywood luminaries like Louise Beavers and Esther Williams as well as noted black intellectual, the Howard University sociologist E. Franklin Frazier. McDaniel, along with several others, treated the assembled crowd of two hundred to a few songs. At this party, as at others McDaniel had hosted, those gathered defied the rigid color line that she was accused of upholding. One shot even showed what white racists considered the unthinkable—Ernest Whitman, Beulah's Bill, dancing with Mary Jane Crofts, who played Alice Henderson. While *Ebony* underscored that most of *Beulah*'s fans were white, it did cite praise for McDaniel as an achiever of "more 'firsts' in Hollywood than any other Negro performer." McDaniel attributed her successes to her drive and commitment to mind power. "When you cease to want, you cease to live," she remarked. "Just like when I won the Academy Award. You sit down and think now you have everything, all you want. But of course, you don't."[65]

McDaniel was also celebrating another victory. In 1948, before the

United States Supreme Court, Loren Miller presented one set of arguments in what had become known as the "Restrictive Covenant Cases." In one of these, *Shelley v. Kraemer*, a Missouri suit, the justices ruled all such restrictive covenants unconstitutional, in turn voiding all pending cases and appeals, including that against the black defendants in the Sugar Hill case. Hattie McDaniel no longer had to worry about losing her South Harvard home.[66]

Following the decision, with her radio career booming and her bank account looking flush, McDaniel undertook a dramatic remodeling of her home. For the project, she hired a popular black interior decorator, Larry C. Williams, to redo the drapes. Williams had been a successful designer in Chicago and reportedly had recently opened a studio in Los Angeles's chic La Cienega district, quickly securing the Beverly Wilshire Hotel as a client. Strikingly handsome and extremely light-skinned, Williams was thirteen years younger than McDaniel. But despite their age difference, he claimed he was immediately smitten with the actress. Williams made it clear: he wanted to win her hand. McDaniel made it clear: she was not interested.[67]

After putting him off for over a year and a half, McDaniel began to fall for the persistent young decorator. On Saturday, June 11, 1949, Hattie McDaniel and Larry Williams dashed off to Yuma, Arizona, for an intimate wedding and reception in the home of some friends. (The night before, Beulah had almost convinced Bill to walk down the aisle.) Photographers snapped away as the bride, wearing a dark dress and a hat of her own design, nervously exchanged vows with her smiling young groom. A large feature photo in *Our World* showed the couple exchanging a "tender kiss." After the ceremony, the newlyweds raced home to Los Angeles. There was no time for a honeymoon; McDaniel had to be back on the air on Monday.[68]

This marriage immediately got off to a bad start. Only a few days after the nuptials, McDaniel marched Williams into her lawyer's office and insisted that he sign away any future claims to her property and financial assets. Not too long afterward, the couple was feuding publicly. According to McDaniel, in late July, Williams threw a fit at an NAACP picnic, balking when she asked for some leftovers for her two Dalmatians. Williams

found the request vulgar and embarrassing, and let her know in front of everyone at the gathering, ranting, "Here am I, in a $1,000,000 decorating business and you a radio star wanting to take scraps to dogs." The dispute continued in the car all the way home.[69]

The quarrels did not stop there. For the next several months, Williams and McDaniel fought almost constantly. The actress later insisted that much of the friction arose over Williams's refusal to attend parties thrown by her less famous friends although he eagerly escorted her to all the large public functions, like Hollywood premieres and concerts. Additionally, the actress believed Williams made her friends and family feel unwelcome. "He didn't want my people," she insisted. "All of my friends stopped coming."[70] McDaniel's good friend Wonderful Smith never even met Williams. To make matters worse, Williams meddled with the *Beulah* show, somehow triggering what was later described as "dissension among the cast." The Hollywood community buzzed that Williams was attempting to take over his wife's career and act as her professional and financial manager. McDaniel's resentment for him grew deeper and deeper.[71]

At the end of October 1949, after only four months of marriage, Larry C. Williams packed his things and moved out.[72]

Although over the next year, Williams and McDaniel were spotted together at various high-profile Hollywood functions, their relationship only grew icier. From the start, the press had hinted that the Williams and McDaniel match was an odd one. *Our World*'s coverage of the nuptials included a picture of the smiling interior decorator posed next to a basket of flowers he had "fussed" with until they were just right. Such language implied what the media, black and white, often refused to discuss openly—that they believed Williams was gay. When Louella Parsons called McDaniel in October 1949 for a comment regarding her disintegrating marriage, the actress made it clear that what was lacking was as much physical as it was emotional. "Baby, it's cold outside," McDaniel told the gossip columnist. "But I'm only mentioning incompatibility, of course. I could say a lot more."[73]

Whether or not Williams was gay is not clear. But it seems certain that some members of the press suspected he was. Additionally, rumors about McDaniel's own sexuality floated around. In part, this derived from the

fact that McDaniel counted among her close Hollywood friends a number of gays and lesbians, including actor Joel Fluellen and her costar Ruby Dandridge. (She was on hand when Dandridge's daughter Dorothy married tap-dancing sensation Harold Nicholas.) But outside of long-remembered, unsubstantiated whispers, there was little evidence to prove anything other than that Hattie McDaniel had an open attitude toward homosexuality, a tolerance which was not uncommon within the entertainment community. In regard to her personal preferences, it seems more that she had long sought to again find that first love and devotion that she had enjoyed with Howard Hickman, and had only succeeded in repeatedly falling for the wrong man.[74]

No one was really surprised when McDaniel's marriage to Williams wound up in divorce court. In December 1950, the actress appeared, requesting an end to what she had described as a totally miserable union. She recounted the humiliating NAACP episode and depicted Williams as only interested in using her to advance his own ambitions. Although she admitted he had never asked her for money, she insisted that during the course of the marriage, he had only contributed $65 to cover household expenses, and happily accepted any cash he could get. Tearfully, she alleged that Williams had harmed her career; Ruby Dandridge, who testified on her good friend's behalf, backed up McDaniel's story. In the end, the judge promptly granted McDaniel's request for a divorce. When questioned by Hedda Hopper about her future love life, the actress retorted, "I've been married enough; I'd just prefer to forget it."[75]

11

· · ·

My Own Life
Even Surprises Me

· · ·

My own life even surprises me, although from the time I was
six, I have always known I wanted to be an actress.

Hattie McDaniel, *Baltimore Afro-American,*
January 26, 1935

URING HER 1950 DIVORCE TRIAL, Hattie McDaniel insisted
that the stress of her fractious marriage had not only distracted
her from her job but also resulted in sleeplessness and a loss of
appetite. "I couldn't eat," the actress testified. "I'm a real hearty eater, but
I got so all I could eat was a little soup to keep me going. I lost a lot of
weight—10 or 12 pounds."[1] Even though ten or twelve pounds did not
sound like much for a large woman, those at McDaniel's *Beulah* party in
1949 could not help but notice that the actress indeed looked a little thin-
ner. Back then, McDaniel attributed it to overwork—the grind of rehears-
ing for and appearing on a five-day-a-week radio series and, during her
downtime, shooting appearances as maids in three more films: *Mickey*
(1948), *Family Honeymoon* (1949), and *The Big Wheel* (1949). "In vaude-
ville, there were lay-offs between engagements and in movies there is time
between pictures or even between working days," she told *Ebony.* "Time
to cook and enjoy it." While that was another play on the timeworn, de-
meaning weight jokes, it was true, the fifty-seven-year-old actress just did
not seem to have quite her old energy and verve. She began shutting her-

self away one day a week, each Sunday, refusing to take calls and see friends. "I just made up my mind that once a week I just have to sit down with myself," she said.[2]

For years, Hattie McDaniel had suffered from a variety of maladies. But by the late 1940s, her health was truly in decline and she knew it. McDaniel seemed to be even contemplating her own mortality. In 1948, she half-jokingly told a white Hollywood columnist that she had composed her own epitaph. "Well, I've played everything but the harp," she wanted it to read. That same year, in an effort to gain control of her weight and improve her physical condition, she placed herself under the care of Dr. Gayelord Hauser. A Swiss-born physician and diet doctor to stars like Greta Garbo, Hauser advocated a holistic approach to diet. An advocate of natural foods, including wheat germ, yogurt, blackstrap molasses, and brewer's yeast, he insisted his patients abstain from "dead foods"—primarily processed sugars and carbohydrates. While his diet included fresh fruit and vegetables, he stressed a regimen high in protein that also included the regular use of the powerful laxative Swiss Kriss. (Louis Armstrong was such a fan of Hauser and Swiss Kriss that he gave packets of the concoction to friends and strangers alike.) Hauser also maintained that diet had a strong impact on emotional outlook and that proper eating helped his patients live longer and happier lives.[3]

Nonetheless, McDaniel's health continued to decline, and she looked to her spirituality and belief in positive thinking as she struggled along. By this point in her life, McDaniel had become immersed in the teachings of Mary Baker Eddy and Christian Science. Eddy, who had faced illness as well, founded a theology that blended Biblical doctrines with the ideologies of mental healing and mind power. She encouraged followers to seek oneness with God's internal presence, through which they could find salvation, happiness, and physical well-being. (Father Divine had also been influenced by Eddy and her followers.) McDaniel must have read Eddy's classic *Science and Health: With Key to the Scriptures*, which explored the magnification of the spiritual self as a path to healing infirmities. It was just the kind of self-help philosophy that appealed to McDaniel. The actress began studying with Carol Malcomb, a Christian Science "Truth Teacher," and working with Alma Cannon, a practitioner who instructed disciples

on mental healing. In the 1950 edition of *Who's Who in Colored America*, McDaniel listed her religious affiliation as "Truth Student," indicating the depth of her commitment to Christian Science's philosophy.

At one level, McDaniel's interest in Christian Science indicated that her infirmities were worsening. But it also revealed that after battling her critics for so long and so bitterly, she was searching for an affirming philosophy that would bring her some peace of mind and restore her earlier energy and optimism. McDaniel may have even been steered toward Eddy's doctrines by Ruby Berkley Goodwin who had earlier embraced Christian Science and perhaps saw it as a positive direction for her good friend. In many ways, Christian Science could be uplifting. Its tenets gave adherents a faith that they could wield considerable power over their lives: anyone could tap into God's energy and make a change for the better. Its egalitarian nature had historically drawn women to the movement. It is not surprising that a strong woman such as Hattie McDaniel, who struggled not only with illness and sexism but also with racism and poverty, found Eddy's teachings appealing.[4]

Hattie McDaniel had other worries as well. Although she made a substantial salary on *Beulah*, she found herself in financial trouble. Butterfly McQueen later ascribed McDaniel's predicament to her liberal spending habits, although Hattie also carried the burden of supporting her family and friends, as well as various charities. Yet it is possible that most of her money problems came from Larry Williams, who reportedly had drained the actress of a considerable amount of cash. On top of it all, the enormous, aging South Harvard home required continual upkeep and investment.[5]

In early May 1950, she threw an extravagant party at her South Harvard home, inviting two hundred guests to say farewell to Eddie Anderson and his wife, Mamie, who were headed off with the Jack Benny radio show for a tour of the United States and Europe. Despite her dwindling bank account, McDaniel went all out and hosted what one paper declared was the "most lavish Hollywood shindig in months." The guests were treated to dinner, dancing, and impromptu performances by Wonderful Smith, Leon G. Kirkpatrick, a concert pianist, and blues singer Monette Moore, who at one time had been married to McDaniel's old beau John Erby. McDaniel ordered an enormous three-tiered cake reading "Bon Voyage—

Mamie and Eddie" and placed it in front of a re-creation of an old-fashioned sailing ship with towering masts that adorned one of the rooms. It was a triumph—family, friends, Hollywood luminaries, including most of those associated with *Beulah*, and neighbors all milled about until the late hours. McDaniel joked with the crowd, "Have a good time. You've been thrown out of better joints than this."[6]

Although few knew it, this was really a farewell party to the home that Hattie McDaniel had treasured and fought so hard to keep. A few weeks later, Hattie McDaniel put her South Harvard house up for sale and announced that she intended to spend her vacation in isolation, working on her autobiography. The title alone captured her philosophy of life; McDaniel announced the book would be called *Help Yourself*.[7]

By the time *Beulah* resumed broadcasting in the fall of 1950, McDaniel had purchased a new place only a few miles away. As yet another indication of her declining health, she was determined to find a home with rooms, as she told the press, "all on one floor." Her new house was a cozier eight-room bungalow on the prestigiously named Country Club Drive. (It was near the swanky Wilshire Country Club.) According to a later report, shortly after she moved in, the Ku Klux Klan burned a cross on her lawn.[8]

Despite such discouraging circumstances, Hattie McDaniel also faced new, exciting opportunities. On December 15, 1949, she made her television debut on CBS's *Ed Wynn Show*. Although by then her generous frame had dwindled some—she looked stooped and tired—she infused her appearance with a little of the old-time, saucy McDaniel spirit. For the television audience, she recreated Beulah and, receiving a phone call from boyfriend Bill, her "professor in the college of love," coyly invited him to "come over and embrace your student body." After some good-natured bantering with comedian Wynn, she offered a snappy rendition of Sophie Tucker's *Some of These Days*. It had been in her repertoire since her vaudeville days, and as she belted out the song's final lines, she finished with a little hoofing. The image of Beulah, the sensible domestic clad in apron and cotton dress, mimicking Tucker, "the last of the Red Hot Mamas," sent spectators off camera into guffaws. It would be one of the last glimpses of the veteran performer's original, iconoclastic act, the satir-

ical antecedent to her cinematic mammies and maids, the foremother of Beulah.[9]

It is very likely that McDaniel's successful television appearance may have eventually triggered an idea in some ABC network executive's mind. Why not put *Beulah* on television? Other radio shows, even those considerably less popular, had made a successful transition to TV. The chance to challenge the color line in television was certainly an exciting prospect for Hattie McDaniel. The small screen had remained a predominantly white medium; early on, black performers were usually consigned to guest appearances on variety shows. Black male performers Scatman Crothers and Bob Howard both had regular roles on weekly series in the late 1940s. The only black woman to have a starring role on television was the talented musician and singer Hazel Scott, who appeared on a small network called Dumont. But none of the African-American female performers had broken into significant roles on national network television. Although television was new terrain to everyone, it was rapidly becoming popular and quickly displacing movies as America's dominant entertainment form. It promised exposure for McDaniel unlike any she had known before. She could become the first African-American performer to star in her own TV series.[10]

However, ABC chose Ethel Waters to play television's Beulah. Although the reason for Waters's selection was not clear, it is likely that McDaniel's ties to the rival powerhouse CBS prevented her from taking on a show that would overlap with her radio obligations. Although she must have been disappointed, McDaniel denied to the press that she was "salty" with Waters for accepting the role and insisted that she was too busy to take on more work anyway. So, in October 1950, Waters debuted as Beulah. But it was far from the tremendous hit that Hattie McDaniel's radio version had been. The *Baltimore Afro-American* rated Waters's small-screen performance as a letdown for such a skilled artist. Some white reviewers agreed, but for different reasons—for them, Waters's Beulah was just a little too stiff and uncomfortable, not the lovable "Mammy" that they had expected. But one, who complained that the story lines were "tortuous" and the acting "rudimentary," condemned the show's insulting stereotyping, declaring that it was even more offensive on television than it had been on the radio. To add to the program's difficulties, Waters was ex-

tremely temperamental. Butterfly McQueen, who played television's Oriole that season, characterized Waters as "plain, pure HELL." (Waters's difficult nature was well known; Bill Robinson had found her so frustrating to work with he taught his wirehaired fox terrier to growl whenever he heard her name.) By November, Bud Harris, television's Bill, had quit the show. Harris protested the degrading depiction of his character, which demanded he use dialect. "I didn't make my reputation on Uncle Tom roles," he explained to the *Chicago Defender*, "and I won't do it now."[11]

In February 1951, with the show a shambles, ABC finally decided to revamp it and replace Waters with Hattie McDaniel for the upcoming season. In part, Waters had already moved on; in 1950 she began her run in the Broadway play *Member of the Wedding* in a serious role as a domestic, which, many agreed, charted new, dramatic territory for black women's images. McDaniel was glad to take over TV's *Beulah*, despite the reality that it would entail taking on a considerable overload of work. In the summer of 1951, once radio's *Beulah* went on its eight-week hiatus, McDaniel began shooting the television series. The cast also included Ruby Dandridge and Ernest Whitman, who reprised their roles as Oriole and Bill. Although ABC may have filmed as many as six episodes with the original team, only one survives. In it, Beulah teaches the Hendersons' awkward son, Donnie, to dance. When he attends a subsequent community recital, he impresses the other kids, not with the waltz that he was supposed to learn but with Beulah's swing steps. Of course, in the end, the Hendersons forgive Beulah for her silly mistake. But it was clear that on television McDaniel would be hemmed in by the same racial stereotypes that had haunted her throughout her Hollywood journey. Beulah's talents were for housekeeping, chasing after Bill, and jazzy dancing; her foolish errors derived from her inability, no matter how quick-witted she was, to really understand the world of her white employers. Yet McDaniel remained determined to make her mark on this emerging, powerful new form of mass media. She had been involved in virtually every aspect of twentieth-century popular entertainment—stage, vaudeville, musical recording, and film. As she worked her way through white show business, she discovered that each form carried similar restrictions, and it was probably no surprise to the seasoned performer that television was no different.[12]

The summer of 1951 was hectic. McDaniel worked hard, trying to get *Beulah*'s television episodes finished before the fall radio season started and she had to return to the air every weekday. Although she was busy, on August 6 she was able to join a number of other Hollywood stars, including Bob Hope, Jane Russell, Tony Curtis, Danny Thomas, and Lionel Hampton, for a celebrity baseball game sponsored by the Hollywood Junior Chamber of Commerce to raise money for impoverished children. McDaniel did not play but joined several white starlets as a bat girl. Not to be outdone by these young women, who were, as the Associated Press reported, "arrestingly clad in shorts," Hattie McDaniel showed up in bright blue pedal pushers with wildly colored socks. In some ways, McDaniel had come full circle. On that afternoon, with Roy Rogers riding around the bases on Trigger and the Lionel Hampton orchestra serenading its leader when he hit a home run, McDaniel drew from her earlier Denver days, when she stole the show with her outrageous comic characters and their crazy costumes.[13]

Late Sunday morning, August 26, Wonderful Smith dropped in on Hattie McDaniel just to say hello. It struck him as odd that the newspaper was still lying in the driveway. As he stopped to pick it up, Sam McDaniel came running from the house. Hattie had fallen. Smith found her on the floor unable to move or speak clearly. As he attempted to comfort her, two doctors were summoned—Sam McDaniel's black physician and, at her stubborn insistence, her white doctor. (While she may have simply wanted her own physician, possibly trained in Hauser's holistic regime or respectful of her Christian Science beliefs, it also may indicate that McDaniel harbored her own prejudices, at least against black doctors.) Both concurred it was heart trouble and she required immediate hospitalization. McDaniel was transported to Los Angeles's Temple Hospital, where specialists determined that in addition to advanced heart disease and diabetes, McDaniel had suffered a stroke. The hospital listed her in serious condition, and without giving details, her attending doctor confirmed to the press that McDaniel's possibility for recovery was "not too good." Although Temple refused to release any further specifics, several weeks later, McDaniel's camp admitted she had suffered a heart attack. CBS radio continued re-

running older *Beulah* shows featuring McDaniel. But ABC shelved her recently taped episodes of the TV version and eventually hired Louise Beavers to take over the role.[14]

McDaniel spent the next two months in the hospital, bedridden and trying to fight her way back. One of her nurses, Jean Mead, remembered the actress as "one of the nicest, friendliest patients" she had ever known. Perhaps McDaniel was mustering all of her strength, physically, emotionally, and spiritually, and attempting to approach her illness with as positive an attitude as possible. By November, she seemed to improve slightly, and doctors released her to convalesce at home with a caretaker. Friends who visited the actress told the press that she was improving each day—that McDaniel was "distressed by reports" she was in failing health and that she planned to resume her radio career before Christmas.[15]

December came around and McDaniel remained confined to her bed. On December 10, she made out her will. In a shaky but still bold hand, she inscribed each page with her initials, and at the end signed her name. Her topmost concern was that her family be provided for—she left the bulk of her estate to Sam McDaniel, her nephew Edgar Goff, her niece Marion Mumphrey, and her two great-nephews, Edgar Goff Jr. and Elzie Emanuel. Sam would take Dannie the Dalmatian. Her Oscar was to go to Howard University; the drama department there had given her a luncheon in honor of her Oscar in 1941. Ruby Berkley Goodwin was to receive a set of demitasse cups and have access to the material needed to complete Hattie's biography. To Carol Malcomb and Alma Cannon, McDaniel left very small amounts of cash and/or various personal possessions. A young acquaintance, Phemie Ann Galloway, was to have an "antique gold pin and matching earrings (black inlay) and ONE HUNDRED AND FIFTY DOLLARS ($150.00) to help with her education." A schoolteacher McDaniel befriended named Estella Fort was to select four dresses from the actress's wardrobe. Another friend, Alma Scott, would also receive four dresses, some serving dishes and figurines, and McDaniel's pots and pans. In many ways, these gifts seemed modest. McDaniel's financial situation, now that she had not worked in almost three months, was declining, and she was leaving whatever she could to the people, none of them stars, who

mattered in her life. McDaniel's bequests also evidenced the pragmatism of a woman who had been very poor and appreciated the value of even the smallest and most common possessions.[16]

McDaniel's will demonstrated a little of that old spunk. Oddly enough, she had never gotten around to filing the final papers in her divorce from Larry Williams. She instructed the lawyers to do so immediately to prohibit Williams from attempting to make any claim against her heirs. To her soon-to-be former husband, she left one dollar.[17]

McDaniel approached her illness as she had other adversities in her life, mixing her fighting spirit with her faith in Christianity and mind power. She continued to insist that she would return to work. Probably some were surprised to see the critically debilitated actress begin to rally back. In January, for the first time in over four months, she was able to sit up. By early April, she was still housebound but able to get around in a wheelchair. But later that month, she relapsed and was forced to take to her bed again. Exactly when the doctors figured it out is not clear, but they eventually discovered that Hattie McDaniel had been suffering with breast cancer for over two years. It was too advanced. There was nothing they could do.[18]

It is possible that even if they could have treated McDaniel, she may have refused. Christian Science rejects traditional medicine and encourages healing through meditation and prayer. Whether or not Hattie McDaniel had recognized the seriousness of her illness earlier, it was likely that her ailments had led her to Eddy's teachings, which dissuaded her from seeking help sooner. Still, it was this combination of stalwart faith and utter tenacity that helped McDaniel carry on. She remained devoted to her career, carefully guarding it with her eye on making a comeback. That summer, SAG formed the Negro Employment Committee to confer with studio bosses on the creation of more and better roles. But several weeks before a scheduled meeting between the committee and the studios, the FBI received information from an anonymous source that alleged that several black actors were Communist sympathizers. It threatened to derail the entire effort. In June, McDaniel joined fifteen other African-American members of SAG in a public statement that denounced Communism and denied all accusations that there were Communists among black film players. Despite the African-American film veterans' attempts to rescue the ef-

fort, SAG's push for better roles remained entangled in accusations of subversivism, ultimately producing almost no tangible results. Over twenty years after Hattie McDaniel had first arrived in Hollywood, filmmakers still found ways to avoid making any kind of substantive change in black cinematic images. They did not need the Southern box office anymore, they had the Red Menace now.[19]

Just as this attempt to compel Hollywood to abandon black stereotyping hit a wall, Hattie McDaniel's condition worsened and she grew weaker. Additionally, months of medical bills had piled up and depleted McDaniel's savings. To cover her escalating expenses, she had taken out a bank loan and had even accepted money from her former husband James Lloyd Crawford, who was now living in Wyoming. Attempting to make ends meet, she had also requested royalties for *Beulah*'s reruns. But no checks were forthcoming. It became clear that Hattie McDaniel could no longer afford to stay in her home. In July, she sold it and became the first African American to move into the industry-supported Motion Picture Country Home. Twice a week, the Country Home's staff got the determined actress out of bed and into a wheelchair. They found her "cheerful" and optimistic despite her grim prognosis. "The ailing Oscar winner," a wire service reported in late September, "is still hoping to make a complete recovery and resume her *Beulah* role." Perhaps her optimism came from the solace of Christian Science and the deep faith that she had maintained all of her life. But it is also possible that friends inserted such announcements to keep McDaniel's spirits high.[20]

In October, her body wracked by cancer, diabetes, and a bad heart, Hattie McDaniel began a rapid descent. An inner fortitude and will to persevere seemed to carry her through the month. Those around her found her courage inspirational. "Her bravery during her long illness has given many of us strength," Ruby Berkley Goodwin wrote. About midmonth, McDaniel finally received a check for *Beulah*'s reruns. But it was too little too late. On Friday, October 24, 1952, she slipped into a coma. She lingered until Sunday afternoon, October 26, when, alone in her room, Hattie McDaniel quietly departed this life.[21]

"Hattie M'Daniel, Negro Star Dies, Only Actress of Race to Win Academy Award," announced the *Los Angeles Times* the next morning.[22]

"I had gone to Arkansas to see my people," remembered Wonderful Smith, "and I got a telegram that she had passed and I came right back, came back immediately." Quickly, news of McDaniel's death spread, through wires, phone calls, and newspaper reports. Across the nation, the major dailies and key African-American publications relayed the word. The *New York Times* reported that the "Beloved Beulah of Radio" had passed. "City Mourns," remarked the *California Eagle*. The *Los Angeles Sentinel* ran a front-page banner headline announcing "Hattie McDaniel Rites Saturday" with a long obituary attributing her remarkable Holly-wood achievements to her unrelenting "determination to succeed."[23] Telegrams poured in at Sam McDaniel's home. "I shall miss her fine per-formances very much indeed," read condolences from General Dwight D. Eisenhower, just over a week away from his winning his first presidential election. On behalf of her mother, Eleanor Roosevelt, who was abroad, Anna Roosevelt cabled their sympathy: "She and I join with Hattie McDaniel's many friends in paying tribute to this woman's great accom-plishments for humanity." The Los Angeles City Council adjourned in Hattie McDaniel's memory. An enormous floral tribute arrived from Hattie McDaniel's old friend Clark Gable.[24]

"The sun and the moon shall be dark and the stars shall withhold their shining," read a CBS radio announcer on October 27, the day after McDaniel's death. "It is with deep regret that we, too, announce the pass-ing of Hattie McDaniel, our beloved Beulah." Now, even more than ever before, McDaniel's image had become intertwined with the black servant born of the white imagination. White society enshrined Hattie McDaniel as "*our* beloved Beulah," the enduring mammy prized more as a possession than a person. But, that night, CBS also ran a special repeat episode of Beulah—one written by Ruby Berkley Goodwin. McDaniel's voice rang out over the air one more time, playing the character born of white fan-tasies but reading the words from a black woman's pen. Although few peo-ple knew it, this was the last tribute to the subtle McDaniel defiance. In a way, through Ruby Berkley Goodwin, Hattie McDaniel had the last word.[25]

Sam McDaniel and the rest of the family began planning a memorial service. Hattie McDaniel had made clear in her will that she wanted "no unnecessary expenditures" to be made on her funeral, that whatever was

left of her life's earnings should go to the family. (All that remained of the estate was $10,000, and much of that was taken by creditors and the Internal Revenue Service after McDaniel's death.) She had requested a modest service to be held at the Angelus Funeral Home's chapel and had instructed that she be buried in a simple white funeral shroud, with gardenias in her hands and her hair. But the outpouring of condolences and grief from both black and white communities convinced the McDaniel family that a much larger and more elaborate funeral was absolutely required. They announced that the services would be open to the public and secured People's Independent Church, where Hattie McDaniel had occasionally worshiped throughout the years. It had a vast and imposing sanctuary that could easily accommodate a large number of mourners.[26]

When the Angelus Funeral Home opened its doors that week for the viewing, the public response was even more overwhelming. Hundreds filed past McDaniel's open casket to pay their last respects to the nation's most famous African-American actress. A *Los Angeles Tribune* photographer caught one shot showing a crowd, mostly African American, packed wall to wall in the funeral home's chapel. Despite her long and devastating illness, McDaniel, surrounded by red roses and white gardenias, appeared peaceful and restored. Baskets of flowers, wreaths, and bouquets from fans, friends, and family adorned the chapel; there were so many that it took a large van to transport them all.[27]

That following Saturday, November 1, mourners began arriving early at People's Independent Church for the service. Fans, the press, and more distant acquaintances quickly filled all the unreserved seats. Before long, the crowd spilled into the streets. The Los Angeles Police Department arrived and closed off four blocks surrounding the church as the gathering grew, by some estimates, to over five thousand strong. The *Los Angeles Times* was awed by the public's reaction, describing it as "an outpouring without precedence in recent Los Angeles history."[28]

Then, shortly before the services began, the hearse slowly made its way through the throng that now filled the sidewalks and streets around the church. Inside the sanctuary sat a number of local dignitaries—the powerful Los Angeles City councilman Kenneth Hahn, boxer Henry Armstrong, SAG's Edward Arnold, and most of the black film colony's core members,

including Clarence Muse, Louise Beavers, Lillian Randolph, and Ernest Whitman. As Wonderful Smith dashed up the church steps, he encountered Lena Horne leaving. "There's no use going in, Wonderful," she said. "There's no seats available." Smith escorted her back in and produced a letter from Sam McDaniel instructing that he be seated with the family. An usher found two spots for them in a pew near the front.[29]

The services began around one o'clock with music from the Jester Harrison Choir, a respected black choral group that often appeared in Hollywood films. People's Independent Church's popular minister Reverend Clayton D. Russell led the services and was assisted by Reverend William Taylor of Grace Memorial Church, Reverend Arthur Peters of Victory Baptist Church, and Reverend H. Mansfield Collins, the former AME bishop who had presided over the funerals of both Susan and Henry McDaniel. After opening remarks and prayers, Lillian Randolph took the pulpit for a solo rendition of "I've Done My Work," followed by vocalist Arthur Lee Simpkins who offered a stirring version of "Oh Dry Those Tears." On behalf of the film industry, Edward Arnold delivered an impassioned eulogy. "All of us say, let your soul rest in peace," he choked out, nearly moved to tears. "You are now resting in His arms."[30]

At the end of the services, a funeral procession of 125 cars somberly made its way to Rosedale Cemetery. Located near the West Adams neighborhood Hattie McDaniel had fought so hard to integrate, Rosedale was not her first choice. Rather, she had hoped to be buried at the Hollywood Park Cemetery, the final resting place for many of filmdom's most notable pioneers, including Douglas Fairbanks, Rudolph Valentino, Victor Fleming, and Florence Lawrence, the industry's first star. But Hollywood Cemetery's proprietors coldly denied her last wish, steadfastly insisting their famous grounds remain for whites only. McDaniel had anticipated this possibility and in her will stated that if "the rules and regulations of the Hollywood Cemetery Association prohibit the burial of persons of my race," she would accept Rosedale as an alternative. But just by requesting to be buried in the Hollywood Cemetery and then being turned down, McDaniel had made a point. Some insist that it also looked doubtful that Rosedale would accept her; reportedly a small group of whites launched a campaign to prevent Hattie McDaniel from being interred there as well.

But Rosedale had never drawn the color line in the past. A number of African Americans, Latinos, and Asians had been buried in its grounds. Since 1914, it had also been the resting place of Allen Allensworth, the highly regarded black Civil War veteran and American military officer who had founded California's first and only all-black town.[31]

Although Hattie McDaniel had instructed that she be buried at Rosedale's "highest possible point," the family selected a grave at one of the cemetery's lowest points, directly across from Rosedale's stately iron gates, and arranged for it to be marked with an unpretentious granite headstone reading "Hattie McDaniel, 1895–1952." At the end of the graveside service, as the mourners dispersed, Reverend Collins observed to a reporter that Hattie McDaniel had been laid to rest at a fitting location "where all who pass will see her name and where she will always be an inspiration to the young of our race for whom she did so much."[32]

"The rest is silence," observed the *Los Angeles Sentinel*.[33]

But the rest was not silence. In many ways, Hattie McDaniel's story did not end on that day in November 1952. She had passed away just as the nation was on the cusp of tremendous change. On December 9, 1952, only six weeks after her death, Thurgood Marshall stood before the United States Supreme Court and presented opening arguments, in part prepared with the assistance of briefs from Loren Miller, in the school desegregation case known as *Brown v. the Board of Education of Topeka, Kansas*. A year and a half later, on May 17, 1954, the Justices ruled that Topeka's practice of segregating public schools was unconstitutional, thus laying the legal groundwork for subsequent civil rights campaigns dedicated to ending racism, discrimination, and disenfranchisement. Hard-fought battles ensued, as a number of black and white activists gave up their lives in the continuing fight for equality. Their sacrifices were not in vain. In 1964, Congress passed sweeping civil rights legislation, followed the next year by a voting rights act. The federal government had finally taken steps to extend educational and employment opportunities and to offer an equal voice in the political process to African-American citizens. These were transformations that both Henry McDaniel, the proud union veteran, and his daughter, the complex artist, had each in their own way struggled for throughout their lives.[34]

Despite these victories, the fight was far from won as African Americans continued to confront poverty and racism. White Americans resisted the full recognition of black equality; they clung to racist ideologies and to degrading black stereotypes—images that they used to justify the continued subordination of African Americans. Despite escalated pressure to improve African-American representation in film and popular culture, the white entertainment industry refused to surrender their old practices and racial chauvinism. The generations of black film performers that followed Hattie McDaniel, especially women, still found it difficult to secure good roles. Lena Horne made only a few films after her career peaked in the 1940s; she returned to New York, performing in nightclubs with occasional television appearances. Dorothy Dandridge, despite being widely celebrated for her talent, found herself repeatedly passed up by Hollywood casting directors. Bitterly disappointed, she died in 1965 of a drug overdose that many believed was intentional. Sidney Poitier was the most successful of the group and forged new ground playing a doctor, a teacher, a police officer, and a priest. In 1964, he became the second African American to win an Oscar. But he was not honored for his portrayals of middle-class professionals or black men in positions of authority. Rather, he won Best Actor for his role in *Lilies of the Field*, in which he played a carefree, drifting ex-veteran, who reluctantly builds a church at the insistence of an extremely bossy white nun.[35]

As African Americans continued to battle for better roles into the 1960s and 1970s, Hattie McDaniel's cinematic work induced more and more criticism. Modern times completely stripped the actress's performances of their context. The mockery and sarcasm, often too subtle on screen to begin with, rapidly vanished into the past. Hattie McDaniel's image, like those of her contemporaries, only echoed the worst of racism and oppression. Her name became synonymous with the degrading image of the stereotypical Mammy. As African Americans struggled to underscore the brutal realities of the abusiveness and destructiveness of the institution of slavery and illuminate the resistance of those held in bondage, McDaniel's seemingly simpleminded characterizations invoked increasing anger and frustration. Her portrayals were not only sources of embarrassment but impediments to the ongoing campaign to uplift and reeducate

American society. The grip that the traditional, degrading black stereo-types had on the American imagination had to be broken. Almost symbol-ically, in the late 1960s, as the students at Howard University pushed for more African-American studies courses and demanded a curriculum that reflected the truth of both the past and present, Hattie McDaniel's treas-ured Oscar disappeared from its place at the university.[36]

Yet Hattie McDaniel, somehow, refused to be erased or silenced. Al-though she had her critics, she also had her supporters. Even as the civil rights movement was gaining momentum and as black pride began to take hold, some contended that McDaniel did not deserve to be entirely dis-missed. African-American entertainer Godfrey Cambridge insisted that the style used by McDaniel and her contemporaries could be "traced back to the social satire of slave humor even back through minstrelsy through countless attempts to cast off completely the artificial stereotype of that fantasy." He maintained that McDaniel and others had sacrificed and suf-fered considerably for their art. "I know the expedient mockery of tam-bourines and banjos hidden in that grin," he wrote in 1964, "and the price those comedians paid whenever they tried to expand beyond the scope of Negro comedy despite prevailing restrictions."[37] While many still cringed at McDaniel's work—her wide, rolling eyes, her large smile, and her seem-ingly unlimited devotion to whites—others continued to defend the ac-tress, noting the nuances in her acting. In 1973, African-American film historian Donald Bogle praised McDaniel's cinematic maids and mammies for being brashly recalcitrant in their dealings in a white-dominated world. He insisted that her performances were spiked with subtle genius and con-tended that her "flamboyant bossiness" was "a cover-up for deep hostil-ity." Others agreed, and in the 1970s, Hattie McDaniel, along with several of her contemporaries, was inducted into the Black Filmmakers Hall of Fame.[38]

Even as the twentieth century came to a close, Hattie McDaniel's work continued to stimulate debate. The general problem of respectful and wide-ranging black representation in American cinema lingered unre-solved. Into the 1990s, African Americans continued to agitate for better roles and improved images. The NAACP and other civil rights groups re-peatedly petitioned Hollywood to change its ways. Successful African-

American entertainer Bill Cosby, who had forged new ground in television playing an undercover spy, a high school teacher, and the devoted father and physician Dr. Huxtable, assailed the perpetuation of black stereotypes. "You think it is an accident that Hattie McDaniel looks the way she looks," he thundered before the National Black Leadership Conference on Youth Violence in 1994. "That's the picture they want. That's funny to them . . . when that male or female steps into the room, all of a sudden they assume what is a caricature of a black person." He passionately called on African Americans in show business to resist the entertainment industry's attempts at making "us that which we are not."[39]

Film director Spike Lee, one of the few successful African-American directors in the film industry, also offered blunt criticism of white American entertainment. In his film *Bamboozled*, made in 2000, he assailed modern Hollywood's fixation with, and white audiences' seemingly insatiable appetite for, black characterizations that harkened back to the days of minstrelsy. Pierre Delacroix, Lee's central character, is an ambitious black television writer who rises and falls on promoting a revival of blackface entertainment. In an interview about the film, Lee maintained that the state of American popular arts was deplorable, and contended that "we've gotten so sophisticated now that you don't have to put on blackface." He argued that black cinema pioneers, like Hattie McDaniel and Bill Robinson, "were great talents and they were doing the best with what was being offered them at the time." Reflecting on making *Bamboozled*, which contained a number of clips from the performances of early black film artists, Lee maintained, "On the one hand, we should have a greater understanding for those people of the past. On the other hand, it made me focus with much more scrutiny on my generation . . . we have choices—a lot more than they had."[40]

Yet, it was undeniable, as Lee often pointed out, that the entertainment industry both fueled and thrived on racist stereotypes, that good parts for black performers were rare. By 2000, after almost seventy-five years of Academy Awards, outside of Poitier and McDaniel, only four more Oscars had gone to African-American performers. In 1982, Louis Gossett Jr. took home the Best Supporting Actor award for *An Officer and a Gentleman*. For his performance as a runaway slave turned Union Army

soldier—an experience Hattie McDaniel's father had actually lived—Denzel Washington received a Best Supporting Actor Oscar in 1989 and in 1996 Cuba Gooding Jr. won in the same catagory for his part in *Jerry Maguire*. Whoopi Goldberg became the second African-American woman to win an Academy Award, honored for her Best Supporting Actress performance in *Ghost* in 1990. In 1999, when hosting the Oscar show where director Elia Kazan, who had cooperated in the 1950s with HUAC, was honored, Goldberg remarked, "I thought the black list was Hattie McDaniel and me."[41]

At the beginning of the twenty-first century, African Americans continued to gain recognition within the motion-picture community. Although still small, the number of African Americans nominated for awards crept up from 2.8% in 2003 to 3.2% in 2005. In 2002, Denzel Washington became the second African-American man to win Best Actor, scoring for his part in *Training Day*; and for her performance in *Monster's Ball*, Halle Berry became the first black woman to win Best Actress. Three years later, in 2005, Morgan Freeman won for Best Supporting Actor for his role in *Million Dollar Baby* and Jamie Foxx took the Oscar for Best Actor for his performance in *Ray*. In an emotional speech, Foxx thanked Sidney Poitier for inspiring him. "He said, 'I give you responsibility,' " Foxx remembered. "So I'm taking that responsibility tonight." But it was Poitier who had in the past pointed to the earlier generation of pioneering black actors as the pathbreakers for African Americans in the film industry. When he received the Motion Picture Academy's coveted Lifetime Achievement Award in 2002, Poitier paid tribute to those past performers who had refused to abandon Hollywood in hopes that their presence would someday open the doors to a better future. "I accept this award in memory of all African-American actors and actresses who went before me in the difficult years," he said, "on whose shoulders I was privileged to stand, to see where I might go."[42]

Indeed, Hattie McDaniel had not been forgotten. On October 26, 1999, forty-seven years after her death, her admirers, remaining friends, and surviving descendants, including great-nephews Edgar Goff Jr. and Elzie Emanuel, gathered at the Hollywood Memorial Park. Renamed Hollywood Forever, the cemetery's new owners were determined to correct a

wrong from the past and grant McDaniel her last wish. Although the family declined the cemetery's offer to have the actress's body reinterred at Hollywood Forever, they did agree to the park's plan to erect a monument to honor her career and achievements. Located near Douglas Fairbanks's elaborate tomb and reflecting pond, the highly polished cylinder of gray-and-pink granite commemorates McDaniel's 1939 Academy Award and carries an inscription composed by Edgar Goff Jr. "Aunt Hattie," it reads, "you are a credit to your craft, your race, and to your family."[43]

Edgar Goff Jr.'s tribute to his great-aunt did capture the essence of what really mattered in Hattie McDaniel's life. She was a woman born of former slaves, who endured incredible poverty and who learned from her parents to value family and hard work above all else. Foremost in her mind was the dedication to earning a living and helping out relatives both close and distant. Hattie McDaniel, the young woman who in 1915 sat with her aging father, carefully and precisely inscribing his history for the government's pension survey, knew the realities of the African-American past and the legacy of bondage. She experienced firsthand the struggles of a working-class black woman in a society that was dominated by white Americans, men, and the rich.

But Hattie McDaniel was also an artist, and opportunities for her were limited. The chances were that she would never succeed in white show business, but she did. And she attempted to use the stage, and later the screen, as a public space to comment on and respond to racism, sexism, and impoverishment. As a performer, she was often misunderstood by the public and underestimated by both her critics and white Hollywood bosses. But at the core, she was a diligent and astute craftswoman whose performances were born out of a rebellious and iconoclastic spirit that drove her throughout her long career.

During her nearly forty-five years in the entertainment business, Hattie McDaniel remained a proud race woman who attempted to challenge white oppression in the way she thought was most effective. Entrapped by the racism of American society and the restrictive roles she was forced to play, McDaniel toiled along, believing that to surrender her career would be a capitulation to white society that ultimately would result in the evaporation of any kind of black participation in filmmaking and the popular

arts. She made compromises with white Hollywood's racism, some hard under any circumstances to defend. But her ambition and self-interest were exactly what propelled her success in the entertainment world. The cost was high, and McDaniel's stubborn refusal to back down from her position and walk away from white show business transformed her into a highly controversial presence that long outlived the woman herself.

Still, if the measure of an artist is in the ability to provoke feelings and emotions, to challenge audiences to think and react, then perhaps Hattie McDaniel may really have been one of the most talented performers of her time. McDaniel's film work endures and compels Americans to continue to confront, one way or another, issues of race and racism. McDaniel was a proud, bold, and restless woman, who honed her skills as a satirist and whose original intentions were to leave her audiences with a sense of unease. Out of that unease, the debate continued, and out of that debate, perhaps the changes that Hattie McDaniel had unquestionably hoped for will come.

In November 1952, not too long after Hattie McDaniel had passed away, Loren Miller reflected on her life in an editorial for the *California Eagle*. Rather than blame McDaniel for cinema's negative black caricatures, he urged society to hold white show business accountable for the propagation of racist ideology. Having known McDaniel for a number of years, he remembered her with admiration. "Even the disadvantages inherent in the stereotyped roles she took could not conceal Miss McDaniel's real ability," he insisted, chiding those who could not (or would not) separate the actress from the characters that she played. Miller, whose commitment to fighting for African-American equality was indisputable, ended with a final tribute:

> In private life, Miss McDaniel was a militant and outspoken proponent of Civil Rights and an opponent of those who strove to disadvantage the Negro. She contributed generously of her time and talent to community affairs. The stage and screen will miss her talent and the cause of democracy has lost a staunch defender.[44]

Filmography

The following is a selected list of films where Hattie McDaniel's appearance or participation in has been documented. Since McDaniel appeared in hundreds of films as an extra and as a singer with Sara Butler's Old Time Southern Singers (which provided musical accompaniment for a number of Hollywood films in the early thirties), it is impossible to compile a complete listing.

1932
Are You Listening? (MGM)
Blonde Venus (Paramount)
Boiling Point (Allied Pictures Corporation)
Crooner (First National)
The Golden West (Fox)
Hypnotized (Sono-Art World Wide Pictures)
Impatient Maiden (Universal)
The Washington Masquerade (MGM)

1933
Goodbye Love (RKO)
Hello, Sister (Fox)
I'm No Angel (Paramount)

1934

Babbitt (Warner Bros.)
The Chases of Pimple Street (MGM)
City Parks (Chesterfield Motion Pictures)
Fate's Fathead (MGM)
Flirtation (First Division Pictures)
Imitation of Life (Universal)
Judge Priest (Fox)
King Kelly of the U.S.A. (Monogram Pictures)
Little Men (Mascot Pictures)
Lost in the Stratosphere (Monogram Pictures)
Merry Wives of Reno (Warner Bros.)
Operator 13 (MGM)

1935

Alice Adams (RKO)
Anniversary Trouble (Hal Roach)
Another Face (RKO)
The Arizonian (RKO)
China Seas (MGM)
The Four-Star Boarder (MGM)
Harmony Lane (Mascot Pictures)
The Little Colonel (Fox)
Murder by Television (Cameo Pictures)
Music Is Magic (Fox)
Okay Toots! (MGM)
Transient Lady (Universal)
Traveling Saleslady (First National)
We're Only Human (RKO)
Wig-Wag (RKO)

1936

Arbor Day (Hal Roach)
The Bride Walks Out (RKO)
Can This Be Dixie? (Fox)
The First Baby (Fox)
Gentle Julia (Fox)
Hearts Divided (Warner Bros.)
High Tension (Fox)
Libeled Lady (MGM)
Next Time We Love (Universal)
The Postal Inspector (Universal)
Reunion (Fox)

Show Boat (Universal Studios)
The Singing Kid (Warner Bros.)
Star for a Night (Fox)
Valiant Is the Word for Carrie (Paramount)

1937
45 Fathers (Fox)
The Crime Nobody Saw (Paramount)
Don't Tell the Wife (RKO)
Merry-Go-Round of 1938 (Universal)
Mississippi Moods (RKO)
Nothing Sacred (Selznick Pictures International)
Over the Goal (Warner Bros.)
Quick Money (RKO)
Racing Lady (RKO)
Saratoga (MGM)
Sky Racket (Victory Pictures)
Stella Dallas (MGM)
True Confession (Paramount)
The Wildcatter (Universal)

1938
Battle of Broadway (Fox)
Carefree (RKO)
Mad Miss Manton (RKO)
The Shining Hour (MGM)
Shopworn Angel (MGM)
Vivacious Lady (RKO)

1939
Everybody's Baby (Fox)
Gone With the Wind (MGM)
Zenobia (Hal Roach)

1940
Maryland (Fox)

1941
Affectionately Yours (Warner Bros.)
The Great Lie (Warner Bros.)
They Died With Their Boots On (Warner Bros.)

1942
George Washington Slept Here (Warner Bros.)
In This Our Life (Warner Bros.)
The Male Animal (Warner Bros.)

1943
Johnny Come Lately (Republic Pictures–Cagney Productions)
Thank Your Lucky Stars (Warner Bros.)

1944
Hi, Beautiful (Universal)
Janie (Warner Bros.)
Since You Went Away (Selznick International Pictures)
Three Is a Family (Master Productions–United Artists)

1946
Janie Gets Married (Warner Bros.)
Margie (Fox)
Never Say Goodbye (Warner Bros.)
Song of the South (Disney)

1947
The Flame (Republic Pictures)

1948
Mickey (Eagle–Lion Films)

1949
The Big Wheel (Samuel H. Stienfel–United Artists)
Family Honeymoon (Universal)

Notes

ABBREVIATIONS USED IN THE NOTES

AMPAS: Margaret Herrick Library, Academy of Motion Picture Arts and Sciences, Beverly Hills, California

BAA: *Baltimore Afro-American*

BF: biography file

CD: *Chicago Defender*

CE: *California Eagle*

Censor Files: production code administration censorship files

CF: clipping file

Census: *United States Federal Census, Population Schedules*, National Archives and Records Administration Microfilm, Washington, D.C.

CS: *Colorado Statesman*

DOS: David O. Selznick

DOSC: David O. Selznick Collection, Harry Ransom Humanities Center, University of Texas, Austin

DPL: Denver Public Library

DS: *Denver Star*

FS: *Franklin's Statesman*

HeMcDPF: Henry McDaniel Civil War pension file, C-2 537 452, National Archives and Records Administration

HMcDC: Hattie McDaniel Collection

LAS: *Los Angeles Sentinel*
LAT: *Los Angeles Times*
NAACP–GOF: NAACP 1940–1955, general office files, general, 1940–45 (films) (Bethesda, Maryland: University Publications of America, 1993), part 18, series B, reels 15–21
NAACP–PP: NAACP 1940–1955, general office files. Publicity protests—Hattie McDaniels (Frederick, Maryland: University Publications of America, 1993), part 15, series B, reel 13
NAACP–RC: NAACP 1940–1955, legal file, restrictive covenants, California, 1940–1950 (Frederick, Maryland: University Publications of America, c. 1989), part 5, reel 20
n.d.: no date
n.s.: no source
NYT: *New York Times*
PC: *Pittsburgh Courier*
USC: University of Southern California, Los Angeles, California
UCLA: University of California, Los Angeles

1: YOUR FATHER WORE THE BLUE . . .

1. Comparison of Hattie McDaniel's handwriting (and her distinctive manner of writing McDaniel) indicates that she filled out the form for her father. HeMcPF: veteran's questionnaire, April 6, 1915.

2. Henry McDaniel never mentioned parents in his pension file, and in census files only listed their birthplaces as either unknown or the United States. HeMcPF, veteran's questionnaire; affidavit, Henry McDaniel, April 3, 1907; Department of Interior questionnaire, July 24, 1901; Clyde Morris, *Our Virginia Ancestors: Morris Family–Spotsylvania County, Duerson Family–Spotsylvania County, Sale Family–Caroline County, Thomas Family–Caroline County, and Others* (Fairfax: C. L. Morris, 1988), 87–90; Census, 1840, Berkeley Parish, Virginia, roll M704-575, 140.

3. HeMcPF: affidavit, Henry McDaniel, April 3, 1907; Ira Berlin, *Many Thousands Gone: The First Two Centuries of Slavery in North America* (Cambridge: Harvard University Press, 1998), 109–141; Edmund S. Morgan, *American Slavery, American Freedom: The Ordeal of Colonial Virginia* (New York: W. W. Norton and Company, 1975), 295–315; John W. Blassingame, *The Slave Community: Plantation Life in the Antebellum South* (New York: Oxford University Press, 1979, 2nd ed.), 249–263; Eugene D. Genovese, *Roll Jordan Roll: The World the Slaves Made* (New York: Random House, 1974), 63–67.

4. For an overview of religion and resistance in the slave community see: Albert J. Raboteau, *Slave Religion: The "Invisible Institution" in the Antebellum South* (New York: Oxford University Press, 1978); Blassingame, *Slave Community*, 192–222; *Salisbury Times*, August 3, 1953, May 28, 1960.

5. Genovese, *Roll*, 57–62, 551–552; Blassingame, *Slave Community*, 251–255.

6. By 1860 Sim Eddings (listed as S. G. Eddins) enumerated forty-one slaves in his inventory and had amassed over $60,000 in personal property. Slave Schedules, 1860, District 8, Fayetteville, Lincoln County, Tennessee, p. 273, National Archives and Records Administration; Robert William Fogel and Stanley L. Engerman, *Time on the Cross: The Economics of American Negro Slavery* (Boston: Little, Brown and Company, 1974), 44–49; HeMcPF: affidavit, Henry McDaniel, April 3, 1907.

7. Census, 1860, District 14, Lincoln County, Tennessee, roll M653–1261, p. 115; Wilma Dunaway, "Put in Master's Pocket: Interstate Slave Trading and the Black Appalachian Diaspora," in *Appalachians and Race: The Mountain South from Slavery to Segregation,* John Inscoe ed. (Lexington: University Press of Kentucky, 2001), 116–132; John Cimprich, *Slavery's End in Tennessee, 1861–1865* (Tuscaloosa: University of Alabama Press, 1985), 7–10; Lester C. Lamon, *Blacks in Tennessee, 1791–1970* (Knoxville: University of Tennessee Press, 1981), 7–16; Sam Bowers Hilliard, *Atlas of Antebellum Southern Agriculture* (Baton Rouge: Louisiana State University Press, 1984), 62, 66, 74, 76.

8. Moses Slaughter in *Slave Narratives: A Folk History of Slavery in the United States from Interviews with Former Slaves* (Washington, D.C.: Library of Congress microfilm, 1941), Indiana, reel 6; HeMcPF: affidavit, Aaron Holbert, August 24, 1888; Cimprich, *Slavery's End,* 10; Lamon, *Blacks in Tennessee,* 20–25.

9. *Goodspeed's History of Tennessee From the Early Times to the Present, Together With a Historical Account and Biographical Sketch of Lincoln County* (Nashville: The Goodspeed Publishing Company, 1887), 898–899; Cimprich, *Slavery's End,* 7; slave schedule, 1860, District 14, Lincoln County, Tennessee, p. 248, National Archives and Records Administration; Census, 1860, District 14, Lincoln County, Tennessee, reel M653–1261, 115.

10. In 1860, Henry McDaniel should have been in his early twenties. C. B. McDaniel shows one 22-year-old male in the slave schedule, but John McDaniel does not show any slaves of this age. Henry McDaniel's war records indicate that in 1860 he remained a slave of John McDaniel, and it was not an uncommon practice to loan out slaves to work on other plantations. Lamon, *Blacks in Tennessee,* 22–24; Clayton Holbert in *Slave Narratives,* Kansas, reel 7, 1860. In the 1860 census, Pleasant Holbert is listed as Pleasant Halbert. Both black and white Holbert families sometimes spelled the name as Halbert. Slave schedules, 1860, District 8, Lincoln County Tennessee, 273, 274, and District 14, Lincoln County, Tennessee, 248, 269, National Archives and Records Administration; Census, 1860, District 8, Lincoln County, Tennessee, reel M653–1261, 84; HeMcPF: affidavit, Aaron Holbert.

11. Cimprich, *Slavery's End,* 10–13; *Goodspeed's History,* 898–99; Helen Crawford Marsh and Timothy Richard Marsh, *Abstracts of Wills, Lincoln County Tennessee, 1810–1895* (Shelbyville, Tennessee: Marsh Historical Publications, 1977), 81; final will, John McDaniel, Lincoln County, Tennessee, signed October 16, 1861, proven November 1861, Lincoln County Library, Fayetteville, Tennessee.

12. The 1900 census shows Susan Holbert's birth date as May 1850. She lists her mother as being born in North Carolina and her father as a native of Tennessee. In 1946, Hattie McDaniel visited the Giles County courthouse looking for records re-

lated to her mother's family that she claimed had lived there. Census, 1900, Denver, Arapahoe, Colorado, reel 121, 198; HeMcPF: affidavit, Susan McDaniel, May 17, 1890; Henry V. Freeman, "A Colored Brigade in the Campaign and Battle of Nashville," *Military Essays and Recollections,* vol. II (Chicago: A. C. McClurg and Company, 1894), 399–421; Cimprich, *Slavery's End,* 19, 81–86; "Did You Know?" *The Giles County Historical Bulletin* October 2000, 23.

13. Although Henry McDaniel's name was initially properly spelled on his enlistment papers, later the government misspelled it as McDaniels and filed all records under that name. Civil War Service Record, Henry McDaniels, enlistment July 31, 1863, National Archives and Records Administration; Cimprich, *Slavery's End,* 81–86; Freeman, "A Colored Brigade," 399–404; HeMcPF: affidavit, Susan McDaniel; *Tennesseans in the Civil War,* vol. I (Nashville: Civil War Centennial Commission, 1964), 397–398.

14. Freeman, "A Colored Brigade," 399–421; Rev. O. Summers, "The Negro Soldiers in the Army of the Cumberland," in George W. Herr, *Episodes of the Civil War: Nine Campaigns in Nine States* (San Francisco: The Bancroft Company, 1890), 424–432; Adam McDaniel's war record shows he signed up on the same day as Henry McDaniel. Civil War service record, Adam McDaniel, company muster roll, August 4–31, 1863, National Archives and Records Administration, "12th U.S. Colored Infantry Regiment," in *Tennesseans in the Civil War*; Cimprich, *Slavery's End,* 88–90, 96–97.

15. Cimprich, *Slavery's End,* 84, 90–91; Civil War service records: Henry McDaniel, company muster roll, January–June 1864; Adam McDaniel, company muster roll, January–February 1864; September–October 1864; John David Smith, "Let Us All Be Grateful That We Have Colored Troops That Will Fight" in *Black Soldiers in Blue: African-American Troops in the Civil War Era,* John David Smith, ed. (Chapel Hill: University of North Carolina Press, 2002), 1–77.

16. Henry McDaniel's regiment had also previously and unsuccessfully skirmished with Forrest at Johnsonville, Tennessee, when the Confederates attacked a supply depot. Civil War service record, Henry McDaniel, company muster roll, July–December 1864; Benjamin Quarles, *The Negro in the Civil War* (New York: Da Capo Press, 1989, reprint of 1953 ed.), 306; Cimprich, *Slavery's End,* 92–96; John Cimprich, "The Fort Pillow Massacre: Assessing the Evidence," in *Black Soldiers in Blue,* 150–168.

17. Quarles, *The Negro,* 306–308; Hondon B. Hargrove, *Black Union Soldiers in the Civil War* (Jefferson, North Carolina: McFarland, 1988), 192–93; Freeman, "A Colored Brigade," 416–417; Anne Bailey, "The USCT in the Confederate Heartland, 1864," in *Black Soldiers in Blue,* 227–248; Herr, *Episodes,* 336–343; Cimprich, *Slavery's End,* 94.

18. John Finnely in *Slave Narratives,* Texas, reel 11; *Tennesseans in the Civil War,* 397–398; Civil War service record, Adam McDaniel, company muster roll, November–December 1864; HeMcPF: declaration for an invalid pension, July 23, 1890; declaration of invalid pension, September 23, 1895; affidavit, Retired Sergeant Ralph Holt, February 6, 1890.

19. HeMcPF: declaration for an invalid pension, July 23, 1890; Cimprich, *Slavery's End,* 94–97.

20. "Minnesota in the Battles of Nashville, December 15 and 16 1864," *Collections of the Minnesota Historical Society,* vol. XII (St. Paul: The Society, 1908), 612; Freeman, "A Colored Brigade," 420–421; Jack Hurst, *Nathan Bedford Forrest: A Biography* (New York: Alfred A. Knopf, 1993), 237–247.

21. HeMcPF: officer's certificate of disability, Captain William S. Cain, April 22, 1887; Captain W. S. Cain, *Autobiography of Captain W. S. Cain* (Topeka: Crane and Company, 1908), 81–82.

22. HeMcPF: officer's certificate of disability, Captain William S. Cain; Civil War service record, Henry McDaniel, company muster roll, November 1864–February 1865; Civil War service record, Adam McDaniel, company muster roll, January–February, 1865; muster out roll, January 16, 1865; record of death and interment, January 12, 1865.

23. HeMcPF: affidavit, Susan McDaniel; Civil War service record, Henry McDaniel, muster out roll, January 16, 1866. For an overview of the AME church see, Carol V. R. George, *Segregated Sabbaths: Richard Allen and the Rise of Independent Black Churches, 1760–1840* (New York: Oxford University Press, 1973).

24. The tight-knit relationship between Aaron, Susan, and Nicholas Holbert, as suggested both in census records and in Henry McDaniel's pension file, indicates that they were very likely siblings. In 1870, Nicholas Holbert lived with Aaron Holbert in Lincoln County. Later, Susan Holbert remains clearly tied to both Nicholas and Aaron. HeMcPF: affidavits, Susan McDaniel, Aaron Holbert, Nicholas Holbert, May 9, 1890, August 24, 1888; surgeon's certificate, April 20, 1887; Census, 1870, Boonshill, Lincoln County, Tennessee, reel M593–1544, p. 371.

25. Census, 1870, Boonshill, Lincoln County, Tennessee roll M593–1544, p. 374; marriage license: Henry McDaniel and Lou Harris, Lincoln County, Tennessee, January 30, 1868, Lincoln County Library, Fayetteville, Tennessee; HeMcPF: affidavits, Susan McDaniel, Nicholas Holbert, Aaron Holbert.

26. The 1870 census lists the children of Charles and Susan Staton as Thomas and Jane. But in 1880, the oldest children of Susan Staton (then McDaniel) are listed as George and Addie. Marriage license: Charles Staton and Susan Holbert, Lincoln County, Tennessee, December 25, 1867, Lincoln County Library, Fayetteville, Tennessee; Census, 1870, Boonshill, Lincoln County, Tennessee, roll M593–1544, pp. 370, 371, 374; Census, 1880, Manhattan, Riley, Kansas, roll T9–394, p. 279A; HeMcPF: affidavits, Susan McDaniel, Nicholas Holbert, Aaron Holbert.

27. For a general overview of Reconstruction see Leon Litwack, *Been in the Storm So Long: The Aftermath of Slavery* (New York: Vintage Books, 1980); Hurst, *Forrest,* 264–265, 277–282; "Report of Outrages: Leander Wright, Henry McDaniel, Nathan Harris, July 5, 1868," Tennessee Register of Outrages, October 1865–1868, records of the assistant commissioner for the State of Tennessee, Bureau of Refugees, Freedmen, and Abandoned Lands, 1865–1869, National Archives Microfilm Publication, M999, vol. 34, accessed on http://freedmensbureau.com/tennessee/outrages/tennoutrages2.htm.

28. Cimprich, *Slavery's End*, 60–80; Lamon, *Blacks in Tennessee*, 33–41.

29. One of the witnesses to the marriage was Squire Holbert who, in 1870, was listed in the same household in Lincoln County with Nicholas and Aaron Holbert and presumably was a brother of Susan Station. Marriage license, Susan Staten (Staton) to Henry McDaniel, Nashville, Tennessee, February 9, 1878, Metropolitan Nashville Davidson County Archives; HeMcPF: veteran's questionnaires, November 9, 1897, April 6, 1915; affidavits, Aaron Holbert, Nicholas Holbert; Census, 1880, Manhattan, Riley, Kansas, roll T9–394, p. 279A; Census, 1870, Boonshill, Lincoln County, Tennessee, roll M593–1544, pp. 371.

30. Nell Irvin Painter, *Exodusters: Black Migration to Kansas after Reconstruction* (New York: W. W. Norton and Company, 1986), 109–116, 195; Robert G. Athearn, *In Search of Canaan: Black Migration to Kansas, 189–1880* (Lawrence, The Regents Press of Kansas, 1978), 6, 32; Lamon, *Blacks in Tennessee*, 49–53.

31. HeMcPF: affidavits, Aaron Holbert, Nicholas Holbert; questionnaire, July 24, 1901; veteran's questionnaire, April 6, 1915; Census, 1880, Manhattan, Riley, Kansas, roll T9–394, p. 279A; Athearn, *Canaan*, 9–17; Painter, *Exodusters*, 184–188; Nupur Chaudhuri, "We All Seem Like Brothers and Sisters: The African American Community in Kansas," *Kansas History*, Winter 1991/92, 270–288.

32. Census, 1880, Manhattan, Riley, Kansas, roll T9–394, p. 279A; HeMcPF: affidavit, Nicholas Holbert, questionnaire, April 6, 1915; Chaudhuri, "We All," 280.

33. HeMcPF: affidavit, W. H. Haywood, July 24, 1890; Chaudhuri. "We All," 276, 283; Census, 1880, Manhattan, Riley, Kansas, roll T9–394, p. 279A.

34. HeMcPF: affidavits, Henry McDaniel, August 15, 1888, July 26, 1901; Aaron Holbert; Nicholas Holbert; questionnaire, July 24, 1901; Athearn, *Canaan*, 77; Census, 1900, Denver, Arapahoe, Colorado, roll 121, p. 198.

35. Gretchen Cassel Eick, *Dissent in Wichita: The Civil Rights Movement* (Chicago: University of Illinois Press, 2001), 17–18; Athearn, *Canaan*, 65; HeMcPF: affidavits, George Points, April 28, 1888, J. M. Campbell, May 23, 1887.

36. HeMcPF: affidavits, Campbell, Points, K. F. Purdy M.D., June 13, 1892; Henry Sherrill, May 19, 1890; surgeon's certificate, January 29, 1890; veteran's questionnaire, April 6, 1915.

37. HeMcPF: declaration for original invalid pension, November 30, 1886; surgeon's certificate, April 20, 1887; War Department, Adjutant General's Office, August 11, 1887; affidavits, Campbell, Points, Nicholas Holbert, Aaron Holbert, Susan McDaniel, Purdy.

38. HeMcPF: affidavit, Henry McDaniel, August 15, 1888; form 3–125, rejection, October 21, 1891; surgeon's certificates, January 29, 1890; June 1, 1891.

39. HeMcPF: affidavits, Henry Sherrill, May 19, 1890; Henry McDaniel, June 2, 1892.

40. Hattie McDaniel later gave conflicting birth dates. However, the earliest mention of her in public records, the Kansas State Census, indicates that she was born in 1893. HeMcPF: veteran's questionnaire, April 6, 1915; Kansas State Census, 1895, Wichita, Sedgwick, Kansas, reel K–138, p. 74, Kansas State Historical Society, Topeka, Kansas.

41. HeMcPF: affidavits, S. Hupp M.D., February 6, 1893; Henry Sherrill and Jacob McAfee, February 6, 1893; officer's certificate of disability, Ralph Holt, 1887; physician's affidavit, Gustave Stegmann, August 20, 1888; surgeon's certificate, November 1, 1893; Department of Interior, appeal, rejection affirmed, March 31, 1894; rejection, August 17, 1895; *LAT,* February 11, 1940.

42. Richard Wright, *Black Boy* (New York: Harper and Brothers Publishers, 1937), 122; Donald R. Shaffer, *After the Glory: The Struggles of Black Civil War Veterans* (Lawrence, Kansas: University of Kansas Press, 2004), 122, 156.

43. HeMcPF: King quoted in Medical Referee to Chief of Law Division, December 15, 1893; rejections, March 16, 1897, April 1, 1898.

44. HeMcPF: affidavit, Hupp.

45. The 1900 and 1910 census records indicate that Lena had married a Taylor in Kansas in 1886 and had four children: Margaret, Charlie, Mabel, and Marie. Charlie was born in Kansas in 1890 and Mabel was born in Colorado in 1893. The same documents show Addie (her name misspelled as Anna in 1900 and Ada in 1910) married a man named Lawrence. She had five children, of which two, Charles and Lorenzo, survived. Both sons were born in Colorado after 1890. Census, 1900, Denver, Arapahoe, Colorado, roll T623_117, p. 330; Census, 1910, Denver, Colorado, roll T624_114, pp. 4A, 86B; HeMcPF: questionnaire, July 24, 1901; A'lelia Bundles, *On Her Own Ground: The Life and Times of Madam C. J. Walker* (New York: Scribner, 2001), 79–80.

46. Bundles, *On Her,* 79–91; *CS,* February 17, 1906; January 5, 19, 1907; March 6, May 29, 1909; Quintard Taylor, *In Search of the Racial Frontier: African Americans in the American West, 1528–1990* (New York: W. W. Norton, 1998), 203–204.

47. Bundles, *On Her,* 84; Taylor, *In Search,* 203–204; *CS,* June 8, 1907; March 6, 1909; March 20, 1909.

48. *Denver Republican* quoted in *CS,* December 7, 1907, April 22, 1905; Stephen J. Leonard and Thomas J. Noel, *Denver: Mining Camp to Metropolis* (Niwot, Colorado: University of Colorado Press, 1990), 77, 130, 192–193.

49. HeMcPF: medical testimony, Joseph Anderson, November 17, 1900; affidavits, Henry McDaniel, July 26, 1901, June 14, 1902; Census, 1900, Denver, Arapahoe, Colorado, roll T623_121, p. 198; T623_117, p. 330; Census, 1910, Denver, Colorado, roll T624_114, pp. 4A, 5A, 86B; *Ballenger and Richards Denver Directory,* 1901, 1902.

50. HeMcPF: Henry McDaniel to Mr. Cains, August 26, 1899; application, November 17, 1898; surgeon's certificate, October 18, 1899; rejection, March 9, 1900; appeal misfiled, March 30, 1900.

51. HeMcPF: application, May 14, 1901, surgeon's certificate, July 3, 1901; affidavit, Henry McDaniel, June 14, 1902; Shaffer, *After the Glory,* 156–157; Fort Collins Post, Records of the Grand Army of the Republic, Colorado, Denver Public Library, Denver Colorado, http://denverlibrary.org/research/genealogy/GAR/gar04.txt.

52. HeMcPF: approval, June 9, 1902; pension granted: Certi. No. 1044945, Henry McDaniel, June 25–July 9, 1902.

53. *CS,* September 9, 1905.

54. *CS,* September 9, 1905; photograph: Henry McDaniel, Folder 6, HMcDC, AMPAS.

55. Letter: Roscoe Conkling Simmons to Hattie McDaniel, January 5, 1945, HUM 2.8, Box 8, Roscoe Conkling Simmons Papers, University Archives, Pusey Library, Harvard University.

2: COMEDIENNE

1. *Chicago Daily Tribune,* December 14, 1947.

2. *CS,* August 26, 1905; January 12, May 5, 12, October 12, 26, December 8, 1906; January 5, 1907; February 12, September 11, 1912; December 6, 1913; Sam McDaniel scrapbook, clipping n.d., n.s., HMcDC, AMPAS; *Chicago Daily Tribune,* December 14, 1947; *FS,* July 16, December 3, 1910; *CE,* June 2, 1938.

3. Census, 1910, Denver, Colorado, roll T624_114, pp. 5A; "Hattie McDaniel," *Current Biography,* 1940, 537; Carlton Jackson, *Hattie: The Life of Hattie McDaniel* (Lanham, Maryland: Madison Books, 1990), photo section; *Elective Spelling Blanks,* folder 26, HMcDC, AMPAS.

4. City directories, the U.S. Census, and pension records indicate that the McDaniel family lived at 1522 Larimer Street, 2447 Lawrence Street, 2623 Market Street, 1431 Twenty-seventh Street, and 2615 Walnut, among other locations. Although in one 1901 pension application Henry McDaniel listed his post office (with no address) as Fort Collins, the family also lived that year in Denver at 1927 Thirty-fifth Street. *Ballenger and Richards Denver Directory,* 1901, 1902, 1910; Census, 1900, Denver, Colorado, roll T623_121, p. 198; Census, 1910, Denver, Colorado, roll T624_114, p. 5A; HeMcDPF: letters: Draft Civil War Division to Henry McDaniel, August 12, 1910; Commissioner to Hon. A. W. Rucker, House of Representatives, February 18, 1911; Commissioner to Hon. John F. Shafroth, June 25, 1913; affidavit, Henry McDaniel, June 2, 1911; declaration for increase of invalid pension, November 28, 1906; surgeon's certificate, October 3, 1906; physician's affidavit, Joseph Anderson M.D., July 3, 1905; Pension Bureau Cert. No. 104494, March 19, 1913.

5. *CS,* May 29, 1909; April 14, 1928; *Ballenger and Richards Denver Directory,* 1901, 1902; Census, 1910, Denver, Colorado, roll T624_114, p. 5A, 86B.

6. *CE,* May 4, 1944.

7. *DS,* November 11, 1916; *CS,* November 4, 18, 1916.

8. Eric Ledell Smith, *Bert Williams: A Biography of the Pioneer Black Comedian* (Jefferson, North Carolina: McFarland and Company, 1992), 24–31.

9. "Universal Studios Biography," March 1, 1945, Sam McDaniel BF, AMPAS; *CD,* July 24, 1926, December 27, 1930.

10. *CS,* November 18, 1916; *BAA,* January 26, 1935; *CD,* March 29, 1941; "The Cakewalk Kids at Walden, Colorado," October 4, 1902, folder 3; misc. photos and clippings, n.d., n.s., Sam McDaniel scrapbook; HMcDC, AMPAS; Lisa Mitchell, " 'Mammy' McDaniel as the Definitive Matriarch," *Los Angeles Times Calendar,* November 7, 1976, 30; *CE,* October 29, 1942.

11. "Universal Studios Biography," "MGM Biographical Information," c. 1930s, Sam McDaniel BF, AMPAS; Lynn Abbot and Doug Seroff, *Out of Sight: The Rise of*

African-American Popular Music (Jackson: University Press of Mississippi, 2002), 360–372, 433–440.

12. *FS*, February 9, 28, 1908; *DS*, November 11, 1916; "O.H. McDaniel, producer," n.d., folder 1; HMcDC, "Universal Studios Biography," Sam McDaniel BF, AMPAS.

13. *FS*, March 13, 1908.

14. *FS*, October 10, December 26, 1908; February 20, March 27, 1909; *DS*, November 11, 1916.

15. *Chicago Daily Tribune*, December 14, 1947; "Hattie Throws a Party: Film Stars Help Star of *Beulah* Show Celebrate Radio Success," *Ebony*, December 1949, 92–97; *BAA*, January 26, 1935; *LAT*, February 11, 1940.

16. "The Passing of Beulah," *Our World*, February 1953, 12–15; *BAA*, January 26, 1935; *LAT* February 11, 1940.

17. "Hattie McDaniel," *Current Biography* 1940, 537; *CS*, October 31, 1908; *Denver Post*, October 27, 1908; *BAA*, January 26, 1935.

18. *CS*, December 5, November 28, 1908; December 16, 1916.

19. *FS*, December 5, 12, 1908.

20. *FS*, February 27, March 13, 1909; *CS*, March 6, 1909.

21. *FS*, March 20, 27, 1909.

22. *BAA*, January 26, 1935.

23. "Press Manual: Hattie 'Mammy' McDaniel," press relations department, Music Corporation of America, box 927, folder 17, DOSC; *FS*, April 30, 1910; Tamara Andreeva, "Hattie Is Hep," *Rocky Mountain Empire Magazine*, April 11, 1948, CF, DPL; Census, 1910, Denver, Colorado, roll T624_114p. 5A; *Ballenger and Richards Denver Directory*, 1916.

24. Some have contended that Henry McDaniel was an entertainer and led the children in his own minstrel troupe. However, it is likely that this story grew out of studio publicity, since Henry McDaniel was, by the early 1900s, hardly physically capable of extensive traveling and playing in a road company. *Salisbury Times*, May 28, 1960; *New York Amsterdam News*, May 20, 1939; Census, 1910, Altus, Oklahoma, roll T624_1255 pp. 37B, 38A; Jackson, *Hattie*, 10–11; *NYT*, March 7, 1948.

25. *FS*, March 12, October 8, 1910; "Photo: Compliments of Brown and McDaniel, Novelty Dancing Entertainers," n.d., folder 27, HMcDC, AMPAS.

26. "Universal Studios Biography," Sam McDaniel CF, "O. H. McDaniel, producer," Folder 1, "Otis McDaniel," Williams Photo Company, Kansas City, n.d., in Sam McDaniel scrapbook, HMcDC, AMPAS; *DS*, November 11, 1916; June 27, 1942; Thomas Cripps, *Slow Fade to Black: The Negro in American Film, 1900–1942* (New York: Oxford University Press, 1977), 108–109.

27. *FS*, October 8, 1910; Smith, *Williams*, 172–174, 230–231.

28. *CE*, May 4, 1944; Elizabeth Clark-Lewis, *Living In, Living Out: African-American Domestics in Washington D.C., 1910–1940* (Washington D.C.: Smithsonian Institution Press, 1994), 107–106, 232–233.

29. *CS*, September 7, 1912; January 24, 1914; March 6, 27, May 9, 1915; *Ballenger and Richards Denver Directory*, 1910, 1916; *DS*, March 6, 1915; Howard Hickman, Colorado State Reformatory prisoner's record, prisoner No. 2213, January 7, 1909,

Colorado State Archives, Denver, Colorado; Census, 1910, Denver, Colorado, roll T624_117, p. 155A.

30. Hickman, reformatory record; *Ballenger and Richards Denver Directory*, 1910.

31. Marriage license, Howard J. Hickman to Hattie H. McDaniel, January 19, 1911, Denver, Colorado, Colorado State Archives; *FS*, October 3, 1908; *DS*, March 6, 1915; *CS*, September 7, 1912.

32. *Ballenger and Richards Denver Directory*, 1910, 1916; *DS*, March 6, 1915.

33. *DS*, April 25, May 23, 1914.

34. *DS*, August 22, September 5, 1914; February 20, 1915; *CS*, September 29, 1914; February 13, 1915.

35. For overviews of race, minstrelsy, and American culture, see Eric Lott, *Love and Theft: Blackface Minstrelsy and the American Working Class* (New York: Oxford University Press, 1995); Alexander Saxton, *The Rise and Fall of the White Republic: Class Politics and Mass Culture in Nineteenth Century America* (New York: Verso, 1990); David Roediger, *The Wages of Whiteness: Race and the Making of the American Working Class* (New York: Verso, 1991); Mel Watkins, *On the Real Side: Laughing, Lying, and Signifying: The Underground Tradition of African-American Humor That Transformed American Culture From Slavery to Richard Pryor* (New York: Simon and Schuster, 1994), 81–103.

36. George Walker, "The Real 'Coon' on the American Stage," *Theatre Magazine*, August 1906, 22–24; Watkins, *Real*, 105–112, 124–133; Annamarie Bean, "Black Minstrelsy and Double Inversion, Circa 1890," in *African-American Performance and Theater History*, Harry J. Elam and David Krasner eds. (New York: Oxford University Press, 2001), 171–191.

37. *DS*, February 20, 1915; Bean, "Black Minstrelsy," 178–180; Tom Fletcher, *100 Years of the Negro in Show Business: The Tom Fletcher Story* (New York: Burdge, 1954), 100–105.

38. *DS*, May 23, 1914.

39. bell hooks, *Talking Back: Thinking Feminist, Thinking Black* (Boston: South End Press, 1989), 5–9.

40. *FS*, March 13, 1908.

41. For an overview of signifying in African-American culture, see Henry Louis Gates Jr. *The Signifying Monkey: A Theory of African-American Literary Criticism* (New York: Oxford University Press, 1988); Watkins, *Real*, 68, 130–133; Paul Laurence Dunbar, *Lyrics of Lowly Life* (New York: Dodd, Mead and Company, 1909), 167, James Goodwin interview, February 23, 2005.

42. Bert A. Williams and Alex Rogers, "Nobody" (New York: Gotham-Attucks Music Co., 1905); Ashton Stevens, *Actorviews* (Chicago; Covici-McGee Company, 1923), 227.

43. *CS*, September 23, 1916.

44. Booker T. Washington, "Interesting People: Bert Williams," *American Magazine*, September 1910, 600–640.

45. *New York Age*, November 24, 1910.

46. *New York Age*, December 12, 24, 1908; Smith, *Williams*, 133–142, 148.

47. Aida Overton Walker, "Colored Men and Women on the Stage," *Colored American Magazine*, October 1905, 571; David Krasner, *Resistance, Parody, and Double Consciousness in African-American Theatre, 1895–1910*, (New York: St. Martin's, 1997), 20–22.

48. *CS*, March 6, 1909; May 20, 1905.

49. *FS*, July 4, 1908.

50. *New York Age*, December 24, 1908.

51. *DS*, February 6, 13, 1915.

52. *DS*, March 6, 1915.

53. Ibid.

54. *DS*, March 6, 13, 1915; *CS*, March 6, 1915.

55. McDaniel chose the verse from the hymn "Immortal Love, Forever Full" by John Greenleaf Whittier and William V. Wallace. *DS*, March 20, 1915; *Ballenger and Richards Denver Directory*, 1916, 1917, 1918.

56. Fletcher, *100 Years*, 108, 251; Eileen Southern, *The Music of Black Americans: A History* (New York: W. W. Norton and Company, 1971), 329.

57. *The Birth of a Nation* (D. W. Griffith, 1915, Republic Pictures rereleased, 1991); Cripps, *Slow*, 44–51.

58. Cripps, *Slow*, 44–52; David Leah, *From Sambo to Superspade: The Black Experience in Motion Pictures* (New York: Houghton Mifflin, 1973), 35–39; Leonard and Noel, *Mining Camp*, 190–202; Robert Goldberg, *Hooded Empire: The Ku Klux Klan in Colorado* (Urbana: University of Illinois Press, 1981), 3–19.

59. *DS*, July 15, December 18, 1915; *CS*, April 24, December 4, 7, 1915; Leonard, *Mining Camp*, 193; Cripps, *Slow*, 53–60.

60. A Spirella was a made-to-order corset that was advertised as having "indestructible stays." *DS*, March 11, April 8, 1916; *Colorado Springs Gazette*, March 17, 1912.

61. *DS*, April 8, 29, 1916.

62. *DS*, April 29, 1916; *CS*, April 29, 1916.

63. *CS*, November 4, 18, 1916; *DS*, November 4, 11, 1916; Burial Record, Otis H. McDaniel, November 15, 1916, Riverside Cemetery Burial Records Office, Denver, Colorado.

64. *DS*, March 24, April 7, 14, 29, 1917; *Ballenger and Richards Denver Directory*, 1917, 1918; Census, 1920, Denver, Colorado, roll T625_162, p. 4B.

65. *CE*, June 2, 1938; *FS*, October 8, 1910; *DS*, May 27, 1916; May 26, 1917; *BAA*, January 26, 1935.

66. *FS*, March 5, 1910; *DS*, December 8, 22, 1917.

67. *DS*, December 22, 1917.

68. *DS*, February 16, 1918.

3: BLUES SINGER

1. *NYT*, January 1, 1920. For an overview of society and culture of the 1920s, see Lynn Dumenil, *Modern Temper: American Culture and Society in the 1920s* (New York: Hill and Wang, 1995).

2. Dumenil, *Modern Temper,* 8–12; David Levering Lewis, *When Harlem Was in Vogue* (New York: Vintage, 1982), 16–23; Goldberg, *Hooded Empire,* 3–5; *NYT,* January 1, 1920.

3. Nathan Irvin Huggins, *Harlem Renaissance* (New York: Oxford University Press, 1971), 13–66; John Hope Franklin, *From Slavery to Freedom: A History of Negro Americans* (New York: Alfred A. Knopf, 1988), 298–318.

4. G. James Fleming and Christian E. Burckel, eds. *Who's Who in Colored America* (Yonkers: Christian E. Burckel and Associates, 1950), 118; HeMcDPF: application for reimbursement, January 5, 1923; clipping, n.d., n.s., Sam McDaniel scrapbook, HMcDC, AMPAS; Susan McDaniel, June 21, 1920, Riverside Cemetery Burial Records Office, Denver, Colorado.

5. HeMcDPF: application for reimbursement, January 5, 1923; Henry McDaniel's death certificate, November 30, 1922, Vital Records, Denver, Colorado; Census, 1920, Denver, Colorado, roll T625_162, p. 4B, roll T625_160, p. 4B.

6. Clipping, n.d., n.s., Sam McDaniel scrapbook, HMcDC, AMPAS; Henry McDaniel, December 5, 1922, Riverside Cemetery Burial Records Office, Denver, Colorado; HeMcDPF: application for reimbursement; Henry McDaniel's death certificate; John Kelly, "Hattie McDaniel: Trod Hill on Way to Stardom," n.d., n.s., Hattie McDaniel CF DPL.

7. HeMcDPF: Etta Goff to Bureau of Pensions, December 4, 1922.

8. HeMcDPF: Etta Goff to Bureau of Pensions, December 4, 1922; Widow Division to Etta McDaniel, January 18, 1923; application for reimbursement, January 5, 1923; return to sender, 2926 Welton to Department of Interior, December 3, 1922; Etta Goff to Commissioner of Pensions, May 17, 1923; reimbursement, U.S. Pension Bureau to Etta Goff, May 23, 1923.

9. HeMcDPF: Etta Goff to Commissioner of Pensions, May 17, 1923; Goldberg, *Hooded Empire,* 3–83; *CS,* June 16, 1923; Leonard and Noel, *Mining Camp,* 190–194.

10. Sam McDaniel married Lula Bell in Casper, Wyoming, on July 28, 1918. "Universal Studios Biography," "MGM Biographical Information," Sam McDaniel BF; "Sam McDaniel and His Kings of Syncopation," Mexicali, September 1924, clippings, n.d., n.s., Sam McDaniel scrapbook, HMcDC, AMPAS; *CS,* June 16, 1923; *San Diego City Directory,* 1924.

11. *Los Angeles City Directory,* 1924, 1925; *CS,* June 16, 1923; Census, 1930, Los Angeles, California, roll T626_144, p. 10B, roll T626_147, p. 6A; *CE,* January 17, 1946; *CD,* March 29, 1941.

12. *CS,* April 13, 1917; October 19, 1918; February 21, April 10, 1920; *City Directory,* Denver, Colorado, 1919, 1923; HeMcDPF: application for reimbursement, January 5, 1923; *CE,* February 24, 1938.

13. *CS,* January 20, 1923.

14. One of Willa May's parents was born in Kansas. Willa May and George Morrison named their daughter Marian, suggesting perhaps she was related through Lena Taylor, who also named one of her daughters Marian. Census, 1920, Denver, Colorado, roll T625_161, p. 5B, 1930, Denver, Colorado, roll T626_237, p. 8B; Jack-

son, *Hattie,* 9; Marriage License, McDaniel and Hickman; Gunther Schuller, *Early Jazz: Its Roots and Musical Development* (New York: Oxford University Press, 1986), 362.

15. Schuller, *Early Jazz,* 359–369.

16. *DS,* September 5, 1914; February 6, 1915; April 8, 29, 1916; March 24, April 14, 1917; Schuller, *Early Jazz,* 362–372.

17. Schuller, *Early Jazz,* 362–372; Austin Sonnier Jr., *A Guide to the Blues: History, Who's Who, Research Sources* (Westport, Connecticut: Greenwood Press, 1994), 195–196; Southern, *The Music,* 365–367.

18. Schuller, *Early Jazz,* 362–372.

19. Sheldon Harris, *Blues Who's Who: A Biographical Dictionary of Blues Singers* (New York: Da Capo, 1979), 360–362; Fleming and Burckel, *Who's Who,* 363.

20. Schuller, *Early Jazz,* 370.

21. Joe Laurie, *Vaudeville: From the Honky-Tonks to the Palace* (New York: Henry Holt and Company, 1953), 237, 401–403.

22. *Variety,* November 12, 26, December 3, 17, 24, 31, 1924; January 7, 14, 21, 28, February 4, 11, 18, 25, March 4, 11, 18, 25, April 1, 8, 1925; Laurie, *Vaudeville,* 237; John E. DiMeglio, *Vaudeville U.S.A.* (Bowling Green: Bowling Green University Press, 1973), 87–95, 109–118.

23. *Variety,* December 24, 1924.

24. *San Jose Evening News* quoted in *CS,* February 14, 1925; *Variety,* February 18, 1925; *LAT,* February 10, 1925; *Denver Post,* March 16, 17, 1925.

25. *Oregon Daily Journal,* quoted in *CS,* February 14, 1925; Schuller, *Early Jazz,* 370; *Variety,* February 19, 1925.

26. *Variety,* February 19, 1925; *Portland Telegram* quoted in *CS,* February 14, 1925; *LAT,* February 10, 1925; *CE,* February 6, 1925; *San Diego Union,* February 16, 1925.

27. *Denver Post,* March 16, 1925; *CS,* February 14, 1925; DiMelgio, *Vaudeville,* 117; Anthony Slide, *The Vaudevillians: A Dictionary of Vaudeville Performers* (Westport, Connecticut: Arlington House, 1981), 154–156.

28. *CS,* May 9, 1925, December 5, 1925; Fleming and Burckel, *Who's Who,* 363; *LAS,* October 30, 1952.

29. Census, 1930, Los Angeles, California, roll T626_144, p. 10B; *Los Angeles City Directory,* 1927; clippings, n.d., n.s., Sam McDaniel scrapbook, "10/15/30 from Sam R. McDaniel, brother to Sis Hattie McD., Los Angeles, California," folder 32, HMcDC, AMPAS; Cripps, *Slow,* 223; *LAS,* October 30, 1952; *CE,* July 24, 1931.

30. The 1910 census shows Addie (name misspelled Ada) with an African-American boarder named John Haig. In 1920, there is an Anna Haig (born in Tennessee), who is African-American and married to a John Haig who is from Scotland. Although Anna Haig is considerably younger than Addie would be, it is possible that this could be she and her second husband, who may have been white and the original census was incorrect. Census, 1910, Denver, Colorado, roll T624_114, p. 4A, T624_160; census, 1930, Denver, Colorado, roll T625_239, p.15B; *CS,* April 14, 1928.

31. *Ballenger and Richards Denver Directory,* 1923–27; *LAT,* February 11, 1940.

32. While on the road in 1926, McDaniel received her mail at 3250 Prairie Avenue in Chicago. *CD,* January 29, 1921; July 24, 1926; *Variety,* October 29, 1952; *Chicago Tribune,* December 14, 1947; Jerry Ames and Jim Siegelman, *The Book of Tap: Recovering America's Long Lost Dance* (New York: David McKay Company, Inc, 1977) 41–45; Watkins, *Real,* 365–367; *CE,* October 30, 1952.

33. Clarence Muse and David Arlen, *Way Down South* (Hollywood, California: David Graham Fischer Publisher, 1932), 15; Jim Haskins and N. R. Mitgang, *Mr. Bojangles: The Biography of Bill Robinson* (New York: William Morrow and Company, 1988), 56, 62; Ames and Siegelman, *Tap,* 41–45; Watkins, *Real,* 365–368.

34. Watkins, *Real,* 365–368; *Chicago Tribune,* December 14, 1947; *CE,* October 30, 1952.

35. *Rocky Mountain News,* April 14, 1941.

36. *Footlights,* November 6, 1928; George P. Johnson Collection, special collections, University Research Library, UCLA; William Howland Kenney, *Chicago Jazz: A Cultural History, 1904–1930* (New York: Oxford University Press, 1993), 48; Ross Laird, *Moanin' Low* (Westport, Connecticut: Greenwood, 1996), 346; Harris, *Blues,* 360–361.

37. Allan Sutton, *American Record Labels and Companies: An Encyclopedia, 1891–1943* (Denver: Mindspring Press, 2000), 128–129; *BAA,* January 26, 1935; Laird, *Moanin',* 346; Godfrey Cambridge, "A Lot of Laughs, a Lot of Changes," *Tuesday Magazine,* September 1964, n. p., George P. Johnson Collection, special collections, University Research Library, UCLA.

38. *CD,* July 24, 1924; Kenney, *Chicago Jazz,* 48, 57, 154; Laird, *Moanin',* 346; Sonnier, *A Guide,* 109.

39. Sutton, *American Record,* 146–147.

40. Hattie McDaniel, "Boo Hoo Blues" and "I Wish I Had Somebody," OKeh, 8434, recorded November 17, 1926, *Female Blues Singers: Complete Recorded Works and Supplements, 1922–1935,* vol. XII, Document Records compact disc, 1997.

41. "I Wish I Had Somebody."

42. "Boo Hoo Blues."

43. "I Wish I Had Somebody."

44. "Boo Hoo Blues."

45. Angela Davis, *Blues Legacy and Black Feminism: Gertrude "Ma" Rainey, Bessie Smith, and Billie Holiday* (New York: Pantheon, 1998), 21.

46. Kenney, *Chicago Jazz,* 3–21; Allen H. Spear, *Black Chicago: The Making of a Negro Ghetto, 1890–1920* (Chicago: University of Chicago Press, 1967), 129–201.

47. Kenney, *Chicago Jazz,* 23–25, 149–151; Laurence Bergreen, *Louis Armstrong: An Extravagant Life* (New York: Broadway Books, 1997), 191–193, 283–285.

48. *LAT,* October 27, 1952.

49. *CD,* November 6, 1926; April 23, 1927; Kenney, *Chicago Jazz,* 53; Bergreen, *Armstrong,* 262, 288; Laird *Moanin',* 346; Jackson, *Hattie,* 14–15.

50. Hattie McDaniel, "Just One Sorrowing Heart," OKeh 8569, recorded December

14, 1927, *Tiny Parham and the Blues Singers, Complete Recorded Works, 1926–1928*, Document Records compact disc, 1995; Laird, *Moanin'*, 346.

51. Hattie McDaniel, "I Thought I'd Do It," OKeh 8569, recorded December 14, 1927, *Tiny Parham and the Blues Singers, Complete Recorded Works, 1926–1928*, Document Records compact disc, 1995.

52. Davis, *Blues*, 11–15.

53. *CS*, April 14, 1928.

54. The 1930 census lists a Nym Langford, born in Missouri, with a wife and a daughter who is three years old. Census, 1930, New York, New York, roll T626_1578, p. 26B; *CE*, February 24, 1938; *CS*, April 14, 1928; *LAT*, February 11, 1940.

55. For information on Dixon, see liner notes to Hattie McDaniel, "Any Kind of Man Would Be Better Than You" and "That New Love Maker of Mine," recorded c. 1929, Pm 12790, *Hot Clarinets: Jimmy O'Brien and Vance Dixon, Complete Recordings in Chronological Order, 1923–1931*, RST Records compact disc, 1995.

56. For information on Jackson see liner notes to Hattie McDaniel and Papa Charlie Jackson, "Dentist Chair Blues, Part One and Two," recorded c. March 1929, Pm 12751, *Papa Charlie Jackson: Complete Recorded Works In Chronological Order, 3 September 1928 to 26 November 1934*, vol. III, Document Records compact disc, 1991.

57. *Salisbury Times*, July 3, 1953; Letter: Simmons to McDaniel-Crawford, January 5, 1945; Easter card, 1950, HUM 2.8, Box 8, Roscoe Conkling Simmons Papers, University Archives, Pusey Library, Harvard University; Andrew Kaye, "Roscoe Conkling Simmons and the Significance of African-American Oratory," *The Historical Journal*, vol. 45, no. 1 (2002), 79–102.

58. *Chicago Daily Tribune*, October 2, 1929; "Hattie Throws a Party," 96.

59. *Chicago Daily Tribune*, October 1, 2, 1929; *CD*, October 5, 1929; Richard and Paulette Ziegfeld, *The Ziegfeld Touch: The Life and Times of Florenz Ziegfeld, Jr.* (New York: Harry Abrams, Inc, 1993), 284; Harris, *Who's Who*, 360; Jackson, *Hattie*, 16.

60. Hattie McDaniel "What Hollywood Means to Me," *The Hollywood Reporter*, September 29, 1947, in Tichi Wilkerson and Marcy Borie, *The Hollywood Reporter: The Golden Years* (New York: Coward-McCann Inc., 1984), 210; *Chicago Daily Tribune*, October 2, 1929, 33; *CD*, October 5, 12, 1929; *Variety*, October 9, 1929, January 8, 29, 1930, February 5, 1930; Richard and Paulette Ziegfeld, *Ziegfeld*, 154–155; Charles Higham, *Ziegfeld* (Chicago: Henry Regency Company, 1972), 201–205; "Haitie McDaniel," *Current Biography*, 1940, 537.

61. While some sources indicate Sam Pick's was called the "Club Madrid," a notice placed by McDaniel in the *Chicago Defender* confirms that she was performing at the Suburban Inn. *Milwaukee City Directory*, 1930; Census, 1930, Milwaukee, Wisconsin, roll T626_2587, p. 10B; roll T626_2591, p. 22A; *Milwaukee Journal*, July 16, 1930; *PC*, May 18, 1940; *CD*, December 27, 1930; *LAT* February 11, 1940.

62. In another interview, McDaniel claimed that the singers and orchestra had left. W. C. Handy, *St. Louis Blues*, reprinted in Davis, *Blues*, 341; *Chicago Tribune*,

December 14, 1947; "Hattie McDaniel," *Current Biography,* 1940, 537; *PC,* May 18, 1940; McDaniel "What Hollywood," 210; *LAT,* February 11, 1940.

63. McDaniel "What Hollywood," 210; *Milwaukee Journal,* July 16, 1930; *PC,* May 18, 1940; *CD,* December 27, 1930.

64. McDaniel, "What Hollywood," 210; Davis, *Blues,* 341; "Hattie McDaniel," *Current Biography,* 1940, 537; "The Passing of Beulah," *Our World,* February 1953, 14; *Chicago Tribune,* December 14, 1947.

4: THE DILEMMA

1. *CE,* October 30, 1952; May 8, 1931.

2. *CE,* May 8, 1931; *PC,* November 11, 1938; *Los Angeles City Directory,* 1930–1933; McDaniel, "What Hollywood," 310.

3. *CE,* March 11, 1932; July 17, 1931; Lonnie G. Bunch III, "A Past Not Necessarily Prologue: The Afro-American in Los Angeles Since 1930," in *20th Century Los Angeles: Power, Promotion, and Social Conflict,* Norman M. Klein and Martin J. Schiesl, eds. (Claremont, California: Regina Books, 1990), 100–130; Ralph Eastman, " 'Pitchin' Up a Boogie': African-American Musicians, Nightlife, and Musical Venues in Los Angeles, 1930–1945," in *California Soul: Music of African Americans in the West,* Jacqueline Cogdell DjeDje and Eddie S. Meadows, eds. (Berkeley: University of California Press, 1998), 79–103; Clora Bryant, *Central Avenue Sounds* (Berkeley: University of California Press, 1998), 2–21.

4. *Los Angeles City Directory,* 1933; *CE,* October 27, 1933; Richard Newman, *Words Like Freedom: Essays on African-American Culture and History* (West Cornwall, Connecticut: Locust Hill, 1996), 82–83.

5. Bryant, *Central Avenue,* 17; Bunch, "A Past," 115–116.

6. Census, 1930, Los Angeles, California, roll T626_144, p. 10B, roll T626_147, 6A; Etta McDaniel photographs, folder 50, HMcDC, AMPAS; *CE,* January 17, 1946; *CD,* March 29, 1941.

7. *LAT,* August 21, 1931; *CE,* May 8, August 24, 1931; March 4, April 8, December 23, 1932; October 30, 1952.

8. *Public Enemy* (Warner Bros., 1931, rereleased MGA/UA Home Video, 1989); *CE,* May 8, 1931; March 4, May 19, 1932; "Universal Studios Biography," Sam McDaniel BF, AMPAS.

9. *CD,* June 21, 1930; Laurie, *Vaudeville,* pp. 494–497; Chris Albertson, *Bessie* (New York: Stein and Day, 1972), 180–187; Ann Douglas, *Terrible Honesty: Mongrel Manhattan in the 1920s* (New York: Noonday, 1995), 467–470; *LAT,* February 11, 1940.

10. *CE,* October 30, 1952; May 8, 1931; January 31, 1936.

11. *CE,* March 11, December 23, 1932; October 24, 1934; August 8, 1935; January 31, 1936; May 4, 1944; Robert Sklar, *Movie Made America: A Cultural History of American Movies* (New York: Vintage, 1975), 84–85.

12. *CE,* May 1, 1931; May, 6, 1932; May 27, 1932; September 21, 1934; October 6, 1938.

13. *CE,* May 27, April 22, 1932; January 31, 1936.

14. Cripps, *Slow*, 142–146; Gregory Black, *Hollywood Censored: Morality Codes, Catholics, and the Movies* (Cambridge: Cambridge University Press, 1994), 3–49; Lott, *Love and Theft*, 6.

15. *PC*, March 11, 1939; Skolsky scrapbook #5, clip, n.s., January 14, 1936, Sidney Skolsky Collection, AMPAS; Cripps, *Slow*, 102, 268–270.

16. *CE*, April 22, 1932; October 30, 1952; McDaniel, "What Hollywood," 310; *LAT* February 11, 1940.

17. *CE*, July 17, October 30, November 6, 1931.

18. *CE*, June 5, July 3, 17, October 29, December 18, 1931; January 1, 1932; February 26; August 4, December 23, 1932; May 12, October 27, 1933; May 16, 1940; *CD*, July 4, 1931.

19. *CE*, January 1, April 15, 29, 1932; July 21, 1933; April 19, 1937; June 2, 1938; May 16, 1940; *BAA*, January 26, 1935.

20. *CE*, July 31, August 28, 1931; Watkins, *Real*, 119–120; Cripps, *Slow*, 108; Kenney, *Chicago Jazz*, 20, 50; Henry T. Sampson, *Blacks in Blackface: A Source Book on Early Black Musical Shows* (Metuchen, New Jersey: Scarecrow Press, 1980), 510.

21. Clarence Muse, *The Dilemma of the Negro Actor* (Los Angeles: Clarence Muse publisher, 1934), 17; Donald Bogle, *Toms, Coons, Mulattoes, Mammies, and Bucks: An Interpretive History of Blacks in American Films* (New York: Continuum, 1990), 53–56; *CE*, May 31, June 14, 28, 1935; April 24, September 11, 1936; November 3, December 1, 1938; June 6, 1940.

22. Muse, *Dilemma*, 1, 22.

23. Sampson, *Blacks in Blackface*, 510; *CE*, July 24, 31, 1931.

24. Watkins, *Real*, 201, 227–228; Bogle, *Toms*, 38–44.

25. *CE*, March 15, 1929; Watkins, *Real*, 249.

26. Watkins, *Real*, 227–228, 247–248.

27. *CE*, July 31, August 28, 1931.

28. *CE*, August 28, 1931.

29. *BAA*, January 26, 1935; *CE*, October 30, 1952; November 6, 1931; *New York Amsterdam News*, November 1, 1952; *NYT*, March 7, 1948.

30. Levette refers to the group as McVey—but it's most often spelled McVea. *CE*, October 30, 1952; Bryant, *Central Avenue*, 219; DjeDje and Meadows, *California Soul*, 32–34; *BAA*, September 30, 1933; *CD*, May 7, 1932.

31. *CE*, May 27, 1932; November 13, 1935.

32. *Chicago Daily Tribune*, December 14, 1947; *CE*, February 12, 1932.

33. *Blonde Venus* (Paramount 1932, rereleased MCA/Universal Home Video, 1993); *The American Film Institute Catalog of Motion Pictures Produced in the United States: Personal Name Index, Feature Films, 1931–1940* (Berkeley: University of California Press, 1993), 374.

34. Gilbert Seldes, "Sugar and Spice and Not So Nice," *Esquire*, March 1934, 60, 120; *PC*, September 12, 1942.

35. *CE*, October 5, 1934; Cripps, *Slow*, 162, 294; Bogle, *Toms*, 45–46.

36. Louise Beaver's mother, Ernestine Beavers, worked for the studios as a choir director. *New York Amsterdam News*, February 16, 1935; Census, 1930, Los Angeles,

California, roll T626_145; Louise Beavers clippings, n.d., n.s., George P. Johnson Collection, special collections, University Research Library, UCLA.

37. *New York Amsterdam News,* February 16, 1935; Louise Beavers clippings, n.d., n.s., George P. Johnson Collection, special collections, University Research Library, UCLA; *CE,* January 31, 1936.

38. *CE,* July 6, 1934; February 17, 1938; *PC,* November 11, 1938; Bogle, *Toms,* 63; "Movie Maids," *Ebony,* August 1948, 56–59.

39. *Boiling Point* (Allied Pictures Corporation 1932, rereleased VCI Home Video, 1995).

40. *I'm No Angel* (Paramount 1933, rereleased MCA/Universal, 1993).

41. *CE,* March 4, 1932; February 3, 1933; clippings, n.d., n.s., Sam McDaniel scrapbook, HMcDC, AMPAS; "Universal Studios Biography," Sam McDaniel BF, AMPAS; *Los Angeles City Directory,* 1930–33.

42. *CE,* March 4, 1932; February 3, 1933; April 6, 1934; May 16, 1940.

43. *CE,* March 30, September 24, 1934; Anna Everett, *Returning the Gaze: A Genealogy of Black Film Criticism, 1909–1949* (Durham: Duke University Press, 2001), 188–193.

44. *CE,* May 13, June 24, 1932; February 3, 1933.

45. Bogle, *Toms,* 35–86.

46. *CE,* November 10, 1933; *Variety,* October 31, 1933; *LAT,* December 2, 1933.

47. *CE,* November 10, 1933; *Variety,* November 7, 14, 21, 1933.

48. *Variety,* November 14, December 5, 12, 1933.

49. *LAT,* December 6, 1933; *Variety,* December 12, 19, 1933.

50. *CE,* January 19, 1933.

5: PROMINENCE

1. *CE,* February 9, 1934; *Judge Priest* (Fox Studios, 1934, rereleased Alpha Video Distributors, 1995); Contract: Hattie McDaniel and Fox Studios, May 25, 1934, box 84, file 2332, Fox Studio legal files, collection 95, University Research Library, UCLA; *LAT,* February 11, 1940.

2. *Judge Priest.*

3. Ben Yagoda, *Will Rogers: A Biography* (New York: Knopf, 1993), 313; Peter Bogdanovich, *John Ford* (Berkeley: University of California Press, 1978), 19, 40; Bogle, *Toms,* 186; Joseph McBride, *Searching for John Ford* (New York: St. Martin's Press, 2001), 210–211.

4. *CE,* March 2, 1934; August 23, 1935; *New York Amsterdam News,* March 10, 1934; Yagoda, *Rogers,* 3–16, 306–309.

5. McBride, *Searching,* 211; *CE,* July 23, 1934; Yagoda, *Rogers,* 312–313.

6. *CE,* June 29, 1934.

7. Ibid.

8. *Los Angeles Examiner,* September 28, 1934; *NYT,* Oct 12, 1934.

9. *Little Men* (Mascot Pictures, 1934); *Variety,* "Little Men," "Babbitt"; *CE,* June 22, July 7, 1934; *American Film Institute Catalog, 1931–1940,* 374.

10. *Imitation of Life* (Universal Studios, 1934, rereleased by Universal Pictures Corporation, 1998).

11. Reports in the *California Eagle* confirm that McDaniel had a small speaking role at the funeral that was cut in the final version. *CE*, August 6, September 21, 1934; December 7, February 17, 1938; *Imitation of Life;* Brooke Kroeger, *Fannie: The Talent for Success of Writer Fannie Hurst* (New York: Times Books, 1999), 197, 202–205; Thomas Schatz, *The Genius of the System: Hollywood Filmmaking in the Studio Era* (New York: Henry Holt and Company, 1988), 231–232.

12. *CE*, January 26, July 6, 1934; Bogle, *Toms,* 60.

13. Censor files, *Imitation of Life*; letter: Joseph Breen to Harry Zehner, March 9, 1934, AMPAS.

14. Ibid., memo for files, Breen, March 9, 1934, AMPAS.

15. Ibid., memorandum, I. Auster to Breen, n.d., AMPAS.

16. Ibid., memorandum, Alice Field to Breen, n.d., AMPAS.

17. Ibid., memorandum, J. B. Lewis to Breen, March 10, 1934, AMPAS.

18. Censor file, *Imitation of Life,* letters, Breen to Zehner, July 20, 1934, Zehner to Breen, June 26, 1934, memorandum, Breen to Wingate, July 3, 1934, AMPAS; *New York Amsterdam News,* February 16, 1935; memo VL to DOS, June 9, 1939, Box 13, folder 21, DOSC.

19. *Imitation of Life*; Schatz, *Genius,* 231; censor file: *Imitation of Life,* letter: Breen to Zehner, November 14, 1934, AMPAS.

20. Bogle, *Toms,* 60; *CE,* September 21, December 7, 1934; February 8, 1935; censor files, *Imitation of Life,* letter, Zehner to Breen, January 24, 1935, AMPAS.

21. Kroeger, *Fannie,* 205–207; *Variety,* November 27, 1934; *Literary Digest,* December 8, 1934; *CE,* February 8, 1935.

22. *CE,* December 14, 1934; Everett, *Returning the Gaze,* 218–232; Kroeger, *Fannie,* 207–212.

23. Sterling Brown, "Imitation of Life: Once a Pancake," *Opportunity,* March 1935, quoted in Everett, *Returning the Gaze,* 223–230; *PC,* December 8, 1934.

24. Pauline Flora Byrd, "Imitation of Life," *Crisis,* March 1935, quoted in Everett, *Returning the Gaze,* 231–232.

25. *CE,* December 14, 1934.

26. Loren Miller, "Uncle Tom in Hollywood," *Crisis,* November 1934, 329–336; Everett, *Returning the Gaze,* 232–233; *CE,* February 1, 1935.

27. *CE,* February 1, 1935; Bogle, *Toms,* 62–64; *New York Amsterdam News,* January 26, February 16, March 2, 1935.

28. Brown, quoted in Everett, *Returning the Gaze,* 229.

29. *PC,* December 15, 1934, quoted in Everett, *Returning the Gaze,* 208–209.

30. *CE,* December 21, 1934.

31. *New York Amsterdam News,* February 16, 1935.

32. *PC,* April 14, 1934; *Voice of the People,* September 12, 1942; *CE,* December 21, 1934; Cripps, *Slow,* 287–289; Bogle, *Toms,* 60–62, 64–66.

33. Wonderful Smith interview, September 23, 2003, Los Angeles, California; Martha Raye, "Harlem Taught Me to Sing," *Ebony,* November 1954, 56; McDaniel, "What

Hollywood," 310; *CE*, May 4, 1944; Arnold Rampersad, *The Life of Langston Hughes: I Too Sing America,* vol. I (New York: Oxford University Press, 1986), 308–309; Cripps, *Slow,* 96, 103, 288; George Haddad-Garcia, "Mae West: Everybody's Friend," *Black Stars,* April 1981, 62–64; Cripps, *Slow,* 108–109; *CE,* June 5, 1936; *The Nicholas Brothers* (A&E Home Video, 2000).

34. *CE,* May 27, 1932; September 21, October 5, 1934; May 4, 1944.

35. *CE,* October 5, 19, 1934; March 13, 1936; Sklar, *Movie Made,* 171.

36. *CE,* October 5, 19, 26, 1934.

37. *CE,* December 21, 1934; January 23, 1935; Haskins and Mitgang, *Mr. Bojangles,* 224–225.

38. *The Little Colonel* (Fox Studios 1935, rereleased CBS/Fox Playhouse Video, 1988); *Hollywood Reporter,* February 6, 1935.

39. Shirley Temple, *Child Star: An Autobiography* (New York: Warner Books, 1988), 97.

40. *The Postal Inspector* (Universal Studios, 1936).

41. *China Seas* (MGM, 1935, rereleased MGM/UA Home Video, 1990).

42. *Alice Adams* (RKO, 1935, rereleased Turner Home Entertainment, 1989).

43. Censor files, *Alice Adams,* RKO Advance Information, n.d., AMPAS.

44. *Motion Picture Daily,* August 5, 1935; *Variety,* August 3, 1935; *NYT,* August 16, 1935; *Alice Adams.*

45. *CE,* June 22, 1934; August 23, February 15, December 20, 1935; Contracts, Hattie McDaniel and Fox Studios, July 15, August 12, 1935, box 946, file 2529, October 12, 1935, box 946, file 2725, Fox Studio legal files, collection 95, University Research Library, UCLA; *Los Angeles City Directory,* 1936; "MGM Biographical Information," Sam McDaniel BF, AMPAS; Smith interview; Paul Goodwin interview, February 12, 2003.

46. Smith interview.

47. Smith interview; Jill Watts, *God, Harlem U.S.A.: The Father Divine Story* (Berkeley: University of California Press, 1992), 21–24, 58–63.

48. Mitchell, "Definitive Matriarch"; *BAA,* January 26, 1935; Watts, *God,* 61–95; Robert Weisbrot, *Father Divine and the Struggle for Racial Equality* (Urbana: University of Illinois Press, 1983).

49. *CE,* August 23, February 15, December 20, 1935.

50. *CE,* January 11, June 21, November 25, 1935; Martin Bauml Duberman, *Paul Robeson* (New York: Alfred A. Knopf, 1988), 169, 203; Leah, *From Sambo to Superspade,* 112.

51. Censor files, *Show Boat,* Breen to Zehner, October 17, 1935; file memorandum, Breen, October 17, 1935, AMPAS.

52. *CE,* December 20, 1935; January 3, March 27, 1936; censor files, *Show Boat,* letter, Breen to Zehner, November 15, 26, 1935, AMPAS.

53. *NYT,* May 15, 1936; *Los Angeles Examiner,* May 13, 1936; Duberman, *Robeson,* 203; *CE,* May 1, 1936.

54. *Show Boat* (Universal Studios, 1936, rereleased MGM/UA Home Video, 1990); Bogle, *Toms,* 85; *CE,* January 1, 1936.

55. *American Film Institute Catalog, 1931–1940,* 374 *CE,* December 20, 1935; *Los Angeles Sentinel,* October 30, 1952; James Goodwin interview, January 23, 2003.

56. For the story of her early life, see Ruby Berkley Goodwin, *It's Good to Be Black* (Garden City: Doubleday, 1953). Ruby Berkley Goodwin clippings, n.d., n.s., George P. Johnson Collection, special collections, University Research Library, UCLA; James Goodwin interview, January 23, 2003, February 19, 2005.

57. Ruby Berkley Goodwin's poems were collected in *From My Kitchen Window* (New York: Wendell Malliet and Company, 1942); *CE,* January 31, 1936; Goodwin clips, n.d., n.s., Johnson Collection; *PC,* October 22, 1938; Fleming and Burckel, *Who's Who in Colored America,* 217; James Goodwin interview, January 23, February 5, 2003; *CE,* December 12, 1934.

58. James Goodwin interview, January 23, February 5, 2003; *Chicago Daily Tribune,* December 14, 1947.

6: AND I'VE ONLY BEGUN TO FIGHT

1. *American Film Institute Catalog, 1931–1940,* 374; "MGM Biographical Information," Sam McDaniel, BF, AMPAS; *CE,* April 23, December 30, 1937; February 24, 1938; *PC,* October 22, 1938.

2. *CE,* July 9, December 16, 1937; March 10, 1938; January 11, 1940; *Los Angeles City Directory,* 1938; *PC,* December 26, 1936; *BAA,* March 9, 1940.

3. *CE,* January 24, March 6, 1936; February 19, 1937; November 28, 1940; Larry Richards, *African-American Films Through 1959* (Jefferson, North Carolina: McFarland and Company, 1998), 38; *Los Angeles Sentinel,* July 20, 1939.

4. Mitchell, "Definitive Matriarch"; *CE,* December 24, 1936; April 7, 1938; August 1, December 19, 1940.

5. *Denver Post,* April 15, 1941; *PC,* December 5, 1936; *CE,* October 12, 1939; August 15, 1940; *Los Angeles City Directory,* 1937–41.

6. Harris, *Blues Who's Who,* 175–176; *PC,* December 5, 1936; January 16, April 3, 1937.

7. *CE,* February 24, 1938; *PC,* April 3, 1937.

8. Eddie Green had appeared on Broadway in the black revue "Hot Chocolates." *CE,* August 26, 1937; John Dunning, *On the Air: The Encyclopedia of Old Time Radio* (New York: Oxford University Press, 1998), 613–14; *Lima News,* September 9, 16, 1937; Richards, *African-American Films,* 55; *LAT,* July 15, 1937; February 11, 1940.

9. *LAT,* April 29, 1981; Ronald Reagan with Richard G. Hubler, *Where's the Rest of Me? The Autobiography of Ronald Reagan* (New York: Karz Publishers, 1981, reprint or 1965 edition), 72–74; Frank Rose, *The Agency: William Morris and the Hidden History of Show Business* (New York: HarperBusiness, 1995), 80; *NYT,* April 30, 1981.

10. *Stella Dallas* (MGM, 1937, rereleased MGM/UA Home Video, 2000); *The Shining Hour* (MGM, 1938, rereleased MGM/UA Home Video, 1992); *Saratoga* (MGM, 1937, rereleased MGM/UA Home Video, 1992).

11. *Shopworn Angel* (MGM, 1938, rereleased MGM/UA Home Video, 1994).

12. Censor files, *Mad Miss Manton,* Breen to J. R. McDonough, RKO, June 10, 1938, AMPAS.

13. *Mad Miss Manton* (RKO, 1938).

14. McDaniel, "What Hollywood," 310; *Hollywood Reporter,* November 6, 1936; Contract, Hattie McDaniel and Fox Studios, July 16, 1936, box 1144, file 3151, Fox Studio legal files, collection 95, Arts Library Special Collections, University Research Library, UCLA; censor files, *Can This Be Dixie?* Clare S. Gunniss to Breen, n.d., AMPAS; *Variety,* November 18, 1936; *People's Voice,* September 12, 1942.

15. *Variety,* March 28, 1936.

16. *Carefree* (RKO, 1938).

17. *CE,* December 23, 1937; *PC,* December 5, 1936.

18. *BAA,* January 26, 1935.

19. Quoted in Donald Bogle, *Dorothy Dandridge: A Biography* (New York: Amistad, 1997), 96–97.

20. *Los Angeles Examiner,* November 17, 1937.

21. *PC,* January 30, 1937.

22. *CE,* April 16, 1937.

23. *PC,* September 24, 1938.

24. *New York Age,* April 3, 1937.

25. *CE,* June 30, 1938.

26. *New Age Dispatch,* February 12, 1937, quoted in Sampson, *Blacks in Black and White,* 488–489.

27. *New York Age,* April 3, 24, 1937.

28. *PC,* February 20, 27, 1937; *CD,* February 27, 1937.

29. Everett, *Returning the Gaze,* 209–213; *CE,* April 16, 1937; *PC,* January 30, 1937.

30. *CE,* April 16, 1937.

31. Eugene W. Jackson II with Gwendolyn Sides St. Julian, *Eugene "Pineapple" Jackson: His Own Story* (Jefferson, North Carolina: McFarland and Company, 1999), 87; James Goodwin interview, January 23, 2003. *Chicago Daily Tribune,* December 14, 1947; *PC,* November 5, 1938; letter, anonymous to Mr. White, February 12, 1946, NAACP–PP.

32. *PC,* October 22, 1938; James Goodwin interview, January 23, February 5, 2005; Wonderful Smith interview, September 23, 2003.

33. *CE,* March 19, 1937.

34. *CE,* August 11, 1938.

35. *CE,* March 19, April 16, 23, October 21, 1937.

36. *CE,* June 30, 1938; James Hatch and Leo Hamalian, eds., *Lost Plays of the Harlem Renaissance 1920–1940* (Detroit: Wayne State University Press, 1996), 227–229.

37. *CE,* April 16, June 18, 1937; June 12, 28, 1935.

38. *CE,* September 2, 1937.

39. *CE,* August 4, 1938.

40. *PC,* September 24, 1937.

41. This quote or variants of it have appeared in a number of sources since McDaniel's

death. One of the earliest sources for this quote comes from Bogle, *Toms,* 82; *London Times,* October 26, 1999.

42. *CE,* March 19, 1937; Cripps, *Slow,* 70–89.

43. Cripps, *Slow,* 327–329; Richards, *African-American Films,* 49.

44. Cripps, *Slow,* 329–335; *CE,* August 26, December 23, 1937.

45. *CE,* August 26, 1937; Sampson, *Blacks in Black and White,* 489.

46. *New York Amsterdam News,* August 12, 1939.

47. *LAS,* February 25, 1937; Richards, *African-American Films,* 101, 114, 140–141; *CE,* October 21, 1937; *PC,* March 6, 1937.

48. *CE,* December 23, 1937.

49. Carol V. R. George, *God's Salesman: Norman Vincent Peale and the Power of Positive Thinking* (New York: Oxford University Press, 1993), 84–88, 135–136; Richard Weiss, *The American Myth of Success: From Horatio Alger to Norman Vincent Peale* (New York: Basic Books, 1969), 223–231.

50. *Salisbury Times,* July 3, 1953; May 28, 1960.

51. Fleming and Bruckel, *Who's Who,* 217, 363; *CE,* December 5, 1940.

52. *PC,* October 22, 1938.

53. *CE,* August 18, 1938; Everett, *Returning the Gaze,* 299–303.

54. *CE,* September 2, 1937.

55. *CE,* April 16, 1937.

56. Black, *Hollywood Censored,* 70–71, 170–171.

57. Darden Asbury Pyron, *Southern Daughter: The Life of Margaret Mitchell* (New York: HarperPerennial, 1991), 36, 218, 427, 435–437.

58. Margaret Mitchell, *Gone With the Wind* (New York: Warner Books, 1999, reprint of 1936 edition).

59. Pyron, *Southern Daughter,* 419, 457; *CE,* January 8, 1937.

60. *CE,* April 14, 1938.

61. *PC,* December 17, 1938.

62. *CE,* February 17, 1938.

63. *CE,* August 25, 1938.

64. *PC,* November 6, 1936; *New York Amsterdam News,* May 20, 1939.

7: SOMETHING DISTINCTIVE AND UNIQUE

1. Mitchell, *Gone With the Wind,* 22–23.

2. Ibid., 23, 37–38.

3. *CE,* February 17, 1938.

4. *CE,* February 17, 1938; David Thomson, *Showman: The Life of David O. Selznick* (New York: Alfred A. Knopf, 1992), 267–271; Roland Flamini, *Scarlett, Rhett, and a Cast of Thousands* (New York: Macmillan Publishing Co., 1975), 71–78.

5. *CE,* April 19, 1937; February 17, 1938; *CD,* February 27, 1937; letters, Frank Lloyd to Selznick, December 28, 1936, Sol Lesser to G. Cukor, November 10, 1936, Eleanor Roosevelt to Katherine Brown, April 22, 1937; memorandum, DOS to Ginsberg, December 12, 1938, box 178, folder 12, DOSC; Margaret Mitchell,

"Gone With the Wind" Letters, 1936–1949, Richard Harwell, ed. (New York: Macmillan Publishing Co., 1976), 84, 131–132, 163, 178.

6. *CD,* March 8, 1940; *CE,* February 17, 1938; letter, Bing Crosby to DOS January 15, 1937, box 178, folder 12, DOSC.

7. Thomson, *Showman,* 266–268; memorandum, DOS to Ginsberg, December 12, 1938, box 178, folder 12, DOSC.

8. Susan Myrick, *White Columns in Hollywood: Reports From the GWTW Sets* (Macon, Georgia: Mercer University Press, 1982), 49; memorandum, Selznick to Cukor, Arnow, Klune, Richards, January 14, 1939, box 178, folder 12, DOSC; Pryon, *Southern Daughter,* 189.

9. Memorandum, DOS to Cukor, Arnow, Klune, Richards, January 14, 1939, box 178, folder 12, DOSC; contract, Hattie McDaniel and Selznick International Pictures, January 27, 1939, box 927, folder 21, DOSC; Rose, *The Agency,* 80.

10. Fleming and Burckel, *Who's Who,* 217; James Goodwin interview, January 23, 2003.

11. David Platt, "The Klan Will Ride Again in *Gone With the Wind,*" *The Daily Worker,* October 29, 1936, 7; letter, Walter White to DOS, June 7, 1938, box 185, folder 16, DOSC; *CE,* August 19, 1937.

12. Kenneth Robert Janken, *White: The Biography of Walter White, Mr. NAACP* (New York: The New Press, 2003).

13. Letter, Walter. White to DOS, June 7, 1938, box 185, folder 16, DOSC.

14. Letters, DOS to Sidney Howard, June 20, 1938; Sidney Howard to Walter White, July 5, 1938, box 185, folder 16, DOSC; W. E. B. Du Bois, *Black Reconstruction in America* (Cleveland: World Publishing Company, 1964, reprint of 1935 ed.).

15. Letter, DOS to Sidney Howard, January 6, 1937, in *Memo From David O. Selznick,* Rudy Behlmer, ed. (New York: Viking Press, 1972), 147; letters, DOS to Walter White, June 20, July 18, 1938; Walter White to DOS, June 28, 1938; Roy Wilkins to DOS, July 25, 1938; DOS to Roy Wilkins, July 28, 1938, box 185, folder 16, DOSC.

16. Letter, DOS to Walter White, June 20, 1938, box 185, folder 16, DOSC; letter, DOS to Sidney Howard, January 6, 1937, in *Memo From,* 147.

17. Memorandum, DOS to Val Lewton, June 7, 1939, box 185, folder 16, DOSC; Cripps, *Slow,* 360; censor files, *Gone With the Wind,* Auster to Breen, September 29, 1937; Breen to DOS, October 14, 1937; memorandum for files, Auster, February 9, 1939, AMPAS; DOS to Howard, January 6, 1939, in *Memo From,* 147.

18. Letter, M. Rabwin to K. Brown, January 9, 1939, box 185, folder 16, DOSC; Thomas Cripps, "Winds of Change: *Gone With the Wind* and Racism as a National Issue" in *Recasting "Gone With the Wind" in American Culture,* Darden Asbury Pyron, ed. (Miami: University Presses of Florida, 1983), 141.

19. Letter, M. Rabwin to K. Brown, January 9, 1939; form letter, n.d., no author, box 185, folder 16, DOSC.

20. Memorandum, Katherine Brown to Marcella Rabwin, January 18, 1939, box 185, folder 16, DOSC.

21. *PC,* February 4, 1939.

22. Memorandum, Marcella Rabwin to Mr. Whitney, February 11, 1939; box 185, folder 16, DOSC.

23. *CE,* December 22, 1938; January 1, February 2, March 9, 1939.

24. Memorandum, DOS to Marcella Rabwin, March 13, 1939; Dorothy Carter to DOS, March 27, 1939; letter, DOS to Jock Whitney, February 10, 1939, box 185, folder 16, DOSC; censor files, *Gone With the Wind*, letters: Minnie L. Johnson, Julia West Hamilton, Caroline B. Day (Phillis Wheatley YWCA, Washington, D.C.) to DOS, June 10, 1939; Francis S. Harmon to Harriette F. Davis, February 16, 1939; Minnie L. Johnson, Arthur Waller to Will Hays, May 12, 1939, AMPAS.

25. Letter, DOS to Jock Whitney, February 10, 1939; unsent letter, DOS to Walter White, February 10, 1939; memorandum, Jock Whitney to DOS, February 15, 1939; Victor Shapiro to John Hay Whitney, February 17, 1939, box 185, folder 16, DOSC.

26. Telegram, Victor Shapiro to *PC,* February 13, 1939, box 185, folder 16, DOSC.

27. Memorandum, Whitney to DOS, February 14, 1939; Shapiro to DOS, March 20, 1939, box 185, folder 16, DOSC; *PC,* February 25, 1939.

28. *LAS,* March 2, 1939; Ruby Berkley Goodwin, "Cut Objectionable Words from *Gone With the Wind,*" *Atlanta World,* February 12, 1939, in Mitchell, *Letters,* 273; memorandum, Shapiro to DOS, February 9, 10, 1939; DOS to Whitney, February 14, 1939; Shapiro to DOS, March 20, 1939, box 185, folder 16, DOSC.

29. *PC,* May 6, 1939; form letter, n.d., no name, box 185, folder 16, DOSC.

30. Memorandum, DOS to Val Lewton, June 7, 1939, box 185, folder 16, DOSC; censor files, *Gone With the Wind,* memorandum for files, Auster, February 9, 1939, AMPAS; Thomson, *Showman,* 292, 316–319; Chrystopher J. Spicer, *Clark Gable: Biography, Filmography, Bibliography* (Jefferson, North Carolina: McFarland and Company, 2002), 176.

31. Memorandum, DOS to Val Lewton, June 7, 9, 1939; Val Lewton to DOS, June 9, 1939, box 185, folder 16, DOSC; Cynthia Marylee Molt, *"Gone With the Wind": A Complete Reference (Jefferson, North Carolina: McFarland and Company, 1990),* 278. For McDaniel's refusal to use the term, see Jackson, *Hattie,* 42.

32. *CD,* March 8, 1940.

33. Myrick, *White Columns,* 43; McDaniel, "What Hollywood," 310; *BAA,* January 9, 1943.

34. Hattie (Mammy) McDaniel, press manual, courtesy Selznick International Pictures, press relations department, Music Corporation of America, n.d., box 927, folder 17, DOSC; *CE,* March 9, 1939; *New York Amsterdam News,* March 18, 1939.

35. Myrick, *White Columns,* 229, 268–269, 275, 293.

36. Butterfly McQueen quoted in Daniel Mayer Selznick and L. Jeffrey Selznick, producers, *"Gone With the Wind": The Making of a Legend* (MGM/UA Studios, 1989); Myrick, *White Columns,* inside cover page, 83–84, 202; *CD,* April 8, 1939; March 8, 1940; Flamini, *Scarlett, Rhett,* 216; Cripps, *Slow,* 361–362.

37. Gary Crosby and Ross Firestone, *Going My Own Way* (Garden City, New York: Doubleday, 1983).

38. Later in her autobiography, Waters excuses studio heads for her exile and blames "certain agents." Most likely she was referring to Charles Butler, who still remained

a representative of Hollywood bosses. Ethel Waters with Charles Samuels, *His Eye Is on the Sparrow: An Autobiography of Ethel Waters* (Garden City, New York: Doubleday, 1951), 258, 261; Watkins, *Real,* 254–255; Jim Pines, *Blacks in Films: A Survey of Racial Themes and Images in Black American Films* (London: Studio Vista, 1975), 57; Duberman, *Robeson,* 260–261.

39. Evelyn Keyes, *Scarlett O'Hara's Younger Sister: My Lively Life In and Out of Hollywood* (Secaucus, New Jersey: Lyle Stuart Inc., 1977), 32; Cripps, "Winds of Change," 144; Madison Davis Lacy, producer, *Beyond Tara: The Extraordinary Life of Hattie McDaniel* (Firethorn Production, 2001).

40. Cripps, *Slow,* 362.

41. Myrick, *White Columns,* 268; Keyes, *Younger Sister,* 31; Thomson, *Showman,* 288–290; Spicer, *Gable,* 176–180.

42. Myrick, *White Columns,* 268, 275; Spicer, *Gable,* 180; Herb Bridges, *The Filming of "Gone With the Wind"* (Macon, Georgia: Mercer University Press, 1984), 163.

43. *New York Amsterdam News,* May 20, 1939; Judy Cameron and Paul J. Christman, *The Art of Making "Gone With the Wind"* (New York: Prentice Hall, 1989), 99.

44. Hattie (Mammy) McDaniel, press manual, courtesy Selznick International Pictures, press relations department, Music Corporation of America, n.d., box 927, folder 17, DOSC; Spicer, *Gable,* 176; *CE,* July 13, 1939; Lena Horne and Richard Schickel, *Lena* (New York: Limelight, 1986, reprint of 1965 edition), 133; Jackson, *Hattie,* 88.

45. Telegram DOS to Howard Dietz, November 29, 1939, box 178, folder 12; telegram DOS to Howard Dietz, November 30, 1939, box 185, folder 16; memorandum, Flagg to O'Shea and Schuessler, October 23, 1939, DOS to O'Shea, November 29, 1939, box 927, folder 21, DOSC; Molt, *Complete Reference,* 280–281; *CE,* November 30, 1939.

46. *CE,* November 2, 30, 1939; *CD,* February 24, 1940; *Motion Picture Herald,* December 16, 1939; Thomson, *Showman,* 322.

47. Thomson, *Showman,* 320–323; Spicer, *Gable,* 181–182; Herb Bridges, *"Gone With the Wind": The Three-Day Premiere in Atlanta* (Macon, Georgia: Mercer University Press, 1999), xiv–xv.

48. Memorandums, DOS to Howard Dietz, November 8, 1939, Howard Dietz to DOS, November 10, 1939, box 185, folder 16; telegram, Calvert to DIS, November 18, 1939, box 187, folder 2, DOSC.

49. Telegrams, DOS to Howard Dietz, November 30, 1939, Howard Dietz to DOS, November 10, 1939, December 1, 1939; letters, Katherine Brown to DOS, December 8, 1939, box 185, folder 16, November 29, 1939, box 178, folder 12; telegram, Howard Dietz to Katherine Brown, December 7, 1939, box 186, folder 10, DOSC.

50. Letter, Hattie McDaniel to DOS, December 11, 1939; telegram, O'Shea to Scanlon, December 10, 1939; memorandum, DOS to John Hay Whitney, December 12, 1939, box 927, folder 21, DOSC.

51. Bridges, *The Three-Day,* xiv, 49, 94; William Pratt, *Scarlett Fever* (New York: Macmillan and Company, 1977), 215–216.

52. Claybourne Carson, Ralph Luker, and Penny Russell, eds., *The Papers of Martin*

Luther King Jr.: Called to Serve, January 1929–June 1951, vol. I (Berkeley: University of California Press, 1992), 30, 81; Bridges, *The Three-Day,* 96.

53. Keyes, *Younger Sister,* 32; Pratt, *Scarlett Fever,* 215.

54. "Three Years of Hullabaloo" and "Atlanta's Most Brilliant Event" Harold Martin, reprinted in *"Gone With the Wind" as Book and Film,* Richard Harwell, ed. (Columbia: University of South Carolina Press, 1983), 144–149.

55. *Gone With the Wind* (MGM, 1939, rereleased Warner Home Video, 1999).

56. Bogle, *Toms,* 82–89.

57. *Gone With the Wind* (MGM, 1939).

58. Ibid.

59. *CE,* December 21, 1939.

60. *Denver Post,* April 15, 1941.

61. *LAT,* December 29, 1939; *Hollywood Reporter,* December 13, 1939; *Variety,* December 13, 1939; Pratt, *Scarlett Fever,* 220; telegrams, DOS to Howard Dietz, November 30, 1939, Howard Dietz to DOS December 1, 1939, box 185, folder 16, DOSC.

62. *NYT,* December 20, 1939; *Variety,* December 20, 1939.

63. *Hollywood Reporter,* December 13, 1939; *LAT,* December 30, 1939.

64. *CE,* December 28, 1939; *Nevada State Journal,* December 20, 1939.

65. *CE,* December 28, 1939; Melvin B. Tolson, *Caviar and Cabbage: Selected Columns by Melvin B. Tolson from the Washington Tribune* (Columbia: University of Missouri Press, 1982), 213; John D. Stevens, "Black Reaction to *Gone With the Wind,"* *The Journal of Popular Film and Television,* Fall 1973, 366–371.

66. *PC,* February 24, 1940.

67. Tolson, *Caviar and Cabbage,* 213–217.

68. *PC,* January 27, 1940; *CD,* January 6, 1940; Carlton Moss, "An Open Letter to Mr. Selznick," *The Daily Worker,* January 9, 1940, reprinted in *As Book and Film,* Harwell, ed., 156–159.

69. DOS to Jock Whitney, February 10, 1939, box 185, folder 16, DOSC; letters, William Kaplan to DOS, January 1, 1940, Howard Dietz to Walter White, January 16, 1940; memorandum unknown to Wilkins, January 31, 1940, reel 17, NAACP-GOF; *PC,* January 27, 1940.

70. Letters, White to Selznick, March 26, April 8, 1940, Selznick to White, April 2, 1940, reel 20, NAACP-GOF.

71. *PC,* quoted in Stevens, "Black Reaction," 367.

72. Moss, "An Open Letter."

73. *New York Amsterdam News,* May 20, 1939.

74. Memorandum, O'Shea to DOS, February 13, 1940, box 927, folder 20; letter, Bertha S. Black and Beulah S. Palmer to Selznick Studio, n.d., box 927, folder 21, DOSC; *CE,* February 1, 1940; *PC,* March 9, 1940; Burckel and Fleming, *Who's Who,* 217.

75. *LAT,* December 29, 1939.

76. DOS to Black and Palmer, February 3, 1940, box 927, folder 21, DOSC.

77. Robert Osbourne, *70 Years of the Oscar: The Official History of the Academy Awards* (New York: Abbeville Press, 1999), 62–65; *Variety,* February 28, 1940.

78. Osbourne, *70 Years,* 62, 70; Cripps, "Winds of Change," 147; *PC,* March 2, 1940; *CE,* March 7, 1940.

79. Carlton Jackson identifies McDaniel's escort as Wonderful Smith. However, the *CE* lists her date as F. P. Yober, and in an interview, Smith indicated that he escorted her not to this awards ceremony but to a later one. Photographs confirm this. *CE,* March 7, 1940; *LAT,* March 1, 1940; Judy Cameron and Paul J. Chrisman, *The Art of "Gone With the Wind": The Making of a Legend* (New York: Prentice Hall, 1989), 38–39; Jackson, *Hattie,* 51; Wonderful Smith interview.

80. For Bainter's introduction, see newsreel footage included in *Beyond Tara.*

81. For McDaniel's speech, see newsreel footage included in *Beyond Tara;* transcript to Selznick dated March 5, 1940, box 927, folder 21, DOSC; *Variety,* March 6, 1940; *CE,* March 7, 1940; Jackson, *Hattie,* 52; Paul Goodwin interview, February 5, 2005.

8: EIGHTEEN INCHES

1. *New York Amsterdam News,* June 8, 1940; *LAS,* March 7, 1940; *CE,* March 7, 1940; *PC,* March 9, 1940; *LAT,* March 1, 1940; *NYT,* March 1, 1940; *The Crisis,* April 1940, cover; *Edwardsville Intelligencer,* March 1, 1940.

2. *Variety,* March 6, 1940.

3. *PC,* April 20, 1940.

4. *LAS,* October 30, 1950; *CE,* January 18, 1940; James F. Tracy, "Revisiting a Polysemic Text: The African-American Press's Reception of *Gone With the Wind,*" *Mass Communication and Society,* vol. IV (2001), 419–436.

5. *PC,* April 27, June 15, 1940.

6. Memorandum, DOS to John Jay Whitney and L. V. Calvert, December 12, 1939, box 927, folder 21, DOSC.

7. Letter, DOS to William Paley, January 3, 1940, William Paley to DOS, January 19, 1940; Daniel O'Shea to DOS, January 8, 1940, box 927, folder 21, DOSC.

8. Memorandums, DOS to Val Lewton, March 5, 1940, Val Lewton to DOS, March 6, 1940, DOS to L.V. Calvert, March 28, letter, DOS to William Paley, February 3, 1940, box 927, folder 21, DOSC.

9. Memorandums, O'Shea to DOS, Scanlon, Birdwell, Klune, February 12, 1940, DOS to O'Shea, February 15, 1940, box 927, folder 21; memorandum, DOS to O'Shea, February 17, 1940, box 927, folder 20; telegrams, Val Lewton to DOS, October 21, 1940; DOS to O'Shea, October 22, 1940, box 927, folder 19, DOSC.

10. *Maryland* (Fox, 1940).

11. *Los Angeles Examiner,* June 29, 1940; *Hollywood Reporter,* July 1, 1940; *NYT,* July 13, 1940.

12. *CE,* August 1, July 11, 1940; January 2, 1941; *PC,* July 31, 1940.

13. Bette Davis, *The Lonely Life: An Autobiography* (New York: G. P. Putnam's and

Sons, 1962), 193–197; memorandum, Bloom to O'Shea, April 12, 1940, box 927, folder 17, DOSC; Gabler, *Empire,* 192.

14. Memorandums, O'Shea to DOS, December 8, 1939, box 927, folder 21; DOS to O'Shea, March 5, 1940, box 927, folder 20, DOSC.
15. Letter, DOS to L. V. Calvert, March 25, 1940; memorandum; DOS to L. V. Calvert, March 20, 1940, box 927, folder 2; telegrams, Calvert to O'Shea, March 11, 1940, DOS to O'Shea, March 28, 1940, box 927, folder 17, DOSC; Tracy, "Revisiting a Polysemic Text," 425.
16. Telegram, Meiklejohn to O'Shea, April 1, 1940, box 927, folder 17, DOSC.
17. *CE,* February 1, 1935; *New York Amsterdam News,* February 16, 1935; *CD,* n.d., in *Fredi Washington Papers, 1925–1979* (New Orleans: Amistad Research Center, 1979), reel 2.
18. Memorandums, DOS to Calvert, March 20, 1940, March 25, 1940, box 927, folder 21; telegrams, O'Shea to Klune, April 13, 1940, Ray and Richard to O'Shea, April 15, 1940; memorandum, Klune to O'Shea, April 18, 1940; letter, Bloom to O'Shea, May 13, 1940, box 927, folder 17, DOSC; Cripps, "Winds of Change," 146.
19. Memorandum, Klune to O'Shea, April 12, 1940, box 927, folder 17, DOSC.
20. Script, "Mammy's Meditations," box 927, folder 17, DOSC.
21. Script, "Mammy's Meditations"; memorandum, Klune to DOS, April 18, 1940; box 927, folder 17, DOSC.
22. Script, "Mammy's Meditations," box 927, folder 17, DOSC.
23. Ibid.
24. Ibid.
25. *CE,* November 2, 1939; memorandum, Klune to DOS, April 18, 1940, box 927, folder 17; *New York Amsterdam News,* April 27, 1940; Victoria Sturtevant, " 'But Things Is Changin' Nowadays an' Mammy's Gettin' Bored': Hattie McDaniel and the Culture of Dissemblance," *The Velvet Light Trap,* Fall 1999, 68–79.
26. Memorandum, Klune to O'Shea, April 12, 1940, DOS to O'Shea, April 24, 1940, box 927, folder 17, DOSC; *Nothing Sacred* (Selznick Pictures International, 1937, rereleased VCI Home Video, 1995).
27. Letter, O'Shea to Hattie McDaniel, April 25, 1940, box 927, folder 17, DOSC; *Variety,* May 1, 1940.
28. *CD,* April 27, 1940, May 4, 11, 1940; *Variety,* May 1, 1940.
29. *BAA,* May 18, June 8, 1940, *CE,* May 16, 23, 1940; letters, O'Shea to Phil Bloom, May 4, 1940, Phil Bloom to O'Shea, May 10, 1940; telegram, May 17, 1940, O'Shea to Hattie McDaniel, May 17, 1940, box 927, folder 17, DOSC; bill for retakes, July 24, 1940, file 287, folder 4151, Fox Studio legal files, collection 95, Arts Library Special Collections, University Research Library, UCLA.
30. *BAA,* June 8, 1940.
31. *BAA,* March 9, 1940; letters, Bloom to O'Shea, May 10, 13, 1940, Bloom to Haley, June 3, 1940, O'Shea to Bloom, May 4, June 4, 1940, box 927, folder 17, DOSC; *CE,* August 1, 1940, Cripps, "Winds of Change," 146–147.
32. *New York Amsterdam News,* June 8, 1940.

33. Letter, Bloom to O'Shea, May 13, 1940, box 927, folder 17, DOSC; *Variety,* June 5, 12, 19, 1940.

34. *BAA,* July 13, 1940; letter, Bloom to O'Shea, May 13, 1940; contracts, Riverside Theatre, Milwaukee, June 11, 1940, RKO Palace, Cleveland, Ohio, June 18, 1940, State-Lake Theater, Chicago, Illinois, June 28, 1940, box 927, folder 17, DOSC; *CD,* May 18, 1940.

35. Script, *Wings Over Jordan,* July 7, 1940, box 927, folder 20, DOSC; *Variety,* August 10, 1940; Dunning, *On the Air,* 74.

36. *CE,* July 4, 18, 1940; telegram, Klune to O'Shea, June 18, 1940, box 927, folder 21, DOSC.

37. Script, *Wings Over Jordon,* DOSC.

38. Letters, Bloom to O'Shea, May 13, 1940, Bloom to Haley, June 3, 1940, DOSC; *Variety,* June 26, July 10, 17, 1940.

39. Letter, Claude A. Barnett to DOS, June 18, 1940; memorandum, DOS to O'Shea, June 24, 1940; letter, O'Shea to Barnett, June 27, 1940, box 927, folder 20, DOSC.

40. Rampersad, *Langston Hughes,* 386–388; letter, Barnett to O'Shea, July 1, 1940; telegrams, O'Shea to Barnett, July 11, 1940, Barnett to O'Shea, July 15, 1940, box 927, folder 20, DOSC; *CE,* May 16, July 18, 1940.

41. Telegram, McDaniel to O'Shea, July 17, 1940, box 927, folder 21, DOSC.

42. *CE,* August 1, 1940; *BAA,* August 3, 1940; prospectus, "Hattie and Hambone Series," September 9, 1940, box 927, folder 19 DOSC; Maurice Horn, ed. *The World Encyclopedia of Cartoons* (New York: Chelsea House, 1980).

43. Bob Thomas, *Selznick* (Garden City, New York: Doubleday and Company, Inc., 1970), 248–250; Leonard J. Leff, *Selznick and Hitchcock: The Rich and Strange Collaboration of Alfred Hitchcock and David O. Selznick in Hollywood* (New York: Weidenfeld and Nicolson, 1987), 119, 266; Schatz, *Genius,* 281–282.

44. Telegrams, O'Shea to DOS, October 16, 1940, Kay [Brown] to O'Shea, October 17, 1940, Brown to O'Shea, October 18, 1940, box 927, folder 19, DOSC.

45. Telegrams, Flagg to O'Shea, November 5, 1940, O'Shea to Flagg, November 8, 1940, box 927, folder 21; "Menu and Recipes for Thanksgiving Dinner," box 927, folder 19, DOSC.

46. Telegrams, Lewton to DOS, October 21, 1940, O'Shea to DOS, October 21, 1940, DOS to O'Shea, October 22, 28, 1940, box 927, folder 19, DOSC.

47. Telegrams, DOS to O'Shea, October 28, 1940, O'Shea to DOS, November 1, 1940; Agreement, Selznick International Pictures and Warner Bros. Pictures, December 13, 1940, box 927, folder 19, DOSC.

48. Daily production report, December 23, 1940; memorandums, Mattison to T.C. Wright, November 29, 1940, Jack Warner to Hal Wallis, November 18, 1940; *The Great Lie,* Warner Bros. Archives, production files, School of Cinema-Television, USC; *CE,* December 5, 1940, January 9, 1941.

49. Memorandum, Mattison to Wright, November 2, 1940; *The Great Lie,* Warner Bros. Archives, production files, School of Cinema-Television, USC.

50. *Variety,* April 4, 1941; *Hollywood Reporter,* April 4, 1941; *CE,* January 23, 1941,

March 27, 1941; *The Great Lie* (Warner Bros., 1941, rereleased MGM/UA Home Video, 1990); memorandum, from research department to Henry Blanke, November 1, 1940; *The Great Lie,* Warner Bros. Archives, production files, School of Cinema-Television, USC.

51. Anthony Holden, *Behind the Oscar: The Secret History of the Academy Awards* (New York: Simon and Schuster, 1993), 138–139; *CE,* January 2, 1941.

52. Neal Gabler, *An Empire of Their Own: How the Jews Invented Hollywood* (New York: Anchor Books, 1988), 190–198; Schatz, *Genius of the System,* 311–315.

53. Gabler, *An Empire,* 191–194.

54. Cast possibilities, *In This Our Life,* n.d.; memorandum, Jack Warner to Hal Wallis, October 25, 1941; *In This Our Life,* Warner Bros. Archives, production files, School of Cinema-Television, USC; *Hollywood Reporter,* May 6, 1941; Gabler, *An Empire,* 317–318; *Affectionately Yours* (Warner Bros., 1941).

55. *CE,* March 27, May 8, 1941; *CS,* March 28, 1941.

56. *CE,* March 27, 1941.

57. *CE,* March 27, 1941; *Times,* March 22, 1941, HMcD BF, AMPAS.

58. *CD,* March 29, April 15, 1941; *BAA,* April 5, 1941; *New York Amsterdam News,* April 5, 1941.

59. *Denver Post,* April 15, 1941; *Rocky Mountain News,* April 14, 1941; *CS,* April 18, 1941; *DS,* April 26, 1941.

60. *Denver Post,* April 15, 1941; *Times,* March 22, 1941, HMcD BF, AMPAS; *CE,* March 27, 1941; *Rocky Mountain News,* April 14, 1941, October 18, 1992; *CS,* April 18, 1941; *DS,* April 26, 1941.

61. Letters, Simmons to McDaniel, January 5, 1945, McDaniel-Crawford to Simmons, May 13, 1941, HUM 2.8, box 8, Roscoe Conkling Simmons Papers, University Archives, Pusey Library, Harvard University; *CE,* May 8, 1941.

62. *CE,* May 8, 1941.

63. *Denver Post,* April 15, 1941; *CE,* May 8, 1941.

64. Letter, McDaniel-Crawford to Simmons, May 13, 1941, HUM 2.8, box 8, Roscoe Conkling Simmons Papers, University Archives, Pusey Library, Harvard University.

65. *CE,* May 8, June 20, 27, 1941.

66. Memorandums, DOS to O'Shea, June 13, 1941, O'Shea to DOS, July 1, 1941, box 927, folder 19, DOSC; Jack Warner to Hal Wallis, October 25, 1941, *In This Our Life,* Warner Bros. Archives, production files, School of Cinema-Television, USC; *They Died With Their Boots On* (Warner Bros. Studio, 1941, rereleased MGM/UA Home Video, 1997).

67. Memorandum, Warner to Wallis, October 25, 1941, *In This Our Life,* Warner Bros. Archives, production files, School of Cinema-Television, USC.

68. *In This Our Life* (Warner Bros. Studio, 1942, rereleased MGM/UA Home Video, 1990).

69. Memorandums, n.a., November 26, 1941, Trilling to Wright, November 24, 1941, *In This Our Life,* Warner Bros. Archives, production files, School of Cinema-Television, USC; *Variety,* December 10, 17, 1941; *CE,* December 11, 1941.

9: Quarrel

1. Patrick Washburn, "The Pittsburgh Courier's Double V Campaign in 1942," *American Journalism,* 1986, vol. III, no. 2, 73–86; Franklin, *From Slavery to Freedom,* 385–406.

2. Clayton R. Koppes and Gregory D. Black, "Blacks, Loyalty, and Motion Picture Propaganda in World War II," *Journal of American History,* September 1986, 383–406.

3. *PC,* May 30, 1942; *New York Amsterdam News,* May 23, 1942; *CE,* May 7, June 4, 1942.

4. *CE,* May 14, 28, June 4, 25, July 2, August 6, 20, November 5, 1942; February 3, March 3, April 1, May 13, June 3, 1943; *Chicago Daily Tribune,* December 14, 1947.

5. Letter, Hattie McDaniel to Commanding Officer of the United States, War Department, July 26, 1945, NAACP-PP; *PC,* August 22, 1942; Jackson, *Hattie,* photo section; *CE,* June 3, 10, 1943; October 30, November 6, 1952; *BAA,* November 22, 1952.

6. *NYT,* October 3, 1946; *DS,* June 20, 1942; *Chicago Daily Tribune,* December 14, 1947; *CE,* January 29, 1942; Paul Goodwin interview, February 5, 2005.

7. Bogle, *Dandridge,* 96; *Chicago Daily Tribune,* December 14, 1947; *DS,* June 20, 27, 1942; *CE,* February 24, 1943; Paul Goodwin interview, February 12, 2003, February 5, 2005.

8. Wonderful Smith interview, September 23, 2003; Paul Goodwin interview; February 12, 2003, February 5, 2005.

9. Wonderful Smith interview, September 23, 2003; *CE,* October 30, 1952.

10. *George Washington Slept Here* (Warner Bros., 1942, rereleased MGM/UA Home Video, 1992); *The Male Animal* (Warner Bros., 1942, rereleased MGM/UA Home Video, 1995); *BAA,* January 9, 1943.

11. Janken, *White,* 252–258; letters, White to Selznick, April 8, 1940, Inglis to White, October 14, 1941, White to "Irene and David," July 28, 1942, White to Embree, October 30, 1942, reel 20; White to Hall, April 11, 1940, White to Johnson, April 13, 1940, reel 15, NAACP-GOF.

12. Letters, Hastie to White, February 7, 1942; Eleanor Roosevelt to "Whom It May Concern," February 17, 1942, White to Hall, April 11, 1940, reel 15, White to Furst, June 9, 1943, reel 17, NAACP-GOF.

13. Steve Neal, *Dark Horse: A Biography of Wendell Willkie* (Garden City, New York: Doubleday, 1984), 213; Janken, *White,* 267; Walter White, *A Man Called White: The Autobiography of Walter White* (New York: The Viking Press, 1948), 199–200.

14. *CE,* February 19, 1942; Janken, *White,* 267–268, 272.

15. Letter; Walter White to Sara Boynoff, March 12, 1942, reel 15, NAACP-GOF.

16. Ibid.

17. Letters, Boynoff to White, March 2, 16, 1942, White to Boynoff, April 1, 13, 1942; reel 15, NAACP-GOF; Jankens, *White,* 267; Leonard Mosley, *Zanuck: The Rise and Fall of Hollywood's Last Tycoon* (Little, Brown, and Company, 1984), 212–213.

18. Almena Davis, "How About This?", undated, reel 20, NAACP-GOF.

19. Letters, Walter White to Almena Davis, April 28, 1942; Davis to White, May 5, 1942, reel 20, NAACP-GOF.

20. Letter, White to Hall, April 11, 1940, reel 15, NAACP-GOF; Bruce Tyler, *Harlem to Hollywood: The Struggle for Racial and Cultural Democracy* (New York: Garland Publishing, 1992), 65; Janken, *White,* 269.

21. *PC,* July 25, August 8, 1942; White, *A Man,* 201.

22. White, *A Man,* 201; *PC,* August 8, 29, 1942; Tyler, *Harlem,* 60–61; "Wendell Willkie Luncheon," July 18, 1942, reel 15, NAACP-GOF.

23. Janken, *White,* 268–269, photo section; Tyler, *Harlem,* 60; *PC,* July 25, August 12, 1942; *BAA,* January 9, 1943; *CE,* January 29, 1942.

24. *PC,* July 25, 1942; Tyler, *Harlem,* 60.

25. Horne and Schickel, *Lena,* 134–137; letters, Walter White to Kyle Crichton, April 6, 1942, reel 20, Phillip Carter to Roy Willkins, January 25, 1943, reel 15, Walter White to Sara Boynoff, April 22, 1942, reel 15, NAACP-GOF; Janken, *White,* 269; *BAA,* January 9, 1943.

26. Zanuck circulated numerous copies of his letters to various Hollywood insiders. For a sample, see letter, Zanuck to Mannix, July 21, 1942, reel 15, press release, NAACP, August 21, 1942, reel 18, NAACP-GOF; *PC,* August 29, 1942; Janken, *White,* 269.

27. *PC,* August 12, 1942.

28. *BAA,* January 9, 1943; *PC,* August 8, 1942.

29. Thomas Cripps, *Making Movies Black: The Hollywood Message Movie from World War II to the Civil Rights Era* (New York: Oxford University Press, 1993), 32–34; *PC,* August 29, 1942.

30. P. L. Prattis to Warner Bros. Studio, June 6, 1942, Edith Peacock McDougald to Warner Bros., August 10, 1942, Private James Samuels to Warner Bros., June 6, 1942, *In This Our Life,* Warner Bros. Archives, production files, School of Cinema-Television, USC; *NYT,* May 8, 1942.

31. Letters, Walter White to Harry Warner, May 25, 1942; Olivia de Havilland to Walter White, November 21, 1942, reel 18, NAACP-GOF.

32. Censor files, *In This Our Life,* Alonzo Richardson to Joseph Breen, June 6, 1942, Breen to Richardson, June 10, 1942, AMPAS.

33. Peter Suskind, clipping undated, reel 18; letters, Walter White to Joseph Harzen, July 10, 1942, Harzen to White, July 13, 1942, reel 20, NAACP-GOF; *PC* July 11, August 8, 1942.

34. Press releases, n.d., *In This Our Life,* Warner Bros. Archives, production files, School of Cinema-Television, USC.

35. Letters, Trilling to O'Shea, July 27, 1942, O'Shea to Trilling, July 29, 1942, box 927, folder 19, DOSC; *CE,* April 22, 1943.

36. *People's Voice,* September 19, 1942; Stephen Vaughn, "Ronald Reagan and the Struggle for Black Dignity," *Journal of African-American History,* Winter 2002, 83–97; *PC,* August 29, 1942; *CE,* May 4, 1944.

37. Horne and Schickel, *Lena,* 136–138.

38. Bogle, *Dandridge,* 96–97; Horne, *Lena,* 138; Gail Lumet Buckley, *The Hornes: An American Family* (New York: Alfred A. Knopf, 1988), 158.

39. *PC,* October 10, 17, 1942; Wonderful Smith interview, *Daily News,* December 20, 1945, HMcD BF, AMPAS; *CE,* June 10, 1943; death record: Lena Gary, October 3, 1942, State of California, *California Death Index 1940–1997* (Sacramento: State of California Department of Health Services).

40. Letter, Walter White to Edwin Embree, October 30, 1942, reel 20, NAACP-GOF.

41. Letter, Norman O. Houston to Walter White, September 16, 1943, reel 20, NAACP-GOF; *People's Voice,* September 19, 1942.

42. Letter, Hughes to White, September 11, 1942, reel 21, NAACP-GOF; letter, Anonymous to White, February 12, 1946, NAACP-PP.

43. Hughes to White, September 11, 1942, reel 21, NAACP-GOF; Jackson, *Hattie,* 119.

44. Rowe denied he was on the payroll to promote Hollywood and black players and insisted that he was acting in an advisory capacity to MGM. Letters, Phillip Carter to Roy Wilkins, December 23, 1942, February 3, 9, 1943, Wilkins to Carter, January 12, 1943, reel 15, NAACP-GOF.

45. Letter, Walter White to Neil [Scott], October 17, 1944, reel 20, NAACP-GOF.

46. Letter, Walter White to Peter Furst, June 9, 1943, reel 17, NAACP-GOF; *CD,* May 8, 1943.

47. Vaughn, "Reagan," 88.

48. Cripps, *Making,* 74–80, 102–125, 151–161.

49. Horne and Schickel, *Lena,* 135; Cripps, *Making,* 74–80.

50. *PC,* October 17, 1942; *CE,* January 8, 1943; *Variety,* March 31, 1943; *American Film Institute Catalog, Personal Name Index, Feature Films, 1941–1950* (Berkeley: University of California Press, 1999), 438.

51. *CE,* May 4, 1944; letter, James Jackson to Walter White, April 6, 1945, reel 20, NAACP-GOF.

52. *Since You Went Away* (Selznick International Pictures, 1942, rereleased Anchor Bay Entertainment, 2000).

53. *LAS,* October 30, 1952; *CE,* November 6, 1952; "The Baby Photo Contest," *More of the Best of Amos 'n' Andy* (Peaceful Productions Compact Disc, 1990); *The Eddie Cantor Show,* December 23, 1942 (original cast cassette tapes, 1994); Dunning, *On the Air,* 224; Leora M. Sies and Luther F. Sies, *The Encyclopedia of Women in Radio, 1920–1960* (Jefferson, North Carolina: McFarland, 2003), 27; *Lima News,* October 7, 1942.

54. *CE,* May 4, April 20, 1944.

55. *BAA,* April 29, 1944; *CE* May 4, 1944.

56. There are no existing copies of the *LAS* for 1944; however, the *CE* reported on the *Sentinel*'s story. *BAA* April 29, 1944; *CE,* May 4, 1944.

57. *CE,* May 4, 1944.

10: OBSOLETE?

1. *Los Angeles Examiner,* May 25, 1944; *BAA,* September 23, 1944; *CE,* May 25, June 15, October 5, 1944.
2. *CE,* December 28, 1944; *BAA,* September 23, 1944; Jackson, *Hattie,* 87–88.
3. *Independent Record,* September 19, 1944.
4. Jackson, *Hattie,* 88; Paul Goodwin interview, February 5, 2005.
5. *CE,* January 4, February 8, 1945.
6. Letter, McDaniel to Commander, July 26, 1945, NAACP-PP.
7. Ibid.
8. Letter, Leslie Perry to Walter White, August 2, 1945, NAACP-PP; *PC,* February 2, 1946; *LAT,* February 11, 1940; James Goodwin interview, February 19, 23, 2005.
9. *Daily News,* December 20, 1945.
10. *New York Amsterdam News,* May 31, 1941; *CE,* June 15, 1944.
11. *CE,* January 29, April 9, 1942; March 24, 1943; *NYT,* October 3, 1946; *LAS,* June 13, 1946; "California Judge Knocks Out Restrictive Covenant as Unconstitutional," *This Month in Building News,* n.d., NAACP-RC.
12. *CE,* March 24, 1943; December 13, 1945; *NYT,* October 3, 1946.
13. *CE,* April 27, 1944; November 13, 1952; letters, Loren Miller to Thurgood Marshall, December 6, 1945, Clifford Forster to A. Wirin, December 11, 1945, NAACP-RC; Loren Miller, "Uncle Tom in Hollywood," 329, 336; "Hollywood's New Negro Films," *The Crisis,* January 1938, 8–9; Rampersad, *The Life,* 65–66, 99, 120; *Fairchild v. Raines,* L.A. No. 18735, Supreme Court of California, August 31, 1944; Clement E. Vose, *Caucasians Only: The Supreme Court, the NAACP, and the Restrictive Covenant Cases* (Berkeley: University of California Press, 1959), 26.
14. Stephen Grant Meyer, *As Long as They Don't Move Next Door: Segregation and Racial Conflict in American Neighborhoods* (New York: Roman and Littlefield Publishers, 2000), 76; *CE,* June 15, 1944, December 13, 1945; *LAS,* June 13, 1946.
15. *LAT,* December 6, 7, 1945; letter, Miller to Marshall, December 6, 12, 1945, NAACP-RC; *NYT,* October 3, 1946.
16. *CE,* December 13, 20, 1945; *NYT,* October 3, 1946; letter, Marshall to Miller, December 11, 1945; "California Judge Knocks Out Restrictive Covenant as Unconstitutional," NAACP-RC.
17. *Daily News,* December 20, 1945; *LAT,* December 20, 1945.
18. *Rocky Mountain News,* April 11, 1948; *CE,* December 20, 1945; *LAS,* January 17, May 2, 1946, May 2, 1946; Wonderful Smith interview, September 23, 2003.
19. *BAA,* January 26, 1946; *CE,* October 29, 1942; January 17, 24, 1946; *CD,* March 29, 1941; July 17, 1943; *American Film Institute Catalog, Personal Name Index, 1941–1950,* 438; death record, Etta G. McDaniel Spaulding, January 13, 1946, *California Death Index,* State of California, Department of Health Services.
20. Telegram, Lena Horne to Walter White, June 15, 1943, reel 17; letters, Houston to White, September 16, 1943, reel 20, William Grant Still to Walter White, June 2, 1943, reel 21, NAACP-GOF.
21. White, *A Man,* 202–205.

22. Letter, Hattie McDaniel to Atty. T. L. Griffith, January 20, 1946, NAACP-PP; *PC,* February 2, 1946.

23. Letter, McDaniel to Griffith, January 20, 1946, NAACP-PP.

24. Minutes of luncheon meeting, October 17, 1945; letter, White to "Roy and office," January 25, 1946, reel 17, NAACP-GOF.

25. *PC,* February 2, 1946; *New York Amsterdam News,* February 2, 1946; letter, White to "Roy and office," January 25, 1946; minutes of luncheon meeting, October 17, 1945, reel 17, NAACP-GOF; Horne, *Lena,* 137.

26. Letters, White to "Roy and office," January 25, 1946; Walter White to Sterling Brown, February 20, 1946, reel 17, NAACP-GOF.

27. *CD,* February 23, 1946; *PC,* February 9, 1946; *New York Amsterdam News,* February 2, 1946.

28. *People's Voice,* February 9, 1946.

29. *PC,* March 2, February 23, 1946; letter, Alfred A. Duckett to Walter White, February 23, 1946, reel 20, NAACP-GOF.

30. Cripps, *Making,* 174–214.

31. *Hollywood Reporter,* June 4, 1946, October 16, 1946; *American Film Institute Catalog, Personal Name Index, 1941–1950,* 438.

32. *Song of the South* (Disney Studios, 1946).

33. Letters, Walter White to Walt Disney, July 20, August 1, 1944; Disney to White, July 25, 1944, reel 21; NAACP-GOF.

34. Censor files, *Song of the South*; letter, Joseph Breen to Walt Disney, December 13, 1944; analysis sheets, n.d., AMPAS.

35. Censor files, *Song of the South*; memorandums FSH to JIB, July 31, 1944, Breen to Disney, August 1, 1944, AMPAS.

36. *Song of the South.*

37. Marc Eliot, *Walt Disney: Hollywood's Dark Prince* (New York: HarperCollins, 1994), 198; letter, June Blythe to Walter White, September 5, 1946, reel 21, NAACP-GOF.

38. Letter, Richard Condon to Walter White, August 13, 1946, reel 21, NAACP-GOF.

39. *Song of the South*; *BAA,* January 9, 1943.

40. *Variety,* October 29, 1946; Eliot, *Dark Prince,* 215.

41. *Time,* November 18, 1946; James Baskette Clippings, n.s., n.d., George P. Johnson Collection, special collections, University Research Library, UCLA; *Variety,* November 6, 1946.

42. *NYT,* December 8, 1946.

43. Letter, Hope Spingarn to Walter White, November 23, 1946, reel 21, NAACP-GOF; James Baskette Clippings, n.s., n.d., George P. Johnson Collection, special collections, University Research Library, UCLA; *CE,* December 18, 1946; *BAA,* November 8, 1947.

44. Telegram, Walter White to [major press outlets], November 27, 1946, reel 21, NAACP-GOF.

45. *Chicago Daily Tribune,* December 14, 1947.

46. *CE,* September 11, 1947.

47. Mitchell, "Definitive Matriarch."
48. Letter, Dr. Stanley Bates to Walter White, August 19, 1947, reel 20, NAACP-GOF.
49. McDaniel, "What Hollywood."
50. *Chicago Daily Tribune,* December 14, 1947.
51. *CE,* December 18, 1947; James Goodwin interview, January 23, February 5, 2003; Fleming and Burckel, *Who's Who in Colored America,* 217.
52. McDaniel, "What Hollywood"; *People's World,* August 19, 1947.
53. Letter, Marshall to Wilkins, October 30, 1947, reel 15, NAACP-GOF; Cripps, *Making,* 181–186; Otto Friedrich, *City of Nets: A Portrait of Hollywood in the 1940s* (Berkeley: University of California Press, 1986), 298–337.
54. "Actors Group," n.s, n.d., Sam McDaniel scrapbook, HMcDC, AMPAS; *BAA,* November 8, 1947; *CE,* September 11, 1947; *Chicago Daily Tribune,* December 14, 1947; Cripps, *Making,* 253; Charlotta Bass, *Forty Years: Memoirs From the Pages of a Newspaper* (Los Angeles: Charlotta A. Bass, 1960), 182–186.
55. "Beulah Is Back," CBS programming publicity release, November 14, 1947, NAACP-PP; *The Call,* March 25, 1949; Sies and Sies, *Women in Radio,* 26; Dunning, *On the Air,* 83–84; *Bridgeport Post,* November 17, 1942.
56. *Dixon Evening Telegraph,* January 6, 1949; "Merry Xmas," n.d., Roscoe Conkling Simmons Papers, University Archives, Pusey Library, Harvard University; "Hattie Throws a Party," 92–97; *LAS,* December 7, 1950; "Movies," *Our World,* March 1948, 45.
57. *The Call,* March 25, 1949; *Variety,* October 28, 1952; "Hattie Throws a Party," 92–97.
58. Dunning, *On the Air,* 84; Gerald Nachman, *Raised on Radio* (New York: Pantheon, 1998), 238–241; *The Beulah Show,* July 16, 1947, (Old Time Radio Today compact disc, 2004).
59. *The Beulah Show,* October 26, 28, 1948, cassette transcriptions, HMcDC, AMPAS; *The Beulah Show,* June 29, 1950 (Old Time Radio Today compact disc, 2004); *NYT,* March 7, 1948.
60. *The Beulah Show,* June 30, 1950 (Old Time Radio Today compact disc, 2004); *The Beulah Show,* October 26, 28, 1948, cassette transcriptions, HMcDC, AMPAS; "Beulah Is Back," NAACP-PP; *Portland Herald Press,* April 24, 1950; "Hattie Throws a Party," 92–97; Nachman, *Raised on Radio,* 238–241; *BAA,* November 27, 1947; February 21, 1948.
61. Letter, Andre W. Difoe to Walter White, n.d., NAACP-PP; *The Call,* March 25, 1949; *New York Amsterdam News,* November 19, 1949; "Movies," *Our World,* March 1948, 45; "Hattie Throws a Party," 92–97; *LAS,* December 7, 1950.
62. *The Call,* March 25, 1949; letter, A Firm Believer in the N.A.A.C.P. to Walter White, December 14, 1947, NAACP-PP; *LAS,* April 25, 1946; May 16, 1946; Fleming and Burckel, *Who's Who,* 363.
63. Fay Jackson, "Psychoanalyzing Willie Best," Willie Best clippings, n.s., n.d., George P. Johnson Collection, special collections, University Research Library, UCLA.
64. "Movies," *Our World,* March 1948, 45.
65. "Hattie Throws a Party," 92–97, Harrison B. Summers, ed. A *Thirty Year History of*

Radio Programs Carried on National Radio Networks in the United States, 1926–1956 (New York: Arno Press and the *New York Times*, 1971), 159, 167, 177, 187.

66. Meyer, *As Long*, 92–95; Vose, *Caucasians Only*, 177–210.

67. "Hattie Gets Hitched," *Our World*, September 1949, 48–50; *LAS*, October 19, 1950.

68. "Hattie Gets Hitched," 48–50; Louella Parsons, "Beulah to Wed Today," n.d., HMcD, BF, AMPAS.

69. Sam McDaniel was a dog lover and raised and trained Dalmatians. *LAT*, December 6, 1950; *Los Angeles Examiner*, October 26, 1949; "Universal Studios Biography," Sam McDaniel, BF, AMPAS.

70. *LAT*, December 6, 1950.

71. *Los Angeles Examiner*, October 26, December 6, 1950; Wonderful Smith interview, September 23, 2003.

72. *LAT*, December 6, 1950; *LAS*, October 27, 1949.

73. *Los Angeles Examiner*, October 26, 1949; *CE*, October 19, 1950; "Hattie Gets Hitched," 48–50; Jackson, *Hattie*, 134.

74. The rumors regarding McDaniel's sexuality were never substantiated beyond Carlton Moss's recollection that they began after actress Tallulah Bankhead, whose sexual exploits were well known, remarked: "Hattie McDaniel is my best friend." Jackson, *Hattie*, 134–135; Bogle, *Dandridge*, 159.

75. *Los Angeles Examiner*, December 6, 1950; *LAT*, December 6, 1950.

11: MY OWN LIFE EVEN SURPRISES ME

1. *LAT*, December 6, 1950; *Los Angeles Examiner*, December 6, 1950.

2. "Hattie Throws a Party," 92–97; *American Film Institute Catalogue of Motion Pictures Produced in The United States: Personal Name Index Feature Films, 1941–1950* (Berkeley: University of California Press, 1999), 438.

3. *Dixon Evening Telegraph*, December 31, 1948; Gayelord Hauser, *Look Younger and Live Longer* (New York: Farrar, Strauss, and Young, 1951); Bergreen, *Louis Armstrong*, 4, 448; *Frederick Post*, November 27, 1939.

4. *Salisbury Times*, May 28, 1960; Last will and testament of Hattie McDaniel, December 10, 1951, Los Angeles, California; Mary Baker Eddy, *Science and Health: With Key to the Scriptures* (Boston: Christian Science Board of Directors, 1994); Fleming and Burckel, *Who's Who*, 363; Watts, *God, Harlem U.S.A*, 22–23; Catherine Tumber, *American Feminism and the Birth of New Age Spirituality* (New York: Rowman and Littlefield, 2002), 19–23, 43–46; James Goodwin interview, January 23, 2003.

5. Wonderful Smith interview, September 23, 2003; *Village Voice*, August 28, 1978; Jackson, *Hattie*, 133.

6. *Dixon Evening Telegraph*, May 24, 1950; *CE*, May 11, 1950; Harris, *Blues Who's Who*, 176.

7. *BAA*, May 27, 1950.

8. *BAA*, May 27, 1950; Wonderful Smith interview, September 23, 2003; *Village Voice*, August 28, 1978; *CE*, October 30, 1952; Mitchell, "Definitive Matriarch."

9. *Ed Wynn Show* (CBS, fall 1949).

10. Watkins, *Real*, 299–302.

11. *East Liverpool Review*, April 30, 1951; *CD*, April 22, October 7, November 5, 23, 1950; *BAA*, August 5, October 21, 1950; Jackson, *Hattie*, 134–138; *Village Voice*, August 28, 1978; Haskins and Mitgang, *Bojangles*, 282; *Dixon Evening Telegraph*, February 20, 1951.

12. *Beulah* (ABC, fall 1951, rereleased on Classic TV, Black Artists of the Silver Screen, vol. I, n.d.).

13. *Dixon Evening Telegraph*, August 7, 1951.

14. Wonderful Smith interview, September 23, 2003; *Mount Pleasant News*, August 28, 1951; *Mansfield News Journal*, August 28, 1951; *Council Bluffs Nonpareil*, September 16, 1951; *Union Bulletin*, January 6, 1952; *The Clearfield Progress*, April 1, 1952; clippings, n.s., n.d., Sam McDaniel scrapbook, HMcDC, AMPAS.

15. "Verse Gives Key to Hattie McDaniel's Life," n.s., n.d., HMcD, BF, AMPAS; *Dixon Evening Telegraph*, November 20, 1951; *Los Angeles Daily News*, November 1, 1951; *Citizen News*, November 5, 1951.

16. Last will, Hattie McDaniel; *Humbolt Standard*, January 21, 1952; "Hattie McDaniel's Academy Award Is Lost," *Jet*, April 13, 1998, 33.

17. Last will, Hattie McDaniel.

18. *Humbolt Standard*, January 21, April 10, 1952; *Williamsport Gazette and Bulletin*, April 23, 1952; death certificate, Hattie McDaniel, October 26, 1952, Los Angeles, California.

19. Vaughn, "Black Dignity," 90.

20. *Dixon Evening Telegraph*, September 26, 1952; *Helena Independent Record*, July 9, 1952; Jackson, *Hattie*, 150.

21. *LAS*, October 30, 1952; clipping, n.s., n.d., Sam McDaniel scrapbook, HMcDC, AMPAS; *Humbolt Standard*, October 23, 1952; death certificate, Hattie McDaniel.

22. *LAT*, October 27, 1952.

23. Wonderful Smith interview, September 23, 2003; *NYT*, October 27, 1951; *LAT*, October 27, 1952; *CE*, October 30, 1952; *LAS*, October 30, 1952.

24. Telegrams, John Dales to Sam McDaniel, October 31, 1952, Anna Roosevelt to Sam McDaniel, October 30, 1952, Sam McDaniel scrapbook, HMcDC, AMPAS; *LAT*, November 2, 1952; *CE*, November 6, 1952.

25. *LAS*, November 6, 1952; *Variety*, October 28, 1952.

26. Last will, Hattie McDaniel; return and petition of John Charles Gross, executor, Hattie McDaniel estate, April 14, 1955, Los Angeles, Superior Court; *CE*, October 30, 1952; Wonderful Smith interview, September 23, 2003; *LAS*, November 6, 1952; Hattie McDaniel clippings, n.d., n.s., George P. Johnson Collection, Special Collections, University Research Library, UCLA.

27. *Los Angeles Tribune*, n.d., Sam McDaniel scrapbook, HMcDC, AMPAS; last will, Hattie McDaniel; "The Passing of Beulah," 12–15; *CE*, November 6, 1952.

28. *LAT*, November 2, 1952; *CE*, November 6, 1952; *Hollywood Reporter*, November 4, 1952.

29. Wonderful Smith interview; *LAT,* November 2, 1952; *CE,* November 6, 1952.

30. *LAT,* November 2, 1952; *CE,* November 6, 1952; clippings, n.s., n.d., Sam McDaniel scrapbook, HMcDC, AMPAS; "Passing of Beulah," 12–15.

31. Last will, Hattie McDaniel; Alice Smith, *It Happened at Allensworth* (Spring Valley, California: Alice Smith, 1997), 23; *CE,* January 13, 1944; Marcia L. Leslie, "The Hattie McDaniel Monument: A Dying Wish Is Honored," *American Visions,* April/May 2000, 42–44; Gordon B. Wheeler, *Black California: The History of African Americans in the Golden State* (New York: Hippocrene Books, 1993), 182.

32. Last will, Hattie McDaniel; *Los Angeles Examiner,* n.d., Sam McDaniel scrapbook, HMcDC, AMPAS.

33. *LAS,* October 30, 1952.

34. For an overview of the mid–twentieth century civil-rights movement, see Taylor Branch, *Parting the Waters: America in the King Years, 1954–1963* (New York: Simon and Schuster, 1988); U.S. Supreme Court, *Brown v. Board of Education,* 347 U.S. 483 (1954); Richard Kluger, *Simple Justice: The History of* Brown v. Board of Education *and Black America's Struggle for Equality* (New York: Alfred A. Knopf, 1987), 635–640.

35. Bogle, *Dandridge,* 505, 545–552; Cripps, *Making,* 284–291 Buckley, *Hornes,* 219–223.

36. For critical discussions of the Mammy image, see Kenneth W. Goings, *Mammy and Uncle Mose: Black Collectibles and American Stereotyping* (Bloomington: Indiana University Press, 1994); Lisa Anderson, *Mammies No More: The Changing Image of Black Women on Stage and Screen* (Lanham: Rowman and Littlefield, 1997); Patricia A. Turner, *Ceramic Uncles and Celluloid Mammies: Black Images and Their Influence on Culture* (New York: Anchor Books, 1994); Janet Davenport, "Remembering Mammy Dearest, Lest We Forget," *Hartford Courant,* November 14, 1999. For a critical appraisal of the Mammy image from *Gone With the Wind,* see the fictional approach of Alice Randall, *The Wind Done Gone* (Boston: Houghton Mifflin, 2001); "Hattie McDaniel's Academy Award Is Lost."

37. Godfrey Cambridge, "A Lot of Laughs, a Lot of Changes," *Tuesday Magazine,* September 1963, n.p. George P. Johnson Collection, Special Collections, University Research Library, UCLA.

38. Bogle, *Toms,* 82–86; *Lincoln Star,* March 17, 1977.

39. *Washington Post,* January 16, 1994; *Guardian,* October 26, 2000; *Chicago Sun-Times,* February 9, 1997; *Plain Dealer,* July 31, 1993; *St. Louis Dispatch,* July 27, 1993.

40. *Houston Chronicle,* October 22, 2000; *Guardian,* October 25, 2000; *Bamboozled* (Forty Acres and A Mule Filmworks, 2000); Spike Lee, *Spike Lee Interviews,* Cynthia Fuchs, ed. (Jackson: University of Mississippi, 2002), 196–197.

41. *Tennessean,* March 22, 1999; *San Francisco Chronicle,* February 4, 2001.

42. *Daily News,* March 26, 2002; *Washington Post,* February 28, 2005.

43. Leslie, "A Dying Wish," 42–44.

44. *CE,* November 13, 1952.

Bibliography

LOCAL, STATE, AND GOVERNMENT DOCUMENTS

CENSUS RECORDS AND GOVERNMENT DOCUMENTS

Kansas State Historical Society, Topeka, Kansas
Kansas State Census, 1895, Wichita, Sedgwick County, Kansas

National Archives and Records Administration, Washington, D.C.
Civil War Pension File, Henry McDaniel, C-2 537 452
Civil War Service Records, Adam McDaniels
Civil War Service Records, Henry McDaniels
Report of Outrages: Leander Wright, Henry McDaniel, Nathan Harris, July 5, 1868,
 Tennessee Register of Outrages, October 1865–68, records of the assistant commis-
 sioner for the State of Tennessee, Bureau of Refugees, Freedmen, and Abandoned
 Lands, 1865–69, National Archives Microfilm Publication, M 999, vol. 34,
 http://freedmensbureau.com/tennessee/outrages/tennoutrages2.htm
Slave Schedules, 1860, Districts 8, 14, Fayetteville, Lincoln County, Tennessee
United States Federal Census, Population Schedules:
 Census, 1840, Berkeley Parish, Virginia
 Census, 1860, District 8, Lincoln County, Tennessee
 Census, 1860, District 14, Lincoln County, Tennessee
 Census, 1870, Boonshill, Lincoln County, Tennessee

Census, 1880, Manhattan, Riley, Kansas
Census, 1900, Denver, Colorado
Census, 1910, Altus, Oklahoma
Census, 1900, 1910, 1920, 1930, Denver, Colorado
Census, 1930, Los Angeles, California
Census, 1930, New York, New York

CITY DIRECTORIES

Ballenger and Richards Denver Directory, 1901, 1902, 1910, 1916, 1917, 1918, 1919, 1923–27
Los Angeles City Directory, 1924, 1925, 1927, 1930–33, 1936–41
Milwaukee City Directory, 1930
San Diego City Directory, 1924

VITAL RECORDS, PUBLIC DOCUMENTS, AND WILLS

Burial Record: Henry McDaniel, December 5, 1922, Riverside Cemetery Burial Records Office, Denver, Colorado

Burial Record: Otis McDaniel, November 15, 1916, Riverside Cemetery Burial Records Office, Denver, Colorado

Burial Record: Susan McDaniel, June 21, 1920, Riverside Cemetery Burial Records Office, Denver, Colorado

Colorado State Reformatory Prisoners' Record, Howard Hickman, Prisoner No. 2213, January 7, 1909, Colorado State Archives, Denver, Colorado

Death Certificate: Hattie McDaniel, October 26, 1952, Los Angeles, California, Vital Records, State of California

Death Certificate: Henry McDaniel, November 30, 1922, Vital Records, Denver, Colorado

Death Record: Lena Gary, October 3, 1942, *California Death Index,* State of California, Department of Health Services

Death Record: Etta G. McDaniel Spaulding, January 13, 1946, *California Death Index,* State of California. Department of Health Services

Fairchild v. Raines, L.A. No. 18735, Supreme Court of California, August 31, 1944

Final Will: John McDaniel, Lincoln County, Tennessee, signed October 16, 1861, proven November 1861, Fayetteville Library, Fayetteville, Tennessee

Fort Collins Post, Records of the Grand Army of the Republic, Colorado, Denver Public Library, Denver Colorado, http://denverlibrary.org/research/genealogy/GAR/gar04.txt

Last Will and Testament: Hattie McDaniel, December 10, 1951, Los Angeles, California

Marriage License: Henry McDaniel and Lou Harris, Lincoln County, Tennessee, January 30, 1868, Lincoln County Library, Fayetteville, Tennessee

Marriage License: Henry McDaniel to Susan Staten (Staton), Nashville, Tennessee, February 9, 1878, Metropolitan Nashville Davidson County Archives

Marriage License: Howard J. Hickman to Hattie H. McDaniel, January 19, 1911, Denver, Colorado, Colorado State Archives

Marriage License, Charles Staton to Susan Holbert, Lincoln County, Tennessee, December 25, 1867, Lincoln County Library, Fayetteville, Tennessee

U.S. Supreme Court, *Brown v. Board of Education,* 347 U.S. 483, 1954

INTERVIEWS

Goodwin, James (telephone), January 23, February 5, 2003 February 19, 23, 2005

Goodwin, Paul (telephone), February 12, 2003, February 5, 2005

Smith, Wonderful, September 23, 2003, Los Angeles, California

PAPERS AND MANUSCRIPTS

Production Code Administration censorship files, Margaret Herrick Library, Academy of Motion Picture Arts and Sciences, Beverly Hills, California

Hattie McDaniel, clipping file, Denver Public Library

David O. Selznik Collection, Harry Ransom Humanities Research Center, University of Texas, Austin

Fox Studio legal files, collection 95, Arts Library, special collections, University Research Library, University of California, Los Angeles

Fredi Washington Papers, 1925–1979, New Orleans, Amistad Research Center, microfilm, 1979

George P. Johnson Collection, special collections, University Research Library, University of California, Los Angeles

Hattie McDaniel Collection and biography file, Margaret Herrick Library, Academy of Motion Picture Arts and Sciences, Beverly Hills, California

NAACP 1940–55, general office files, 1940–45, films, Bethesda, Maryland: University Publications of America, 1993, part 18, series B, reels 15–21

NAACP 1940–55, general office files, publicity protests—Hattie McDaniel, Frederick, Maryland: University Publications of America, 1993, part 15, series B, reel 13

NAACP 1940–55, legal file, restrictive covenants, california, 1940–50, Frederick, Maryland: University Publications of America, c. 1989, part 5, reel 20

Roscoe Conkling Simmons Papers, University Archives, Pusey Library, Harvard University

Sam McDaniel biography file, Margaret Herrick Library, Academy of Motion Picture Arts and Sciences, Beverly Hills, California

Sidney Skolsky Collection, Margaret Herrick Library, Academy of Motion Picture Arts and Sciences, Beverly Hills, California

Warner Bros. Archives, production files, School of Cinema-Television, University of Southern California

NEWSPAPERS

Baltimore Afro-American, 1933, 1935, 1940, 1941, 1943, 1944, 1947, 1948, 1950, 1952
Bridgeport Post, 1947
California Eagle, 1931–52
The Call, 1949
Chicago Daily Tribune, 1929, 1947
Chicago Defender, 1921, 1924, 1926, 1927, 1929–1944, 1950
Chicago Sun-Times, 1997
Citizen News, 1951
Clearfield Progress, 1952
Colorado Springs Gazette, 1912
Colorado Statesman, 1905–25, 1928, 1941, 1951
Council Bluffs Nonpareil, 1951
The Crisis, 1940
Denver Post, 1908, 1916, 1925, 1941
Denver Star, 1914–18, 1941, 1942
Dixon Evening Telegraph, 1948–52
East Liverpool Review, 1951
Edwardsville Intelligencer, 1940
Franklin's Statesman, 1908–10
Frederick Post, 1939
Guardian, 2000
Helena Independent Record, 1952
Hollywood Reporter, 1935, 1936, 1939, 1940, 1941, 1946, 1952
The Houston Chronicle, 2000
Humbolt Standard, 1952
Independent Record, 1944
Lima News, 1937, 1942
Lincoln Star, 1977
Literary Digest, 1934
London Times, 1999
Los Angeles Daily News, 1951
Los Angeles Examiner, 1934, 1936, 1937, 1940, 1944, 1949, 1950
Los Angeles Sentinel, 1937, 1939, 1940, 1946, 1949, 1950, 1952
Los Angeles Times, 1925, 1931, 1932, 1933, 1939, 1940, 1945, 1952, 1981
Mansfield News Journal, 1951
Milwaukee Journal, 1930
Motion Picture Daily, 1935
Motion Picture Herald, 1939
Mount Pleasant News, 1951
Nevada State Journal, 1939
New York Age, 1908, 1910, 1937
New York Amsterdam News, 1934, 1935, 1939, 1940, 1941, 1942, 1944, 1946, 1949, 1952
New York Times, 1920, 1934, 1935, 1936, 1939, 1940, 1946, 1948, 1951, 1952

People's Voice, 1942, 1946
People's World, 1947
Pittsburgh Courier, 1934, 1936, 1937, 1938, 1939, 1940, 1942, 1946
Plains Dealer, 1993
Portland Herald Express, 1950
Rocky Mountain News, 1941, 1948, 1992
Salisbury Times, 1953, 1960
San Diego Union, 1925
San Francisco Chronicle, 2001
Tennessean, 1999
Union Bulletin, 1952
Variety, 1924, 1925, 1929, 1930, 1933–43, 1946, 1952
Village Voice, 1978
Voice of the People, 1942
Washington Post, 1994, 2005

AUDIO RECORDINGS AND SHEET MUSIC

The Beulah Show, 1947–50, Old Time Radio Today compact disc, 2004
The Beulah Show, October 26–29, 1948, cassette transcriptions, Margaret Herrik Library, Academy of Motion Picture Arts and Sciences, Beverly Hills, California
The Eddie Cantor Show, December 23, 1942, original cast cassette tapes, 1994
More of the Best of Amos 'n' Andy, Peaceful Productions compact disc, 1990
McDaniel, Hattie, "Boo Hoo Blues" and "I Wish I Had Somebody," OKeh 8434, recorded November 17, 1926, *Female Blues Singers: Complete Recorded Works and Supplements, 1922–1935,* vol. XII, Document Records compact disc, 1997
McDaniel, Hattie, "Just One Sorrowing Heart" and "I Thought I'd Do It," OKeh 8569, recorded December 14, 1927, *Tiny Parham and the Blues Singers, Complete Recorded Works, 1926–1928,* Document Records compact disc, 1995
McDaniel, Hattie, "Any Kind of Man Would Be Better Than You" and "That New Love Maker of Mine," recorded c. 1929, Pm 12790, *Hot Clarinets: Jimmy O'Brien and Vance Dixon, Complete Recordings in Chronological Order, 1923–1931,* RST Records compact disc, 1995
McDaniel, Hattie, and Papa Charlie Jackson, "Dentist Chair Blues, Part One and Two," recorded c. March 1929, Pm 12751, *Papa Charlie Jackson: Complete Recorded Works In Chronological Order, 3 September 1928 to 26 November 1934,* vol. III, Document Records compact disc, 1991
Williams, Bert A., and Alex Rogers, "Nobody," New York: Gotham-Attucks Music Co., 1905

FILMS, DVD, AND VIDEO RECORDINGS

Alice Adams, 1935, RKO, rereleased Turner Home Entertainment, 1989
Bamboozled, 2000, Forty Acres and a Mule Filmworks

Beyond Tara: The Extraordinary Life of Hattie McDaniel, producer Madison Davis Lacy, 2001, Firethorn Production

Beulah, ABC, fall 1951, rereleased on Classic TV, *Black Artists of the Silver Screen,* vol. I, n.d.

The Birth of a Nation, 1915, D. W. Griffith, rereleased Republic Pictures, 1991

Blonde Venus, 1932, Paramount, rereleased MCA/Universal Home Video, 1993

Boiling Point, 1932, Allied Pictures Corporation, rereleased VCI Home Video, 1995

Carefree, 1938, RKO

China Seas, 1935, MGM, rereleased MGM/UA Home Video, 1990

Ed Wynn Show, CBS, fall 1949

George Washington Slept Here, 1942, Warner Bros., rereleased MGM/UA Home Video, 1992

Gone With the Wind, 1939, MGM, rereleased Warner Home Video, 1999

Gone With the Wind: The Making of a Legend, 1989, producers Daniel Mayer Selznick and L. Jeffrey Selznick, MGM/UA Studios

The Great Lie, 1941, Warner Bros., rereleased MGM/UA Home Video, 1990

I'm No Angel, 1933, Paramount, rereleased MCA/Universal, 1993

Imitation of Life, 1934, Universal Studios, rereleased by Universal Pictures Corporation, 1998

In This Our Life, 1942, Warner Bros. rereleased MGM/UA Home Video, 1990

Judge Priest, 1934, Fox Studios, rereleased Alpha Video Distributors, 1995

The Little Colonel, 1935, Fox Studios, rereleased CBS/Fox Playhouse Video, 1988

Little Men, 1934, Mascot Pictures

Mad Miss Manton, 1938, RKO

The Male Animal, 1942, Warner Bros., rereleased MGM/UA Home Video, 1995

Maryland, 1940, Fox

The Nicholas Brothers, 2000, A&E Home Video

Nothing Sacred, 1937, Selznick International Pictures, rereleased VCI Home Video, 1995

The Postal Inspector, 1936, Universal Studios

Public Enemy, 1931, Warner Bros., rereleased MGA/UA Home Video, 1989

Saratoga, 1937, MGM, rereleased MGM/UA Home Video, 1992

Show Boat, 1936, Universal Studios, rereleased MGM/UA Home Video, 1990

The Shining Hour, 1938, MGM, rereleased MGM/UA Home Video, 1992

Shopworn Angel, 1938, MGM, rereleased MGM/UA Home Video, 1994

Since You Went Away, 1944, Selznick International Pictures, rereleased Anchor Bay Entertainment, 2000

Song of the South, 1946, Disney Studios

Stella Dallas, MGM, 1937, rereleased MGM/UA Home Video, 2000

Thank Your Lucky Stars, 1943, Warner Bros., Studio, rereleased MGM/UA Home Video, 1987

They Died With Their Boots On, 1941, Warner Bros. Studio, rereleased MGM/UA Home Video, 1997

BOOKS AND ARTICLES

Abbot, Lynn, and Doug Seroff. *Out of Sight: The Rise of African American Popular Music.* Jackson Mississippi: University Press of Mississippi, 2002.

Albertson, Chris. *Bessie.* New York: Stein and Day, 1972.

The American Film Institute Catalog of Motion Pictures Produced in the United States: Personal Name Index, Feature Films, 1931–1940. Berkeley: University of California Press, 1993.

The American Film Institute Catalog of Motion Pictures Produced in the United States: Personal Name Index, Feature Films, 1941–1950. Berkeley: University of California Press, 1999.

Ames, Jerry, and Jim Siegelman. *The Book of Tap: Recovering America's Long Lost Dance.* New York: David McKay Company, Inc., 1977.

Anderson, Lisa. *Mammies No More: The Changing Image of Black Women on Stage and Screen.* Lanham: Roman and Littlefield, 1997.

Athearn, Robert G. *In Search of Canaan: Black Migration to Kansas, 1879–1880.* Lawrence, Kansas: Regents Press of Kansas, 1978.

Bailey, Anne. "The USCT in the Confederate Heartland, 1864." In *Black Soldiers in Blue: African-American Troops in the Civil War Era.* John David Smith, ed. Chapel Hill: University of North Carolina Press, 2002.

Bass, Charlotta. *Forty Years: Memoirs From the Pages of a Newspaper.* Los Angeles: Charlotta A. Bass, 1960.

Bean, Annamarie. "Black Minstrelsy and Double Inversion, Circa 1890." In *African American Performance and Theater History.* Harry J. Elam and David Krasner, eds. New York: Oxford University Press, 2001.

Bergreen, Laurence. *Louis Armstrong: An Extravagant Life.* New York: Broadway Books, 1997.

Berlin, Ira. *Many Thousands Gone: The First Two Centuries of Slavery in North America.* Cambridge: Harvard University Press, 1998.

Black, Gregory. *Hollywood Censored: Morality Codes, Catholics, and the Movies.* Cambridge: Cambridge University Press, 1994.

Blassingame, John W. *The Slave Community: Plantation Life in the Antebellum South.* 2nd ed. New York: Oxford University Press, 1979.

Bogdanovich, Peter. *John Ford.* Berkeley: University of California Press, 1978.

Bogle, Donald. *Dorothy Dandridge: A Biography.* New York: Amistad, 1997.

Bogle, Donald. *Toms, Coons, Mulattoes, Mammies, and Bucks: An Interpretive History of Blacks in American Films.* New York: Continuum, 1990.

Branch, Taylor. *Parting the Waters: America in the King Years, 1954–1963.* New York: Simon and Schuster, 1988.

Bridges, Herb. *The Filming of "Gone With the Wind".* Macon, Georgia: Mercer University Press, 1984.

Bridges, Herb. *"Gone With the Wind": The Three-Day Premiere in Atlanta.* Macon, Georgia: Mercer University Press, 1999.

Bryant, Clora. *Central Avenue Sounds.* Berkeley: University of California Press, 1998.

Buckley, Gail Lumet. *The Hornes: An American Family*. New York: Alfred A. Knopf, 1988.

Bunch III, Lonnie G. "A Past Not Necessarily Prologue: The Afro-American in Los Angeles Since 1930." In *20th Century Los Angeles: Power, Promotion, and Social Conflict*. Norman M. Klein and Martin J. Schiesl, eds. Claremont, California: Regina Books, 1990.

Bundles, A'lelia. *On Her Own Ground: The Life and Times of Madam C. J. Walker*. New York: Scribner, 2001.

Cain, Captain W. S. *Autobiography of Captain W. S. Cain*. Topeka: Crane and Company, 1908.

Cameron, Judy, and Paul J. Christman. *The Art of Making "Gone With the Wind."* New York: Prentice Hall, 1989.

Carson, Claybourne, Ralph Luker, and Penny Russell, eds. *The Papers of Martin Luther King Jr.: Called to Serve, January 1929–June 1951*. Vol. I. Berkeley: University of California Press, 1992.

Chaudhuri, Nupur. "We All Seem Like Brothers and Sisters: The African-American Community in Kansas." *Kansas History*, Winter 1991/92, 270–288.

Cimprich, John. "The Fort Pillow Massacre: Assessing the Evidence." In *Black Soldiers in Blue: African-American Troops in the Civil War Era*. John David Smith, ed. Chapel Hill: University of North Carolina Press, 2002.

Cimprich, John. *Slavery's End in Tennessee, 1861–1865*. Tuscaloosa: University of Alabama Press, 1985.

Clark-Lewis, Elizabeth. *Living In, Living Out: African-American Domestics in Washington D.C., 1910–1940*. Washington, D.C.: Smithsonian Institution Press, 1994.

Cripps, Thomas. *Making Movies Black: The Hollywood Message Movie from World War II to the Civil Rights Era*. New York: Oxford University Press, 1993.

Cripps, Thomas. *Slow Fade to Black: The Negro in American Film, 1900–1942*. New York: Oxford University Press, 1977.

Cripps, Thomas. "Winds of Change: *Gone With the Wind* and Racism as a National Issue." In *Recasting "Gone With the Wind" in American Culture*. Darden Asbury Pyron, ed. Miami: University Presses of Florida, 1983.

Crosby, Gary and Ross Firestone. *Going My Own Way*. Garden City, New York: Doubleday, 1983.

Davenport, Janet. "Remembering Mammy Dearest, Lest We Forget," *Hartford Courant*, November 14, 1999.

Davis, Angela. *Blues Legacy and Black Feminism: Gertrude "Ma" Rainey, Bessie Smith, and Billie Holiday*. New York: Pantheon, 1998.

Davis, Bette. *The Lonely Life: An Autobiography*. New York: G. P. Putnam's Sons, 1962.

"Did You Know?" *The Giles County Historical Bulletin*, October 2000, 23.

DiMeglio, John E. *Vaudeville U.S.A.* Bowling Green: Bowling Green University Press, 1973.

Douglas, Ann. *Terrible Honesty: Mongrel Manhattan in the 1920s*. New York: Noonday, 1995.

Duberman, Martin Bauml. *Paul Robeson*. New York: Alfred A. Knopf, 1988.

Du Bois, W. E. B. *Black Reconstruction in America.* Cleveland: World Publishing Company, 1964. Reprint of 1935 edition.

Dumenil, Lynn. *Modern Temper: American Culture and Society in the 1920s.* New York: Hill and Wang, 1995.

Dunaway, Wilma. "Put in Master's Pocket: Interstate Slave Trading and the Black Appalachian Diaspora." In *Appalachians and Race: The Mountain South from Slavery to Segregation.* John Inscoe, ed. Lexington: University Press of Kentucky, 2001.

Dunbar, Paul Laurence. *Lyrics of Lowly Life.* New York: Dodd, Mead and Company, 1909.

Dunning, John. *On the Air: The Encylopedia of Old Time Radio.* New York: Oxford University Press, 1998.

Eastman, Ralph. " 'Pitchin' Up a Boogie': African-American Musicians, Nightlife, and Musical Venues in Los Angeles, 1930–1945." In *California Soul: Music of African Americans in the West.* Jacqueline Cogdell DjeDje and Eddie S. Meadows, eds. Berkeley: University of California Press, 1998.

Eddy, Mary Baker. *Science and Health: With Key to the Scriptures.* Boston: Christian Science Board of Directors, 1994.

Eick, Gretchen Cassel. *Dissent in Wichita: The Civil Rights Movement.* Chicago: University of Illinois Press, 2001.

Eliot, Marc. *Walt Disney: Hollywood's Dark Prince.* New York: HarperCollins, 1994.

Everett, Anna. *Returning the Gaze: A Genealogy of Black Film Criticism, 1909–1949.* Durham: Duke University Press, 2001.

Flamini, Roland. *Scarlett, Rhett, and a Cast of Thousands.* New York: Macmillan Publishing Co., 1975.

Fleming, G. James, and Christian E. Burckel, eds. *Who's Who in Colored America.* Yonkers: Christian E. Burckel and Associates, 1950.

Fletcher, Tom. *100 Years of the Negro in Show Business: The Tom Fletcher Story.* New York: Burdge, 1954.

Fogel, Robert William, and Stanley L. Engerman. *Time on the Cross: The Economics of American Negro Slavery.* Boston: Little, Brown and Company, 1974.

Franklin, John Hope. *From Slavery to Freedom: A History of Negro Americans.* New York: Alfred A. Knopf, 1988.

Freeman, Henry V. "A Colored Brigade in the Campaign and Battle of Nashville." *Military Essays and Recollections.* Vol. II. Chicago: A. C. McClurg and Company, 1894.

Friedrich, Otto. *City of Nets: A Portrait of Hollywood in the 1940s.* Berkeley: University of California Press, 1986.

Gabler, Neal. *An Empire of Their Own: How the Jews Invented Hollywood.* New York: Anchor Books, 1988.

Gates Jr., Henry Louis. *The Signifying Monkey: A Theory of African-American Literary Criticism.* New York: Oxford University Press, 1988.

Genovese, Eugene D. *Roll Jordan Roll: The World the Slaves Made.* New York: Random House, 1974.

George, Carol V. R. *God's Salesman: Norman Vincent Peale and the Power of Positive Thinking.* New York: Oxford University Press, 1993.

George, Carol V. R. *Segregated Sabbaths: Richard Allen and the Rise of Independent Black Churches, 1760–1840.* New York: Oxford University Press, 1973.

Goings, Kenneth. W. *Mammy and Uncle Mose: Black Collectibles and American Stereotyping.* Bloomington: Indiana University Press, 1994.

Goldberg, Robert. *Hooded Empire: The Ku Klux Klan in Colorado.* Urbana: University of Illinois Press, 1981.

"Gone With the Wind" as Book and Film. Richard Harwell, ed. Columbia: University of South Carolina Press, 1983.

Goodspeed's History of Tennessee from the Early Times to the Present, Together with a Historical Account and Biographical Sketch of Lincoln County. Nashville: Goodspeed Publishing Company, 1887.

Goodwin, Ruby Berkley. *From My Kitchen Window.* New York: Wendell Malliet and Company, 1942.

Goodwin, Ruby Berkley. *It's Good to Be Black.* Garden City: Doubleday, 1953.

Haddad-Garcia, George. "Mae West: Everybody's Friend." *Black Stars,* April 1981, 62–64.

Hargrove, Hondon B. *Black Union Soldiers in the Civil War.* Jefferson, North Carolina: McFarland, 1988.

Harris, Sheldon. *Blues Who's Who: A Biographical Dictionary of Blues Singers.* New York: Da Capo, 1979.

Haskins, Jim, and N. R. Mitgang. *Mr. Bojangles: The Biography of Bill Robinson.* New York: William Morrow, 1988.

Hatch, James, and Leo Hamalian, eds. *Lost Plays of the Harlem Renaissance 1920–1940.* Detroit: Wayne State University Press, 1996.

"Hattie Gets Hitched." *Our World,* September 1949, 48–50.

"Hattie McDaniel's Academy Award Is Lost." *Jet,* April 13, 1988, 33.

"Hattie McDaniel." *Current Biography,* 1940.

"Hattie Throws a Party: Film Stars Help Star of *Beulah* Show Celebrate Radio Success." *Ebony,* December 1949, 92–97.

Hauser, Gayelord. *Look Younger and Live Longer.* New York: Farrar, Strauss, and Young, 1951.

Herr, George W. *Episodes of the Civil War: Nine Campaigns in Nine States.* San Francisco: Bancroft Company, 1890.

Higham, Charles. *Ziegfeld.* Chicago: Henry Regency Company, 1972.

Hilliard, Sam Bowers. *Atlas of Antebellum Southern Agriculture.* Baton Rouge: Louisiana State University, 1984.

Holden, Anthony. *Behind the Oscar: The Secret History of the Academy Awards.* New York: Simon and Schuster, 1993.

hooks, bell. *Talking Back: Thinking Feminist, Thinking Black.* Boston: South End Press, 1989.

Horn, Maurice, ed. *The World Encyclopedia of Cartoons.* New York: Chelsea House, 1980.

Horne, Lena, and Richard Schickel. *Lena.* New York: Limelight, 1986. Reprint of 1965 edition.

Huggins, Nathan Irvin. *Harlem Renaissance*. New York: Oxford University Press, 1971.

Hurst, Jack. *Nathan Bedford Forrest: A Biography*. New York: Alfred A. Knopf, 1993.

Jackson, Carlton. *Hattie: The Life of Hattie McDaniel*. Lanham, Maryland: Madison Books, 1990.

Jackson II, Eugene W. with Gwendolyn Sides St. Julian. *Eugene "Pineapple" Jackson: His Own Story*. Jefferson, North Carolina: McFarland and Company, 1999.

Janken, Kenneth Robert. *White: The Biography of Walter White, Mr. NAACP*. New York: The New Press, 2003.

Kaye, Andrew. "Roscoe Conkling Simmons and the Significance of African-American Oratory." *The Historical Journal*, vol. 45, no. 1, 2002, 79–102.

Kenney, William Howland. *Chicago Jazz: A Cultural History, 1904–1930*. New York: Oxford University Press, 1993.

Keyes, Evelyn. *Scarlett O'Hara's Younger Sister: My Lively Life In and Out of Hollywood*. Secaucus, New Jersey: Lyle Stuart Inc., 1977.

Kluger, Richard. *Simple Justice: The History of* Brown v. Board of Education *and Black America's Struggle for Equality*. New York: Alfred A. Knopf, 1987.

Koppes, Clayton R. and Gregory D. Black. "Blacks, Loyalty, and Motion Picture Propaganda in World War II." *Journal of American History*, September 1986, 383–406.

Krasner, David. *Resistance, Parody, and Double Consciousness in African-American Theatre, 1895–1910*. New York: St. Martin's Press, 1997.

Kroeger, Brooke. *Fannie: The Talent for Success of Writer Fannie Hurst*. New York: Times Books, 1999.

Laird, Ross. *Moanin' Low*. Westport, Connecticut: Greenwood Press, 1996.

Lamon, Lester C. *Blacks in Tennessee, 1791–1970*. Knoxville: University of Tennessee Press, 1981.

Laurie, Joe. *Vaudeville: From the Honky-Tonks to the Palace*. New York: Henry Holt and Company, 1953.

Leah, David. *From Sambo to Superspade: The Black Experience in Motion Pictures*. New York: Houghton Mifflin, 1973.

Lee, Spike. *Spike Lee Interviews*. Cynthia Fuchs, ed. Jackson: University of Mississippi, 2002.

Leff, Leonard. J. *Selznick and Hitchcock: The Rich and Strange Collaboration of Alfred Hitchcock and David O. Selznick in Hollywood*. New York: Weidenfeld and Nicolson, 1987.

Leonard, Stephen J., and Thomas J. Noel. *Denver: Mining Camp to Metropolis*. Niwot, Colorado: University of Colorado Press, 1990.

Leslie, Marcia L. "The Hattie McDaniel Monument: A Dying Wish Is Honored." *American Visions*, April/May 2000, 42–44.

Lewis, David Levering. *When Harlem Was in Vogue*. New York: Vintage, 1982.

Litwack, Leon. *Been in the Storm So Long: The Aftermath of Slavery*. New York: Vintage Books, 1980.

Lott, Eric. *Love and Theft: Blackface Minstrelsy and the American Working Class*. New York: Oxford University Press, 1995.

McBride, Joseph. *Searching for John Ford*. New York: St. Martin's Press, 2001.

Marsh, Helen Crawford, and Timothy Richard Marsh. *Abstracts of Wills, Lincoln County Tennessee, 1810–1895.* Shelbyville, Tennessee: Marsh Historical Publications, 1977.

Memo From David O. Selznick. Rudy Behlmer, ed. New York: Viking Press, 1972.

Meyer, Stephen Grant. *As Long as They Don't Move Next Door: Segregation and Racial Conflict in American Neighborhoods.* New York: Rowman and Littlefield Publishers, 2000.

Miller, Loren. "Hollywood's New Negro Films." *The Crisis,* January 1938, 8–9.

Miller, Loren. "Uncle Tom in Hollywood." *The Crisis,* November 1934, 329, 336.

"Minnesota in the Battles of Nashville, December 15 and 16, 1864." *Collections of the Minnesota Historical Society,* vol. XII. St. Paul: The Society, 1908, 612.

Mitchell, Lisa. " 'Mammy' McDaniel as the Definitive Matriarch." *Los Angeles Times Calendar,* November 7, 1976, 30.

Mitchell, Margaret. *Gone With the Wind.* New York: Warner Books, 1999. Reprint of 1936 edition.

Mitchell, Margaret. *Gone With the Wind Letters, 1936–1949.* Richard Hartwell, ed. New York: Macmillan Publishing Co., 1976.

Molt, Cynthia Marylee. *Gone With the Wind: A Complete Reference.* Jefferson, North Carolina: McFarland and Company, 1990.

Morgan, Edmund S. *American Slavery, American Freedom: The Ordeal of Colonial Virginia.* New York: W. W. Norton and Company, 1975.

Mosely, Leonard. *Zanuck: The Rise and Fall of Hollywood's Last Tycoon.* Little, Brown, and Company, 1984.

"Movie Maids." *Ebony,* August 1948, 56–59.

Morris, Clyde. *Our Virginia Ancestors: Morris Family–Spotsylvania County, Duerson Family–Spotsylvania County, Sale Family–Caroline County, Thomas Family–Caroline County, and Others.* Fairfax: C. L. Morris, 1988.

"Movies." *Our World,* March 1948, 45.

Muse, Clarence. *The Dilemma of the Negro Actor.* Los Angeles: Clarence Muse publisher, 1934.

Muse, Clarence, and David Arlen. *Way Down South.* Hollywood, California: David Graham Fischer Publisher, 1932.

Myrick, Susan. *White Columns in Hollywood: Reports From the "GWTW" Sets.* Macon, Georgia: Mercer University Press, 1982.

Nachman, Gerald. *Raised on Radio.* New York: Pantheon, 1988.

Neal, Steve. *Dark Horse: A Biography of Wendell Willkie.* Garden City, New York: Doubleday, 1984.

Newman, Richard. *Words Like Freedom: Essays on African-American Culture and History.* West Cornwall, Connecticut: Locust Hill, 1996.

Osbourne, Robert. *70 Years of the Oscar: The Official History of the Academy Awards.* New York: Abbeville Press, 1999.

Painter, Nell Irvin. *Exodusters: Black Migration to Kansas After Reconstruction.* New York: W. W. Norton and Company, 1986.

"The Passing of Beulah." *Our World,* February 1953, 12–15.

Pines, Jim. *Blacks in Films: A Survey of Racial Themes and Images in American Films.* London: Studio Vista, 1975.

Platt, David. "The Klan Will Ride Again in *Gone With the Wind.*" *The Daily Worker,* October 29, 1936, 7.

Pratt, William. *Scarlett Fever.* New York: Macmillan and Company, 1977.

Pyron, Darden Asbury. *Southern Daughter: The Life of Margaret Mitchell.* New York: HarperPerennial, 1991.

Quarles, Benjamin. *The Negro in the Civil War.* New York: Da Capo Press, 1989. Reprint of 1953 edition.

Raboteau, Albert J. *Slave Religion: The "Invisible Institution" in the Antebellum South.* New York: Oxford University Press, 1978.

Rampersad, Arnold. *The Life of Langston Hughes: I Too Sing America.* Vol. I. New York: Oxford University Press, 1986.

Randall, Alice. *The Wind Done Gone.* Boston: Houghton Mifflin, 2001.

Raye, Martha. "Harlem Taught Me to Sing." *Ebony,* November 1954, 56.

Reagan, Ronald, with Richard G. Hubler. *Where's the Rest of Me? The Autobiography of Ronald Reagan.* New York: Karz Publishers, 1981. Reprint of 1965 edition.

Richards, Larry. *African-American Films Through 1959.* Jefferson, North Carolina: McFarland and Company, 1998.

Roediger, David. *The Wages of Whiteness: Race and the Making of the American Working Class.* New York: Verso, 1991.

Rose, Frank. *The Agency: William Morris and the Hidden History of Show Business.* New York: HarperBusiness, 1995.

Sampson, Henry T. *Blacks in Blackface: A Source Book on Early Black Musical Shows.* Metuchen, New Jersey: Scarecrow Press, 1980.

Saxton, Alexander. *The Rise and Fall of the White Republic: Class Politics and Mass Culture in Nineteenth Century America.* New York: Verso, 1990.

Schatz, Thomas. *The Genius of the System: Hollywood Filmmaking in the Studio Era.* New York: Henry Holt and Company, 1988.

Schuller, Gunther. *Early Jazz: Its Roots and Musical Development.* New York: Oxford University Press, 1986.

Seldes, Gilbert. "Sugar and Spice and Not So Nice." *Esquire,* March 1934, 60, 120.

Shaffer, Donald R. *After the Glory: The Struggles of Black Civil War Veterans.* Lawrence, Kansas: University Press of Kansas, 2004.

Sies, Leora M., and Luther F. Sies. *The Encyclopedia of Women in Radio, 1920–1960.* Jefferson, North Carolina: McFarland and Company, 2003.

Sklar, Robert. *Movie Made America: A Cultural History of American Movies.* New York: Vintage, 1975.

Slave Narratives: A Folk History of Slavery in the United States from Interviews with Former Slaves. Washington D.C.: Library of Congress Microfilm, 1941.

Slide, Anthony. *The Vaudevillians: A Dictionary of Vaudeville Performers.* Westport, Connecticut: Arlington House, 1981.

Smith, Alice. *It Happened at Allensworth.* Spring Valley, California: Alice Smith, 1977.

Smith, Eric Ledell. *Bert Williams: A Biography of the Pioneer Black Comedian*. Jefferson, North Carolina: McFarland and Company, 1992.

Smith, John David. "Let Us All Be Grateful That We Have Colored Troops That Will Fight." In *Black Soldier in Blue: African-American Troops in the Civil War Era*. John David Smith, ed. Chapel Hill: University of North Carolina Press, 2002.

Sonnier Jr., Austin. *A Guide to the Blues: History, Who's Who, Research Sources*. Westport, Connecticut: Greenwood Press, 1994.

Southern, Eileen. *The Music of Black Americans: A History*. New York: W. W. Norton and Company, 1971.

Spear, Allen H. *Black Chicago: The Making of a Negro Ghetto, 1890–1920*. Chicago: University of Chicago Press, 1967.

Spicer, Chrystopher J. *Clark Gable: Biography, Filmography, Bibliography*. Jefferson, North Carolina: McFarland and Company, 2002.

Stevens, Ashton. *Actorviews*. Chicago: Covici-McGee Company, 1923.

Stevens, John D. "Black Reaction to *Gone With the Wind*." *The Journal of Popular Film and Television*, Fall 1973, 366–371.

Sturtevant, Victoria. " 'But Things Is Changin' Nowadays an' Mammy's Gettin' Bored': Hattie McDaniel and the Culture of Dissemblance." *The Velvet Light Trap*, Fall 1999, 68–79.

Summers, Harrison B., ed. *A Thirty-Year History of Programs Carried on National Radio Networks in the United States, 1926–1956*. New York: Arno Press and the *New York Times*, 1971.

Summers, Rev. O. "The Negro Soldiers in the Army of the Cumberland." In George W. Herr, *Episodes of the Civil War: Nine Campaigns in Nine States*. San Francisco: Bancroft Company, 1890.

Sutton, Allan. *American Record Labels and Companies: An Encyclopedia, 1891–1943*. Denver: Mindspring Press, 2000.

Taylor, Quintard. *In Search of the Racial Frontier: African Americans in the American West, 1528–1990*. New York: W. W. Norton, 1998.

Temple, Shirley. *Child Star: An Autobiography*. New York: Warner Books, 1988.

Tennesseans in the Civil War. Vol. I. Nashville: Civil War Centennial Commission, 1964.

Thomas, Bob. *Selznick*. Garden City, New York: Doubleday and Company Inc., 1970.

Thomson, David. *Showman: The Life of David O. Selznick*. New York: Alfred A. Knopf, 1992.

Tracy, James F. "Revisiting a Polysemic Text: The African-American Press's Reception of *Gone With the Wind*." *Mass Communication and Society*. Vol. IV, 2001, 419–436.

Tolson, Melvin B. *Caviar and Cabbage: Selected Columns by Melvin B. Tolson from the "Washington Tribune"*. Columbia: University of Missouri Press, 1982.

Tumber, Catherine. *American Feminism and the Birth of New Age Spirituality*. New York: Rowman and Littlefield, 2002.

Turner, Patricia A. *Ceramic Uncles and Celluloid Mammies: Black Images and Their Influence on Culture*. New York: Anchor Books, 1994.

Tyler, Bruce. *Harlem to Hollywood: The Struggle for Racial and Cultural Democracy*. New York: Garland Publishing, 1992.

Vaughan, Stephen. "Ronald Reagan and the Struggle for Black Dignity." *Journal of African-American History,* Winter 2002, 83–97.

Vose, Clement E. *Caucasians Only: The Supreme Court, the NAACP, and the Restrictive Covenant Cases.* Berkeley: University of California Press, 1959.

Walker, Aida Overton. "Colored Men and Women on the Stage." *Colored American Magazine,* October 1905, 571.

Walker, Aida Overton. "Opportunities the Stage Offers Intelligent and Talented Women." *New York Age,* December 24, 1908.

Walker, George. "The Real 'Coon' on the American Stage." *Theatre Magazine,* August 1906, 22–24.

Washburn, Patrick. "The Pittsburgh Courier's Double V Campaign in 1942." *American Journalism,* 1986, Vol. III, no. 2, 73–86.

Washington, Booker T. "Interesting People: Bert Williams." *American Magazine,* September 1910, 600–640.

Waters, Ethel with Charles Samuels. *His Eye Is on the Sparrow: An Autobiography of Ethel Waters.* Garden City, New York: Doubleday, 1951.

Watkins, Mel. *On the Real Side: Laughing, Lying, and Signifying: The Underground Tradition of African-American Humor That Transformed American Culture From Slavery to Richard Pryor.* New York: Simon and Schuster, 1994.

Watts, Jill. *God, Harlem U.S.A.: The Father Divine Story.* Berkeley: University of California Press, 1992.

Weiss, Richard. *The American Myth of Success: From Horatio Alger to Norman Vincent Peale.* New York: Basic Books, 1969.

Weisbrot, Robert. *Father Divine and the Struggle for Racial Equality.* Urbana: University of Illinois Press, 1983.

Wheeler, Gordon B. *Black California: The History of African Americans in the Golden State.* New York: Hippocrene Books, 1993.

White, Walter. *A Man Called White: The Autobiography of Walter White.* New York: Viking Press, 1948.

Wilkerson, Tichi, and Marcy Borie. *The Hollywood Reporter: The Golden Years.* New York: Coward-McCann Inc., 1984.

Wright, Richard. *Black Boy,* New York: Harper and Brothers Publishers, 1937.

Yagoda, Ben. *Will Rogers: A Biography.* New York: Alfred A. Knopf, 1993.

Ziegfeld, Richard, and Paulette Ziegfeld. *The Ziegfeld Touch: The Life and Times of Florenz Ziegfeld, Jr.* New York: Harry Abrams, Inc, 1993.

Index

A professor of history and coordinator of the film studies program at California State University, San Marcos, Jill Watts has written two previous books, *God, Harlem U.S.A: The Father Divine Story* and *Mae West: An Icon in Black and White*.